GEORGIAN CANADA
Conflict and Culture
1745-1820

GEORGIAN CANADA
Conflict & Culture

This exhibition has been organized
by the Royal Ontario Museum and is presented
Under the gracious Patronage of Her Majesty The Queen
with the generous support of the
Ontario Ministry of Citizenship and Culture
in celebration of the Bicentennial of Ontario.

René Villeneuve

GEORGIAN CANADA
Conflict and Culture
1745-1820

Donald Blake Webster
with Michael S. Cross and Irene Szylinger

RÕM
Royal Ontario Museum

© The Royal Ontario Museum, 1984
100 Queen's Park, Toronto, Canada M5S 2C6
ISBN 0-88854-309-3

Cover photograph: *The Death of Wolfe* by Benjamin West (see no. 44).

Typesetting by Alpha Graphics
Printed in Canada by McLaren Morris and Todd Limited
Bound in Canada by John Deyell Company

Canadian Cataloguing in Publication Data
Webster, Donald Blake, 1933–
 Georgian Canada

Catalogue of an exhibition held at the Royal Ontario
Museum, Toronto, Ont., June 7–Oct. 21, 1984.
Bibliography: p.
ISBN 0-88854-309-3

1. Antiques–Ontario–Exhibitions. 2. Art, Modern–
18th century–Ontario–Exhibitions. 3. Art, Modern–
19th century–Ontario–Exhibitions. I. Cross,
Michael S., 1938– II. Szylinger, Irene. III. Royal
Ontario Museum. IV. Title.

N6546.06W42 1984 709'.713'0740113541 C84-098568-1

Mary Terziano, editor
Jean Lightfoot, designer
Hugh Porter, production coordinator

CONTENTS

FOREWORD

In 1784 refugees of the War of American Independence, who became known as United Empire Loyalists, began to move into the areas around the northern shores of the St Lawrence, Lake Ontario, and Lake Erie. Some ten thousand of these people settled in what is now the Province of Ontario, and the subsequent two centuries of development is now being celebrated.

Over these two centuries Ontario has emerged from an unsettled wilderness to become one of the most advanced and prosperous regions in the world. During the first thirty years the population increased tenfold. Before 1800, over a million acres of farmland had been settled and we quickly became agricultural and commodities exporters, shipping over eight million bushels of wheat alone by 1802. Our industrial and manufacturing strength also took root in that first generation; by 1820 we were producing everything from furniture and ceramics to milled lumber and cast iron.

Our original Loyalist settlers, and those who have come after them, have been of many national, linguistic, and cultural origins, and Ontario has evolved into today's multicultural society. We began as, and we continue to be, a society that encourages initiative, individuality, and diversity. Through stresses and strains, through sacrifices, through vision and perseverance, we have built a strong and vibrant province within a strong and vibrant nation.

I commend the Royal Ontario Museum for organizing this splendid and dramatic exhibition in honour of Ontario's Bicentennial and for showing us in such a colourful way the age, the conditions, and the conflicts from which we have emerged. A look at Ontario today, and the realization of what we have managed to do from new beginnings in a new land, should strengthen our confidence in what lies ahead in the next two centuries.

William G. Davis
Premier of Ontario

The Ontario Bicentennial, which commemorates the first major settlement of this province in 1784 by Loyalists from the newly independent United States, has particular meaning to the Royal Ontario Museum. From its inception more than seventy years ago, the Museum has been deeply rooted both in Ontario history and in contemporary Ontario society. Its scientific and cultural collections and its educational programmes and services now rank it among the great museums on the continent and second to none in Canada. The Museum is also a unique and respected teaching and research institution, and its influence through staff operations and achievements today extends around the world.

We are particularly gratified to be presenting *Georgian Canada: Conflict and Culture* during the Bicentennial year. Composed of treasures assembled from more than fifty lenders, including Her Majesty The Queen, and from our own collections, it is the most complex exhibition the Museum has yet organized. In exploring the panorama of Canada's formative decades, when conflict between Great Britain and the nascent United States persisted even after the peace was signed, the exhibition highlights the many interconnected events that led to the creation of a new country.

With paintings by the foremost artists of the time and elegant examples of 18th-century British and colonial craftsmanship, the exhibition projects an image of the spirit and tenor of the age. The creation of Canada is, of course, only an episode in the story of the glory and grandeur of the British Empire, but the tangible expressions of that grandeur, the art and the crafts, remain a part of the Canadian heritage. That is the essence of *Georgian Canada: Conflict and Culture*, an exhibition that offers a somewhat different perspective of Canada's formative years.

Edwin A. Goodman
Chairman, Board of Trustees
Royal Ontario Museum

It was in 1980 that the Royal Ontario Museum began to make plans for a Georgian exhibition. At that time we thought that it might well be the first major exhibition to be mounted after the reopening of the renovated and enlarged main building. The record, however, reveals that *The Search for Alexander*, *Treasures from the Tower of London*, and *Silk Roads · China Ships* have preceded *Georgian Canada: Conflict and Culture* since the Museum reopened.

The decision of the Government of Ontario to celebrate the Bicentennial of the arrival of the first major influx of United Empire Loyalists inspired the Museum to stage the Georgian Canada exhibition during the summer months of 1984. Generous financial underwriting of the exhibition by the Ontario Ministry of Citizenship and Culture has made the exhibition possible, and the encouragement and tangible support of our friends in the government are gratefully acknowledged.

In October of 1981 we invited Donald Blake Webster, who was then the curator in charge of our Canadiana Department, to take on the development and organization of what was to become the Museum's Bicentennial exhibition. At that point Mrs Mary Allodi, associate curator, assumed the administrative responsibilities for the Canadiana Department, and Mr Webster began to devote himself full time to preparations for the exhibition.

The ROM is extremely fortunate to have Mr Webster on staff. He is an acknowledged authority on early Canadian furniture and the author of several important books on this subject. Moreover, the Museum has Mr Webster to thank for its comprehensive holdings of early Canadian ceramics. It was also he who a few years ago headed a team in a salvage archaeology project on the site of the Brantford Pottery—an industrial archaeology operation that established new standards for fieldwork carried out under difficult environmental conditions.

In assembling this exhibition Donald Webster has utilized his knowledge of the existence and location of hundreds of important artifacts pertinent to the historical and cultural development of Canada from 1745 to 1820. The Museum is greatly indebted to him, to his wife, Lonnie, and to all the staff members to whom he pays tribute in his acknowledgements.

Georgian Canada: Conflict and Culture is not an exhibition conceived primarily for scholars and specialists, but rather one that will appeal to visitors of different ages and backgrounds. With its opulent silver, elegant furniture, and great paintings ranging from portraits to battle scenes, the exhibition makes history come alive before our very eyes. We hope that this exhibition will be of interest and significance to new Canadians and to non-Canadians, as well as to descendants of the United Empire Loyalists whose arrival here two hundred years ago is being celebrated during 1984.

James E. Cruise
Director, Royal Ontario Museum

ACKNOWLEDGEMENTS

It is a great tribute to many people, within the Museum staff and outside it, that *Georgian Canada: Conflict and Culture* has evolved from rough ideas to completed production in something under three years. It now becomes my duty and very great pleasure to thank profoundly those most particularly involved in this complex and intensive undertaking. Far too many people have had some part for it to be possible to mention everyone, but those who have had specific roles or have been especially helpful or supportive must certainly be recognized here.

I am grateful, first, for the support of the director, James Cruise, the associate director, Barbara Stephen, and Charles Tomsik, head of exhibitions, who decided to proceed with the exhibition in 1981, and who have since quietly worked to smooth its organization and progress. My sincere thanks are also due Michael Cross, associate dean of Arts and Sciences at Dalhousie University, Halifax, for his anecdotal essay on Georgian Canada for the catalogue, and to Irene Szylinger, exhibition research assistant, for her help and her contribution of the biographical and bibliographical sections.

Most of the Canadiana Department staff have been immersed in the project and essential to it. Karen Smith and Patricia Heimbecker, particularly, have admirably handled voluminous correspondence and computerization of all catalogue entries and text. Betty Pratt and Carol Baum have taken on the details of preparing our own collection components for the exhibition and the management of loans as they are received.

Many individuals were especially helpful in suggesting leads and sources and providing information. I am most of all indebted to Fern Bayer of the Government of Ontario Art Collection; Geoffrey de Bellaigue, surveyor of The Queen's Works of Art; Charles Bourque of the Toronto Historical Board; James Burant of the Public Archives of Canada; Maurice Careless of the University of Toronto; John Chown of the Canadian War Museum; W. Ross DeGeer, agent general for Ontario, London; Jonathan Fairbanks of the Museum of Fine Arts, Boston; Anne Farnam of the Essex Institute; Donald Fennimore of the Henry Francis du Pont Winterthur Museum; Ross Fox of the National Gallery of Canada; Ebenezer Gay of the Harvard University Collection of Historical Scientific Instruments; Robin Gibson of the National Portrait Gallery, London; Frank Goodyear of the Pennsylvania Academy of the Fine Arts; Conrad Graham of the McCord Museum; John Hardy of the Victoria and Albert Museum; Morrison Heckscher of the Metropolitan Museum of Art; Charles Humber of the United Empire Loyalists' Association; Robert Little of the Montreal Museum of Fine Arts; Sir Oliver Millar, surveyor of The Queen's Pictures; Edward Nygren of the Corcoran Gallery of Art; John Russell, C.M., gentleman and friend; and Carl Thorpe of the Ontario Ministry of Citizenship and Culture.

Within the Museum the very special gratitude of the entire institution is due those who have worked with great diligence and dedication on various aspects of

the exhibition, and who more than any others are responsible for its successful production. It has been a remarkable collaboration.

Among my colleagues, Heri Hickl-Szabo was an immediate supporter, and Corey Keeble, Peter Kaellgren, Brian Musselwhite, and Kenneth Lister have always been willing, whatever the request. Susan Wilson, Diane McKay, Christopher Toogood, and George Pawlick, with Susan Richardson, have spent two years restoring museum objects for the exhibition. Lorne Render and Robert Barnett were there at the beginning, while Danielle Boyer-Tarlo, coming late to the project, developed the gallery design and layout to a very tight schedule. Georgina Grant as programmer produced the text, graphics, and labels, and William Robertson and Brian Boyle did much of the special photography. Elizabeth Peck, Heather Maximea, Susan Haight, and Barry McQuade have managed all of the intricate loan logistics and records. Vivian Peverley, Harry Beaver, and Gary Wallace, and their teams, as of this writing, have their heaviest involvements yet to come. Ken MacKeracher and Susan Fraser, with Audrey Ellard, Stephanie Orange, Ellen Davidson, Georgette Frampton, and Pat Bolland, are composing an active schedule of special programmes and events around the exhibition, while Barbara Chisholm is organizing the Members' Volunteer Committee.

John Campsie and Mary Terziano as editors, and Jean Lightfoot as designer, have over long hours with too little lead time produced the catalogue from diverse components, while Alyson Hannas has developed the poster and graphics.

Finally, I would like especially to thank my wife, Lonnie, whose discerning eye was invaluable in initial selections; my sorely missed colleague, the late Charles H. Foss, C.M., F.R.S.A., who was, in this as always, a fountain of good ideas, and my own eleven-times-great-aunt, Hannah Webster Dustin (1657–1731?), who was part of it all, and whose exploits provided inspiration.

LENDERS TO THE EXHIBITION

Our very deepest gratitude goes especially to the many lenders who provided the core of the exhibition, and without whom *Georgian Canada: Conflict and Culture* could never have been composed.

American Antiquarian Society, Worcester, Massachusetts
Amon Carter Museum, Fort Worth, Texas
Art Gallery of Nova Scotia, Halifax
Joseph Brant Museum, Burlington, Ontario
Broadlands, Romsey, Hampshire, England. The home of Lord Mountbatten
Canadian War Museum, Ottawa
Cathedral Church of St James, Toronto
The Corcoran Gallery of Art, Washington, D.C.
The Corning Museum of Glass, Corning, New York
The Detroit Institute of Arts
The Dietrich Brothers Americana Corporation, Philadelphia
The City of Dublin, The Hugh Lane Municipal Gallery of Modern Art
Essex Institute, Salem, Massachusetts
Dr Ebenezer Gay, Cambridge, Massachusetts
Harvard University Collection of Historical Scientific Instruments,
 Cambridge, Massachusetts
Mr Heri Hickl-Szabo, Toronto
The Historical Society of Pennsylvania, Philadelphia
Mr Charles Humber, Toronto
Indianapolis Museum of Art
Legislative Assembly of Ontario, Queen's Park, Toronto
Fortress of Louisbourg, National Historic Park, Parks Canada
McCord Museum, McGill University, Montreal
Mr Donald McLeish, Toronto
The Metropolitan Museum of Art, New York
Missouri Historical Society, St Louis
The Montreal Museum of Fine Arts
Musée de la Basilique Notre-Dame, Montréal
Musée des Ursulines de Québec
Museum of Fine Arts, Boston
Museum of the City of New York
National Army Museum, London
National Gallery of Art, Washington, D.C.
National Gallery of Canada, Ottawa
National Maritime Museum, Greenwich
National Portrait Gallery, London
The New York Public Library

Pennsylvania Academy of the Fine Arts, Philadelphia
Philadelphia Museum of Art
The Public Archives of Canada, Ottawa
Her Majesty The Queen
Mrs C. C. Radcliff, Toronto
The Royal Artillery Institution, Woolwich
Royal Canadian Military Institute, Toronto
Royal College of Physicians, London
Mr John L. Russell, Montreal
United States Naval Academy Museum, Annapolis, Maryland
Vancouver Maritime Museum
Victoria and Albert Museum, London
Wadsworth Atheneum, Hartford, Connecticut
The Weir Foundation, Queenston, Ontario
Wellcome Institute for the History of Medicine, London
The Henry Francis du Pont Winterthur Museum, Winterthur, Delaware
Yale Center for British Art, New Haven, Connecticut
Yale University Art Gallery, New Haven, Connecticut

INTRODUCTION

The Ontario Bicentennial, which *Georgian Canada: Conflict and Culture* celebrates, commemorates the first substantial settlement by United Empire Loyalists in 1784 of what was then western Quebec, soon to be Upper Canada. The exhibition also reflects the contemporaneous beginnings in 1783 of Canada as a modern nation, with internationally recognized borders, as well as established systems of government and law.

Georgian Canada: Conflict and Culture is an exhibition that perhaps swims upstream. Many Canadians perceive Confederation in 1867 as the beginning of modern Canada, and Sir John A. Macdonald, the first prime minister, as the founding father. Anything earlier remains enveloped in a sort of "dark ages". That scenario, of course, is incomplete. The history of modern Canada begins far earlier, with the recognition of British control in 1763, and the accelerated settlement that followed the American Revolution. Confederation, historic as it was, was also simply the implementation of an old idea whose time had finally come, a change of course in the already long and substantial national progression.

That Canada was created in a peaceful and methodical fashion is another illusion that is probably too ingrained to be dispelled. Canada in fact emerged out of nearly two centuries (1629–1814) of recurrent colonial as well as world-power conflict and war, ultimate military conquest, and then successive (and successful) defences against further conquest.

Canada first became a binational land in 1713, when Great Britain was confirmed in possession of mainland Nova Scotia and Newfoundland. Exactly half a century later New France came into the British realm. Biculturalism in the 1760s became government policy—policy that prevails to this day. During the American Revolution Canada successfully resisted absorption into the newly independent United States, with nearly present-day boundaries established in 1783. Sir Guy Carleton, after 1786 Lord Dorchester, Canada's first governor in chief, suggested and pressed for full confederation and central government as early as 1788, but conditions then were wrong.

Upper Canada, already populated by the Loyalists and a steady stream of followers, became a separate province under Canada's by-then third constitution, the Constitutional Act of 1791. Finally, in 1812–1814 came another successful defence against invasion, which ended with permanently unfortified borders agreed on and recognized essentially as they remain today.

Those were exciting and suspenseful times. A new nation was gradually being created here, and a huge land mass was being settled and populated. It was an age of individualism, when ruggedness was essential to survival and perseverance a requisite to prosperity.

It was also an age of anxiety and stress—probably greater than those of today—generated by continual personal insecurity. Good health could never be taken for granted; medical care was virtually non-existent and life expectancy was short. There were no assurances even of sufficient food to sustain a growing population, and there were times, such as the "hungry year" of 1788–1789, when widespread starvation actually threatened. Basic livelihood was no more assured. People made their livings by their skills or labour, their brains or wits, but there were few support services of any kind. Concepts of unemployment insurance, welfare, public compensation, and pensions were far in the future.

Canada's leaders, both military and civil—who were often the same people—were by and large competent and dedicated. Some few, certainly Lord Dorchester, and perhaps such men as Frederick Haldimand, John Graves Simcoe, John Wentworth, Isaac Brock, and others, were true creators with far-ranging vision. Canada in her formative years was fortunate in having founders and leaders of that calibre.

Canada was also a land of contrasts, beginning with her extremes of climate. She gradually developed as well national patterns which have proved most persistent. Two distinct and adverse European populations—culturally and linguistically—guaranteed perpetual friction. At once a maritime, agricultural, and resource exploitive country with great natural blessings, Canada developed extremes of wealth and poverty, ranging from the well-staffed mansions of Montreal to the near starvation of the frontiers. Politically, socially, and economically, Canada also showed an early tendency to oligarchies, though not of British formalism. Such structures still persist as well, though in very different forms and environments.

Britain had been badly bruised by the self-unification of the American colonies. British policy in Canada thus became "divide and rule". Provincial partitions—Nova Scotia, New Brunswick, and Cape Breton Island in 1784, and Upper and Lower Canada in 1791—were enacted readily enough, but unity and any sense of single nationality were discouraged. The eventual national

inheritance, of course, became constituent provinces as fractious principalities, but also as an effective balance to national government.

In the Georgian age Canada was very much a part of the British Empire, and Canadians generally considered themselves British subjects. As British subjects, first-generation Canadians developed a habit-pattern of deference to law and government. This emerged perhaps not so much from an urge for public order for its own sake, as from fear of the disorder and inherent violence (even then) of American society. The permanent posting of British military garrisons in all larger towns, of course, visibly reinforced the message. The early habit of willing acceptance of imposed order became ingrained in the national disposition and has created an underlying national stability through many destabilizing events and situations. By 1820 these and other national patterns were largely established, or well on their way.

At the outset of discussion of *Georgian Canada* in 1981, we realized that no museum exhibition had ever yet tried to cover in one sweep the whole age of modern Canada's creation. It has been a broad and complex undertaking, popularly unfamiliar and perhaps controversial. The Government of Ontario, however, accepted and supported the idea as a major Bicentennial project, without a qualm that it would be of national rather than solely provincial scope.

The exhibition as it has emerged is necessarily a very broad-brush panorama of Georgian Canada and of the events and people that shaped it. Within this has been included a flavouring of the elegance and opulence of the best of that age, particularly in furniture and silver—the decorative arts of Britain and the United States that so strongly influenced the tastes and fashions of Canada.

Canada has also been a mixed and multicultural society from the beginning—American, including ex-slave blacks, English, French, Scottish, German, Irish, and Indian. Not all immigrants were agricultural pioneers—nor perhaps were even a majority of them. Many were townspeople—artisans and craftsmen, merchants and entrepreneurs, traders and speculators, officers and soldiers, government officials, clergy, and even artists, writers, and scholars. Their possessions and domestic amenities were not by any means limited to the pioneer stereotype of homemade pine furniture, wooden spoons, and barrel-stave buckets. Many people enjoyed fine and fashionable furniture that they had brought with them, commissioned locally, or ordered from England or American seaboard cities. Good silverware, china services, and glassware were hardly unusual. Although portrait painters were not active in Canada until the 1780s, even earlier settlers had their portraits done on visits to England or the American colonies.

Georgian Canada was a far more complex society than that just of the frontier yeomen and fur trappers. It was, in spite of a raw physical environment, an aware and increasingly sophisticated society, one that read books and newspapers, enjoyed music and occasional theatre, followed politics and world events, and had many outside contacts with Britain and the United States.

It was also an acquisitive society and economically an upwardly mobile one. Crown land was taken up, by speculators as well as settlers, as fast as it was offered. Log cabins or "first houses" were replaced as soon as possible by substantial frame or masonry structures. Household possessions as well increased rapidly. Upholstered furniture, clocks, wall mirrors, paintings, silverware, and other luxuries limited to the relatively wealthy in 1790 were in common and widespread use by 1820.

For this exhibition, we decided early on to concentrate on the sophisticated and socially dominant rather than the conventional pioneer aspects of Georgian Canada. British and American influences on taste and fashion were all-pervasive; they determined Canadian trends in everything from architecture to clothing to table settings. These influences, rather than just the pioneer experience, largely defined the national directions and alignments Canada began to take. Thus a requisite part of the exhibition became a spicing of the elegance and grandeur of the origins of those influences.

Canada today to an unfortunate degree still neglects her history. Yet more than many countries, Canada lives today, albeit often unconsciously, with the broad effects and consequences of that history. Canadian life is still guided by national traits and approaches that were established as long as two centuries and more ago. The time-span of *Georgian Canada* may seem to lie in the mists of the pre-Confederation dark ages but, as was true in the old television programme "This Is Your Life", there we still are, bumps, warts, and all. If this exhibition somehow succeeds in providing a better awareness of modern Canada's beginnings, and of why this country is as it is, the exercise will have been well worthwhile.

BRITISH NORTH AMERICA
1745–1820

MICHAEL S. CROSS

"To enter Canada," Northrop Frye once wrote, "is a matter of being silently swallowed by an alien continent." By the middle of the 18th century the continent had indeed swallowed most of the explorations of the previous 250 years. What impression had been left on the silent north by Corte-Real or Frobisher or Hudson? Or on the prairies by Kelsey or La Vérendrye? Or on the Pacific coast by the seaborne probings of the Russians Bering and Chirikoff? Only along the coastlines of Newfoundland and Nova Scotia and in the St Lawrence valley did the noise of European settlement and European warfare disturb the alien silence. There alone it was the year of our Lord 1745.

Like an empty forest when a tree falls, the rest of the continent was silent only because the Europeans could not hear. The land was alive with peoples—Micmac, Algonquin, Iroquois, Cree, Kwakiutl, Inuit, and a hundred more—peoples who filled the land with the noise of living societies. On the eastern half of the continent, European settlement, trade, and war had already disrupted many of these societies; for them it was a time of destruction. For others, on the prairies and the Pacific coast, the impact of European penetration lay ahead; for them it was still a time of growth. But all of them, in 1745, were silent to European ears that chose not to hear. To Europeans, the indigenous peoples, like the land itself, were only barriers to ambition or fields for exploitation.

The politics of Canada, the pace of exploitation, the structure of the European society planted there, all were determined by four great forces: European territorial ambitions and the resulting wars; European economic needs; the influence of the native peoples; and Christianity. By 1745 the last, Christianity, had lost much of its power to determine Canadian development. The missionary urge of the Catholic church had contended with the soldiers' lust for conquest and the fur traders' lust for profit, and had lost. North America would not be the New Jerusalem that the early Jesuits had hoped for, and which Bishop Laval had struggled to make it in the late 17th century. Instead, it would be the battleground in a war fought by soldiers and traders, with the native peoples as their most important instruments.

THE RISE AND FALL OF LOUISBOURG

In 1745 all of these factors had come to focus on the fortress of Louisbourg. Louisbourg, on the eastern short of Isle Royale (later Cape Breton Island), was Europe's symbol of defiance to the alien continent. The French had established a settlement on the site in 1713; since then, the great fortress had grown, consuming in the process the energies and genius of countless engineers and workmen and millions of *livres* from the French treasury. The traditional story is probably apocryphal, but it tells something of the scale of the undertaking. Louis XV was found by an adviser gazing westwards from a window in his palace at Versailles. Asked what he was looking for, he replied wistfully, "The walls of Louisbourg; they have cost so much I should be able to see them from here." The cost of Louisbourg was great, but so was the plan—a French garrison city built, against all logic, in the North American wilderness. It was a characteristically European construction with huge stone bastions and gracefully designed barracks surrounded by stone houses and buildings. For such a fortress, in contrast to the rough-and-ready earth-and-log fortifications common in North America, all the construction materials had to be imported from France, along with tools, mules and horses, and workmen. Louisbourg defied the continent in its location as well as in its design; it was the product of an imperial bureaucrat's plan, positioned on a map to control the fisheries and the trade of the east coast and the maritime approaches to continental New France. Transferred from the map to the real world of Isle Royale, Louisbourg proved to be a place of fog and damp cold, poor soil and indefensible terrain.

In this barren place lived some four or five thousand French men and women. The officers and merchants among them also attempted to defy the continent, recreating as much as possible of the life of a provincial garrison town in France. The ordinary people could less easily ignore their environment, the harsh climate in which they had to struggle to make their living by fishing or by trade, the shortages of supplies and even of food that were all too common in this isolated outpost. The harshness was felt most keenly by the soldiers, who lived in cold, overcrowded barracks and subsisted on inadequate rations of fish and bread. As in other 18th-century armies, private soldiers were treated as

little better than criminals and were denied many of the rights of ordinary citizens, even the right to marry. Drinking and whoring released some of the tensions of military life, but in December 1744 the anger of the troops over their treatment and the special hardships of military service in Louisbourg erupted in mutiny. The garrison seized control of the fortress and compelled the government officials to promise improved conditions. Few improvements were made, however, and the persistent discontent weakened the defences of Louisbourg when it was attacked by British forces and American colonials in the following year. As usual, authority had the last word. When the defeated troops returned to France after the fall of Louisbourg, three of the ringleaders of the mutiny were executed for their impertinence.

Louisbourg was the headquarters for the French effort in the ceaseless war with Great Britain for control of eastern North America. In this war—sometimes declared, as in 1744, more often undeclared—the native peoples were important participants. They were used by both sides as shock troops, efficient fighters who had the additional advantage that they struck terror in their enemies by their alienness. And so when war broke out between France and Great Britain in 1744, both sides mobilized their Indian allies. French and Micmac forces besieged the British toehold at Annapolis Royal in Acadia in the summer of 1744 but were forced to retreat when British reinforcements arrived from New England. In the spring of 1745 the French and Micmacs again attacked Annapolis Royal. The defenders, under the command of Paul Mascarene, seemed certain to suffer the fate that so terrified New Englanders and stimulated their genocidal native policy: Annapolis Royal, they feared, would fall to the attackers and its garrison would become victims of the scalping knife. But the restless, expansionary enterprise of New England saved Annapolis Royal and won Nova Scotia.

On 11 May 1745 a party of Massachusetts Indians landed within cannon shot of the walls of Louisbourg. They were followed by more than two thousand New England militiamen led by William Pepperrell, and supported by British marines and a fleet under Commodore Peter Warren. The New England initiative in attacking Louisbourg sprang in part from the determination of the colonies to remove French competition in trade and fishing. It also reflected the growing ambition of a maturing Massachusetts. Conquest of Louisbourg would remove the ever-present French threats to New England: the physical threat of French military power and the spiritual threat of French Catholicism. The expedition of 1745 was also a tribute to the persuasive powers of William Shirley, governor of Massachusetts, whose personal dreams of glory coincided with the ambitions of his colony. Shirley convinced the faint-hearted that the impossible was not too difficult for New Englanders and that the mightiest fortress in North America could be taken by an amateur army of colonists.

The audacious attempt was made by the ragtag militia of New England. And it succeeded. After a siege of nearly seven weeks, during which the fortress was pounded by some six thousand cannonballs, Governor du Chambon capitulated, and on 28 June 1745 the jubilant New Englanders entered Louisbourg. It had been a brilliant victory, but greater foresight would have made it a bitter-sweet one for Great Britain; for its effect was to convince New Englanders of the superiority of their citizen-soldiers over European professionals, and this confidence would strengthen their growing sense of independence of the mother country. Many New Englanders would have agreed with the Boston clergyman who saw "the finger of God" in their conquest of Louisbourg, and with the Massachusetts chronicler of the victory who insisted that it was the duty of New Englanders to spread the empire of their Puritan God "from the *Eastern* to the *Western* Sea, and from the River of Canada to the Ends of *America*".

The Treaty of Aix-la-Chapelle in 1748 restored Louisbourg to the French; but, once conquered, the fortress had lost its power of intimidation. The fall of Louisbourg had opened the possibility of a decisive conflict to end the long stalemate between France and Great Britain in North America.

NEW FRANCE: THE YEARS OF SUCCESS

The lines for such a conflict were clearly drawn in the centre of the continent. Here, since the time of Champlain, the two European powers had struggled for control, competing in the fur trade and waging war through their Indian surrogates. By 1745 their positions were entrenched. The British were strategically positioned on Lake Ontario in Fort Chouegan at Oswego, New York. There they were sheltered by their Iroquois allies, those implacable warriors who were justly called the Romans of North America. North of the lakes the French maintained a string of military encampments and fur-trade depots anchored by Fort Niagara and the major stronghold, Fort Frontenac, on the site of present-day Kingston. Ontario was a key to the conflicting strategic interests of France and Great Britain. Through it passed the fur-trade routes to Montreal and Europe; it was the cockpit of Indian politics; and Fort Frontenac was the first line of western defence for the St Lawrence heartland of New France.

New France had been a remarkable success story. Established as a trading and military base, it had never received the rush of settlers that had strengthened the British colonies to the south. For every one of New France's fifty thousand inhabitants in the 1750s, there were twenty British Americans. Yet New France had resisted British attacks, survived generations of warfare with the Iroquois, and sent out its explorers and traders across the width of the continent. The society that had taken shape was one of great strength. On the long, narrow farms that ran down to the St Lawrence and the Richelieu lived men and women who, much more than most others on the continent, had blended their European heritage and the American environment into something unique.

The land-holding system of old France, seigneurialism, had been brought to Canada, but under Canadian conditions it had been softened and improved. Seigneurs were still granted great tracts of land which they peopled with tenants. Such tenants, in theory, were liable for the traditional feudal dues paid by French peasants. In fact, Canadian tenants were lightly taxed and enjoyed an independence unknown by their counterparts in France. The fact that they insisted on being called habitants rather than peasants testified both to their freedom and to their consciousness of it.

The secret of the habitants' emancipation lay in their numbers and their mobility. Few immigrants came to New France, and tenants for seigneuries were scarce. Seigneurs had to lighten feudal burdens in order to keep habitants on their estates. The shortage of habitants was made more acute by the freedom offered by the forest. Young men could slip away to trade furs despite all the efforts of the government to keep them on the farms. Few French Canadian families did not have members who were, or had been, involved in the fur trade. To maintain the agricultural population necessary to feed its armies, the government had to make farming as attractive as possible; and to this end it limited the dues that seigneurs could charge, gave bonuses to farm families with many children, and conceded the Canadian habitants a degree of freedom unparalleled in France.

Despite the exigencies of the environment and the pressure of nearly constant war, the habitants enjoyed considerable prosperity and evolved a lifestyle in harmony with the natural environment, if not with their American colonial neighbours. Prosperity allowed them to enjoy luxuries denied French peasants. Horses were especially prized, for in France common people could never have hoped to own horses. Horses had to be imported from France; so did most manufactured products and metal goods.

Much in the everyday life of New France, however, was the product of the local environment. The sturdy habitant (after several generations, bigger and stronger than his French counterpart) smoked American tobacco, ate American squashes, and used an American canoe and American snowshoes. He dressed in furs and skins and wore a colourful sash, all imitative of Indian costume. From the Indians, too, he learned trapping techniques and all the skills necessary for survival in the North American environment.

New France was a blend of the Old World and the New. The dangers it faced also came from both worlds. By the middle of the 18th century Great Britain was emerging as the dominant western power and was anxious to prove her superiority in North America. The British colonies were also ready to flex their muscles. Truculent in their adolescent confidence, the Thirteen Colonies saw room for expansion in the French territories to the west. It was there that the first clashes of a new war began. This war, begun in 1755, would be New France's last.

NEW FRANCE: THE FINAL STRUGGLE

The war began with the familiar ebb and flow. In the Ohio valley French forces defeated the British and Virginians first under George Washington and then under General Braddock, but in Acadia the French forts of Gaspereau and Beauséjour fell to the British. In Nova Scotia, too, the stern realities of war were seen in all their starkness. Impatient with the uncertainties that had seen the territory change hands so often, and unwilling to accept anything but unconditional allegiance to the British Crown by the French-speaking population, the British expelled the Acadians in 1755 from their farms in the Annapolis valley and on the Chignecto peninsula. While troops burned their farms and settlements and slaughtered their cattle, six to seven thousand Acadians were herded onto ships and carried off into exile, to be scattered through the Thirteen Colonies and the West Indies.

In Ontario the French held their ground, buoyed by General Montcalm's brilliant capture in 1756 of Chouegan and the surrounding British forts, which had menaced French Ontario. Nevertheless, Great Britain was growing stronger everywhere. In the east a stronghold to rival Louisbourg had emerged. Halifax, founded in 1749, bristled with British arms. It was there, in May 1758, that Britain's finest military leader enjoyed a last leisurely meal at the Great Pontac Hotel before setting off for a new assault on Louisbourg. Brigadier James Wolfe looked more

like some early romantic poet than a general—he was later to say that he would rather have written Gray's *Elegy* than conquer Quebec—a slight, pale, melancholy young man of thirty-one. But a general he was. The hooded eyes in the poet's face had seen war. Wolfe had learned his craft in the bloodiest school, the slaughter of rebellious Scots by the English army after the Highland uprising of 1745. He was to put that cruel training to good use in the coming year.

But for the moment the bloodshed was far away. At the Pontac, Halifax's grand hotel at the foot of Duke Street near the harbour, the convivial company of Wolfe and his officers was gathered. Colonels James Murray, William Howe, and Ralph Burton and other senior officers were there; so were the naval commanders, led by Admiral Edward Boscawen, and Governor Charles Lawrence of Nova Scotia with the leading governmental figures. The forty-seven guests were served by fifteen attendants and entertained by ten musicians, and they consumed, presumably with the assistance of the musicians and the help, seventy bottles of Madeira, fifty of claret, and twenty-five of brandy. As this grand entertainment demonstrated, neither the rude environment of North America nor the exigencies of war prevented this British military gentry from maintaining their European standards of *politesse*. Thus fortified, Wolfe sailed with his forces from Halifax on 28 May 1758.

Again the impregnable fortress fell. Wolfe and his army entered Louisbourg on 28 July. The bleeding away of the life of New France had begun. A month later, thirteen hundred kilometres to the west, Pierre-Jacques Payen, Sieur de Noyan, surrendered Fort Frontenac to Lieutenant Colonel John Bradstreet. The St Lawrence was now open to British attackers from both east and west. The assault came in the summer of 1759. The last stronghold in French Ontario, Fort Niagara, fell on 25 July.

Meanwhile, Wolfe moved on the final French bastion. In June 1759 his great fleet filled the St Lawrence before Quebec. Despite the puncturing of the Louisbourg myth of invincibility, Wolfe was not prepared to try a direct assault upon the legendary defences of Quebec. The British settled in to wear Quebec down by bombarding civilian targets in the city, disrupting supplies, and spreading terror. As Wolfe's army fired every farm in the district, the harassed and hungry defenders could see the smoke and flame of their burning countryside. Their spirit was shaken by tales of the desecration of their churches and the killing of their priests by the Puritan New Englanders let loose by Wolfe.

In view of Wolfe's role in the suppression of the uprising in Scotland, there was a certain irony in the fact that it was Scots who secured his victory. After three months of his scorched-earth campaign he still had not forced Quebec to surrender. He could not wait indefinitely, for winter would bring ice into the river and cut off reinforcements and supplies by sea. On 12 September Wolfe sent ships east of the city, in a ruse designed to convince the French commander, Montcalm, that the danger lay in that quarter. That same night he sent his Highlanders up the cliff directly west of the city. In the morning the British army was on the Plains of Abraham, awaiting its enemy.

It was the most famous, and fateful, battle in Canadian history, and the participants behaved as if they knew that history would watch their every move—Montcalm, in his tragic pride, riding out of the city with his army to confront the British, rather than relying on the strength of his fortress; Wolfe leading his soldiers, reckless of the danger, shot through the wrist, binding the wound with a handkerchief and pressing on with the attack. The French, gloriously martial in their glistening white uniforms, were fatally confused by Montcalm's disastrous attempt to fight a European pitched battle with a motley force of French regulars and Canadian militiamen. The stolid British infantry, drawn up in scarlet lines, waited for their charge to close to forty yards, then raked them with fire, stepping forward, platoon by platoon, through the acrid gunsmoke and withering the French lines with great musket volleys. Finally the French broke and ran, pursued by Wolfe's ferocious Highlanders. The general himself led the pursuit, only to be struck in the right breast by a musket ball; but on being assured that the battle was won, he proclaimed— romantically, historically—"Now, God be praised, I will die in peace." And as Wolfe lay dying, the defeated Montcalm, wounded by grapeshot, slumped over his horse, retreated into the doomed city, where he died in agony early the next morning.

The actors had all played their roles to perfection. The drama was only slightly diminished by the anticlimactic ending. The exhausted British did not assault the city, and it was not until five days later, 18 September, that Quebec capitulated and British troops marched into the fortress. There was much indecisive skirmishing ahead. In May 1760 the French under Chevalier de Lévis were able to defeat the British forces under Wolfe's successor, General James Murray, and to lay siege to Quebec. Just when it seemed they might recapture the city, the ice in the river broke up and the first ships of the year arrived. They proved to be British, not French. Lévis was forced to flee on 18 May, abandoning his camp with most of his ammunition and supplies. It was a drama nearly up to the previous season's triumph. Murray, relating the bravery of his men under the French siege,

enthused in a letter to General Jeffrey Amherst, "It is so romantick." Perhaps it was—for the generals. In the same letter, Murray reported the delight of the British soldiers that the ships from home carried £20,000 for the garrison, which had not been paid since the previous August.

It was not so "romantick" for the conquered French. Their fate was delineated in the orders Murray issued to his officers, such as those given to Colonel Hunt Walsh and Captain Leslie on 15 November 1759. Those officers were sent with parties of troops into the parishes around Quebec, there

> ...to disarm the Inhabitants, drive before [them] from thence their Oxen, Horses, Sheep and carry off or destroy all the Grain or Forage, which they are possessed of, over and above what [you] may deem absolutely necessary for their Subsistence...procure the names of such of the Inhabitants...as are still out in arms, in order to burn and totally destroy their possessions.

They were also to take a hostage from each parish. This was indeed a conquest, one which left much of the best agricultural land burned over, villages destroyed, and people hungry and suppressed.

THE PROBLEMS OF VICTORY

War had created British Canada. The one major British settlement before the conquest, Halifax, was founded for strategic reasons and for two hundred years after its establishment would truly flourish only in times of war or rumours of war. The great new British colony of Quebec would also be dominated by military considerations and ruled for the first generation after 1759 by military governors: General James Murray, General Guy Carleton, and Sir Frederick Haldimand. Military necessity— the need to ensure that Canada was secure, first, against any further French threat, and then against the growing rebelliousness of the Thirteen Colonies—dictated British policy. Except in loyal Nova Scotia, there was no grant of British parliamentary institutions. The governors of Canada were autocrats. For the sake of military security, however, the British attempted to gain the goodwill of the people. Those whom they saw as the "natural" leaders of the Canadian habitants, the seigneurial landholders and the Catholic clergy, were given British patronage, permitted to hold their lands, to maintain French civil law, and to practise their religion relatively undisturbed.

The acquisition of French Canada necessitated new imperial strategies and new attitudes by the British towards an empire which now included foreign Europeans. The immediate British response to the conquest of Quebec was jubilation on the part of both people and politicians. The people cheered the culmination of decades of struggle with France and the end of a bloody war. The politicians had broader reasons for satisfaction. The accession of Canada to the Empire, confirmed by the peace treaty of 1763, served a number of important purposes. It weakened France militarily and economically; it brought the economic potential of the northern half of the continent into British hands; and it provided a check to the ambitions of the Thirteen Colonies. Indeed, the only serious topic of debate before the peace treaty was whether the growing militancy of the American seaboard colonies could be best controlled by the establishment of British forces in Quebec or by turning Canada back to the French. Pride and economics led Britain to opt for the retention of Canada and for the building of Quebec into an imperial barrier against the Americans.

Quebec was a huge, sprawling territory, extending into the midwest, where it limited the westward expansion of the Thirteen Colonies. It was also a new kind of colony for the British, one populated chiefly by Europeans of alien nationality, language, and religion. The goal in dealing with this population was clear enough: to win its loyalty for military purposes and to exploit it for economic gain. What was less certain was how best to achieve these aims.

The Proclamation of 1763, which established civil institutions in the new colony, was based on the assumption that the French Canadians would soon realize the advantages of English government, law, and religion, and would abandon their culture to embrace a superior one. Military government would be necessary during the transition period, but the Proclamation envisaged that very soon Quebec would have an assembly and English institutions. A report in the *London Evening Post* in 1767 typified this optimistic chauvinism:

> Private letters from Quebec advise, that some priests of the Romish persuasion having abjured their religion, and turned Protestants, the example has had so great an effect upon many of their disciples, that proselytes are daily coming over to the reformed religion.

The British government soon realized, however, that precious few Catholics were becoming converts and that the French were hostile to the introduction of English law and uninterested in the prospect of an elected assembly. Protestantism, English law, and representative institutions, in fact, were desired only by the small community of Scottish and American merchants who had

followed the flag to Quebec and had quickly gained control of the province's trade. Just as quickly, they demanded the rights and institutions with which they were familiar. Their aggressiveness brought them into conflict with the rigid military governor, James Murray, and convinced him that a legislature that would inevitably be dominated by the merchants would be as troublesome as those in the Thirteen Colonies.

These apprehensions were reinforced by the unrest in the Thirteen Colonies. It was clear that the goal sought in Quebec—a stable base in an increasingly unstable continent—could not be achieved by the plans of 1763. The Quebec Act, passed in 1774, reflected a new strategy. The boundaries of Quebec were pushed farther west and south to surround the seaboard colonies. French civil law was recognized and permitted to stand alongside English criminal law. Toleration was extended to the French language and the Catholic religion. The intention to establish an elected assembly, expressed in the Proclamation of 1763, was dropped.

The Quebec Act set off a storm in the Thirteen Colonies and was viewed as one of the "Intolerable Acts" of the British parliament that justified rebellion. Radicals in England were equally offended. The Quebec Act, they charged, was tyrannical because it denied an assembly and adopted archaic French law. In the British election in the summer of 1774, the Quebec Act was a significant issue. Edmund Burke urged the people to vote against candidates who supported the vile law: "You are drawing a line between freedom and despotism." The bitterest attacks on the Quebec Act, however, were against its religious provisions and were expressions of the anti-Catholic bigotry that was so potent in 18th-century Britain. In a typical passage, the *Middlesex Journal* fantasized: "One would imagine that the days of James the Second were again revived, and the Pope, priests and popery let in by gatefulls upon us."

More serious for the British government was the fact that the Quebec Act did not work. Instead of cowing the Yankees, it helped stir them to revolution. Nor did it succeed in winning French Canadian support for the British in their war against the American revolutionaries.

DANGER FROM THE SOUTH

It was an obvious strategy for the American rebels to attempt to stir the French Canadians into joining them, and they achieved some success in this endeavour. In the summer of 1775 agitators crossed into the parishes south of Quebec City and, as reported by a contemporary British observer, told the people "that the liberty they had enjoy'd for fifteen years was to be taken from them, that they were to be made the slaves of their seigneurs, who were to be the tools of the Governor". When American armies invaded Quebec in the fall of 1775, the bitter British observer was angered to see the French Canadians "pay court to the invaders… The insolence of the habitants was insufferable but what could we do, we had no force to keep them within bounds."

Seigneurs, repaying their debt to the British, attempted to rouse their tenants to fight for the new mother country. In some parishes they were greeted with sullen silence; in a few they were driven out by angry inhabitants. Most French Canadians, unreconciled to British rule, either appeared sympathetic to the American rebels or, more frequently, seemed to feel that if the foreigners from Britain and the foreigners from the Thirteen Colonies wished to quarrel, it was no business of theirs.

The Americans took Montreal and sent two armies against Quebec under Generals Richard Montgomery and Benedict Arnold. If the British hold on Quebec was made tenuous by lack of support from the French, at least the British did not make the same mistakes as Montcalm. Instead, they hunkered down in Quebec to wait out the American onslaught. On 14 November 1775 Benedict Arnold and his forces were on the Plains of Abraham. The rebels were formidable and were made more so by a misconception. A journal kept by a member of the Quebec garrison recorded that the American soldiers were dressed in canvas uniforms: "The Canadians who saw them first reported, that they were a hardy race not sensible of cold, being *Vetu en toile*; the report spread; the word *toile* was changed to *tole*, the rumour ran that the Bastonois were all cover'd with sheet iron."

Even sheet iron would not have been enough. The Americans camped outside Quebec in mid-November 1775. Exhausted and half-starved after an epic struggle through the forests between New England and Quebec, Benedict Arnold's army was struck by smallpox, as were the Quebec defenders under Guy Carleton. Although augmented by Montgomery's army from Montreal, the Americans saw their strength ebbing away, sapped by disease, cold, and lack of supplies. They had to seize the initiative. On New Year's Eve, in a raging blizzard, they attacked the city in a pincer movement of which the two claws were to meet in Quebec's Lower Town. Falling into confusion in the snowstorm, the invaders were an easy prey for Carleton's soldiers. General Arnold was wounded; General Montgomery was killed; and the Americans were routed with five hundred casualties.

The siege continued through the winter but represented little threat to the city. The French Canadians in the area lost their

enthusiasm for the invaders when the Americans seized supplies from local farmers and paid for them in the paper money issued by the Continental Congress—currency whose real value has been enshrined in the popular saying "not worth a Continental damn". Like the French before Quebec in 1760, the Americans lived in the hope of reinforcements when the ice broke. Instead, the first ship to arrive, on 6 May 1776, was the British frigate *Surprise*, forerunner of a powerful fleet. The surprise was an unpleasant one for the rebels, who had no choice but to retreat. As British reinforcements poured in, the Americans hastily abandoned all their strongholds in the province.

The hero of the day was the governor, Guy Carleton, defender of Quebec. He was made a Knight of the Bath for his heroism. Yet had it not been for the snowstorm on New Year's Eve 1775, Carleton might instead have borne the opprobrium of being the man who lost Quebec. In fact, Carleton had endangered the province by overestimating the support of the population. Firm in his belief that he had won French Canadian backing by his wooing of seigneurs and clergy, he allowed many of the British regulars to be shipped off to reinforce besieged Boston. When the French Canadians failed to rush to his support, Carleton could not defend the province. He had to give up Montreal without a fight and shelter in Quebec until blizzards and the British fleet saved him. Then his slowness in organizing pursuit allowed the American army to escape. The *Surprise* had arrived at Quebec on 6 May, but it was not until 19 June that Carleton and his forces reached St-Jean, near the New York border, after the Americans had fled to Lake Champlain. Fortunately for Carleton, any sort of victory was good enough.

The Americans did not return—not for nearly two generations. These would be the first generations of European Canadians to live in peace. There were many rumours of war, especially after Britain plunged into conflict with revolutionary France in 1793. France's close friendship with the United States and the attempts of American-based French agents to stir unrest among the French Canadians kept British North Americans uneasy.

THE COMING OF THE LOYALISTS

Even in times of peace, then, the regional communities of British North America were shaped largely by the impact of war and by the British strategies that flowed from the anticipation of war. The first substantial British settlement was Halifax, but if British Canada dated from the founding of Halifax, it had a new beginning in the aftermath of the American revolutionary war.

Thousands of refugees, the Loyalists, brought their American traditions and outlooks to British North America. They also brought a powerful bitterness towards, and suspicion of, the new United States.

The Loyalists created two new colonies, New Brunswick and Upper Canada. They compelled the grant of a new form of government—and a new name, Lower Canada—to Quebec and forced French Canada to contemplate the new prospect of becoming a minority. And they demanded new strategies for the British Empire.

Some historians have suggested that as many as one-third of the people in the Thirteen Colonies remained loyal to Britain. Less than five percent, however, were so dedicated to the Empire, or so repelled by the emerging republic, that they left America and emigrated to Canada. For many there was little choice. Those who had been highly visible in their support of King George had to flee revolutionary revenge. Visible minorities, too, often became voluntary or involuntary Loyalists. Anglicans, Highland Scots, Mohawk Indians, many educated people (New Brunswick received an influx of Harvard graduates), people who, for one reason or another, were associated with the old regime or were disliked by their neighbours—these were the Loyalists.

The Loyalists fled to the last British bastion in the Thirteen Colonies, New York, for transportation by sea to Nova Scotia or to England or, in some cases, to the West Indies. Some made their way overland to Quebec. Those with time to retreat in dignity brought with them the family silver and prized items of furniture. A few were able to carry into the wilderness of New Brunswick impressive libraries. Most, however, fled with a few possessions and the clothes on their backs to start life anew. Along the St Lawrence they herded into camps to live on government rations, hatred of the Yankee rebels, and dreams of a new Britain in America. They were a burden that the Empire gladly shouldered, but they were a problem it found difficult to solve.

GOVERNOR WENTWORTH AND THE LOYALISTS IN NOVA SCOTIA

In Nova Scotia, which received a large proportion of officers and governmental officials, the Loyalist influx produced immediate tensions. Many Loyalists expected to assume positions of leadership and were openly hostile to the pre-Loyalist Yankees who inhabited the province. Many of those pre-Loyalists had been reluctant to fight against their cousins in New England and had

maintained an uncomfortable neutrality during the Revolution. In the western part of Nova Scotia a religious revival had preoccupied a large number who were drawn to the teachings of the wandering evangelist Henry Alline. Alline's "great awakening", with its focus on the next world rather than the turmoil of this one, may have been a necessary release for Nova Scotia Yankees, torn between their economic links to the Empire and their blood ties to New England.

For many Loyalists the Yankees' neutrality stood in shameful contrast to the sacrifice of those who had earned the gratitude of Britain. The Loyalists' vocal patriotism, the favours they received, and the large land grants given them (sometimes worked by black slaves brought with them) aroused in their turn the animosity of the Nova Scotia Yankees. A power struggle between the two groups developed and remained central in the colony's politics for two generations.

At the centre of this controversy was a Loyalist governor determined to make Nova Scotia an imperial bulwark against the menacing Americans. John Wentworth, governor of Nova Scotia from 1791 to 1808, was born in New Hampshire and had served as royal governor of that colony. With the outbreak of the Revolution, he fled to Nova Scotia and then to England. After a stint as surveyor general of His Majesty's woods in North America, Wentworth took up his gubernatorial post in Halifax in the spring of 1792. He found a colony in tatters. Strained and nearly bankrupted by the effort and expense of absorbing the Loyalist influx and torn by tensions between the Loyalists and the pre-revolutionary Yankee settlers, the province had become popularly known as "Nova Scarcity".

John Wentworth set himself to the task of bolstering both the colony's economy and its defences. He built his Governor's Road between Pictou and Halifax and persuaded Britain to spend hundreds of thousands of pounds on the Halifax garrison and fortifications. To augment the forces available for defence he strengthened the militia and raised the Royal Nova Scotia Regiment from local recruits.

Wentworth also created a kind of court at Halifax. In his wife, Frances, he had the perfect hostess. While she was a bit too emancipated for some staid Haligonians—she smoked cigars on occasion and was rumoured to have once been the mistress of Prince William, the future King William IV—she gave the capital welcome glitter and panache, making Government House the social centre of the city and filling it night after night with dinner parties and balls. The Wentworths were determined to stimulate patriotism in Nova Scotia and their entertainments

furthered this end. Their blending of the practical with the pleasurable was illustrated at their first large ball at Government House in December 1792, when the decorations included representations of the Governor's Road, a new flour mill, and the Shelburne lighthouse.

The social life of the community also received stimulus from the presence in Halifax between 1794 and 1800 of Prince Edward, Duke of Kent and Strathearn, youngest son of the king. The glamour of the royal presence was increased by a touch of scandal surrounding the prince. With him he brought a woman known as Madame St Laurent who was, in fact, Alphonsine-Thérèse-Bernadine Julie de Montgenet, wife of the French Baron de Fortisson. From his villa on Bedford Basin, Prince Edward managed the armed forces of Nova Scotia and the social life of Halifax.

Wentworth's ambitious plans for Nova Scotia, his own and the prince's social prominence, and Halifax's importance in wartime as the headquarters of the British fleet, all helped to arouse the pride and patriotism that Wentworth sought. But once aroused, that patriotism was not so easily controlled. As Nova Scotians grew more confident, they also grew more independent. A story is told of Richard John Uniacke that illustrates Nova Scotia's growing sense of its own independence. Uniacke, a long-time public servant in Nova Scotia, visited England in 1806. As historian D.C. Harvey commented, Uniacke

> …considered it his duty to call upon the Secretary of State for the Colonies and give him the benefit of his observations, not only upon purely Nova Scotian affairs, but also upon the British North American colonies in general, the conditions in the United States of America…[and] the sort of treaty that should be concluded between the British Empire and Napoleon… His observations extend to some 8,000 words and reveal considerable insight; but what here interests me is his calm assumption of imperial partnership.

Nova Scotians were loyal to the Empire but increasingly thought of their government, in the words of a report of the legislature in 1819, as "the senior British Government in the North American Colonies". They expected to be listened to in the councils of Empire and to be free to form independent judgements.

Sir John Wentworth—he was knighted in 1795—encountered the sturdy independence fostered by his plans in 1799. To create the sort of province he envisaged, the governor sought to maintain a tight control over the elected assembly. His supporters in that body, mostly from Halifax, became known as the Court party. In 1799, however, there emerged an opposition

group, the so-called Country party, led by William Cottnam Tonge. The opposition clashed with Wentworth and his executive over the development of the province, the country people preferring that money be spent on local roads rather than on Wentworth's provincial highways and great monuments such as the new Government House. They clashed over patronage—over Wentworth's favouring of Loyalists for government jobs over pre-Loyalist settlers. They clashed over the question where power lay—whether with the imperially appointed governor or the locally elected assembly. By the time Wentworth retired in 1807, neither side had won a clear victory but the seeds of popular politics had been sown.

THE FOUNDING OF NEW BRUNSWICK

The struggle for influence between Loyalist and pre-Loyalist might have been more intense had there not been a safety-valve for land- and office-hungry Loyalists. The Loyalist migration into the northwestern reaches of Nova Scotia eased some of the pressure. There, in 1784, a new Loyalist province was created. New Brunswick, linking Quebec and Nova Scotia, would be a linchpin in the new, truncated British North America, a solid British colony checking the northern ambitions of Massachusetts, unalloyed by the dubious pre-revolutionary populations of her neighbours. In the summer of 1784 Saint John strained at the seams with refugees, looking more like a gold-rush town than a centre of loyal conservatism. Soon many of the refugees were moving again. Upriver they went, some to settle on generous estates along the Saint John River, others to build the institutions of government at the new capital in the forest, Fredericton.

Land and office created in New Brunswick a powerful Loyalist elite, which Thomas Carleton, first governor of the colony, treated with extraordinary generosity. But then, New Brunswick was the kind of wilderness frontier that had always encouraged a profligate attitude on the part of government. A petition to Carleton in August 1786 indicates the scale on which early land speculators thought. A certain Joseph Gray wrote to the lieutenant governor to explain that his father-in-law had been one of a group of five men who in 1765 had been granted the township of Hillsborough, a gift totalling 126,642 acres. Gray's father-in-law, Joseph Gerrish, and Michael Francklin had bought out the other partners, and Joseph Gray had become manager of the township. After twenty one years they had settled only seventeen families comprising sixty-seven people, most of them Acadians who had drifted back into the Maritimes. Now Gray, on behalf of the owners, wanted a new grant of land, equal to the acreage occupied by their handful of settlers.

In New Brunswick, as in Nova Scotia, events did not unfold as planned in London. The ordinary Loyalists and the immigrants who followed them showed the same distressing independence of mind as other colonists. By 1792 Governor Carleton was confronted by an assembly which disputed his use of patronage and, what was worse, insisted on control over provincial revenues. Soon a running battle broke out between the executive and the assembly about who was to have control of the rich timber lands of the province and the fees that flowed from them. The Loyalist province became as fractious a colony as any of the North American possessions.

JOHN GRAVES SIMCOE AND THE FOUNDING OF UPPER CANADA

To the west, similar ambitions motivated the creation of the other Loyalist province. From the camps on the St Lawrence the Loyalists moved west beyond the Ottawa River, where, as in Nova Scotia, their presence made necessary the creation of a new province. The migrants into what was to become Upper Canada joined those who had fled there directly. Already the initial population pattern of Upper Canada had been established. In the west, centring on Detroit—still in British hands for another decade—were communities that lived by supplying the fur trade of the American west and the north and by provisioning the western British forts. At Niagara were settled the veterans of the border war, the hard men of Butler's Rangers who had so terrified the rebels by their raids into American territory. To the north and west were their Indian allies, the Mohawks, established on a huge reservation around Brantford. Along the shore of Lake Ontario a straggle of population swelled into a major settlement at Kingston, a stronghold in the British Empire as its predecessor, Fort Frontenac, had been in the French. And at Glengarry, on the Ottawa River, Highlanders from the Hudson Valley of New York who had followed their chieftain, Sir John Johnson, into exile had created a facsimile of a Highland community.

The distance of the western settlements from Quebec suggested the need for a division of the province. So did the demands of the Loyalists for their familiar English laws, institutions, and land tenure. The Constitutional Act of 1791 divided Quebec at the westernmost seigneury into Upper and Lower Canada, provided for assemblies in each, and gave English law to Upper Canada.

The raw, new colony of Upper Canada was sparsely peopled by

a scattering of Loyalist refugees from the former American colonies with an admixture of so-called "late Loyalists"—mostly land-seekers who had left the United States for economic rather than political reasons. And, of course, there were the Indians, notably the Mohawks, those redoubtable warriors who had fought England's wars for a century and a half and who therefore had to join the Loyalist flight from the United States. But even the ability of this fledgling colony to survive was not yet certain. In 1788 bad weather had brought the "hungry year" and the threat of mass starvation. Supplies from the military had kept the colony alive, and still in the 1790s the military was by far the most important economic factor.

Given the part played by war in the formation of Canada, it was clear that military considerations would have a central place in plans for the future. John Graves Simcoe, who became lieutenant governor of Upper Canada in 1792, was a soldier who still smarted at the defeat of British arms by the American rebels. And he was a visionary. Looking upon the struggling beginnings of Upper Canada, he saw enormous promise. With frenetic energy he set about creating his model colony. Dissatisfied with Newark, on the Niagara frontier, as a capital, because it was so close to the enemy, he searched for a defensible site. When his first plan for a great fortress-city on the River Thames was turned down by Guy Carleton, now Lord Dorchester, he settled on York. From the new capital he pushed out military highways: Dundas Street to the west, Yonge Street to the north, Danforth Road and the Kingston Highway to the east. The roads would focus the province on York and, as much as any other factor, would make York-Toronto the economic as well as the political capital.

All of this was part of Simcoe's design for Upper Canada. So too was his drive to people the province. He issued a proclamation, which was widely distributed in the United States, inviting land-seekers to Upper Canada. All those who would swear their loyalty to King George could receive free land in the province. (The loyalty of some who came was dubious; among those taking up grants was the executioner of Major André, the British officer who had dealt with the American traitor Benedict Arnold.)

Simcoe's plan went beyond the building of a populous and economically viable colony. His was to be a colony on the Roman model, a warrior colony. The grateful new settlers would be expected to serve in the militia. Simcoe had visions of a population of sturdy farmer-warriors, one hand on the plough, the other on the sword. The highways were constructed to facilitate the rapid movement of troops. York was to be as much a military depot as a political capital. All of this was stimulated by Simcoe's belief in the treachery of the Americans, who might launch a surprise attack at any moment.

Simcoe's planning was not simply defensive. He dreamed of a prosperous and happy Upper Canada that would be a monument to the superiority of British institutions. As such, it would be so attractive that it would drain population from the United States, fatally weakening that mad republican experiment. Its example of superior government would win back the lost American colonies by serving "to counteract, and ultimately to destroy or to disarm the spirit of democratic subversion, in the very country which gave it existence and growth". Soon the day would come when Upper Canada would be strong enough for its soldier-citizens, led by their commander, John Graves Simcoe, to launch an offensive. They would slash into the western territories of the United States and begin to dismember the American union. Perhaps, with luck, George Washington himself would be lured into the field so that Simcoe could lay to rest the rebel president's exaggerated military reputation.

Thus, while his people were still struggling with the numbing toil of carving farms from the wilds, Simcoe was carrying out, by the light of his own fervid vision, London's injunction to build a loyal and British colony. The late war, American injustice, and patriotic sacrifice were kept alive by the establishment of an honour roll. By a proclamation of 8 April 1796 Simcoe allowed all those who had "joined the Royal Standard in America, before the treaty of separation in the year 1783" to distinguish themselves by the title "United Empire Loyalist".

The morals of the pioneers were not forgotten. An earlier proclamation, on 11 April 1793, had been designed to "suppress all vice, profaneness and immorality which if not timely prevented, may justly draw down the Divine Vengeance upon Us and our Country". To this end, all of the laws made in Britain "against Blasphemy, Profaneness, Adultry [sic], Fornication, Polygamy, Incest, Profanation of the Lord's Day, Swearing and Drunkenness" were declared to be in force in Upper Canada.

Simcoe's enthusiasms swelled into delusions. By the time he left Upper Canada in 1796 he had profoundly affected the colony with his highways, his capital, and his settlement policy. Even he could see by then, however, that the United States was not about to collapse and that Upper Canada was going to be a colony of settlement, not a military colony on the Roman model.

THE GROWTH OF POLITICAL OPPOSITION

For an autocratic activist such as Simcoe, the elected provincial assembly was a nuisance, a rabble that did not always appreciate the genius of his schemes. However, if the British North American colonies were to be truly British, as the imperial planners wished, they would have to have elected assemblies. But assemblies meant politics, and politics meant the agitation of many of the same issues that had produced unrest in the Thirteen Colonies. Some political issues seemed to grow naturally, almost inevitably, in colonial soil. That proved just as true in Loyalist colonies as in others. By 1806 the government of Upper Canada had an opposition. Robert Thorpe, judge of the Court of King's Bench, Joseph Willcocks, a member of the assembly from Niagara, and others attacked the government over patronage and asserted the rights of the elected assembly—both tried and true colonial issues.

The unrest of the age, rooted in the ideals of the French Revolution and in the liberalism that produced widespread unrest in England itself after 1815, made opposition even more likely. Sometimes the opposition took overtly seditious form. In June 1794 concern over the inflammatory writings being circulated in Lower Canada by certain "wicked and designing men" led to the formation in Quebec City of a society "for the purpose of supporting the Laws and Constitution". The need for vigilance had been well demonstrated in Quebec in the previous year, when a conspiracy had been uncovered among soldiers of the Royal Fusiliers. The conspirators had plotted to incite their regiment to mutiny, capture the governor and Prince Edward, who was in the city, and hold them to ransom on pain of death if the mutineers' demands were not met. Then, with the ransom money, they had planned to desert to the United States. Three of the conspirators received between four hundred and seven hundred lashes; the ringleader, Joseph Draper, was sentenced to death by firing squad.

Most of the opposition was more legitimate. Nothing could have been more natural than the anger aroused by the iniquitous land system on Prince Edward Island. In an astonishing example of profligacy, the English Board of Trade had divided up the entire island into sixty-seven estates, for which in 1767 a group of court favourites were permitted to draw lots. Few of the owners ever bothered to go to Prince Edward Island; the estates were either managed by agents, who were instructed to extort as much revenue as possible from the tenants, or else simply left vacant.

These great estates were a great temptation to officials on the island. In 1781 Lieutenant Governor Walter Patterson made a show of responding to the complaints of the tenants by ordering the forfeiture of estates that the absentee owners had done nothing to settle. It turned out, however, that Patterson was simply anxious to have the lands for himself, and in 1786, in response to political pressure by the landlords in England, he was recalled. His successor, Edmund Fanning, had the same ambitions and was able to purchase forty-eight thousand acres from the departing Patterson for £98.

During the early 19th century, opposition by the tenants to the bizarre land system and to the local oligarchy at Charlottetown took the form of political opposition in the assembly and revolt in the countryside. The tenants organized mass refusals to pay rents and petitions to demand that Britain end the dominance of absentee landlords.

In Lower Canada the usual struggles for control over land, patronage, and revenue were given an additional edge by ethnic hostilities. The French Canadians may have been uninterested in the boon of representative government, but they soon learned to use it effectively. The assembly of Lower Canada rapidly divided into parties: a British party that supported the executive and a majority *parti canadien*. The *parti canadien* demanded the usual rights for the provincial parliament and showed a deep suspicion of policies for economic development designed to profit only the small group of British merchants that monopolized the colony's commerce. The party became a potent force both inside and outside the legislature when it established a newspaper, *Le Canadien*, in 1806.

The Canadian liberals, led by a bright young lawyer named Pierre Bédard, met their match in an autocratic governor, Sir James Craig, who arrived in Quebec in 1807. Craig escalated the conflict beyond a war of words. In 1809, when the assembly was fractious, he simply dissolved it. In the election that followed, the *parti canadien* increased its representation in the assembly, so Craig dissolved the assembly again in 1810. To improve the odds in favour of the British party during the next election campaign, the governor seized the press of *Le Canadien* and threw its editors into jail. Despite such intimidation, the *parti canadien* again won the election.

It was the threat of war with the United States that convinced Britain of the need to pacify Lower Canada. In 1811 the tyrannous Craig was recalled and replaced by the amiable Sir George Prevost, a bilingual Swiss. Prevost was conciliatory to the French Canadians, even appointing Craig's recent prisoner, Pierre Bédard, to a judgeship.

THE WAR OF 1812

The war that ended the uneasy peace in North America came in 1812. It started almost by accident. Preoccupied as she was by the struggle with Napoleon, Britain attempted to avoid war with the Americans. One of the major causes of the quarrel with the United States was the orders-in-council under which British warships had been seizing American vessels trading with France. The British government was now prepared to withdraw these orders-in-council, but on this occasion, unlike 1775, chance worked against the British. On the late afternoon of 11 May 1812, while the matter of conciliatory gestures to the Americans was still under discussion, the British prime minister, Spencer Perceval, was walking through the lobby of the House of Commons. He was confronted by a man named Bellingham, who had suffered business losses for which he held the government responsible. Bellingham took out a pistol and shot Perceval through the heart. The assassination—the only one that has ever claimed the life of a British prime minister—cost his country dear. Because of the resulting confusion in the government, it was not until 16 June that the decision to withdraw the offending orders-in-council was revealed. While the news was starting its month-long voyage to America, the United States declared war on 18 June 1812.

Again Canada was threatened from the south. The colonies were badly prepared, for Britain had had to concentrate her attention and her forces on the war in Europe. The lieutenant governor of Upper Canada, Francis Gore, had been on leave of absence since October 1811, leaving the province under the administration of Major General Isaac Brock. With only one British regiment stationed in Upper Canada, Brock's position was not an enviable one. He could mobilize the militia to defend the province, but there were few supplies and fewer weapons for them. The troops standing guard along the Niagara River, Brock told Governor General Sir George Prevost in early July, were suffering because there were not even tents to accommodate them.

Worse still was the attitude of the people. Upper Canada's population was overwhelmingly of American origin—Loyalists and later land-seekers and their offspring. Brock was convinced that many of these former Americans would welcome annexation to the United States, and the response to the outbreak of war seemed to confirm his fears. When ordered to turn out with their militia units, many Upper Canadians refused to respond. The legislature seemed unimpressed by the seriousness of the situation and refused to suspend habeas corpus or to grant the governor other emergency powers. The harried Brock wrote to Prevost's adjutant, Lieutenant Colonel Edward Baynes, in late July: "My situation is most critical, not from anything the enemy can do, but from the disposition of the people—the population, believe me is essentially bad."

Brock's opinion of the other key players in the military game, the Indians of the province, was no higher; he believed that the native people, like the white population, had been influenced by American propaganda and bribes. Yet, with insufficient British troops and a militia at best uninterested and at worst disloyal, he had to risk including the Indians in his defence force. To reduce the possibility of treachery, he planned to intersperse "this fickle race", as he called them, among his other troops. "I should be unwilling in the event of a threat", he wrote, "to have three or four hundred of them hanging on my flank." Brock also advised Prevost that gaining the assistance of the Indians would be expensive, for the "fickle race" would have to be heavily bribed.

Brock's pessimism and his low opinion of the population were not qualifications for election as a national hero, but these characteristics have been overshadowed by his conduct of the campaign, and even more by his death. Despite his suspicions of the Indians, Brock made brilliant use of them. Indians, fur traders, and British regulars shared in the first triumph of the war, the capture of the American outpost of Michilimackinac on Lake Huron on 16 July 1812.

More important was Brock's use of his Indian allies, or rather of their reputation, to defeat the first invasion of Upper Canada. On 11 July General William Hull and twenty-five hundred American soldiers entered the province from Detroit. But British ships controlling the lakes made it difficult for Hull's army to receive supplies, and the Americans' consequent disposition to retreat was reinforced by Brock's cunning. General Hull was known to have an exaggerated fear of Indians. A counterfeit British order, allowed to fall into American hands, made it appear that some five thousand Indians were massing at Amherstburg, near Detroit. Fearing that this imaginary force might attack his rear, Hull scuttled back into Detroit.

As Brock marched to the frontier with the small force that was in reality all he could muster, Hull awaited the attack of the Indian hordes he still imagined to be gathering. To maintain the pressure Brock sent a demand for surrender which warned, regretfully, that once the attack on Detroit began, his Indian allies would "be beyond control". On 16 August Brock crossed the river with his little army of seven hundred whites and six hundred Indians to besiege Detroit, which was defended by twice

as many American troops. The war of nerves succeeded. Hull, with visions of multitudes of Indian warriors before his eyes, surrendered the city and his entire army without a shot.

Brock was the hero of the day. He found the militia now more enthusiastic, for after the victory at Detroit it became clear to many Canadians that the best way to avoid a long, damaging war was to rally to British arms and defend the province. But Brock did not have long to enjoy his new-found popularity. On 13 October 1812 American invaders crossed the Niagara River and were met by the British forces at Queenston. Leading the charge against the enemy up the heights of the Niagara escarpment, Brock was killed by an American sharpshooter. The next day British reinforcements routed the Americans and drove them back across the river. The victory at Queenston Heights and Brock's dramatic death created a war spirit, a national spirit, in Upper Canada.

The war dragged on for another two years. The British forces generally had the better of it. The burning of Upper Canada's capital, little "muddy" York, in 1813 was more than compensated for by the British burning of Washington in the following year. British forces occupied Maine, and Nova Scotia grew rich on the plunder from captured American vessels. Upper Canada weathered the American invasion of 1813 and emerged strengthened in its loyalty. Brock would have been pleased to see how fierce the war spirit had become.

There was irony at the end of the war, as at the beginning. The war had broken out in 1812 because news of the British government's conciliatory measures had arrived too late to prevent it. In 1814 one of the largest battles of the war was fought at New Orleans after a peace treaty had been signed, again because the news did not arrive from Europe in time to forestall the event.

Despite the military advantage Britain enjoyed at the war's end, she was anxious to establish peace and gladly returned to the Americans the territories occupied by British troops. Many Canadians resented the generous terms, but in fact Canada had gained much from the war. The successful defence against the vastly more populous United States and the performance of the militia—already being exaggerated at the expense of the British regulars and the Indians, who had done most of the hard fighting—had begun to forge for Upper Canadians a sense of identity and something like the beginnings of nationalism.

The War of 1812 would grow in memory and become the seedbed of a Tory myth in Upper Canada. Those who had been prominent in leading the defence, men such as Attorney General John Beverley Robinson and the Anglican rector of York, John Strachan, would live by the lessons of 1812. The dangers of American-style radicalism, the virtue of commitment to British values, and the right to rule of those who had saved the province from the Yankees would become the rationale for the Tory oligarchy known as the Family Compact.

The most important result of the war was peace. Despite the tensions later produced by the rebellions of 1837 and the American Civil War of 1861–1865, Canada and the United States would not go to war again. These colonial societies forged in continual conflict would now have the opportunity to work out their destinies without mutual strife. It would be two generations, however, before the psychology of garrison societies would begin to change, and before Canadians would be genuinely free of the burden imposed by the fear of war along their frontier.

RENEWED DISCONTENT

The War of 1812 had been an important turning point for British North America in many ways. Yet it had not resolved the domestic tensions that had begun to produce the politics of opposition in the immediate prewar years. The foreign threat had temporarily quieted partisan politics but disaffection rapidly reemerged.

The lodestone for discontent of all sorts in Upper Canada was a good-hearted but mentally unbalanced Scotsman named Robert Gourlay, who came to Upper Canada in 1817 hoping to found a settlement for poor people from Britain. To gather information about the province, as an aid in developing his plans, Gourlay circulated a questionnaire throughout Upper Canada. The thirty-first and last question asked: "What, in your opinion, retards the improvement of your township in particular, or the province in general?" The replies convinced Gourlay that there were serious problems in Upper Canada, and he began an agitation against the evils of the land-granting system, the practice of reserving certain land "for the support of a Protestant clergy" (the clergy reserves), and the policy, adopted as a result of the recent war, of excluding Americans from settling.

Gourlay issued addresses to the people, each more critical of the government than the last, and in the spring and summer of 1818 he organized township meetings where grievances could be aired. In acting thus, Gourlay was challenging an entrenched provincial oligarchy. Such oligarchies dominated the government of a number of colonies; in Lower Canada it was the Chateau Clique, in Nova Scotia the Council of Twelve. In Upper

Canada the small ruling group became known as the Family Compact.

Gourlay's attacks on the "system of paltry patronage and ruinous favouritism" were bound to anger the Compact, the more so when his instrument of agitation was the popular township convention, a device that called to mind the direct democracy of the hated American republic. The oligarchy acted decisively. In the fall of 1818 a law was pushed through the legislature banning such conventions. But Gourlay continued his denunciations, and in December 1818 he was arrested and charged under an almost forgotten sedition act. After languishing in jail, he was banished from the province in August 1819.

While this silenced Gourlay, it did not end the agitation. Gourlay became a martyr in the eyes of many, and an opposition rallied around his memory. In the provincial election of 1820 the first large opposition group was elected as "Gourlayites", and during the ensuing decade this opposition was consolidated as the Reform party.

THE FAMILY COMPACT AND THE LAND QUESTION

The group in power, the Family Compact, had emerged slowly and organically from the system created by the Constitutional Act. The elaborate governmental structure made an oligarchy almost unavoidable. The translation to the colonies of the British form of government, designed for a much larger and more sophisticated society, created the need for a body of well-educated public servants. There were few men in these emerging colonies qualified to govern; there were even fewer who had the social polish that British governors demanded of their intimate associates. Simcoe had nothing but scorn for the bulk of the elected representatives in Upper Canada who were, he said, men of "a Lower Order, who kept but one Table, that is who dined in Common with their Servants". In these circumstances it was almost inevitable that government office would fall to a tiny elite of men, each of whom would, of necessity, hold several positions. By 1820 the inner core of the Compact consisted of six or eight men. At the head was the Anglican rector of York, John Strachan, who exercised a paternal authority in the oligarchy because many of its younger members had attended his exclusive Cornwall grammar school. As well as leading the provincial church, Strachan sat on the executive council. The young attorney general, John Beverley Robinson, was a member of the executive council and at the same time speaker of the assembly.

Lesser members of the oligarchy also understood how the system of preferment worked. Surveyor General Thomas Ridout assiduously prepared his sons for advancement, first sending them to Strachan's school and then finding them jobs in the civil service. He advised one son in 1811 that "a situation in a public office will make you known, and give you the independence of a gentleman. It will give you their society too."

At the base of the Family Compact and, by the same token, among the roots of the opposition's discontent was the land-granting system. The same favouritism that had mortgaged the future of New Brunswick and Prince Edward Island operated also in Upper Canada. By 1788 Loyalists who had borne arms were receiving a minimum of three hundred acres, free of any fees; officers received up to five thousand acres. Other Loyalists received two hundred acres. Simcoe's proclamation of 1792 provided another huge land giveaway. Implementing provisions of the Constitutional Act of the previous year, it set aside one-seventh of every township as a Crown reserve, and another one-seventh as a clergy reserve. While settlers could receive free grants of two hundred acres, the governor could make larger grants, up to townships of one hundred square miles, to those who brought in settlers. It did not stop there. Early colonial governments had few rewards to offer for loyal service, and so enormous tracts of land were given as bonuses to officials, militia officers, and other worthies. One outstanding beneficiary of this system was Colonel Thomas Talbot, rewarded by the British government in 1803 for service in Ireland with a grant that eventually grew to over sixty thousand acres and made him the feudal baron of the north shore of Lake Erie. By 1824 eight million acres of Upper Canada had been given to individuals, and another three million were held in Crown and clergy reserves. A further million acres in western Upper Canada were given to a private company, the Canada Land Company, in 1826.

Much of this land, including many of the Loyalist grants, was held for speculation. Even in the most densely populated part of Upper Canada, the Home District around York, most land was held in the hope of future gain. A settler who obtained a grant of land would not receive a patent of final ownership until he had completed certain improvements; this usually meant building a small house, and clearing and fencing at least five acres. Official grantees, however—military and government officers and Loyalists—could receive patents with no obligations. As a result, of 550,000 acres in the Home District under patent in 1812, only half were occupied in some fashion and only 19,000 acres (less than four percent) were cultivated.

By the end of the 1820s almost all of the arable land in the

province had been granted away. Millions of acres remained idle, in the possession of speculators, the Crown, and the Anglican church; but already, by the 1830s, in areas such as the Home District, a landless class of labourers was being created, men who could never hope to own land.

FROM LIBERALISM TO NATIONALISM IN LOWER CANADA

Land was an important element also in the unrest that troubled Lower Canada. Here, however, it took a different form, since much of the land had been granted away centuries earlier, and the issue now was the shortage of arable acreage for the sons of habitant families. In addition, the relations of English and French added a unique quality to the politics of Lower Canada. At the end of the War of 1812 the leadership of the popular forces had passed from men such as Bédard, liberals who sought to win for Lower Canada the benefits of English parliamentary government, to "nationalists", men who sought to defend the unique characteristics of the French Canadian way of life. The leader of the nationalists was the new speaker of the assembly, Louis-Joseph Papineau. A clever and sophisticated man, aristocratic in bearing (he was in fact seigneur of Petite-Nation on the Ottawa River), Papineau gave new firmness, and indeed rigidity, to the *parti canadien*. The clashes between Papineau and equally haughty governors would propel the politics of Lower Canada towards impasse and eventual rebellion.

THE GROWTH OF TRADE

The political aims of the imperial planners clearly had failed. Everywhere in the colonies, by 1820, there were oppositions and worsening confrontations. Greater success attended the planners' economic hopes. The principal hope—that British North America might replace the lost Thirteen Colonies in the trading empire—was slow of accomplishment; but during the wars against revolutionary France, the colonies proved their worth. Trade between British North America and the home country increased, fostered by incentives such as the fishing bounties granted to Nova Scotia and Newfoundland. After 1806 the growth was spectacular. In that year Great Britain and Napoleonic France began full-scale economic warfare, and continental Europe was closed to British shipping and British trade. Cut off by Napoleon from supplies of Baltic timber, on which she had relied for her naval construction, Britain looked to the colonies.

To encourage the production of desperately needed timber, Britain offered a variety of inducements. Established companies were given bonuses to set up branches in Canada. As an assurance to both the British companies and the colonials that investment in the timber trade would be wise, even after the war, increased tariffs against foreign timber entering the British market guaranteed colonial wood a large price advantage. The stimulation had immediate, dramatic results. In 1806 New Brunswick shipped 7,000 loads of timber to Britain; in 1807, 156 ships carried 14,000 loads; three years later there were 410 ships in the trade, bearing 51,000 loads of New Brunswick timber. By the end of the Napoleonic wars in 1815, New Brunswick was exporting 92,500 loads.

As the fur trade declined, timber and wheat became the major staple products. The trade in these commodities could be wonderfully lucrative, as during the Napoleonic wars, but it was intrinsically unstable, dependent in peace time on foreign markets over which Canadians had no control. In particular, it depended on British politics for the maintenance of the imperial tariff preferences that gave British North America an advantage in competition with European suppliers.

The precariousness of the staple trades began to show in the 1820s when Britain started to tinker with the preferences. Later, in the 1840s, when the preferences were withdrawn, the Canadian economy was thrown into a frightening depression.

SOCIAL LIFE IN THE COLONIES

The timber trade brought more than an economic cycle of boom and bust. For many men it brought adventure and escape from the boredom of life on frontier farms. The long winter of cutting in the forests of New Brunswick and Upper and Lower Canada was a time of wrenchingly hard work; but it was also a time of rough companionship and of ample food and rum, greatly preferable to the loneliness and subsistence provisions of farm life. The labours of winter were followed by the heady adventure of the river drive down the Ottawa and the St Lawrence, or the Mirimachi and the Saint John, to the timber ports. On the Ottawa River the logs were tied together into "cribs" on which adventurous rivermen rode down the exhilaratingly dangerous Chaudière rapids. When they reached the St Lawrence the cribs were lashed together to form giant rafts of timber, on which the raftsmen lived in huts and raised large sails to speed their passage to Quebec.

All along the rivers were dangers and enticements. The

inhabitants of the river banks soon learned that when spring arrived it was time to hide their chickens and pigs and liquor and daughters from the roistering raftsmen. The adventure of the timber drive reached its climax in the timber ports of Quebec and Saint John. Thousands of raftsmen received their winter's wages and spent them in these cities; they were joined by thousands of sailors from the timber ships, waiting to carry their wooden cargoes to Liverpool. Blessed as they were by the economic stimulus of the timber trade, Quebec and Saint John were plagued at the same time by the armies of prostitutes and gamblers who came to prey on the raftsmen and the sailors.

The uproarious atmosphere of the port cities was a far cry from the aristocratic stability envisaged for British North America by imperial planners. The raftsman leaving the pay office of his employer, a year's wages in his pocket, was beset by crowds of card-sharps and keepers of lodginghouses and brothels, all anxious to help him release the winter's tensions. In the rows of shops that catered to his kind, he could outfit himself with gaily embroidered shirts, colourful sashes, and the umbrellas that were symbols of affluence for these rough men. Suitably attired he would—in the phrase of the day—"dash off", flaunting his finery and his money in the countless grogshops and bordellos. Soon, in a matter of days or weeks, the money would be gone, perhaps the finery too. Then it would be time for the raftsman to make his way upriver to look for a job for the next winter, to start the cycle of drudgery and adventure and drunkenness and riotous living over again.

Most Canadians had little such excitement in their lives. Farming, in the first generations, was hard and endless work. It could also be a lonely life, although for those with families there was at least companionship and the shared dream of independence. Diversions were few, but perhaps for that reason appreciated all the more. Taverns flourished everywhere, even in the most remote areas, and in the towns there was often a drinking establishment for every eighty or ninety people. For men the tavern, usually the one reasonably large building in the community, was the major social centre. There they gathered to drink, to hold political meetings, to see travelling entertainers, even to hold sessions of municipal governments and courts. Women were not generally welcome at taverns; thus their lives were even lonelier than those of the men and, not surprisingly, many women sought relief from the dark and the wilderness by drinking alone in their homes.

Even in the backwoods, however, there were communal events to break the boredom. Religious revivals attracted large crowds to camp meetings, which might go on for weeks. Highly emotional religion provided relief for the psyche as well as salvation for the soul. Bees—gatherings held for the purpose of raising barns, clearing out stumps, or harvesting crops—also brought neighbours together. The hosts of a bee were expected to supply generous quantities of food and liquor, and as a result such occasions often degenerated into drunken brawls. Whether bees were an efficient way of accomplishing the work to be done was questioned by middle-class moralists, but that they were popular social activities cannot be doubted.

The weight of governmental authority was only lightly felt in the backwoods. The functions of local government, the judiciary, and the police were exercised by unpaid magistrates, local notables whose effectiveness depended on the respect they commanded in their communities. As in Britain and France, much of the effective social control was informal and traditional, imposed by local codes of conduct.

One common and dramatic form of control was the charivari. Local rules of conduct sometimes differed from those sanctioned by formal law. This was especially true in regard to marriage, the central institution in a family-centred society. Some marriages that were legal were nevertheless disapproved of. Such dubious unions would include those between old men and young girls or between boys and older women, interracial marriages, and marriages contracted by widows too soon after the death of their husbands. Communities often expressed disapproval of such weddings by charivaris. People dressed up in exotic costumes, parading as Indians or animals or birds; most participants would wear the ancient symbol of sexuality, animal horns. They armed themselves with pots and pans, whistles, bells, and all varieties of noisemakers to produce the "rough music" that was an essential part of the charivari.

This collection of grotesques, shaking the air with its cacophony, would march to the home of the offending couple, there to disturb the wedding night with its din. Sometimes the crowd could be bought off with money or liquor; but there were times when the charivari turned into a riot, even a lynching. The justice dispensed was as rough as the music, but the charivari helped to maintain the bonds of community in a strange new world.

In the towns, charivaris were popular even among the more sophisticated citizens. In the first decade of the 19th century York was troubled by a number of large and violent charivaris in which young social leaders and military officers participated. Nevertheless, the leaven of office-holders and army officers made

possible the emergence of a fashionable elite society at an early stage in all the major towns. The rewards of imperial service and the proceeds from large estates allowed this class to build grand homes, to import furniture from Britain or the United States, and wines and brandies from Europe, and to send its sons home to Britain to be educated, and often to the Continent to have their rough edges polished. Theirs was a world that had little in common with that of the frontier farmer.

It was a world that, in some respects, demanded the best of its inhabitants, and often got it. One family that rose to the challenge was the Baldwin family of York. The Baldwins migrated from Ireland to Upper Canada in 1799, bringing with them a reputation for public service and all the advantages of a good education, but only modest means. William Warren Baldwin, an Edinburgh-trained physician, moved his family to York in 1802, where he began his rapid rise. Finding medicine not as lucrative as he had hoped, Baldwin quickly retrained as a lawyer. He built a flourishing practice and, equally important to his success, became a considerable social lion. Though the Baldwins were considered odd by the Tory elite of York because of their liberal politics, William Warren's fine pedigree, erudite conversation, and polished manners won him entry to the best homes. By 1812 he was judge of the surrogate court and a wealthy man. Astuteness in choosing friends and patrons had brought him the inheritance of the rich estates of the Honourable Peter Russell. But Baldwin was not simply a courtier. He served his community well as lawyer, judge, patron of charities, stalwart of the Reform party, and originator of a major political innovation— responsible government. Like many other members of the elite, Baldwin tried his hand at an astonishing range of activities, from farming to doctoring to duelling, and was remarkably good at most of them. It was typical that, when the Law Society of Upper Canada decided it needed a suitably impressive headquarters, Baldwin took on the job of designing one. With no background in architecture he quickly absorbed textbooks on the subject and produced the design for Osgoode Hall, York's most striking building and perhaps the best building in all of the British North American colonies.

The world of the elite did not always coexist easily with that of the common people. The disgust of one governor general, the Earl of Dalhousie, with the latter was apparent in his journal. In June 1820 he reported: "This week has been enlivened with garrison races which we thought would have brought out what gaiety was in Quebec. Scarcely anybody came to the ground except the common people, & these ill behaved, drunk & riotous.

No sport..." The common people were also carriers of the illnesses and epidemics so common in 19th-century society. Dalhousie recorded in December 1820:

> Several instances of Hydrophobia [Rabies] have lately occurred, proceeding it appears from the practice of the poorest classes of people here keeping large dogs for the purpose of dragging on small sleds such firewood as they can gather within the near woods. These animals are starved & worked like dray horses, until exhausted by fatigue & want of water, it is imagined that their bite has all the poison of madness. However that may be, it is not a little extraordinary that two such instances of the most decided Hydrophobia should have occurred at this time, the one a soldier at Montreal of 37th Regt. bit in Oct. by a dog laying in the passage of the barracks, the other in Quebec, a boy nine years old bit by a dog, also in October. The animal was yoked in a sled & was let loose & hunted on this child in play.

This passage captures important themes in 19th century society. It suggests the fear of disease, at a time when so little could be done to control or treat it. It speaks of the problems of the poor, too impecunious to buy the firewood necessary for survival in the harsh climate. It reflects the gulf between the classes and the resultant lack of understanding and insensitivity on the part of the elite. For example, in many towns where fear of hydrophobia was widespread, the poor were forbidden to keep dogs. Yet without dogs they could not get firewood, without firewood they could not have heat, and without heat they could not survive.

GEORGE WILLIAMS'S HALIFAX, 1820

George Richard Williams, captain in the 47th Regiment of His Britannic Majesty's forces, was the third generation of his family to serve in British North America. His grandfather had been a terrified young cadet at the 1745 siege of Louisbourg. His father had shared the shame of the British defeat at the hands of the American rebels in 1783. George had won distinction and acquired a permanent limp from a leg wound in the Battle of Stoney Creek in Upper Canada in June 1813. The Williamses were representative of the British military class that did so much to shape the Canadian colonies. The leadership, culture, and cosmopolitanism of generations of army officers enriched the society of these small communities, even as supply contracts, military construction, and spending by soldiers vitalized their

economies. Military expenditures may well have been the largest single factor in the economy of colonial Canada.

In 1820, as George Williams moved about in the official circles of Halifax, where he had been posted four years earlier, he saw the proof of the military influence. Although much of the navy and the garrison had been removed after the peace in 1815, sailors and soldiers were still highly visible in the streets of Halifax. Had George frequented the low taverns and brothels of the city, the military presence would have been all the more apparent.

Above the town loomed the growing fortifications of the citadel, planned as yet another impregnable fortress on the lines of Louisbourg and Quebec. The citadel at Halifax was constructed as a defence against an American attack that never came. Given the record of the fortresses at Louisbourg and Quebec, this was indeed fortunate. To the south of the citadel, the harbour mouth, too, bristled with fortifications. During the American war, a great chain had extended across the entrance to the Northwest Arm to stop enemy ships. Like the fortifications, this defence had never been tested. Halifax had known only the plunder of war, not its miseries.

The military class that had led Nova Scotia since Halifax's founding in 1749 had brought wealth and sophistication but had not altogether effaced the North American environment. George Williams's Halifax was a curious mixture of Europe and North America, of an old civilization and a new world. The most prominent landmark was the town clock, a huge and graceful monument to the royalty of the Old World erected on the brow of Citadel Hill. Donated in 1830 by King George III's son, Edward Duke of Kent, after a tour of duty as commander-in-chief in Halifax, the town clock ticked out the time in a precise European fashion.

The official buildings of stone were in the same mode. Since 1800 Government House had been the home of the governors of Nova Scotia. Province House, a graceful English Georgian building with Ionic columns, just reaching completion in 1820, was to be the seat of the legislature and the pride of the government; many visitors spoke of it as the most splendid edifice in North America. These two stone structures represented the bases of colonial society; Government House represented the Crown, Province House the colonial leadership consisting of council and assembly. A third great stone public building, Admiralty House, was headquarters of the Royal Navy.

The three official buildings shared British Halifax with the homes of the merchants, whose livelihoods depended on the trade of the Empire and the expenditures of the armed forces. To the north of the citadel stretched a district of handsome houses embellished by impressive porticoes, grand entrance steps, and ornate doors. Yet, like the public buildings, the merchants' homes stood beside coarse sand streets. In places, farms, such as Gorsebrook, owned by merchant-banker Enos Collin, and John Young's model farm, Willow Park, extended into the city. The central town was dominated by the market, regarded by the prominent citizens as an irksome necessity. The market was the gathering place of the rough truckmen who brought their carts to transport produce and who were a perpetual nuisance—rude and noisy, playing football across the square while awaiting business, and refreshing themselves at the two grogshops in the market. The excesses of the truckmen were kept in check by municipal by-laws, which did not prevent their drinking but did prohibit smoking in the streets.

The market attracted another element, which George Williams found even less desirable than the truckmen. He was disgusted, when he passed the market, by an infuriating parody of the military. Since the American Revolution, Nova Scotia had been home to a large black population—servants and slaves of the Loyalist refugees to the province who had made up more than ten percent of the total number. A new influx had come in the 1790s when Britain settled Maroons from Jamaica in Nova Scotia. Again, during the War of 1812, blacks had fled to freedom behind the British lines in occupied New England. Settled in Nova Scotia at the war's end, some of these poverty-stricken blacks had been given used and surplus British uniforms as their only clothing. Many lounged about the market hoping for odd jobs, wearing these increasingly tattered imperial remnants.

THE JOURNEY OF GEORGE WILLIAMS

In 1820, when the lieutenant governor of Nova Scotia, George Ramsay, Earl of Dalhousie, was elevated to governor general of British North America, Captain Williams had the opportunity to compare the influence of the military on the various colonies. Before Dalhousie left for his new capital of Quebec, he ordered a survey of the military capabilities of his realm. To fulfil these orders, George Williams set off in the spring of 1820 at the head of a party of engineers and officers on a gruelling overland journey. Their survey began in Saint John, New Brunswick. More purely a commercial centre than Halifax, Saint John prospered or declined along with the fortunes of two great imperial trades, the shipment of timber to Britain and the

provision trade with the West Indies. George Williams approved of the evidence of British enterprise to be seen on the docks of Saint John, but it was the military situation that he was concerned with, so he pushed his party upriver to Fredericton.

Fredericton was Halifax in miniature, a military and governmental outpost in the boundless forests of the New Brunswick interior. With its garrison, its government establishment, its descendants of the Loyalist elite, and its fine New-England-style homes, it was a secure, well-defended stronghold. Captain Williams was less pleased with what he found to the north. After leaving Fredericton, the party struggled through the forest to the Miramichi River, the commercial artery of central New Brunswick. Here the civility of Halifax and Fredericton was replaced by the harshness of the frontier. The timber trade along the Miramichi and the fleet of droghers that carried the timber to Britain attracted a floating population of New Brunswickers, "Pay Islanders" from across the Northumberland Strait, and Irish immigrants. Now that the markets for timber had slackened in the inevitable post-war slump, many were unemployed and desperate. Captain Williams included in his report a warning of serious unrest and criminal activity along the Miramichi. His prediction was accurate. In 1822 the small troop detachments on the river would have to be reinforced to protect property against wandering bands of men who seized the necessities of life that a fickle economy did not allow them to earn.

For Englishmen the journey through the forest from the Miramichi north and west to Lower Canada had the novelty of a hunting trip—at least, until the weeks dragged into months and the voraciousness of Canadian insects took its toll in swollen faces and puffy hands. The enthusiasm for an adventure in the woods was typical of middle-class English romantics. It was an attitude markedly different from that shown by native Canadians or lower-class American and British immigrants. For most of these the forest landscape was as invisible as any workplace; when it did thrust itself upon their notice, it was seen as an enemy. Visitors like George Williams deplored the hostility of Canadians to trees and their ruthless employment of any means—the axe, fire, girdling—to destroy the forest. Conservation was of no concern to people who saw a forest that was apparently endless, nor was romanticism about the dark groves likely to stir those who had to wrest every acre of farm land away from the trees.

Summer was well advanced when the party reached the St Lawrence. This was another world—perhaps several worlds. Each English traveller would find in French Canada what he expected to find. Some, including George Williams, found a society of order and obedience, habitants and seigneurs and priests, each element in its appropriate station, a society free from the bumptious striving of timberers or the democratic levelling of the Americans. The engineers, men of progress, were less touched by the placid order. They found an unprogressive society, stifling in its conservatism, delivering up its meagre surpluses to drone priests and petty lordlings.

None of them found the society that was there, a society that had mastered the arts necessary to a conquered minority, the arts of survival and self-sufficiency. It was a society learning to preserve the essentials of its cultural wellbeing under the weight of foreign rule and ever-worsening economic problems. With each generation that passed, the neat farms and sleepy villages that Captain Williams found so charming became less adequate to support the growing population. Shut off from commerce by the conquerors, the habitants saw their economic horizons growing ever narrower. The stubborn strength with which they survived as a people under such disadvantages would not become apparent to Captain Williams and his countrymen until the habitants rose up in their thousands against the threat to their society in the rebellions of 1837–1838.

Even in this period of postwar withdrawal, the travellers observed military detachments at the ready all along their route. Some of those detachments found it hard to resist the pressures of the North American environment. The lure of opportunity in the United States was always a powerful attraction for Canadians; it was no less so for British soldiers. Despite the best attempts of military authorities, soldiers—especially at frontier posts such at St John and Isle aux Noix in Lower Canada—deserted to the United States in alarming numbers. Captain Williams heard complaints from all the post commanders. In that particular year of 1820, of 3,371 British regulars serving in the two Canadas, 199 or nearly six percent deserted. The problem was one that the army would never solve; it would increase to epidemic proportions until in 1857 twenty-eight out of every one hundred British regulars in Canada deserted.

By midsummer Williams and his party had pushed on to Upper Canada. They visited four areas: two posts where garrisons kept a wary eye on the recent enemy along the western frontier and the Niagara River; Kingston, a major establishment where Fort Henry commanded the head of the St Lawrence; and the provincial capital, York.

York had been chosen as the capital in the 1790s largely for military reasons. The first lieutenant governor of Upper Canada,

John Graves Simcoe, had felt that both Kingston and Niagara were too vulnerable and too difficult to supply. York, on the other hand, with Indian allies close at hand and convenient water and land transportation routes, was ideally located. Alas, in 1813 York proved impossible to defend and fell to the invaders.

By the time Captain Williams arrived in 1820, the town had only a small, poorly armed garrison, squatting in decaying fortifications. Nor were the troops held in high regard by the more progressive citizens. Simcoe had set aside a military reserve of a thousand acres west of York. Though the reserve had shrunk somewhat, largely because General Brock had given part of it away to his cousin, military land still stretched from Peter Street to Dufferin Street, and from the lake to modern Queen Street (or Lot Street, as it then was). This barrier to urban expansion irked land speculators.

Nevertheless, for an officer York was nearly as comfortable a posting as Halifax. In small communities military officers were among the social leaders, much sought after to grace parties and to marry merchants' daughters. They took major roles in cultural life, often presenting musical and theatrical performances. In the winter of 1818-1819 the officers of the York garrison had mounted a successful season of plays and had talked of building a proper theatre. But nothing had come of the proposal, and by 1820 even the garrison had lapsed into the torpor that seemed to grip the capital in the decade after the war. Samuel Peters Jarvis, a pillar of York society, sympathized in 1823 with young people who went off to Niagara seeking a livelier environment. There, he told his wife, they would spend their time

> …agreeably & pleasantly, and with much more satisfaction than they would at York—which to the younger part of the Society, must be daily growing more stupid… In part, such a thing as a Sociable Evening party is scarcely known now.

But York still bore little resemblance to the Toronto of the late 19th and early 20th centuries, Toronto the Good, the bastion of puritanism. By the middle of the 1820s the town was reviving, both economically and socially. From 1824 on, professional theatre companies from the United States visited regularly— until one Edward Nowlan was killed outside the theatre in 1828 by a young printer, Charles French. In the public mind the performance inside the theatre and the murder outside became connected, and for the next few years theatricals were held in ill repute. The players returned in 1833, but not everyone welcomed them. The radical leader, William Lyon Mackenzie, thundered against the immorality of play-acting in his newspaper, the *Colonial Advocate*:

> Only think of allowing such a party of strolling vagrants to keep a giddy party of foolish people up on a Saturday night until, perhaps, 2 or 3 o'clock upon Sabbath morning… Do our authorities wish the morals of our youth reduced to a more degraded state than it is?

Perhaps Mackenzie was influenced by the fact that the wretched French, who committed the murder outside the theatre in 1828, had been employed on the *Colonial Advocate*.

Such frivolities did not interest Captain Williams, who pressed on to complete his circuit before winter. The party travelled from Kingston along the Rideau system to the Ottawa River, following the route already being talked of as the site for a military canal. Six years later, after the favourable recommendations of Williams and others, Colonel John By would arrive and would begin cutting the Rideau Canal, to provide a transportation link between Montreal and Kingston that would be more secure from American attack than the St Lawrence valley route.

THE GOVERNOR GENERALSHIP OF LORD DALHOUSIE

Williams travelled on to Montreal and finally to Quebec to report to Governor General Dalhousie. Arriving in late September, he had to cool his heels awaiting Dalhousie's return. Dalhousie had taken an instant dislike to Quebec and its people, and even in his first year as governor general spent as much time as possible at a rustic retreat near Sorel, where he and his aides hunted, fished, and discussed the failings of the French Canadians.

On 4 October 1820 Dalhousie returned to the capital aboard the steamer *Swiftsure*, the technological marvel of the day. At his meeting with Williams, he babbled enthusiastically about the wonderful vessel with its two thirty-horsepower engines. It had carried them, he told the wondering officer, at eight to nine knots per hour, against the tide. Man had conquered nature.

Dalhousie and Williams went meticulously over the reports and drawings that chronicled the survey of Canada's military capabilities. The subject was close to Dalhousie's heart and interests. His concern with the inadequacies of the colonial defences as reported by Captain Williams also provided a welcome opportunity to get out of Quebec by undertaking extensive tours to view the defences for himself. In 1820 he had visited the Ottawa River, the settlements of veterans along the Rideau, and military posts on the St Lawrence. The following year he was off again to Kingston, Niagara, Sandwich on the western frontier of Upper Canada, and even to Lake Superior. In

1823 he toured the Eastern Townships of Lower Canada and then travelled to Nova Scotia.

Dalhousie laid great stress on the importance of such visits to the colonies under his administration. Not only could he see for himself the state of the defences, but he could build a sense of unity, so crucial when the American threat lingered over British North America. The need for the governor to travel, he wrote in his journal in 1823,

> ...is a point...which ought to be pressed upon the King's Ministers as necessary to fix the attention of the people on the connexion & intercourse between these component parts of the British Empire in America, and to assimilate the policy of all as one powerful whole. At present we are 5 disjointed pieces in no way capable of assisting each other.

But popular as he was among the stolid Scots of Nova Scotia, Dalhousie never understood or liked the French Canadians, and his distaste was reciprocated by the political leaders of Lower Canada. His politically stormy tour of duty did much to alienate French Canada and set it on the path to rebellion. He left Canada in 1828, defeated in his aim of turning the French Canadians into North Britons. He was not the first, or the last, imperial planner to be frustrated by the intractable French Canadians and their strange environment. Yet the very novelty of that environment, its vast natural resources, and the sparseness of its population made it an irresistible canvas for planners and dreamers. The Canada that would eventually appear on that canvas would be drawn in rough outline by those planners, but the image would be distorted and often obscured by the materials with which they had to work: the geographic, economic, and cultural realities of the country.

THE DEATH OF A CULTURE

In Upper Canada, when the Loyalists arrived, Indians were still much in evidence. Although the government began to take Indian land by treaty in the 1780s and to confine the native people on reservations, they were still to be seen all over the province. On his tour of inspection to Detroit in 1793, Simcoe had recorded regular meetings with Indians. The most impressive was on the Six Nations reserve. There the educated and urbane chief, Joseph Brant, had negotiated a substantial reward for his people's war service: a reserve stretching six miles on either side of the Grand River from its source to its mouth. As Simcoe approached Brant's settlement "the Indians hoisted their flags and trophies of war and fired a *feu de joie* in compliment of

His Excellency the Representative of the King their Father".

In the event, Brant proved to be a little too urbane. He had close connections with the Loyalist elite at Niagara, and his sister Molly was married to the Superintendent of Indian Affairs, Sir William Johnson. Encouraged by his friends, some of whom had mercenary motives, Brant sold off large blocks of land, often at very low prices. By 1798 over sixty percent of his people's patrimony was in white hands. The Mohawks, too, would fade into invisibility.

The native peoples maintained a certain profile in eastern Canada so long as they had a role to play in the two activities that were of paramount imperial interest: the fur trade and warfare. The last war in which they played an important part was the War of 1812. And after 1821, when the Hudson's Bay Company absorbed Montreal's North West Company, the fur trade through Montreal disappeared. The Indians remained a matter of romantic concern for certain Britons for whom the thought of Canada evoked the image of "the noble savage". Some hoped to assimilate them into white society as quickly as possible and hailed every evidence of modernization as a step towards that goal. In May 1807 Lieutenant Governor Francis Gore of Upper Canada journeyed west of York to the Credit River to observe in person one such piece of evidence, when thirty-seven Mississauga Indians were vaccinated with considerable publicity. However, as Canada itself became modernized and populated most observers came to see the Indians as a hopelessly outdated race. Whether sympathetic or hostile to the native peoples, such observers saw them as fated for extinction. John Howison, an acerbic and influential commentator on Upper Canada, visited the Brant settlement and expressed the common view in his *Sketches of Upper Canada* published in 1821:

> Various attempts have been made to civilize the Indians; but the failure of most of these, with the very partial success of others, convincingly proves, that they are a people whose habits and characters are incapable of improvement, and not susceptible of amelioration... An intercourse with the Europeans has rendered them vicious, dissipated, and depraved... In a few years hence, if the population of Upper Canada increases as it has lately done, in all probability not an Indian will be found below Lake Huron.

There were still frontiers where the Indian was an important factor, and where the Indian voice was heard. On the prairies before 1821 the native people were wooed and bribed by both sides in the fur-trade war between the Hudson's Bay Company and the Nor'Westers. On the Pacific coast, the strong and richly

cultured Indian societies were very late in coming under white influence. The first contact occurred in 1774 when the Spaniard Juan Pérez met a party of Haidas. Four years later Captain James Cook established relations with Indians in Nootka Sound.

This was the beginning of the coastal fur trade and of English-Spanish rivalry in the region. An American navigator in the pay of the Spanish, Joseph Ingraham, left a remarkable account of Pacific Coast Indians, observed during a voyage in 1789–1790. It was then a region of developed, sophisticated societies with strong artistic traditions. It was also a region that echoed the white world of the east in its warlike proclivities. "They constantly live in fear," Ingraham wrote, "and are jealous of each other."

If native politics were warlike and complicated, as Ingraham claimed, the Indians must nevertheless have been amazed at the hostilities between the polyglot groups of Europeans with whom they made their first contact. In 1789 and 1790 the Spanish and the British attempted to outmanoeuvre each other in exploiting the population and establishing strongholds. Both sides came to the coast with crews of adventurers of varied nationality. When the Spaniards released a ship captured from the British South Sea Company, part of its crew decided to stay behind. These "British" seamen were an Austrian, two Dutchmen, and six Portuguese. Also left behind was a passenger on the British ship, one Matutaray, a six-foot-four-inch native of the Sandwich or Hawaiian islands. Quite understandably, the coastal Indians attempted to keep these strangers at arm's length, to limit relations to trade for furs, and to bargain as hard as possible in that trade.

This hardheaded attitude led to frequent clashes with Europeans who tried to cheat Indian traders or who violated Indian customs. It also allowed most coastal tribes to profit from the fur trade and to enrich their cultures: wood-carving, for example, flourished as a brilliant art form in these materially richer societies. The fact that only a small number of Europeans was involved helped to avoid the total disruption of Indian societies that had occurred east of the Rockies. The competition between the Spanish, the British, and the Americans allowed astute Indian leaders to play off the traders against each other and to push up the price of furs. Until mid-century, when settlers began to come in significant numbers, the coastal Indians demonstrated the vitality and strength of native cultures when not confronted by overwhelming European pressure.

THE BIRTH OF AN IDENTITY

British North America was shaped in significant measure by European ambitions and economic forces and by the impact of these on the indigenous peoples. None of the regional societies evolved exactly as the imperial planners had hoped or expected. The geographical realities of the terrain and the desires, needs, and strengths of the people set each colony off in its own idiosyncratic direction. The momentum thus gained was to prove increasingly self-sustaining, even though by 1820 the direction of the movement was not yet entirely clear.

The movement towards self-awareness was most highly developed in Nova Scotia and in French Canada, but it was evident everywhere. It could be seen in things both large and small—in the emergence of indigenous political movements and in personal awareness of a colonial identity. At the end of the War of 1812 John Beverley Robinson, the brilliant young Upper Canadian who had served as acting attorney general during the conflict, went to England to complete his legal studies. His talents attracted influential British patrons, and he was offered lucrative legal positions and a seat in parliament. Instead he chose to return to Upper Canada where his duty and his affections lay. John Beverley Robinson, offered the enticements of a career at the heart of the Empire, had learned that he was a Canadian.

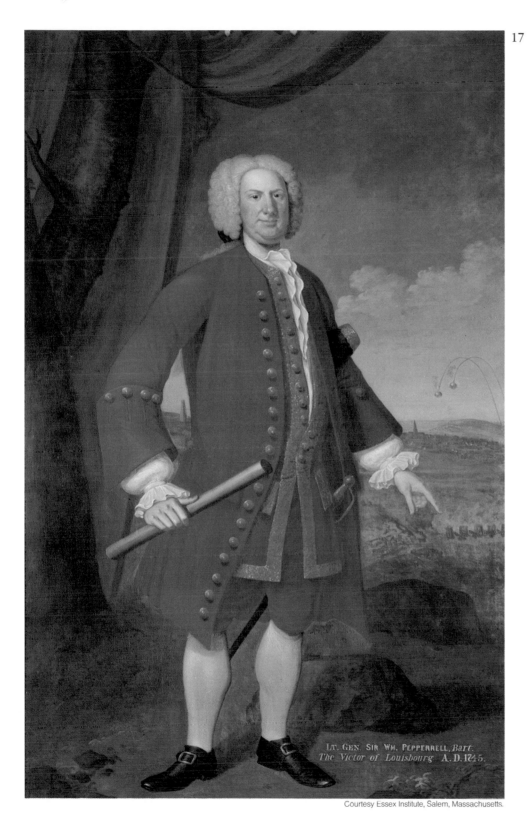

LT. GEN. SIR WM. PEPPERRELL, *Bart.*
The Victor of Louisbourg A.D. 1745.

17 **Portrait of Sir William Pepperrell**
(See page 53.)

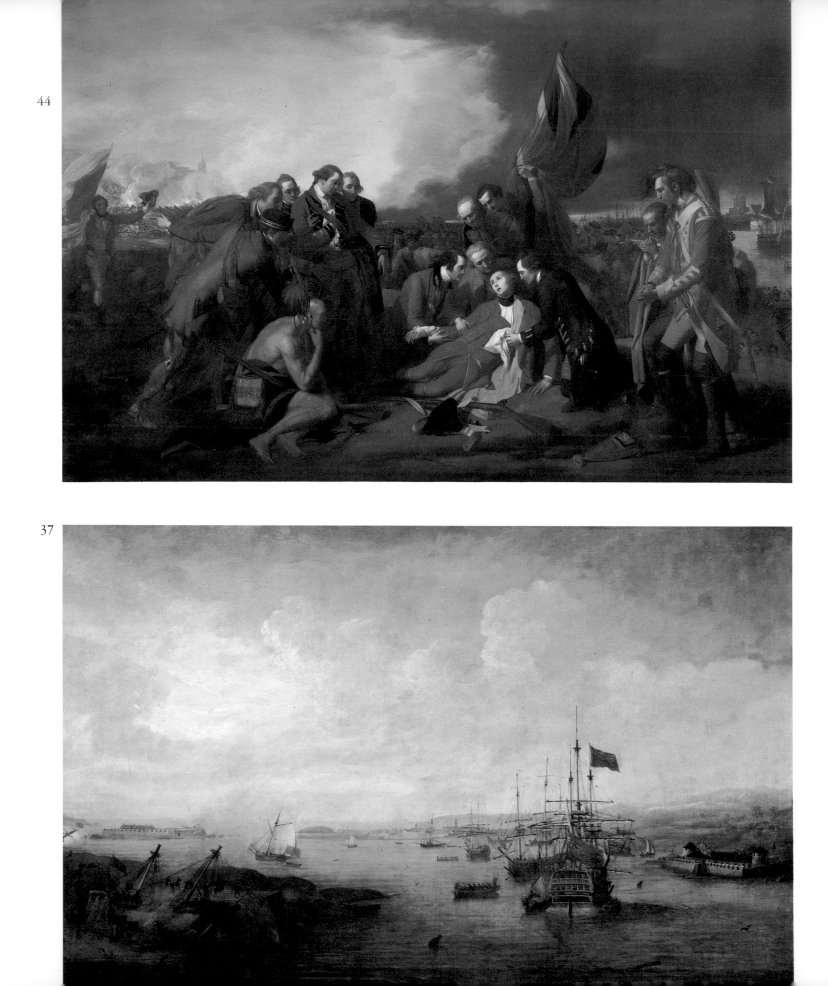

44

37

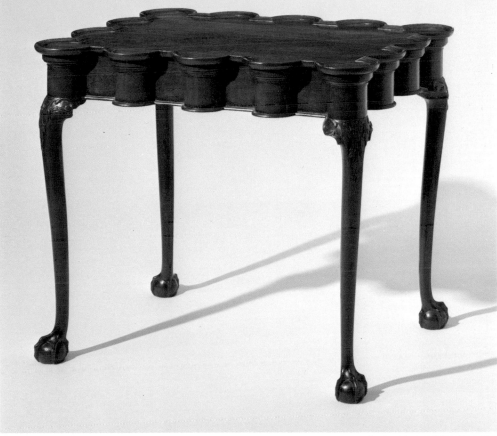

25

Courtesy Museum of Fine Arts, Boston.

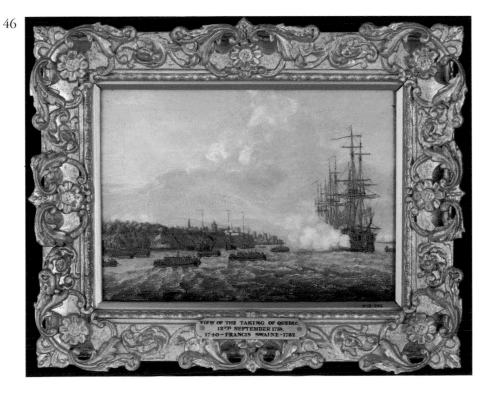

46

VIEW OF THE TAKING OF QUEBEC
13TH SEPTEMBER 1759.
1740 - FRANCIS SWAINE - 1782

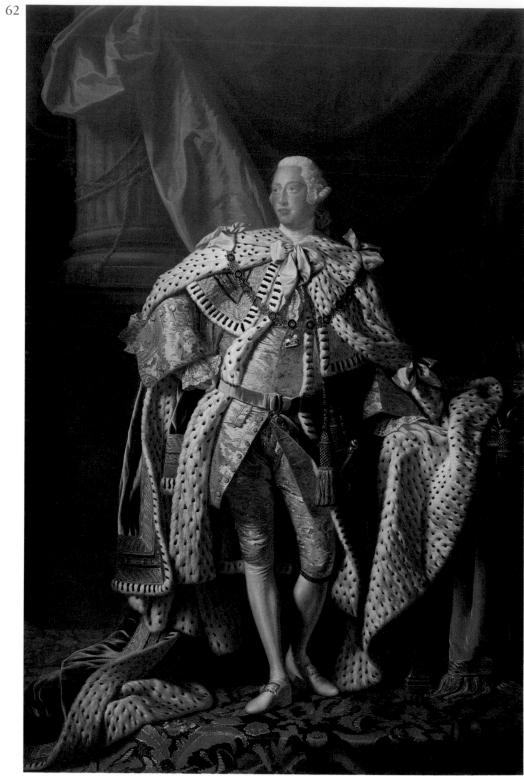

62 **Portrait of George III in Coronation Robes** (See page 86.)

Courtesy Indianapolis Museum of Art.

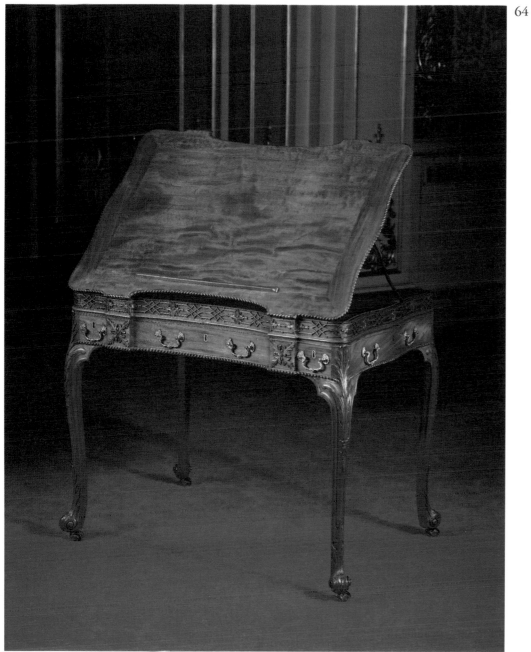

64

64 Queen Charlotte's Work Table
(See page 86.)

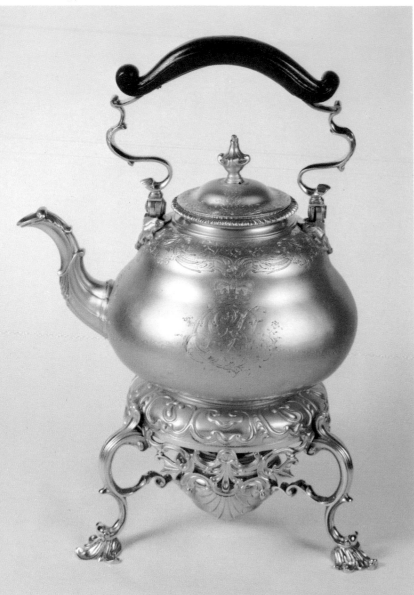

67 **Tea-Kettle and Stand** (See page 88.)

91 **Block-Carved Secretary-Desk** (See page 111.)

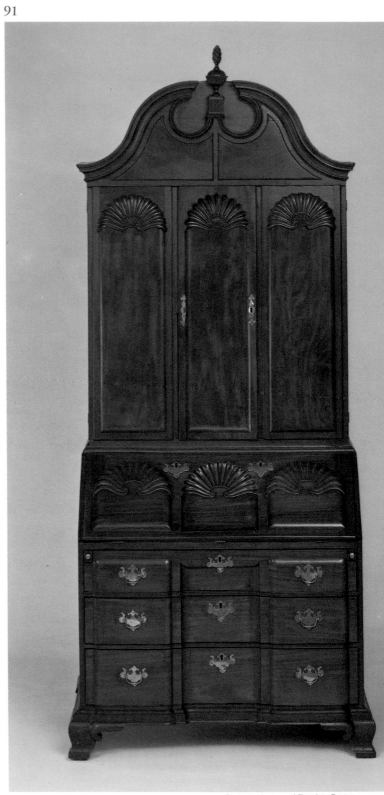

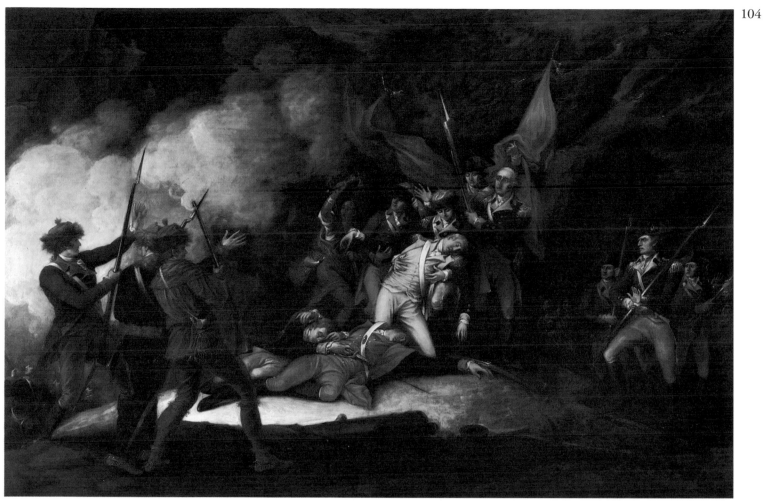

104 **The Death of General Montgomery in the Attack on Quebec** (See page 118.)

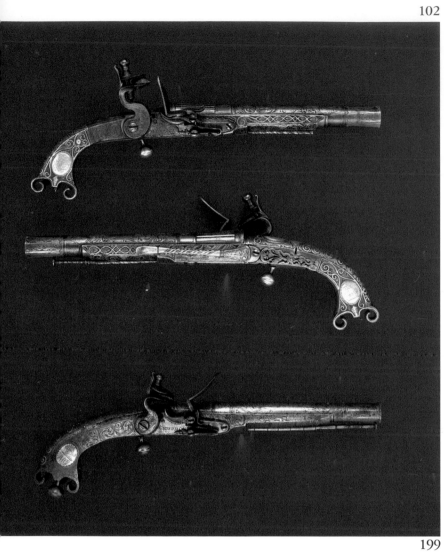

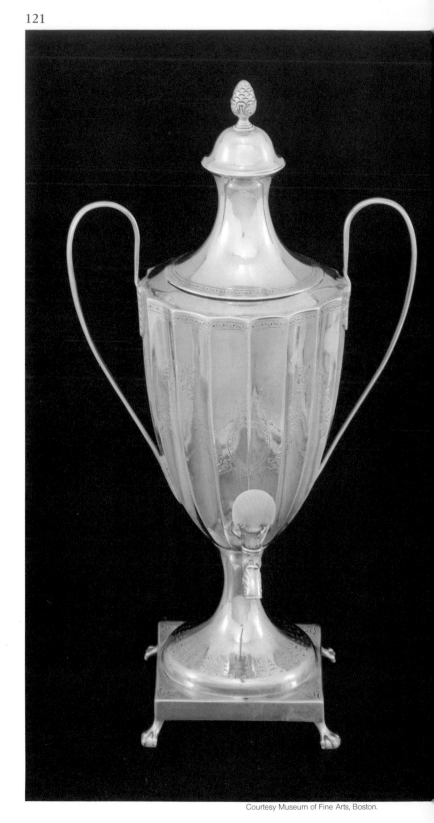

199

102 and **199**　**Flintlock Pistols** (See pages 117 and 182.)

121　**Coffee Urn** (See page 129.)

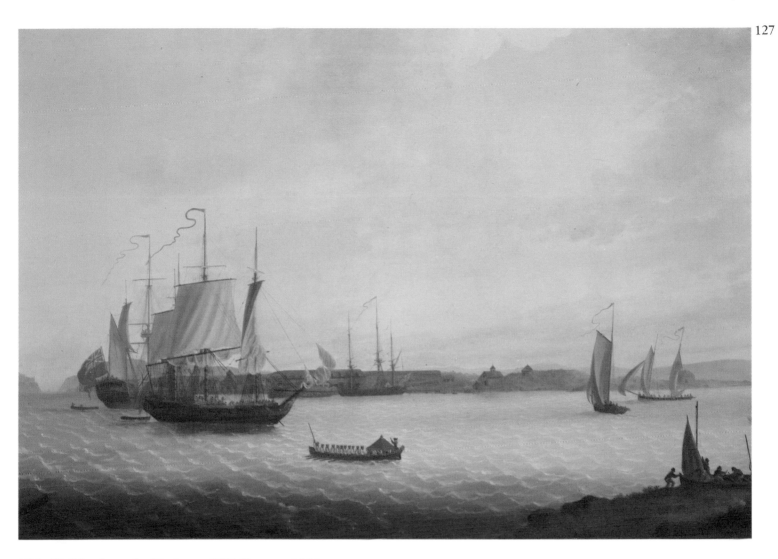

127 **Halifax from the Harbour, 1792** (See page 134.)

138

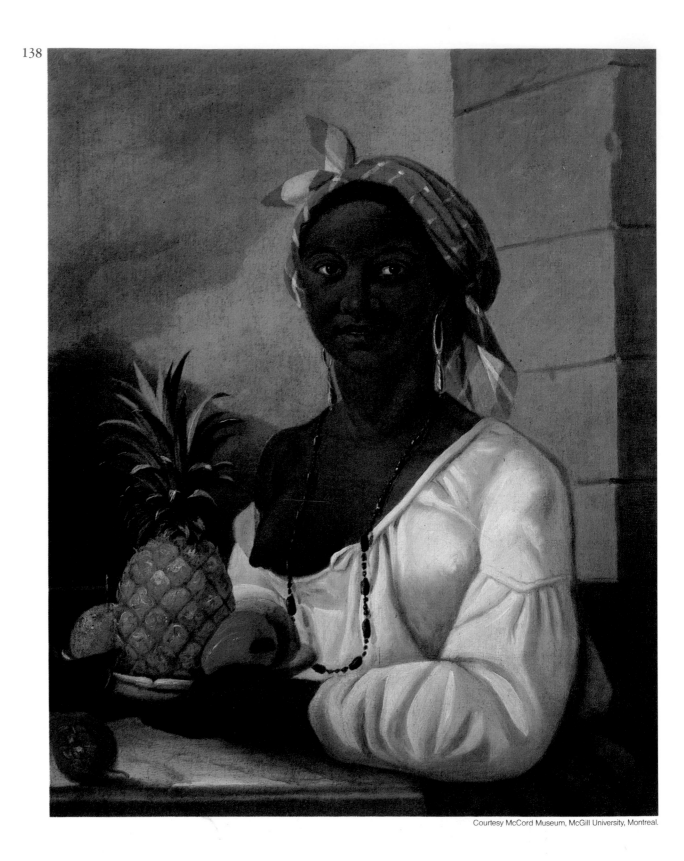

34

150

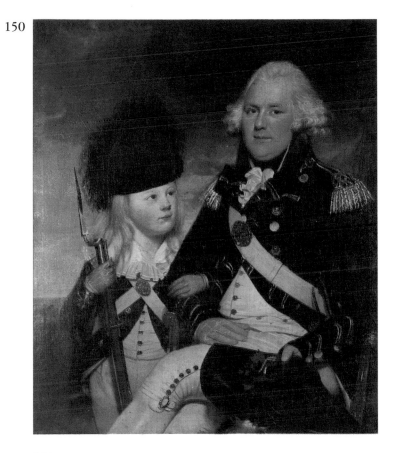

141

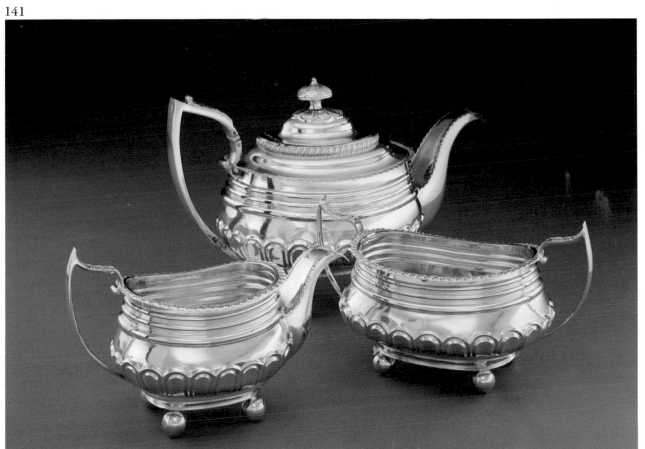

35

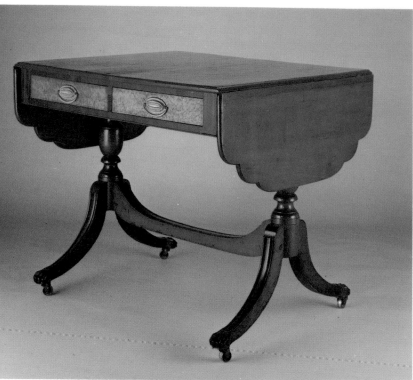

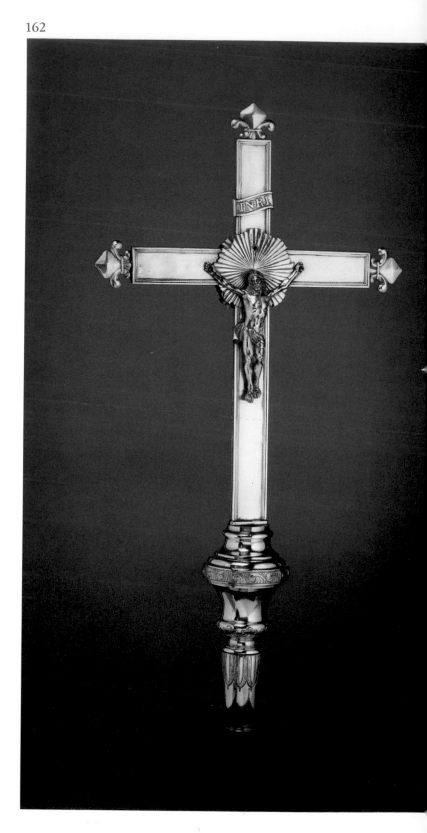

152 **Sofa Table** (See page 151.)

162 **Processional Cross** (See page 158.)

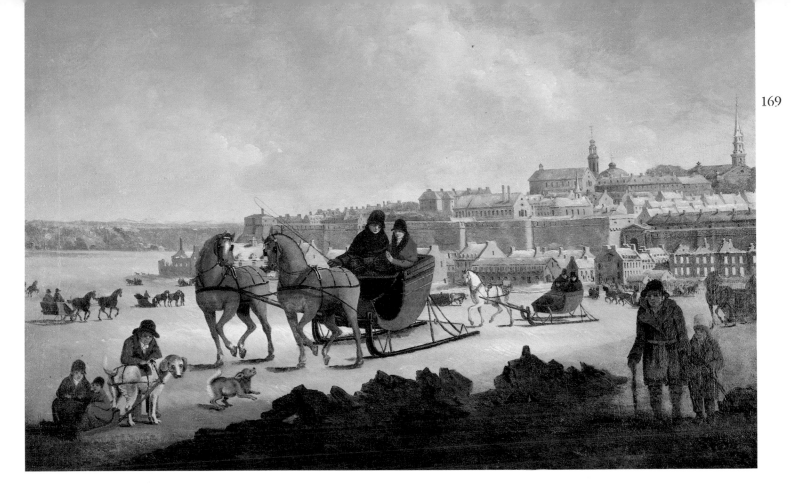

169

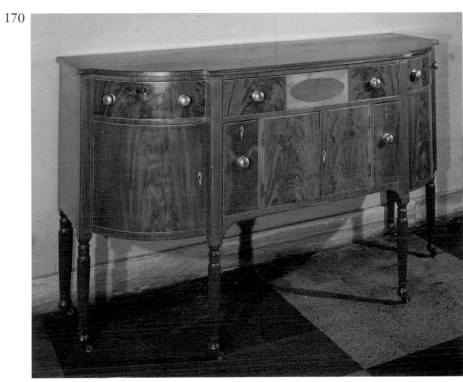

169 **Northwest Part of the City of Quebec**
(See page 163.)

170 **Sheraton Sideboard** (See page 163.)

170

37



203

174

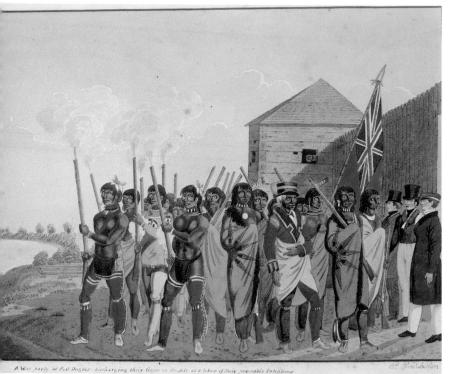

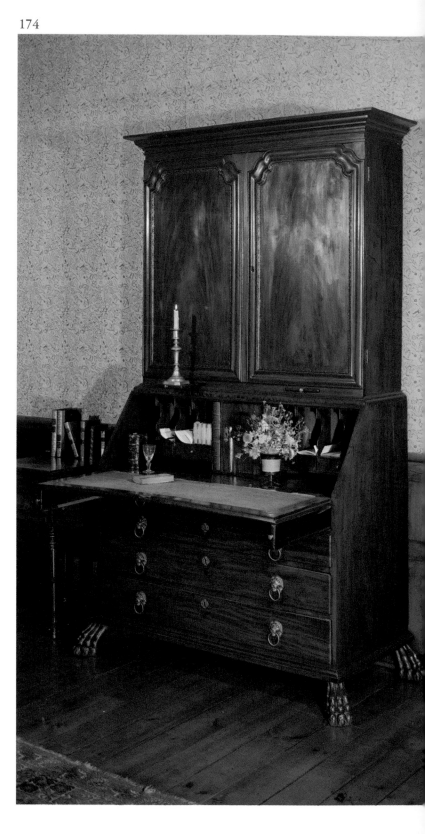

174 Secretary-Desk of Edward, Duke of Kent and Strathearn
(See page 166.)

203 War Party at Fort Douglas...
(See page 184.)

228

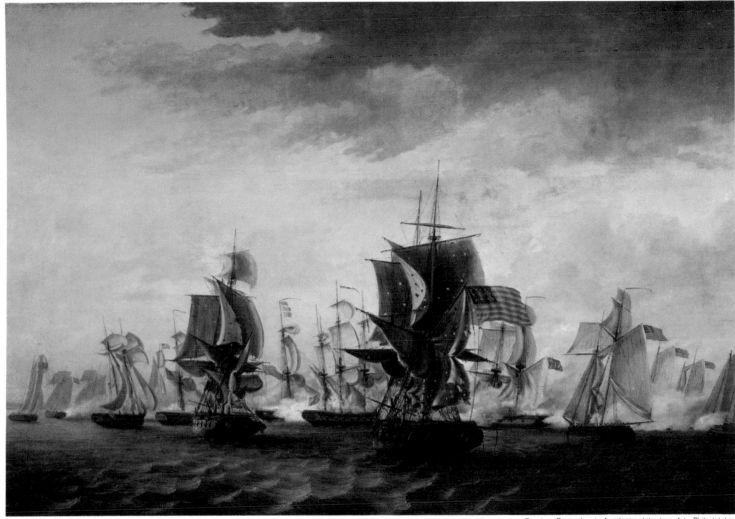

Courtesy Pennsylvania Academy of the Fine Arts, Philadelphia.

228 The Battle of Lake Erie, 1813 (See page 199.)

(See page 199.)

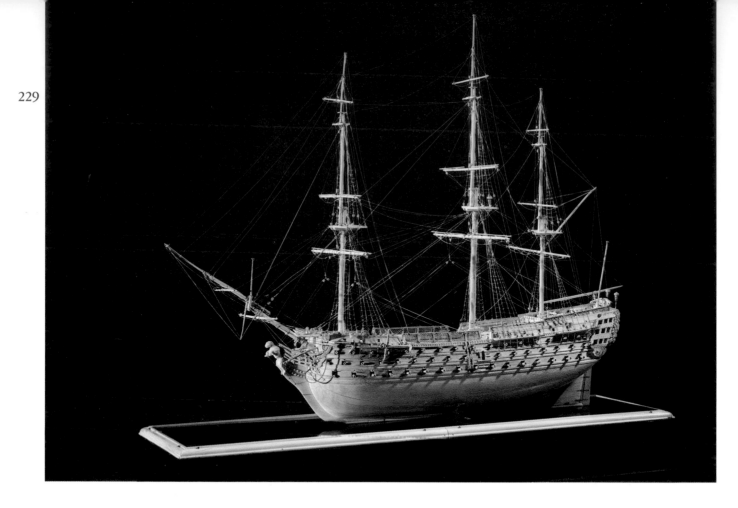

229

236

CATALOGUE

1

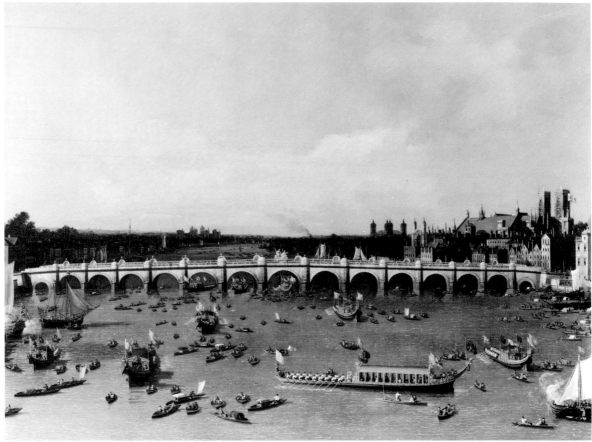

2

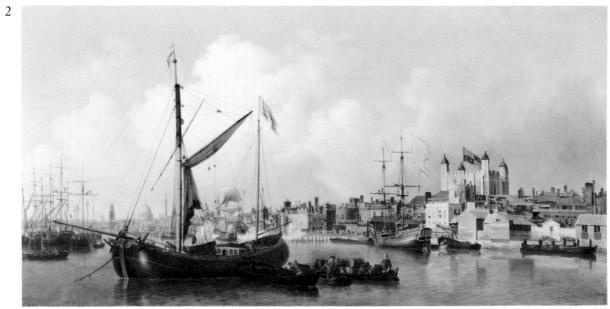

1

The Lord Mayor's Procession at Westminster Bridge, 1747

Canaletto (Giovanni Antonio Canal, 1697-1768), London, 1747
Oil on canvas, 96.5 x 127.0 (38 x 50)
Yale Center for British Art, New Haven, Connecticut, Paul Mellon Collection, B1976.7.94

The Venetian landscape painter Canaletto went to England in May 1746, when the War of the Austrian Succession (1740-48) interrupted the travels of his natural patrons, British visitors to the Continent. He remained in London until 1755.

Canaletto's urban views and landscapes are brilliant, with extremely fine brush strokes and precise execution and lighting. They had a profound influence on the future direction of British landscape art, even on that executed in Canada in later years. The influence is particularly evident in the later work of Samuel Scott, who gave up marine and battle scenes, such as those of the British fleet off Quebec in 1759 (see nos. 41, 42), to specialize in marine oriented urban landscapes.

2

The River Thames and the Tower of London on the King's Birthday, 1771

Signed by Samuel Scott (1702?-72), London, 1771
Oil on canvas, 100.8 x 193.0 (39¾ x 76)
Yale Center for British Art, New Haven, Connecticut, Paul Mellon Collection, B1976.7.147

Although Samuel Scott gave up his specialty of marine paintings (see nos. 41, 42) in favour of urban landscapes, his later work was often oriented from the Thames River. His London scenes, which typically include boats or merchant ships, provide an essentially maritime view of the city. In this famous view the most prominent building is the great Tower of London built in the Middle Ages; a royal standard flies above it. The painting was first exhibited at the Royal Academy of Arts, London, in 1771.

3-6

Governor's House and St Mather's Meeting House, Halifax

A View Down Prince Street, Halifax

Halifax from Georges Island

Halifax from Dartmouth

Dominic Serres (1722-93), London, c. 1760
Oil on canvas, 38.1 x 55.9 (15 x 22)
Art Gallery of Nova Scotia, Halifax, 82.41-44, purchased with funds provided by the Gallery's Art Trust Fund (Mrs Stewart L. Gibson Bequest), the Cultural Foundation of Nova Scotia, and private and corporate donations

These four varied views, done just ten years after Halifax was founded, are the earliest known oil paintings of a Canadian city. They were painted by Dominic Serres in London, after sketches brought back by Richard Short, a Royal Navy officer who visited Halifax and was at the siege of Quebec in 1759. The four paintings are the only ones known of what was originally probably a set of six, all after Short sketches; they were engraved and first published as prints by John Boydell in London in 1761.

These pictures, like *The Secret Expedition Against Havana* (see no. 52), were done quite early in Serres' career. Richard Short is known as an artist only for his Halifax sketches, and a set of six of Quebec, done shortly after the bombardment and siege, and also published by Boydell in 1761.

3

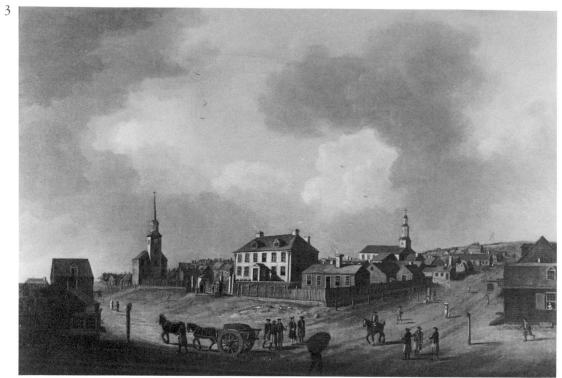

Courtesy Collection of the Art Gallery of Nova Scotia, Halifax.

4

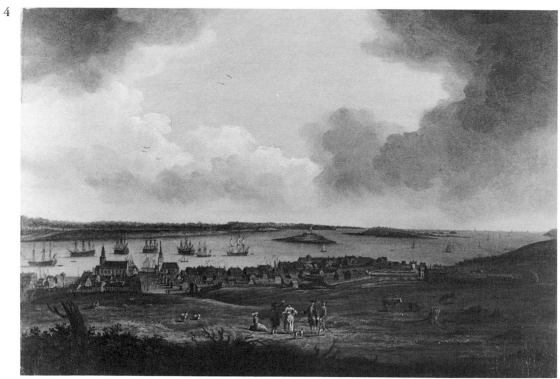

Courtesy Collection of the Art Gallery of Nova Scotia, Halifax.

5

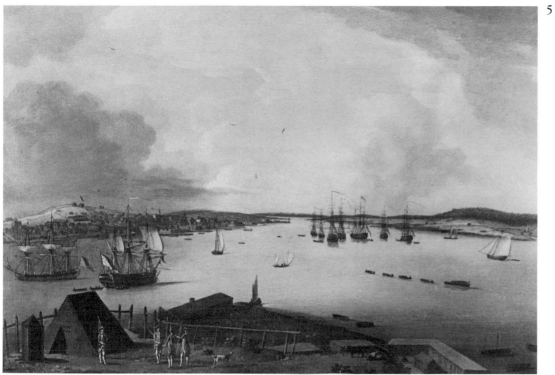

6

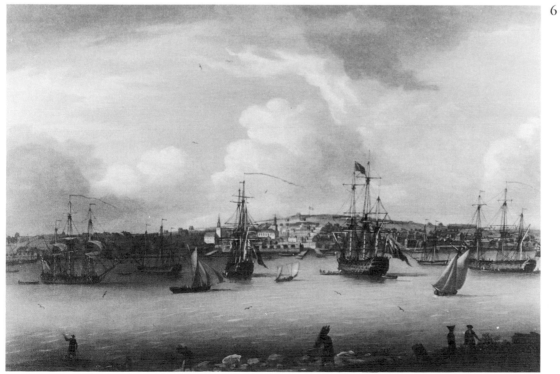

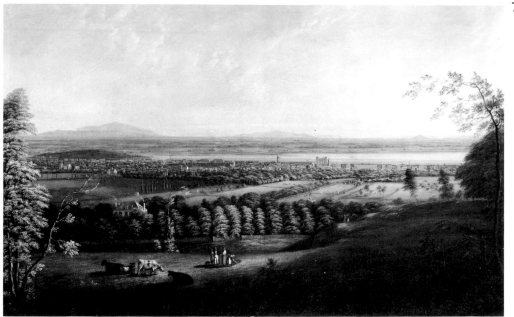

Courtesy McCord Museum, McGill University, Montreal.

7
Montreal from the Mountain

Attributed to James Duncan (1806–81), Montreal, c. 1830–40
Oil on canvas, 150.5 x 241.9 (59¼ x 95¼)
McCord Museum, McGill University, Montreal, M966.61

Landscape painting in the 18th-century British manner did not emerge in Canada until well into the 19th century, and then it tended to follow earlier British influences. This pastoral scene of Montreal, which by 1830 had developed into a large and sophisticated city, includes the requisite foreground elements of placid cattle, groups of people, and outlying farms. The city is laid out as a background panorama. The scene follows the 18th-century British school of landscape painting—with nature a dominant theme over the works of man—which led into the highly romanticized American Hudson River School of the mid-19th century.

James Duncan, who was born in Ireland, came to Canada about 1830 and settled in Montreal. There he established himself as an art teacher and an artist, working both in oil and in watercolour. He published a number of lithographs, was a partner in a photographic firm in the 1850s, and became an illustrator for the *Illustrated London News* and the *Canadian Illustrated News*. Duncan probably left a greater body of work than any other early Canadian artist—largely comprising small watercolour views of Montreal and its people.

8
Cut-Glass Chandelier

Irish, Waterford, c. 1780–90
Glass, 157.5 x 121.9 (62 x 48)
The Montreal Museum of Fine Arts, anonymous gift, 970.Dg.4

Until the development of lamps fuelled by liquid oil in the 19th century, candles and sputtering, smoky lamps fuelled by fat were the only forms of artificial lighting. The grandest lighting fixture was the hanging multi-candle chandelier, which was produced in great variety. Canadian examples were usually made entirely of soldered sheet iron, or they consisted of a central wooden column with radiating iron arms that held the candle sockets. In the grandest houses, however, imported glass chandeliers were the apex of Georgian opulence. They might hold up to twenty candles, depending on size, and their multiple glass prisms reflected and diffused light. This chandelier, imported from the famous Waterford Glass-works in Ireland, was in use in Montreal in the late 18th century.

Portrait of George II Before His Accession

Studio of Sir Godfrey Kneller (1646/49–1723), London, 1716
Oil on canvas, 155.6 x 59.7 (61¼ x 23½)
National Portrait Gallery, London, 205

George II (1683–1760; reigned 1727–60), the second of
Britain's Hanoverian kings, had as his prime interests first the
army, and then music, particularly that of Georg Friedrich
Handel. The king was not the patron of the arts that his queen,
Caroline, became, but he was extremely astute politically. It was
George II's Whig ministers, particularly the elder William Pitt
(1708–78), who orchestrated Britain's North American wars.
George II was the last British king to lead an army into battle in
person—against the French at Dettingen in 1743.

Godfrey Kneller was born in Germany and trained in Holland,
but he settled in England in 1676. He was appointed principal
painter to the court and knighted in 1691 by William III. In 1715
George I created him a baronet.

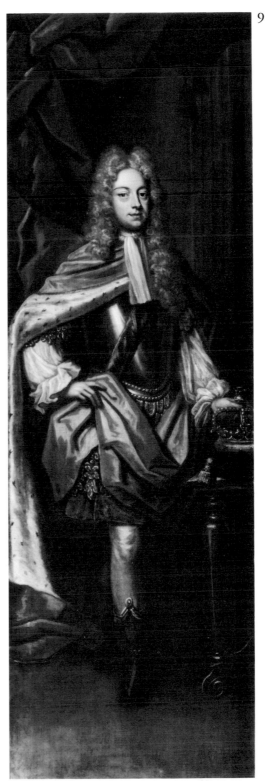

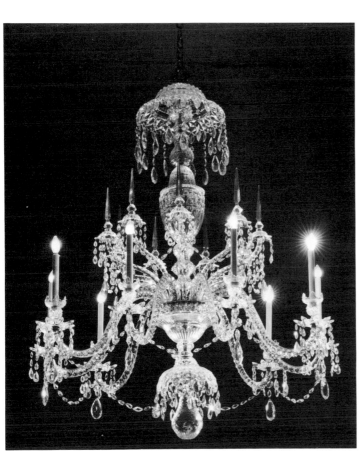

Courtesy The Montreal Museum of Fine Arts.

Courtesy National Portrait Gallery, London.

KING GEORGE'S WAR
1744–1748

King George's War was the North American phase of the European War of the Austrian Succession, in which France and Great Britain were ranged on opposite sides. The British-French conflict quickly spread to this continent. It signalled the beginning of the final rounds in the contest for North America, leading first to British conquest and control, but ultimately to the establishment of the independent United States in the south and British North America in the north.

By 1744 the struggle for North America was already well over a century old. There had been three previous British assaults on Quebec, a successful one in 1629, an unsuccessful one in 1690, and a disastrous one in 1711. The Treaty of Utrecht in 1713 had finally acknowledged British possession of mainland Nova Scotia, including French Acadia, and of Newfoundland. Since 1670 the Hudson's Bay Company had claimed Rupert's Land, which consisted of all lands drained by rivers flowing into Hudson Bay; the Treaty of Utrecht confirmed the claim.

Cape Breton Island remained French. At Louisbourg, which had a splendid natural harbour, the French began to build a great fortified town and garrison of stone in the 1720s, to serve as the guardian of the approaches to New France and the city of Quebec. The fortress of Louisbourg was regarded throughout its existence as a threat to the New England colonies. In any future British campaign against New France, it had to be a primary objective.

The Treaty of Aix-la-Chapelle, which provided for little but the restoration of conquests, marked the end of King George's War in 1748. No attempt had been made against Quebec. The fortress of Louisbourg was taken in 1745, but after three years of occupation by New England and British troops, it was returned intact to France, as a treaty negotiators' trade-off for British control of Madras in India. That move roused the anger of the already restive New England colonies.

Halifax was founded in 1749 as a naval base, army garrison, and counterbalance to Louisbourg. Immigration was encouraged in an effort to solidify British control of mainland Nova Scotia. Settlers arrived from Great Britain, Germany, and New England. The French, however, were actively inciting the Acadian population of ten thousand—a gnawing worry to the council of Nova Scotia. Governors Charles Lawrence of Nova Scotia and William Shirley of Massachusetts began to consider drastic solutions.

In any event, the Treaty of Aix-la-Chapelle proved to be only a temporary truce. Six years later, in 1754, war broke out again in North America, and by the time it ended New France had been taken by the British. Although British Canada was peacefully settled and governed, it was in fact created as a result of war. It was to see two more conflicts (1775–81 and 1812–14) before finally emerging as a developing new nation, with internationally recognized borders, an established system of law and government, and a rapidly growing population.

Courtesy Canadian War Museum, Ottawa.

Courtesy Canadian War Museum, Ottawa.

10
Flintlock Musket, English "Brown Bess" or Long Land Pattern

English, marked by R. Farlowe (1702–50), London, 1728
Steel, walnut stock, 156.8 (61¾)
Canadian War Museum, Ottawa

The flintlock "Brown Bess", the standard musket of the British soldier in the colonial wars, was designed to replace a diversity of weapons, probably during the reign of Queen Anne (1702–14). The origin of the name is obscure, but the earliest known example, in the Tower of London, is dated 1717.

The "Brown Bess", which weighed about five kilograms, proved to be a very reliable military weapon for more than a century. It was a muzzle-loader that fired round balls. In the hands of well-disciplined troops, positioned in ranks for loading and firing in volleys, this musket could be loaded and fired at a rate of three to four shots per minute. A British battle line four ranks deep could thus deliver about fifteen full volleys per minute, a rate of fire no other army could match. Although produced in different versions and gradually shortened over the years, the "Brown Bess" continued in service with little change well into the 19th century.

R. Farlowe, whose mark is on the lockplate, was a London gunmaker who also worked on military contract. He is known to have produced military brass-barrelled blunderbusses as well.

11
Flintlock Musket, French Pattern of 1717

French, marks of Mauberge Arsenal, c. 1717–24
Steel, walnut stock, 157.5 (62)
Canadian War Museum, Ottawa

France also began to replace a diversity of arms with a standardized infantry musket early in the 18th century. Although it had a flintlock mechanism judged at the time to be slightly less reliable than that of the British "Brown Bess", the French musket was changed more rapidly, with new patterns appearing in the late 1740s and again in 1763. Still, the French Pattern of 1717 musket and the British Long Land "Brown Bess" remained the basic infantry weapons through the Seven Years' War (1756–63), and in some instances as late as 1800.

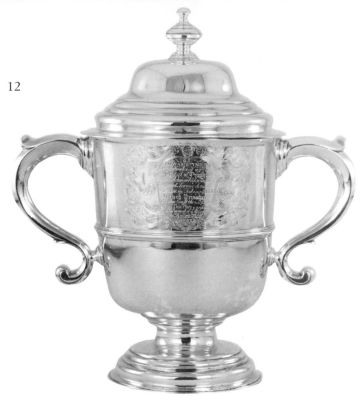

12
Two-Handled Covered Cup

Presented to Captain Edward Tyng (1683–1755)
American, marked by Jacob Hurd (1702/3–58), Boston, 1744
Silver, 38.4 x 34.9 (15⅛ x 13¾)
Yale University Art Gallery, New Haven, Connecticut, Mabel
Brady Garvan Collection, 1932.48

Known as the Tyng cup, this tall piece in a Queen Anne style
represents the apex of American silver in the early 18th century.
It was made by the most eminent colonial silversmith of that
period. The cup is marked HURD on the rim and lid, and JACOB
HURD on the base.

Early in King George's War, French privateers—some based at
the fortress of Louisbourg—began preying on British and
colonial American merchant ships, sometimes with unintended
results. The engraved dedication in the cartouche reflects the
gratitude of the merchants of Boston for the outcome of Tyng's
encounter with a French privateer: "To, EDWARD TYNG Esqr.,
Commander of ye SNOW, Prince of Orange, As an Acknowledge-
ment of his good Service done the TRADE in Taking ye First
French Privateer on this Coast the 24th of June, 1744. This
Plate is presented BY Several of ye Merchts., in Boston, New
England."

The cup was stolen from Edward Tyng's Loyalist son William
during the American Revolution, but was later restored to the
Tyng family by the Massachusetts legislature.

13
The British Fleet Entering the Harbour of Louisbourg, 1745

Signed by Peter Monamy (1680–1749), London, c. 1747
Oil on canvas, 69.9 x 125.7 (27½ x 49½)
Royal Ontario Museum, Canadiana Department, Sigmund
Samuel Collection, 955.220

Painted after a sketch by Captain Philip Durrell, and second-hand
description, this somewhat distorted panorama shows the entry
of a British naval squadron into Louisbourg harbour in May
1745. The squadron, under the command of Commodore Peter
Warren (see no. 15), carried a force of thirty-five hundred New
England militiamen led by Colonel William Pepperrell (see
no. 17).

The view of Louisbourg is approximately from Lighthouse
Point, with the fortified town to the left across the harbour, the
Island Battery in the centre at the harbour entrance, and the
Queen's Battery on the far shore. Two other versions of this
picture are known, one in the National Maritime Museum,
Greenwich, and the other privately owned.

Peter Monamy was a self-taught English marine painter who
followed the 17th-century Dutch style of Willem van de Velde.
Monamy did seascapes and battle scenes on commission and for
sale through dealers.

14
The Landing of New England Forces in the Expedition Against Cape Breton, 1745

Engraved by Brooks after J. Stevens; published by R. Wilkinson
for John Bowles, London, c. 1747–48
Copper engraving on paper, hand coloured, picture area
31.8 x 47.9 (12½ x 18⅞)
Royal Ontario Museum, Canadiana Department, Sigmund
Samuel Collection, 958.36.1

This often-illustrated but fanciful view of the amphibious assault
on the fortress of Louisbourg is one of the very few prints
published to commemorate North American actions during
King George's War. The scene certainly originated from descrip-
tion (or imagination) and not from an on-the-spot drawing, for
the terrain is most unlike that of Louisbourg. Moreover, it
stretches credibility that New England militiamen were as well
uniformed and accoutred as the parade-ground troops disembarking
here—if indeed they were in uniform at all.

13

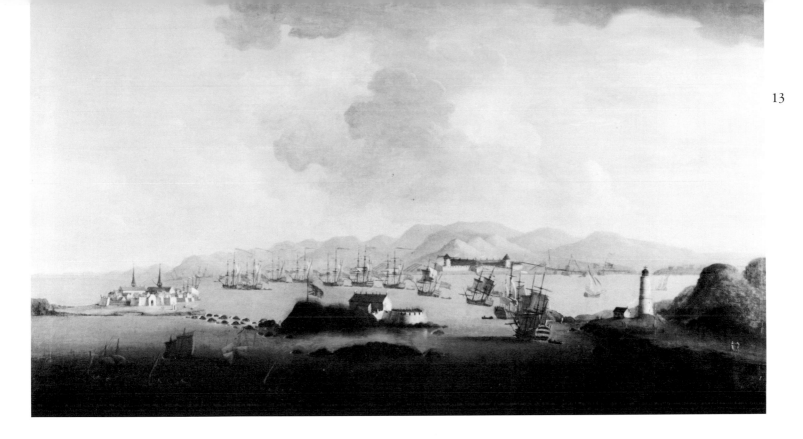

14

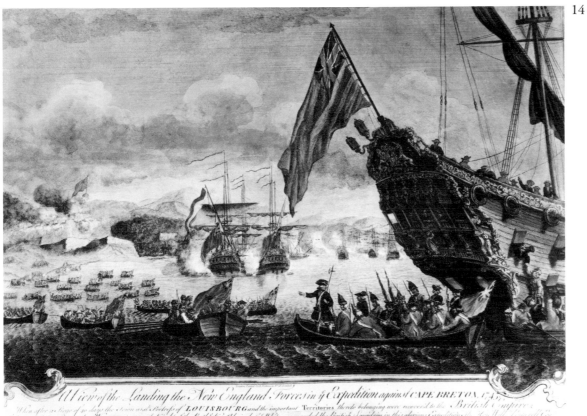

View of the Landing the New England Forces in ye Expedition against CAPE BRETON 1745.

51

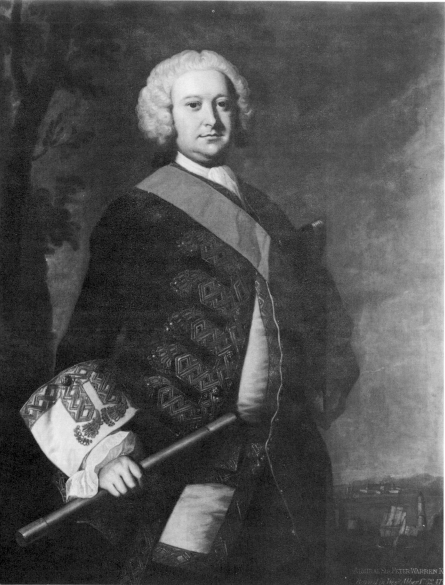

15

15
Portrait of Vice-Admiral Sir Peter Warren

Thomas Hudson (1701–79), London, c. 1747–50
Oil on canvas, 127.0 x 101.6 (50 x 40)
National Maritime Museum, London, gift of the Society for
Nautical Research, London, OP 1930–2

Commodore Peter Warren (1703–52) was commander of a small
British naval squadron in the West Indies when in 1744 he
received an appeal from Governor William Shirley of Massachu-
setts for aid in an expedition against the fortress of Louisbourg.
Warren was granted rather reluctant permission from London,
and proceeded to Boston. Accompanied by some thirty-five
hundred colonial militiamen under William Pepperrell of Massa-
chusetts and a colonial fleet of some ninety vessels, Warren's
squadron sailed for Louisbourg in late March of 1745. While
Warren's warships blockaded Louisbourg harbour, Pepperrell's
volunteer army landed, laid siege to the fortress, and on 17 June
secured its capitulation.

This portrait was commissioned shortly after Peter Warren
was knighted and appointed vice-admiral in 1747. Another
version of the portrait is in the National Portrait Gallery,
London, and a third is privately owned.

Thomas Hudson was a prominent London portraitist, though
never a court-appointed painter. In his studio he employed
numerous assistants who specialized in painting costume and
backgrounds. The scene of the Louisbourg expedition of 1745 in
the lower background of this portrait is almost certainly by—or at
least copied from—the painting by Peter Monamy (see no. 13).

16
Double-Chairback Settee

English, 1740–50
Mahogany, 100.3 x 140.3 (39½ x 55¼)
American Antiquarian Society, Worcester, Massachusetts

With its highly elaborate carving, this settee is a fine and opulent
example of the early Chippendale style, as it evolved from the
Queen Anne. The double-chairback settee is an English and Irish
form, adopted in North America almost exclusively by Massachu-
setts cabinetmakers. There are no known later Canadian versions
of this design.

This settee was imported by Thomas Hancock of Massachusetts
between 1740 and 1750. It was inherited by his nephew John,
who became a leader in the revolt of the colonies against Britain.
John Hancock's is the first signature on the Declaration of
Independence.

16

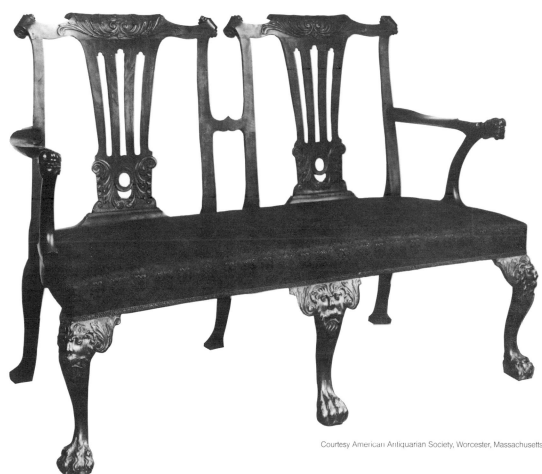

Courtesy American Antiquarian Society, Worcester, Massachusetts.

17 (See colour plate page 25.)
Portrait of Sir William Pepperrell

John Smibert (1688–1751), Boston, 1746
Oil on canvas, 223.6 x 142.2 (88 x 56)
Essex Institute, Salem, Massachusetts, gift of George Atkinson
Ward, 106,806

William Pepperrell (1696–1759) was a wealthy colonial landowner and businessman, who became a colonel in the colonial militia and in 1730 was appointed chief justice of Massachusetts. He was chosen by Governor William Shirley to command the land forces in the expedition against Louisbourg in 1745.

Pepperrell raised a force of some thirty-five hundred men, but neither he nor his militia officers had had any actual battle experience. Under the protection of Commodore Peter Warren's small Royal Navy squadron, the ragtag army left Boston for Cape Breton on 24 March 1745. A combination of good planning on the part of the British, ineffectual leadership of the mutinous French defenders of the fort, and just plain luck brought about the fall of Louisbourg on 17 June. It is said that the whole expedition was fuelled by rum—a story that is perhaps only partly true. In any case, the success of the expedition generated surprise and great joy in Boston and London. Pepperrell was made a baronet (the first native American to receive the honour), and Warren was promoted to the rank of vice-admiral.

John Smibert was a London portraitist who went to Boston and opened a studio there in 1729. He painted both Pepperrell and Governor Shirley in the summer of 1746 (the Shirley portrait is lost). Peter Pelham of Boston, the first American mezzotint engraver, produced mezzotints after the portraits.

The backgrounds of 18th-century portraits often included scenes of events in which the subject had played a notable part. The burning fortress, with arching British mortar bombs above it, is particularly appropriate for this picture.

18

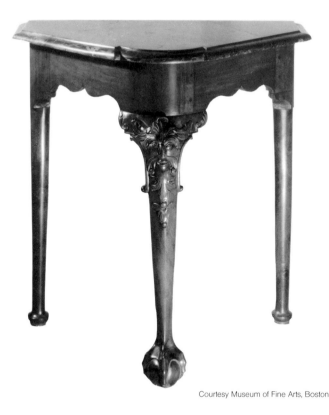

18
Console Table

American, attributed to John Goddard, Sr (1723–85), Newport, Rhode Island, c. 1740–60
Cuban mahogany, with marble top, 73.7 x 37.5 (29 x 14¾)
Museum of Fine Arts, Boston, gift of Mr and Mrs Maxim Karolik, 41.586

This table is an American example of English mid-Georgian taste. The strong claw-and-ball front foot generates the Rhode Island attribution for the piece, though the grotesque-mask knee carving is remarkable and rare on American furniture. It is, in fact, a form of decoration most commonly seen on German and English bellarmine stoneware jugs of the late 17th century.

John Goddard and his brother James (b. 1727) were the progenitors of one of the largest and most important American family cabinetmaking groups of the 18th century. The Goddards produced furniture now regarded as among the finest examples of 18th-century American craftsmanship. Three Goddard sons later came to Nova Scotia as Loyalist immigrants, but they are not at present known to have worked as cabinetmakers there, nor has any early Nova Scotia furniture attributable to them been found.

19
Two-Handled Covered Grace Cup

Presented to Benjamin Pickman, 1749
American, marked by William Swan (1715–74), Boston, c. 1745–49
Silver, 31.5 (12⅜)
Essex Institute, Salem, Massachusetts

This fine silver cup was presented in 1749 to Benjamin Pickman of Salem, Massachusetts, who was one of William Pepperell's officers at the capture of Louisbourg in 1745. The inscription, in an engraved scrollwork cartouche, reads "THE Gift of the Province of the MASSACHUSETTS BAY TO Benjamin Pickman, Esqr., 1749". Although somewhat smaller, the cup is in the same style as, and very similar to, the Tyng cup by Jacob Hurd (see no. 12).

19

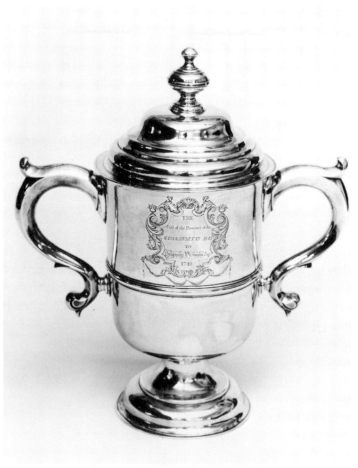

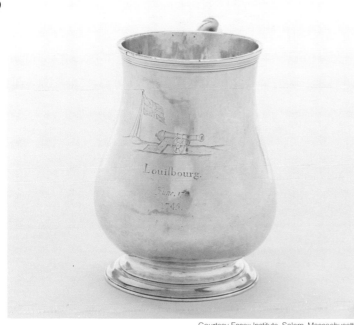

Courtesy Essex Institute, Salem, Massachusetts.

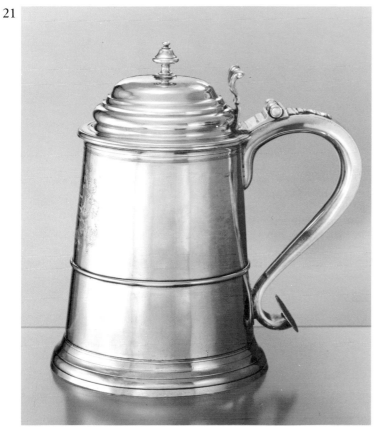

Courtesy Yale University Art Gallery.

20
Cann

Presented to Sir William Pepperrell (1696–1759)
English, marked by William Holmes, Sr (1717–82/83), London, 1745
Silver, 13.7 x 7.9 (5⅜ x 3⅛)
Essex Institute, Salem, Massachusetts, 105,867

Another piece of presentation silver celebrating the first capture of the fortress of Louisbourg, this cann was a gift to Sir William Pepperrell from the City of London. While the cann is not inscribed specifically to Pepperrell, it is engraved with a cannon, the Union Jack, and the legend "Louisbourg, June 17, 1745".

21
Lidded Tankard

Presented to Jeremiah Moulton (1688–1765)
American, marked by John Burt (1692/93–1746), Boston, c. 1745
Silver, 21.0 x 13.8 (8¼ x 5⅜)
Yale University Art Gallery, New Haven, Connecticut, Mabel Brady Garvan Collection, 1930.1195

This tankard, with the Moulton family crest engraved on the front, was presented to Colonel Jeremiah Moulton by Sir William Pepperrell in honour of Moulton's service as commander of a regiment at the capture of Louisbourg in 1745. The oval disc-terminal at the lower end of the handle is engraved with a map of Louisbourg and the legend "Lewisburg" and "taken by the English / June 17, 1745". Jeremiah Moulton later became a sheriff, a member of the Massachusetts council, and a judge of common pleas.

John Burt, who had apprenticed as a silversmith with John Coney, specialized in making gifts for students to present to their tutors at Harvard College, from which Burt's first son graduated in 1736. His three other sons he trained in silversmithing.

Because of the scarcity and cost of basic metal—melted-down coins or scrap silver—North American silver of the 18th century is generally thinner, lighter, and in ornamentation far simpler than comparable English silver of the same period.

Courtesy Fortress of Louisbourg, National Historic Park, Parks Canada.

22
Gravestone of Captain Richard Mumford

Carved by William Stevens (1710–94), Newport, Rhode Island, 1745–46
Carved slate, 109.2 x 73.7 (43 x 29)
Fortress of Louisbourg, National Historic Park, Parks Canada, 1B.13A3.1

Recovered in 1939 in the ruins of the French hospital at Louisbourg, this gravestone is a reminder of a Rhode Island militia captain, Richard Mumford (1700–1745), who died not of battle wounds but of illness. The stone is inscribed "Here lies Interred the body of Richard Mumford Esq. who was the Captain of the First Company of Foot Soldiers sent by the Colony of Rhode Island & to assist in the Reduction of Cape Breton, who died on the fifth day of October Anno Dni: 1745 in the 45th Year of his age." Carved in Newport, the stone was brought to Louisbourg, probably in the spring of 1746.

After the evacuation of the French, the New Englanders remained in Louisbourg as an occupation garrison, until they were relieved by British regulars in the spring of 1746. Although the British had lost only some 130 men in battle, and the French about 50, disease took a desperate toll. A militia doctor reported that "putrid fevers and dysenteries . . . became contagious, and the people died like rotten sheep." In all, some one thousand militiamen died during the autumn and winter, and were buried at Louisbourg.

The Louisbourg experience was not unusual. Death was so ever-present in the colonies that gravestone carving developed into a profession in the 17th century, with sons succeeding fathers in family businesses. The Stevens of Newport, Rhode Island, carved gravestones through four generations.

The earliest decoration was two-dimensional. Motifs of skulls and crossbones, hourglasses (representing mortality), or winged angels' heads (perhaps representing resurrection) were typical. This 17th-century style of gravestone carving continued into the late 18th century. Some stones of this type dating from the Loyalist period still stand in early Nova Scotia and New Brunswick graveyards.

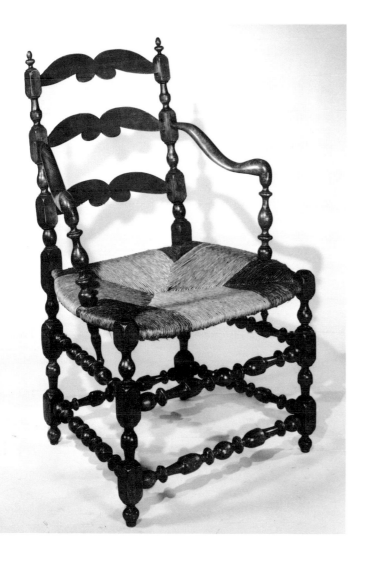

23
Salamander Armchair

French Canadian, c. 1720–40
Maple, 99.1 x 58.7 (39 x 23⅛)
Royal Ontario Museum, Canadiana Department, 960.106

Armchairs of this type, though they embody French characteristics in the back slats and curved arms, appear to be a uniquely French Canadian form, with no direct French design equivalents. With straight structural members and ball and vase turnings alternating with square sections, these chairs are essentially 17th-century design forms. Salt-marsh grass from the shores of the lower St Lawrence was used for the original rush seats.

Although it is an unusually elaborate example of Canadian French Régime furniture, the chair shows the stylistic isolation of French Canadian artisans from the mainstream of European fashion: its style is half a century behind that of French equivalents. The indigenous furniture of New France in the first half of the 18th century was far simpler and less ornate than French counterparts, and also generally followed styles that were passé in France.

THE SEVEN YEARS' WAR
1756–1763

The Seven Years' War was the first British-French conflict to begin in North America, and the first in which both Britain and France gave substantial support to their overseas colonies. After the unsuccessful expedition of Colonel George Washington and his four hundred Virginia militiamen to halt French occupation of the Ohio River valley in 1754, the conflict assumed a much more determined and decisive direction than had King George's War. This determination was heightened by the formal declaration of the war in Europe in May 1756.

Under Canadian-born Pierre de Rigaud, marquis de Vaudreuil-Cavagnal as governor, and Louis Joseph de Montcalm-Gozon, marquis de Saint-Véran as military commander, New France enjoyed several successes from 1755 to 1757. However, British military strength, in particular British sea power, was growing rapidly, as French capability to aid New France began to decline. The coming of the elder William Pitt as British secretary of state led to reorganization of the army and a strong emphasis on naval power. For the first time in a century of colonial skirmishing there was now both the motivation and the decision not merely to defend British interests in North America, but to conquer New France.

The war turned against France in 1758. The French outpost forts of Frontenac (Kingston, Ontario), Oswego, New York, and Duquesne (Pittsburgh, Pennsylvania) were lost or abandoned. Montcalm received only seventy-five reinforcements that spring, and New France was in such poor condition that she could not have fed more troops had they arrived. By early 1758 only Fort Carillon (Ticonderoga), Louisbourg, and isolated Fort Niagara remained as outlying defences.

On 2 June 1758 a British armada of 175 vessels commanded by Admiral Edward Boscawen—"Old Dreadnought"—arrived off Louisbourg. The fleet carried some eleven thousand troops under the overall command of General Jeffrey Amherst. With thirty-one-year-old Brigadier James Wolfe leading, an amphibious force landed on 8 June, to face three thousand defenders. There were also five French first-rate ships and seven frigates in the harbour, but they were blockaded.

Wolfe's siege gradually tightened. Louisbourg was in desperate shape, and the French warships either escaped, were captured, or were burned. Governor Augustin de Drucourt requested terms and surrendered the town and fortress on 26 July 1758. The sea route to Quebec now lay open and undefended.

To prevent any repetition of 1748, when treaty negotiators traded Louisbourg back to France, British engineers, using thousands of tons of blasting powder, systematically demolished the fortress of Louisbourg in 1760 and 1761. The ruins of the fortified town lay under piles of overgrown rubble for two centuries, until Parks Canada began its archaeological and reconstruction programme in 1959. Even today, however, about seven-eighths of the remains of the original French fortress still lie undisturbed.

The decisive year was 1759, called in Britain the "glorious year", when it "rained victories" around the world. Under Pitt's direct orders, Amherst, with an army of eight thousand, was attacking into New France by way of Fort Carillon (Ticonderoga) and Crown Point on Lake Champlain. Bridagier John Prideaux, meanwhile, advanced westwards to occupy Oswego and take Fort Niagara. By September no French defences remained in the west, and the British were on the doorstep of Montreal.

In the three-pronged campaign of 1759—on the St Lawrence against Quebec, on Lake Champlain, and in the west—Britain and the American colonies had more than fifty thousand troops in the field, a number nearly equal to the total population of New France. For the siege of Quebec, Wolfe, now a general, sailed from Halifax with 9000 troops in early May 1759, in an armada of 141 vessels commanded by Vice-Admiral Charles Saunders. Rear-Admiral Philip Durrell led the way up the St Lawrence, and Wolfe's army landed on Île d'Orléans on 27 June. Two days later they took Lévis, opposite Quebec, and then occupied the Montmorency shore east of the city.

Montcalm, however, was strongly fortified in Quebec. A long siege commenced, with constant artillery bombardment from the British, and periodic attempts against the fleet by the French. By early September Wolfe was despondent; he even considered breaking off the siege until the following spring.

A new plan for a landing and assault upriver from Quebec emerged from Wolfe's brigadiers, George Townshend, James Murray, and Robert Monckton. The surprise landing was

accomplished successfully before dawn on 13 September. By noon the historic battle of the Plains of Abraham was over.

Wolfe and Montcalm were both mortally wounded; the British sustained 664 casualties and the French 1400. Townshend assumed temporary command of the British forces. French Brigadier Gaston Lévis, on learning of the battle, marched from Montreal with a relief force, but he was too late. Quebec had capitulated on 18 September 1759. With Wolfe dead, Murray assumed command in Quebec. In early May 1760 Lévis besieged Quebec for a few days. The occupying British garrison had been decimated by cold and disease, but the arrival of a new British naval squadron ended that threat.

Of New France only Montreal remained. In July Murray, with a small force, sailed up the St Lawrence towards Montreal.

Amherst, with an army of ten thousand, left Oswego to march towards Montreal from the west. Colonel William Haviland, now in command on Lake Champlain, advanced northwards at the same time. The position of Montreal became untenable. The three separate British forces converged in early September and on 8 September 1760 Vaudreuil surrendered Montreal and all of New France.

While the battle for Canada was over, the final resolution was still to come—from the battlefields of Germany, the West Indies, and India. An armistice finally came in 1762 and was followed by the Treaty of Paris in 1763. Canada was confirmed as a British realm; the only exceptions were the fishing islands of St Pierre and Miquelon off Newfoundland, which remain today the sole French colonial possessions in North America.

Document of the Surrender of Lieutenant Colonel George Washington to the French at Fort Necessity, Pennsylvania, 3 July 1754

Handwritten document, 23.5 x 36.8 (9¼ x 14½)
Royal Ontario Museum, Canadiana Department, Sigmund Samuel Collection, 959.19.1

Late in 1753 George Washington (1732–99), who was only twenty-one years old at the time, volunteered to carry a warning from Governor Robert Dinwiddie of Virginia to the French who were moving into the Ohio country claimed by the British. On that mission Washington learned that the intruders, far from withdrawing, were planning further advances. Washington returned to Virginia, where he was made a lieutenant colonel in the militia and sent with a company of about four hundred men to halt the invasion of British territory. On 3 July 1754 the Virginians were overwhelmed at Fort Necessity, near the site of present-day Uniontown, Pennsylvania, and Washington was forced to surrender. Although he and his men were released, the French retained two hostages, one of them Robert Stobo, a legendary wild man of colonial times.

Three copies of the surrender were made, all written in French. The copy carried to Virginia by Washington is now in the University of Virginia Library. The hostage copy, sent to Quebec with Stobo, is now in the Archives nationales du Québec. The Royal Ontario Museum copy is the one eventually dispatched to France, where it came into private hands after a sacking of state papers during the French Revolution.

Although it seems a minor episode, Washington's engagement and defeat at Fort Necessity marked the beginning of the Seven Years' War, which ended only with the capitulation of New France.

25 (See colour plate page 27.)
Turret-Topped Tea Table
American, Boston, c. 1750–70
Mahogany and secondary maple, 69.9 x 76.2 (27½ x 30)
Museum of Fine Arts, Boston, gift of Maxim Karolik, 41.592

One of only five known examples of the form, this table has a moulded top, with ten half-round and four three-quarter-round carved blocks applied to the sides and corners. The cabriole legs have carved knees and brackets, and well-shaped claw-and-ball feet. The turret-top design appears to be a purely colonial American form, produced exclusively in Boston and probably by a single maker. English counterparts are not known.

26
His Majesty's Declaration of War Against the French King
Printed by Thomas Baskett, London, 17 May 1756
Printed document, 49.5 x 41.6 (19½ x 16⅜)
Royal Ontario Museum, Canadiana Department, Sigmund Samuel Collection, 960x279.1

When George II issued a formal declaration of war against France on 17 May 1756, armed conflicts in the American colonies of the two countries had been in progress for almost two years. The provocative words of the declaration made Britain's views very clear: "The unwarrantable Proceedings of the French in the West Indies, and North America, since the Conclusion of the Treaty of Aix la Chappelle, and the Usurpations and Encroachments made by them upon Our Territories, and the Settlements of Our Subjects in those Parts, particularly in Our Province of Nova Scotia, have been so notorious, and so frequent, that they cannot but be looked upon as a sufficient Evidence of a formed Design [to]...promote their ambitious Views, without any Regard to the most solemn Treaties and Engagements." By the time the war ended, France had lost most of her colonial empire.

27

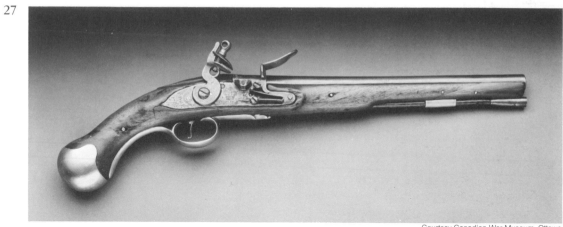

29

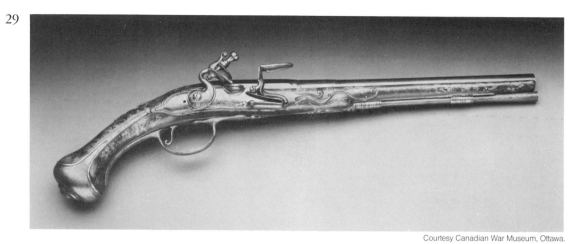

28

30

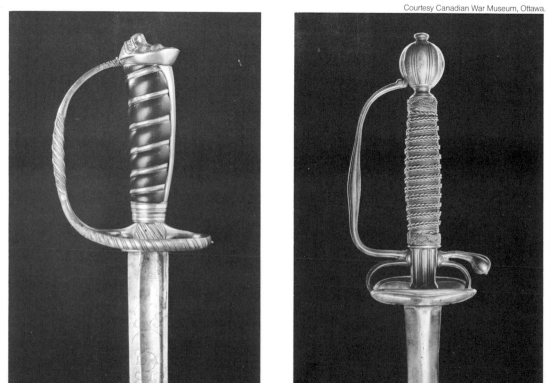

62

27
Flintlock Sea Service Pistol

English, marked by Robert Edge (active c. 1725–c. 1763),
London, 1762
Steel and brass, walnut stock, 30.5 (12)
Canadian War Museum, Ottawa

The Sea Service pistol, the earliest standardized pattern of
English naval pistol, remained in use with little change from the
1730s through the Napoleonic Wars. The cavalry version of the
weapon was generally carried in pairs, in saddle holsters.

The maker of this pistol, Robert Edge, also made flintlock
holster pistols marked with the royal cipher, on contract for the
ordnance department. Edge operated as a London gunmaker
from about 1725 to about 1763, producing a great variety of
weapons, including contract muskets.

28
Short Sabre of Colonel Robert Rogers

German blade, English hilt, c. 1755
Steel blade, silver hilt, 74.9 (29½)
Royal Ontario Museum, Canadiana Department, gift of
Colonel R. G. L. Rogers, 975.84

Robert Rogers (1731–95) was born in Massachusetts, but when
he was still a child his family moved to the New Hampshire
frontier. In 1755 he organized the colonial company known as
Rogers' Rangers, which served throughout the Seven Years' War.
At the beginning of the American Revolution, Rogers, who was a
Loyalist, was involved in the formation of the Queen's Rangers,
and later of the King's Rangers. After the war, Rogers emigrated
to England.

Military officers usually purchased their own swords, which
basically conformed to a stipulated military pattern but were
often more elaborate than issue swords. The sword of a field
officer was generally a short curved-bladed sabre, or sometimes a
straight thin-bladed sword or small-sword.

With its English silver hilt and lion's-head pommel, this sword
is representative of the type worn by British officers during the
Seven Years' War and the American Revolution. German blades
are common on such swords; the blades were made in quantity
and exported specifically for hilting by English swordmakers.

29
Flintlock Pistol

French, marked by Pierre Fromentin Abbeville, Somme,
c. 1750
Steel, walnut stock, 35.6 (14)
Canadian War Museum, Ottawa

French officers, like their British counterparts, often carried
their own privately purchased weapons, whether pistols or
swords. Usually the weapons were fairly plain, serviceable pieces,
rather than elaborately decorated presentation arms. This
horseman's or saddle-holster pistol, of military size, was a
privately purchased weapon of the type carried by French officers
during the period of the Seven Years' War.

30
Officer's Small-Sword

French, c. 1750
Steel blade, silver hilt, 81.3 (32)
Canadian War Museum, Ottawa

Although perhaps less common than the curved-bladed short
sabre, the small-sword, with a straight blade, was often worn by
English and French officers, as well as by colonial American
officers. The country of origin of the sword was not necessarily
always that of its owner.

A fine example of the small-sword type, this handsome
silver-hilted and wire-wrapped piece epitomizes swords carried by
officers in North American campaigns from King George's War
through the American Revolution. Although French in origin, it
is of a type that might have been used by any senior officer in any
North American regiment.

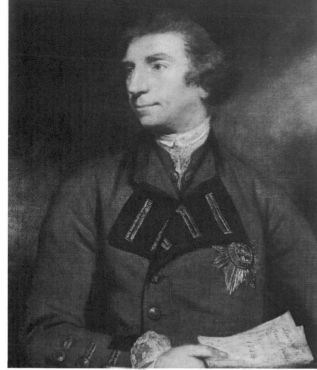

31
Portrait of Jeffrey Lord Amherst

Signed by Joshua Reynolds (1723–92), London, c. 1785
Oil on canvas, 74.9 x 62.2 (29½ x 24½)
National Gallery of Canada, Ottawa, 8004

Jeffrey Amherst (1717–97) was a British army officer who had already seen duty in the War of the Austrian Succession when in 1758 he was made a major general and chosen by the elder William Pitt to command the British assault on the fortress of Louisbourg. The following year Amherst was appointed commander in chief of British forces in North America. He directed the capture of Montreal in 1760. From then until 1763, when he returned to England, Amherst served as military governor of British North America.

Sir Joshua Reynolds was the most fashionable British portraitist of the mid-18th century. He studied under Thomas Hudson in the early 1740s (see no. 15), and later spent two years in Italy. When he established his own studio in London, he became an immediate success, with so many aspiring sitters that by 1755 he was employing several assistants and in 1759 he raised his portrait prices simply to reduce the volume of business. Reynolds was a founder and the first president of the Royal Academy of Arts, established in 1768. On the death of Allan Ramsay in 1784 (see nos. 62, 63), he became court painter to George III.

32
A View of the Siege of Louisbourg, 1758

Inscribed and signed by Thomas Davies (1737?–1812), Louisbourg, 1758
Watercolour on paper, 35.7 x 51.0 (14⅛ x 20⅛)
The Royal Artillery Institution, Woolwich

Thomas Davies was an artillery lieutenant in command of a British shore battery at Louisbourg. He did this graphic scene of the siege from the land side, showing the various British artillery positions surrounding the beleaguered fortress. On this only existing picture of the artillery siege (which was repeated at Quebec), the inscription and legend read "A View of the Siege of Louisbourgh Commanded By His Excellency Major General Amherst in the year 1758 taken from the Center Redout Hill. Drawn on the Spot by Thomas Davies, Capt. Lieut: R. Artillery".

A career army officer, Thomas Davies had a long association with North America; he served in both the Seven Years' War and the American Revolution. Like all military officers of the period, he had been trained in drawing and watercolour painting. Thomas Davies left a legacy of sparkling watercolours that span the years between 1757, when he first sketched Halifax, and 1790, when he left Canada for the last time (see nos. 33, 33a, 68, 75, 107, 108).

33
The Plundering and Burning of Grymross

Inscribed and signed by Thomas Davies (1737?–1812), Halifax, 1758
Pencil and monochrome wash, 37.0 x 53.3 (14½ x 21)
National Gallery of Canada, Ottawa, 6270

The burning of Grymross (now Gagetown, New Brunswick) was only one incident in the campaign initiated by Governor Charles Lawrence of Nova Scotia to expel the Acadians from eastern Canada. After the fall of Louisbourg in 1758, an expedition led by Robert Monckton sacked the Saint John River valley. By 1762 the French fishing settlements and farmsteads of Cape Breton and Prince Edward Island had been burned to the ground as well, and their inhabitants scattered or transported. The sufferings of the Acadians were immortalized in Longfellow's poem *Evangeline*.

The full inscription reads "A View of the Plundering and Burning [of] the City of Grymross Capital of the Neutral Settlements, on the River St. Johns in the Bay of Fundy, Nova Scotia by the Army under the Command of the Honbl. Col. Robert Moncton, in the Year 1758. Drawn on the Spot by Thos: Davies Capt: Lieut: of the Royal Regt. of Artillery".

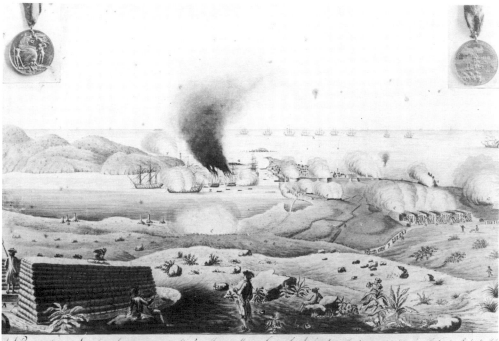

Courtesy Royal Artillery Institution, Woolwich. Photograph by PACE.

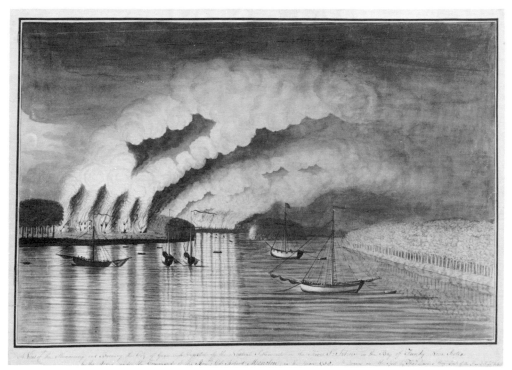

Courtesy National Gallery of Canada, Ottawa.

32

33

65

33a

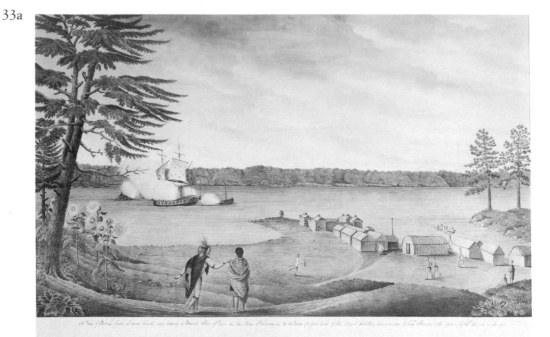

A View of Fort La Galet, Indian Castle, and takeing a French Ship of Warr on the River St. Lawrence, by 4 Boats of 1 Gun each of the Royal Artillery Commanded by Capt Streachy, the

Courtesy National Gallery of Canada, Ottawa.

33a
A View of Fort La Galette, 1760

Inscribed and signed by Thomas Davies (1737?–1812), La Galette, 1760
Watercolour on paper, 38.5 x 58.7 (15⅛ x 23⅛)
National Gallery of Canada, Ottawa, 6271

General Amherst's campaign against Montreal in 1760 required first the taking of a number of small posts on the Richelieu and St Lawrence rivers. La Galette (now Ogdensburg, New York) was one of those posts, a rather minor one, which surrendered without a battle. The French ten-gun *Outaouaise* was attacked and captured by four British row-galleys or galliots, one of which Thomas Davies commanded.

The full inscription reads "A View of Fort La Galet, Indian Castle, and takeing a French Ship of Warr on the River St. Lawrence, by 4 Boats of 1 Gun each of the Royal Artillery Commanded by Captn. Streachy 1760 taken by Ct. Lt. Davies on the spot".

66

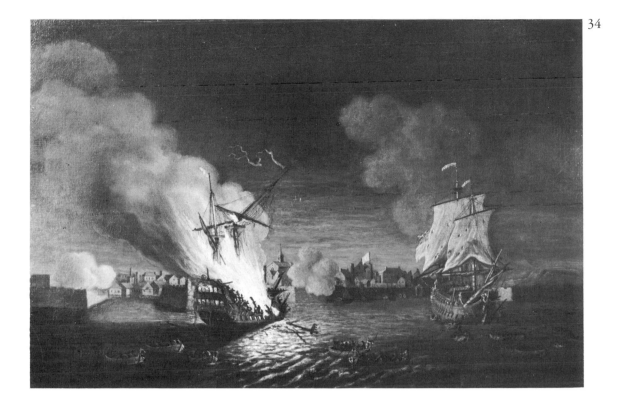

34

Capture of the French Ships *Prudent* and *Bienfaisant* in Louisbourg Harbour, 26 July 1758

Richard Paton (1717–91), London, unsigned but marked on the stretcher, "Painted 1761 by R. Paton"
Oil on canvas, 41.3 x 62.2 (16¼ x 24½)
Royal Ontario Museum, Canadiana Department, Sigmund Samuel Collection, 956.94

The fortress of Louisbourg had been besieged by the British fleet of Admiral Edward Boscawen, and an army under the command of Jeffrey Amherst and James Wolfe, since 2 June 1758. By late July the French defenders had only two ships remaining, the *Prudent* and the *Bienfaisant*, both trapped at anchor in the harbour. On 26 July, in an audacious pre-dawn operation, six hundred British sailors rowed into the harbour to board and

capture the two ships. The French skeleton crews were asleep in their bunks, with no watches posted. The *Prudent* drifted aground on a falling tide and was deliberately burned; the *Bienfaisant* was towed off as a prize. The loss of the vessels was the final blow to the beleaguered and now desperate fortress; Louisbourg capitulated later the same day.

Richard Paton, though largely self-taught, became one of the foremost 18th-century British marine painters—mainly of naval scenes that showed a strong influence of Samuel Scott (see nos. 41, 42). A number of Paton's oils were engraved and published as prints. Although he was an exhibitor at the Society of Artists in London for many years, it was not until late in his career that he began to exhibit annually at the Royal Academy of Arts, where this painting was shown in 1779.

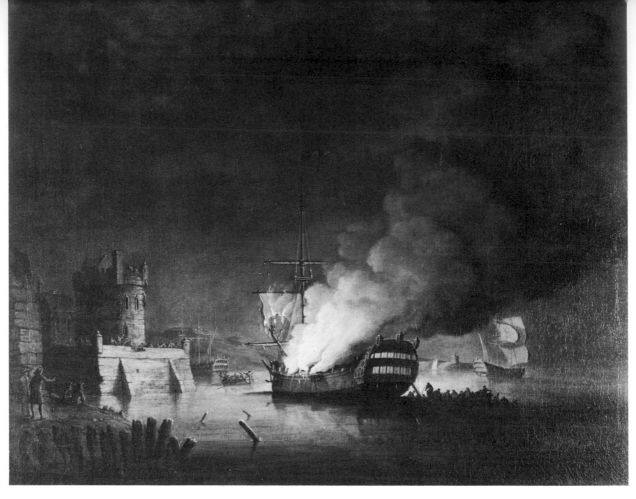

35

35
The Burning of the *Prudent* in Louisbourg Harbour, 26 July 1758

Signed by Francis Swaine (c. 1719/20–82), London, c. 1760–62
Oil on canvas, 62.9 x 75.6 (24¾ x 29¾)
Royal Ontario Museum, Canadiana Department, Sigmund
Samuel Collection, 956.41

In this view of the same scene, painted by Francis Swaine, the *Prudent* is hard aground off the fortress walls and burning furiously, as the French crew rows for shore and the British captors make for their fleet. The remains of the *Prudent*, and all her guns, still lie where the ship sank; the underwater site is reserved for future archaeological work by Parks Canada.

Francis Swaine was a well-known marine painter, specializing in shipping and battle scenes (see nos. 43, 45, 46), usually in canvases of small size, which were sometimes executed on commission. He seems to have been influenced by Peter Monamy (see no. 13), after whom he named his son. Swaine was most active in the 1760s and 1770s, exhibiting regularly at the Society of Artists, though never at the Royal Academy of Arts.

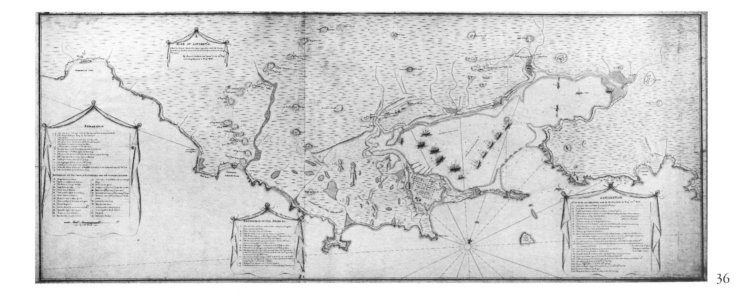

36
A Plan of Louisbourg

Samuel Holland (1728?–1801), Louisbourg, 1759
Ink and watercolour on paper, 62.0 x 155.4 (24⅜ x 61⅛)
Royal Ontario Museum, Canadiana Department, Sigmund
Samuel Collection, 949.39.23

Surveyed and drawn either during or immediately after the siege
of Louisbourg, and certainly on James Wolfe's orders, Holland's
elaborate plan shows quite accurately the coast of the entire
Louisbourg area. Included in the plan are the British siege and
artillery positions, the three French fortifications, and several
burning French vessels in the harbour.

Samuel Holland, who was Dutch born, joined the British army
in 1754; he first came to Canada two years later. At the siege of
Louisbourg, he was a captain lieutenant in the Sixtieth Regiment
and acting engineer to Brigadier James Wolfe; he was also
present when Wolfe died at Quebec. In 1764 he became surveyor
general of Quebec. During the American Revolution, Holland
served with a German mercenary regiment. In 1779 he was
appointed to the governor's council; he settled in Quebec City the
following year. Among the numerous surveys Holland super-
vised in his long, active life was one in 1782/83 for the new
Loyalist settlements at Cataraqui.

37 (See colour plate page 26.)
The Town and Harbour of Louisbourg

Richard Paton (1717–91), London, c. 1759–60
Oil on canvas, 96.5 x 160.0 (38 x 63)
Royal Ontario Museum, Canadiana Department, Sigmund
Samuel Collection, 951.197

This panorama of Louisbourg must have been sketched in 1759,
the year after the capture of the fortress by the British, for the
Island Battery to the left, the fortified town in the centre, and the
Queen's Battery to the right are all intact. Having already taken
Louisbourg once in 1745, and then had their military success
nullified by the Treaty of Aix-la-Chapelle—which restored the
fortress to the French—the British had no assurance that this
new victory would remain permanent.

To prevent a repetition of the earlier reversal, and mindful of
the restless mood of the New England colonies, early in 1760 the
British commenced the deliberate and systematic demolition of
all fortifications at Louisbourg, a project that took several
months and many thousands of kilograms of gunpowder. When
they had finished, all that remained of the fortress was great piles
of stone rubble. Since 1959, Parks Canada has first excavated and
then reconstructed about one-eighth of the original structure.

Although many of Richard Paton's paintings were later
engraved, this one was not. It probably served, however, as the
model for J. F. W. DesBarres' very similar aquatint *A View of
Louisbourg from the North East*, published in *The Atlantic
Neptune* about 1775.

38

38
Portrait of James Wolfe

Attributed to Joseph Highmore (1692–1780), London,
c. 1750–55
Oil on canvas, 73.7 x 61.3 (29 x 24⅛)
Royal Ontario Museum, Canadiana Department, Sigmund
Samuel Collection, 953.195

This is one of the few known life portraits of James Wolfe
(1727–59), who ranks among the best-known figures in Cana-
dian history. Although of short duration, his involvement in the
creation of British North America was decisive. When Wolfe
arrived on this continent in 1758, he was already a veteran of the
battles of Dettingen, Falkirk, and Culloden, having served in the
British army since the age of fifteen. At the siege of Louisbourg
he was one of three brigadiers to General Jeffrey Amherst, but he
was the one who emerged from that engagement with the
greatest distinction. His historic triumph came on 13 September
1759 at the battle of the Plains of Abraham. Although Wolfe was
mortally wounded, the battle precipitated the surrender of
Quebec, which ensued a few days later.

Joseph Highmore was a portraitist who studied under Godfrey
Kneller (see no. 9), and began painting professionally in 1715.
He executed both individual and group portraits. Although an
excellent painter and a fashionable one at the height of his career,
Highmore was never appointed court painter; he retired in 1762.

39
Portrait of Louis Joseph de Montcalm-Gozon, Marquis de Saint-Véran

Artist unknown, probably French, 18th century
Oil on canvas, 91.4 x 71.1 (36 x 28)
Royal Ontario Museum, Canadiana Department, Sigmund
Samuel Collection, 951.91

Louis Joseph de Montcalm (1712–59), a native of Provence, was
a French career officer who had served in the army since the age
of sixteen and had participated in numerous campaigns. After
appointment as a field marshal, he was sent to Canada in 1756 to
assume command of all French and French colonial forces.
Although he himself was a brilliant military tactician, his armies
were increasingly outnumbered and outsupplied by the better-
equipped British forces. Montcalm, like Wolfe, lost his life at the
battle of the Plains of Abraham in September 1759. Mortally
wounded on the field, he was cared for by Ursuline nuns and died
early the next morning. To this day his skull is preserved at the
Ursuline convent in the city of Quebec.

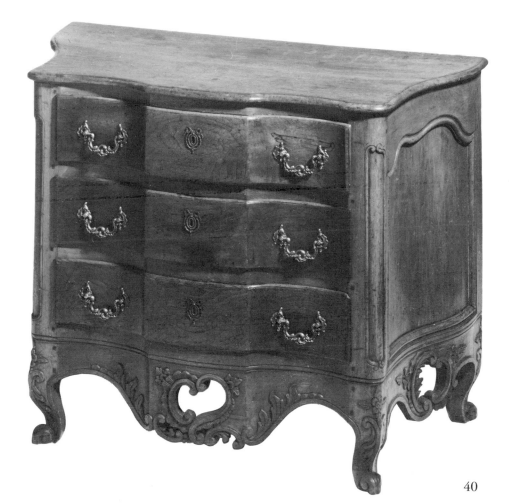

40

40
Three-Drawer Commode

French Canadian, c. 1740–60
Butternut and secondary pine, 83.8 x 106.7 (33 x 42)
Royal Ontario Museum, Canadiana Department, gift of the
Laidlaw Lumber Company, 954.137

This small but ideally proportioned commode, with a carved
rocaille base, is derived from the French Louis XV type of the
provinces of Provence and Languedoc. The serpentine side
panels, block-carved reverse-arbalete drawer fronts, and open-
work floral carving of the base panels are all very well executed
and make the piece one of the finest surviving examples of this
rare Quebec form.

41

The Defeat of the French Fireship Attack, 28 June 1759

Signed by Samuel Scott (1702?–72), London, c. 1760
Oil on canvas, 73.7 x 172.7 (29 x 68)
Royal Ontario Museum, Canadiana Department, Sigmund
Samuel Collection, 949.28.2

On 28 June 1759, only two nights after James Wolfe's army had first encamped on the Île d'Orléans, the French launched a fireship attack on the British fleet commanded by Vice-Admiral Charles Saunders. Seven old French vessels were towed upriver from the British fleet, set afire, and allowed to drift downstream with the current. The French, however, had misjudged the drift and ignited the fireships too soon. Some drifted ashore. Others were nearly burnt out by the time they reached the anchored British ships and were easily grappled and towed away.

Working from sketches and descriptions, Samuel Scott did this pair of dramatic scenes (see no. 42) about a year after the events had occurred. Another pair of Scott views of the same engagements, and also a pair by Dominic Serres, are in the National Maritime Museum, Greenwich.

Samuel Scott began his career in the mid-1720s, with marine scenes that imitated the works of Willem van de Velde. By the 1740s Scott was among the most accomplished marine artists in Britain. His most ambitious works were large paintings of sea battles. In the early 1740s he began to paint urban and river landscapes. This interest was intensified after he came under the influence of Canaletto (see no. 1), who went to England in 1746. For the remainder of his career, Scott largely abandoned marine painting to specialize in London city and river views (see no. 2).

42

The Defeat of the French Fireraft Attack, 28 July 1759

Signed by Samuel Scott (1702?–72), London, c. 1760
Oil on canvas, 78.1 x 156.2 (30¾ x 61½)
Royal Ontario Museum, Canadiana Department, Sigmund
Samuel Collection, 949.28.1

Exactly a month after the first fireship attack, the French launched a second and stronger one. This time more than a hundred rafts, shallops, and old river schooners were chained together, end-to-end, to form a blazing line almost two hundred metres long. As a group of British boats grappled the flaming mass, one sailor commented "Damme, Mate, did'st thee ever take Hell in tow before?" With that, the fiery menace was hauled clear of the British fleet. The next morning James Wolfe sent word to the French that if there were another fireship attack on the British fleet he might be tempted to secure his own fireships alongside the two transports that were then holding French prisoners.

41

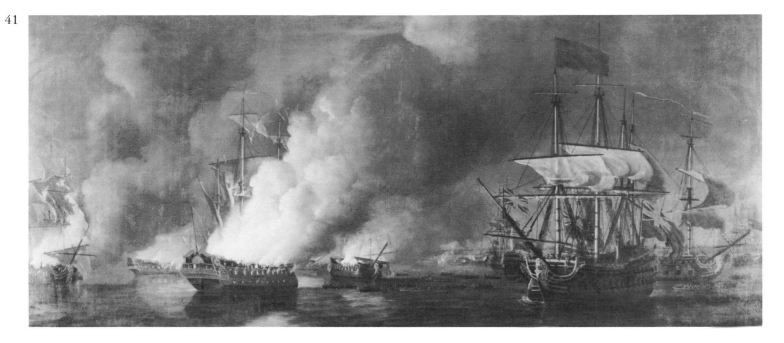

42

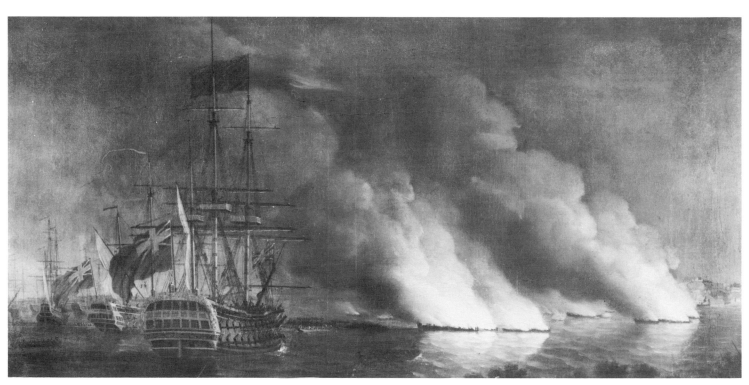

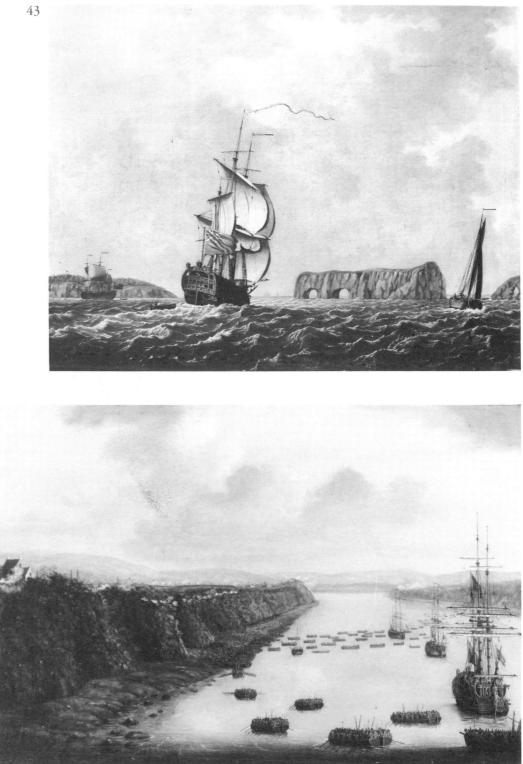

43

45

43
HMS *Vanguard* off Percé

Signed and dated by Francis Swaine (c. 1719/20–82), London, 1760
Oil on canvas, 71.5 x 92.0 (28⅛ x 36¼)
Royal Ontario Museum, Canadiana Department, Sigmund Samuel Collection, 948x267.2

HMS *Vanguard*, a seventy-gun warship built in 1748, was part of Vice-Admiral Charles Saunders's fleet at the siege of Quebec; the ship remained on the North American station after the Seven Years' War. She was sold out of service in 1774.

This view of HMS *Vanguard*, approaching Île Percé at the eastern tip of the Gaspé Peninsula, is one of a number of paintings done by Francis Swaine after drawings by Captain Hervey Smyth, aide-de-camp to James Wolfe (see nos. 45, 46). Many of them were published as engravings between 1760 and 1765.

44 (See colour plate page 26.)
The Death of Wolfe

Benjamin West (1738–1820), signed and dated "B. West 1776— retouched 1806", London, 1776
Oil on canvas, 165.4 x 244.5 (65⅛ x 96¼)
Royal Ontario Museum, Canadiana Department, gift of Colonel Alexander Fraser and others, 931.26

After his death on the Plains of Abraham in September 1759, James Wolfe became a legendary hero. Myriad posthumous medals, miniature likenesses, portraits, and prints were produced to honour him.

Benjamin West did six monumental paintings of the famous death scene. The first one, executed in 1771, is now in the National Gallery of Canada, Ottawa. The Royal Ontario Museum painting, which dates from 1776, was either West's third or his fourth rendering of the subject. The basic scene has been reproduced or adapted many times—in the forms of copies by other artists, prints, and printed decoration on commemorative ceramics. It eventually brought West the wealth that enabled him to support his continuous stream of students.

Benjamin West, who was American born, left the colonies in 1759 to study in Italy. In 1763 he settled in London, where he prospered as a painter of both portraits and historical and religious scenes, often done on a very large scale.

45
Landing of the British Troops and the Battle of the Plains of Abraham

Francis Swaine (c. 1719/20–82), London, c. 1763
Oil on canvas, 29.8 x 45.7 (11¾ x 18)
The Public Archives of Canada, Ottawa, C 2736

This view of the events of 13 September 1759 shows the pre-dawn, unopposed landing of the British off the ramparts of Quebec. The painting was done in London some time later, from a sketch provided to Francis Swaine by Captain Hervey Smyth, aide-de-camp to General Wolfe. Swaine's work, in turn, was the basis for a print engraved by P. C. Canot and published by Robert Sayer about 1765.

46 (See colour plate page 27.)
View of the Taking of Quebec, 13 September 1759

Francis Swaine (c. 1719/20–82), London, c. 1763
Oil on copper, 15.0 x 20.2 (5⅞ x 8)
Royal Ontario Museum, Canadiana Department, Sigmund Samuel Collection, 953.203

This most unusual, small—almost miniature—scene of the landing at Quebec was also done by Francis Swaine after a sketch by Captain Hervey Smyth. Unlike the preceding painting, this low, near-water-level view is not known to have been engraved for a print.

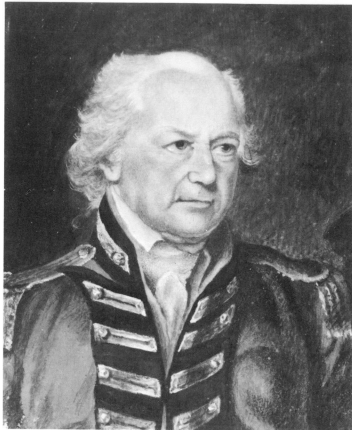

47

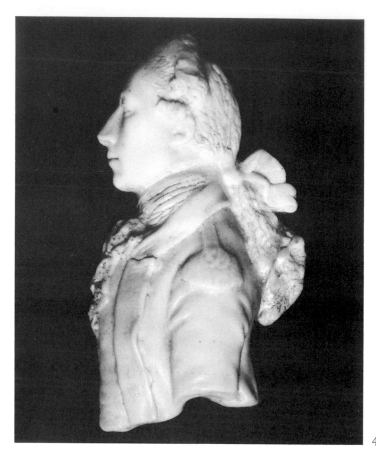

48

47
Portrait Miniature of Field Marshal George Townshend, First Marquis Townshend

Signed by W. G. Chaplin, late 18th century
Watercolour on ivory, 8.1 x 6.4 (3¼ x 2½)
The Public Archives of Canada, Ottawa, C 108975

George Townshend (1724–1807), who had accompanied James Wolfe in the expedition against Louisbourg in 1758, was appointed Wolfe's senior brigadier for the Quebec campaign in 1759 (see nos. 32, 45, 46). After Wolfe's death (see no. 44), Townshend assumed command of the British forces at Quebec and prevented a French counterattack. He returned to England late in 1759, turning over command to Brigadier James Murray.

There is no record of W. G. Chaplin, the presumed artist, but the miniature is after a portrait by Mather Brown (1761–1831), a Boston-born student of Benjamin West. In 1781 Brown moved to England, where he painted portraits as well as miniatures until his death.

48
Cameo Portrait Miniature of General James Wolfe

Isaac Gosset (1713–99), London, c. 1765
Cast and sculpted wax, 20.0 x 17.3 (7⅞ x 6⅞)
Royal Ontario Museum, Canadiana Department, Sigmund Samuel Collection, 963.54

James Wolfe (1727–59), whose dramatic death on the Plains of Abraham crowned his greatest victory, became an almost instant folk hero in Britain, just as Admiral Horatio Nelson did after his death at the battle of Trafalgar half a century later.

An example of the plethora of Wolfe memorabilia that appeared in the 1760s, this miniature cameo bust was probably copied from a print. The moulded figure was produced in multiple copies, of which other examples are known.

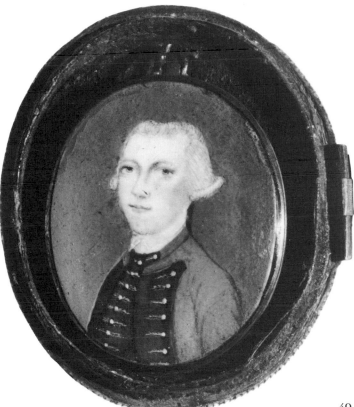

49

49
Portrait Miniature of General James Wolfe

Artist unknown, English, probably London, c. 1765–80
Oil on ivory, 3.7 x 3.0 (1½ x 1⅛)
Royal Ontario Museum, Canadiana Department, Sigmund
Samuel Collection, 960.249

This portrait miniature of James Wolfe (1727–59), in a thin
brass frame, is another piece of memorabilia, which was certainly
done from a second- or third-hand likeness, probably in numer-
ous copies. True miniatures, portraits as small as two centimetres
by five centimetres, were in vogue in England between 1740 and
1770. Thin sheets of ivory were a favourite painting base of the
miniature portraitists.

50

Commemorative Pitcher

English, marked Wedgwood, c. 1780
Creamware, transfer-printed decoration, 27.0 x 12.1 (10⅝ x 4¾)
Royal Ontario Museum, Canadiana Department, gift of Josiah
Wedgwood and Sons Limited, 960.86

With a transfer-printed scene taken from Benjamin West's *The Death of Wolfe* on one side (see no. 44) and the legend "Good Health and Success to the Right Honble. the EARL of DERBY" on the other, this creamware pitcher represents a type that became extremely popular after about 1770. These pitchers were produced in many forms by many potteries in the 1770s and 1780s—still another memento drawn from Benjamin West's famous painting.

While white salt-glazed stoneware remained the prevailing ceramic material between 1720 and 1760, creamware was developed during that period, though it was not refined by Josiah Wedgwood until after 1760. By 1770 numerous Staffordshire potters were producing light-coloured creamware, which Wedgwood had named "Queen's Ware". Until about 1760 all coloured decoration was hand applied, but the use in England of the technique of transfer-printing coincided with the refinement of creamware as a body.

Transfer-printing seems to have been an Italian development of the early 1740s. It remains today a standard technique for applying decorative motifs on ceramics.

51
Portrait of Lieutenant Colonel Paulus Aemilius Irving

Signed by George Romney (1734–1802), London, June 1783
Oil on canvas, 76.2 x 61.0 (30 x 24)
Royal Ontario Museum, Canadiana Department, Sigmund Samuel Collection, 951.58.3

Paulus Irving (1714–96) was a Scottish-born career army officer, who commanded the Fifteenth Regiment at the battle of the Plains of Abraham. Posted to Quebec under Jeffrey Amherst and James Murray, Irving was appointed to the first governor's council in 1764. He became acting governor in the summer of 1766—during the interim between Murray's departure and the arrival of Guy Carleton—and left Quebec at the end of the year.

Paulus Irving was sixty-nine years old when he sat for this portrait by George Romney, who had first come to London in 1762. By the 1780s Romney was one of the triumvirate (with Joshua Reynolds and Thomas Gainsborough) of London's most fashionable portraitists. He never exhibited at the Royal Academy of Arts, perhaps because Reynolds, who was its president, had an antipathy for him. But then, he never needed to, for his appointment books were constantly filled. When Romney finally retired in 1798, his work was already in decline.

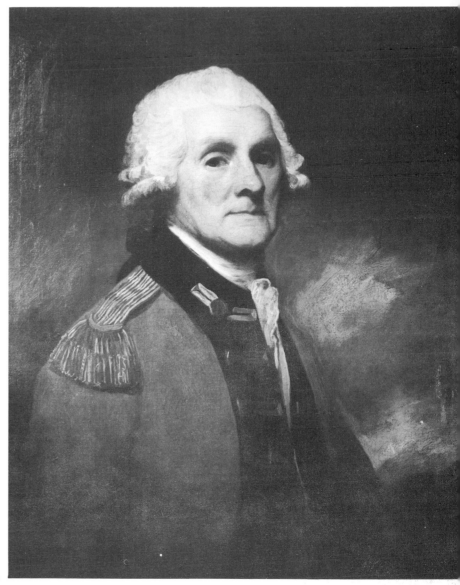

51

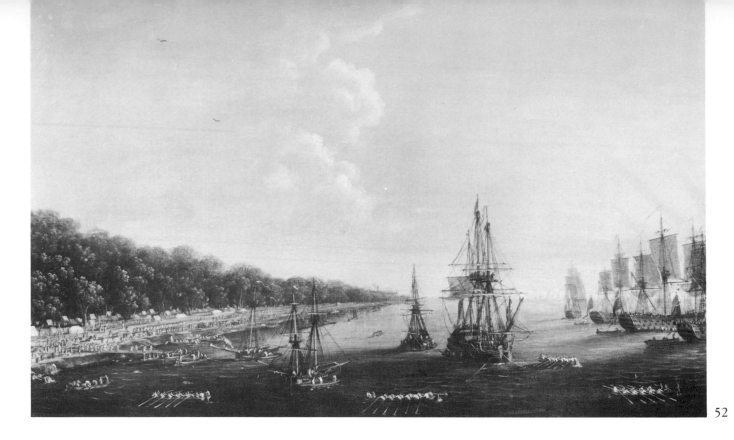

52
The Secret Expedition Against Havana

Signed by Dominic Serres (1722–93), London, 1763
Oil on canvas, 39.4 x 62.2 (15½ x 24½)
Royal Ontario Museum, Canadiana Department, Sigmund
Samuel Collection, 951.69.1

Spain's entry into the Seven Years' War in 1761, as a French ally, was provocation for British retaliation. Although hostilities in North America had ceased in 1760, far-removed operations, which would affect treaty negotiations and the final outcome, were in fact of critical importance to the future of Canada. An expedition led by Admiral Sir George Pocock began a siege of Havana on 13 June 1762. The city was finally taken in August, after heavy losses, and was occupied for a year. Cuba, however, was restored to Spain by the Treaty of Paris in 1763, in return for Spanish cession of Florida to Britain.

Dominic Serres was born in France but went to Spain as a young man and became a seaman. He was taken to England as a captured sea captain, probably in 1748 or 1749. On his release, he settled in England. With influential backing, he became a very successful marine painter, specializing in battle scenes (see no. 118). Serres was a founding member of the Royal Academy of Arts in 1768, and was appointed marine painter to the king in 1780. He painted and exhibited prodigiously until his death in 1793.

53
Two-Handled Cup

Presented to George, Prince of Wales (1762–1830)
English, marked by Robert Salmon, London, 1790
Silver-gilt, 53.3 (21)
By gracious permission of Her Majesty The Queen

This cup, a memento of the siege of Havana in 1762, was made for presentation to the Prince of Wales in 1790 (though its inscription is dated 1783) to commemorate his majority in 1783. A Prince of Wales badge decorates the rim on each side, and the handle of the lid terminates in a royal crown finial. One side of the cup is engraved with the arms of the Bourbon kings of Spain. On the other side is the inscription "This CUP which is made of Spanish Dollars Taken at the SURRENDER of the HAVANNA Augst. 12, 1762, was presented to the PRINCE of WALES By . Sir . John . Swinn Dyer Bart. The Day His Royal Highness came of Age . Augst. 12th 1783."

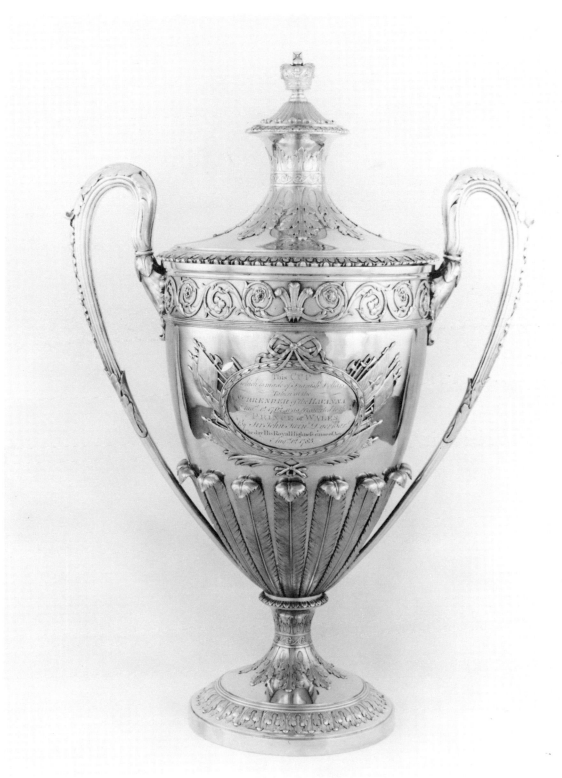

53

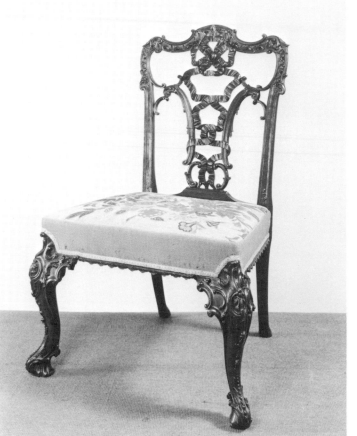

Crown Copyright, Victoria and Albert Museum, London.

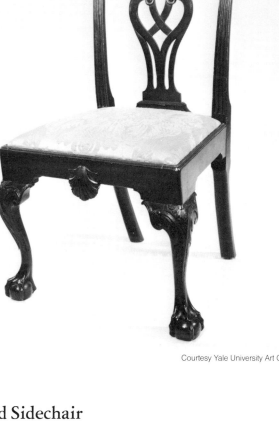

Courtesy Yale University Art Gallery.

54
Carved Ribband-Back Chair

English, c. 1755
Mahogany, 100.3 x 66.0 (39½ x 26)
Victoria and Albert Museum, London, Clarke bequest,
W.65–1935

The ribband-back chair—so called because of the ribbon-and-bow carving on the back—is a rarefied type that comes directly from Thomas Chippendale's design book of 1753, *The Gentleman and Cabinet-maker's Director*. The ribband-back was essentially a temporary fashion, produced in England in the 1750s, though a few colonial American examples are known, notably from Philadelphia. While the carved ribband-back form was short-lived, the basic design of this Chippendale type persisted for many decades. Canadian examples exist dating from the 1790s.

55
Carved Sidechair

American, Philadelphia, c. 1760–80
Mahogany, 101 (39¾)
Yale University Art Gallery, New Haven, Connecticut, Mabel
Brady Garvan Collection, 1930.2502

American versions of cabriole-legged Chippendale chairs are rarely as opulent as the most extreme English work, but still they achieve a high degree of ornamentation, particularly New York and Philadelphia examples. This piece, with carved knees, claw-and-ball feet, and reeded back uprights with scrolled tips, shows a direct derivation from the original English form. The shell motif—seen here dropped from the seat rail and extended from the top rail—was common on English furniture of this period, and even more common on late colonial American furniture. It appears only rarely on Canadian furniture, for its period of popularity had passed by the late 18th century.

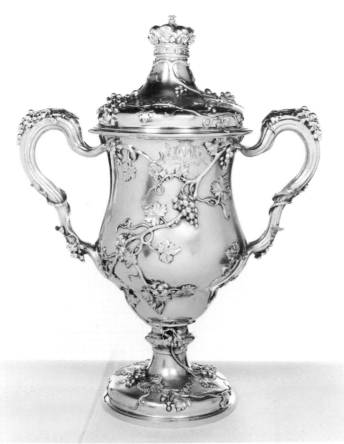

Crown Copyright, Victoria and Albert Museum, London.

56
Cup and Cover

English, attributed to Thomas Heming, London, c. 1760–70
Silver-gilt, 41.3 x 27.9 (16¼ x 11)
Victoria and Albert Museum, London, M.9-1970

This finely formed silver cup is a handsome example of the covered wine or punch cup that was common in the 18th century but later became obsolete. Such cups were often chosen as gifts or presentations.

A crown finial tops the lid, and both lid and body are suitably entwined with detailed and separately cast and applied grape vines and leaves and bunches of grapes. The grape vine in endless variety remained a favourite decorative motif for vessels associated with wine or punch well into the 19th century.

The cup is attributed to Thomas Heming, a London silversmith, who produced many pieces of silver for George III and Queen Charlotte.

57
Tea Urn

English, marked by Thomas Whipham and Charles Wright, London, 1767–68
Silver, 53.3 (21)
Victoria and Albert Museum, London, gift of C. D. Rotch, M.4-1918

This extremely elaborate tea urn is finely embossed with scroll and floral motifs, as well as with most unusual Chinese figures, apparently carrying serving trays. The square base, valved spigot, and handles are separately attached; the cover is a replacement. Because of the weight of silver required, and the many hours of a craftsman's costly labour, silver objects of this extreme opulence were never produced by colonial American or Canadian makers.

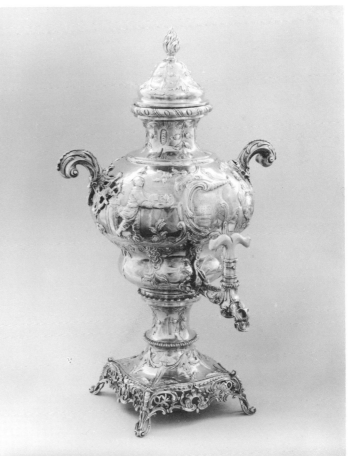

Crown Copyright, Victoria and Albert Museum, London.

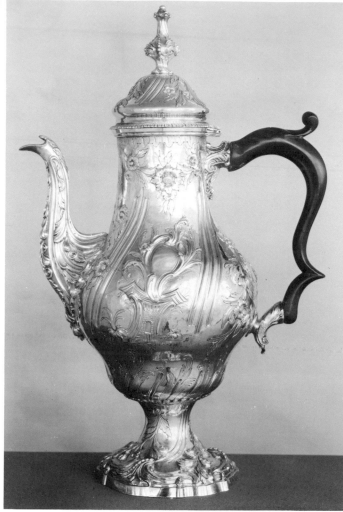

Crown Copyright, Victoria and Albert Museum, London.

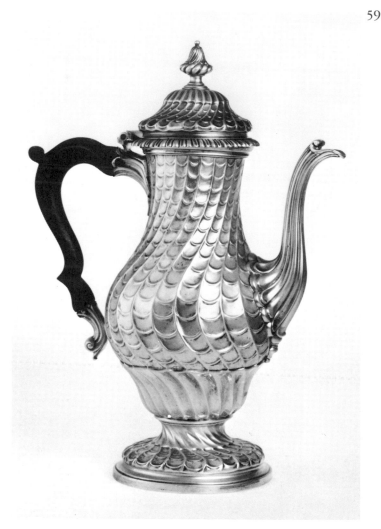

58
Coffee Pot

English, marked by William Tuite, London, 1762–63
Silver, 47 (18½)
Victoria and Albert Museum, London, Bond gift, 494-1875

This coffee pot, which is rather larger than most, was probably originally part of a full coffee service. It has an applied swan-necked spout and a wooden handle. The body and lid are finely embossed with spirals, cartouches, and floral decorations.

Spiralled fluting and reeding was highly fashionable in the 1760s. The motif is quite common on silver teapots and pitchers of that period, and also within the "air-twist" stems of wine-glasses.

59
Coffee Pot with Embossed Body

English, marked by John Swift, London, 1764
Silver, 30.5 x 12.1 (12 x 4¾)
Royal Ontario Museum, European Department, bequest of Miss L. Aileen Larkin, 967.15.3

Embossing of silver in spiralled scale patterns was in vogue in England in the 1760s; a number of pieces decorated in this fashion are known from different London makers. This coffee pot, with an applied swan-necked spout, an acorn finial on the hinged lid, and a wooden scroll handle, was probably part of a multi-piece service.

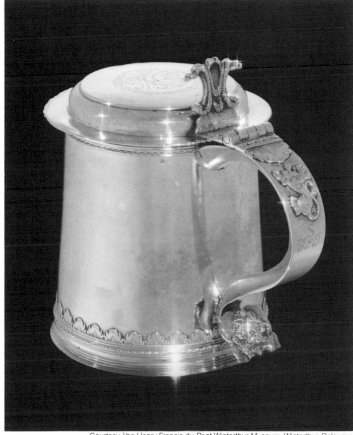

Courtesy The Henry Francis du Pont Winterthur Museum, Winterthur, Delaware.

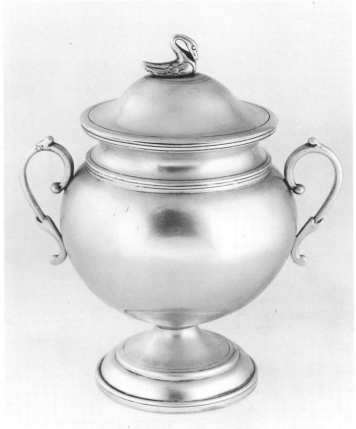

60
Lidded Tankard

American, marked by Cornelius Kierstede (1675–1757), New York, c. 1720
Silver, 19 x 14 (7½ x 5½)
The Henry Francis du Pont Winterthur Museum, Winterthur, Delaware, gift of Charles K. Davis, 56.84

This tankard, with an applied lion rampant on the handle and a relief cherub's head on the lower handle extension, is a supreme example of colonial American silver of the early 18th century. It was probably made as a wedding gift for a member of the prominent Connecticut Sill family.

Cornelius Kierstede left New York to settle in New Haven, Connecticut, in 1724, but this tankard may date from his New York period.

61
Sucrier or Sugar Bowl

French Canadian, marked by M. Gatien, Quebec, c. 1760–65
Silver, 25.4 x 25.4 (10 x 10)
Private collection

Although their main source of patronage was the church, Quebec silvermakers in the French period, and immediately after it, also made domestic flatware. But domestic table hollow-ware dating from before the late 18th century is extremely rare today.

This sucrier, which is heavier than might be expected, is probably not of pure silver, but of silver alloyed with tin or antimony. Bulking out of metal was also a standard practice of pewterers. The bowl is starkly simple and unornamented; the base is applied and the handles are separately cast and applied. The lid, however, carries a cast and applied swan as its finial and handle—a most unusual touch.

Gatien, the maker, was listed as a silversmith in Quebec in 1762. He is known for only a few existing pieces.

62 (See colour plate page 28.)
Portrait of George III in Coronation Robes

Studio of Allan Ramsay (1713–84), London, c. 1767
Oil on canvas, 246.4 x 160.0 (97 x 63)
Indianapolis Museum of Art, James E. Roberts Fund, 66.21b

George William Frederick of Hanover (1738–1820; reigned 1760–1820) came to the throne as George III on 25 October 1760. He succeeded his grandfather, George II, since his own father had died in 1751, apparently of pneumonia.

George III proved to be an exceptionally strong-willed king. He quickly incurred the displeasure of the American colonies with the Proclamation of 1763 and the Stamp Act of 1765. In fact, his insensitivity to the views of the colonists in large part led to the American Revolution. He was apparently a stubborn and rigid man, with intense likes and dislikes that extended even to the artists he patronized.

As early as 1780, the king began to show signs of mental instability, which may have been caused by early senility, a condition known today as Alzheimer's disease. By the 1790s the condition had become debilitating. George III opened Parliament for the last time in 1805. From that point on, the Prince of Wales served in his stead, although he was not confirmed as prince regent until 1811.

After his accession George III appointed Allan Ramsay as his principal painter and commissioned a state portrait in coronation robes. A companion portrait of Queen Charlotte was done late in 1761, soon after the couple's marriage (see no. 63).

Ramsay spent much of his time producing copies of the royal portraits—with studio assistants filling in costume and background. There exist today some ninety-one known versions of the full-length portrait of the king, and innumerable half-length and head-and-shoulders versions. Not as many copies were made of the portrait of Queen Charlotte, although production was copious enough.

This pair of portraits was probably purchased from Ramsay by the king, for they were given to his fourth son, Edward Augustus, Duke of Kent and Strathearn, from whose estate they were eventually sold.

63
Portrait of Queen Charlotte Sophia

Studio of Allan Ramsay (1713–84), London, c. 1767
Oil on canvas, 246.4 x 160.0 (97 x 63)
Indianapolis Museum of Art, James E. Roberts Fund, 66.21a

Charlotte Sophia (1744–1818), the German-born niece of the Duke of Mecklenburg-Strelitz, was married to the new king, George III, in September 1761. As Queen Charlotte, she was a constant patron of London craftsmen and artisans throughout the 1760s—particularly of cabinetmakers and silversmiths.

The royal couple had four children. The eldest, George Augustus Frederick (1762–1830), Prince of Wales, became prince regent, and eventually George IV. The youngest, Edward Augustus, Duke of Kent and Strathearn (1767–1820), was the father of Queen Victoria, who came to the throne in 1837.

64 (See colour plate page 29.)
Queen Charlotte's Work Table

English, William Vile (died 1767), London, 1763
Mahogany and secondary oak, 80.0 x 97.2 (31½ x 38¼)
By gracious permission of Her Majesty The Queen

After his marriage to Charlotte Sophia in September 1761, George III purchased Buckingham House in London, and immediately began renovations and additions. The finest English cabinetmakers—Benjamin Goodison, John Bradburn, John Cobb, and William Vile—were commissioned to build furniture in the new "Chippendale" mode. Oddly enough, Thomas Chippendale himself seems not to have been among the cabinetmakers employed.

William Vile was then perhaps the most famous and fashionable English cabinetmaker. He received numerous orders for furniture from both the king and the queen, among them one for a writing table for Queen Charlotte's dressing room. The result was this magnificent block-carved work table with foliate relief decoration. The three-drawer table, on early castors, is of mahogany veneered over oak. The hinged top lifts to expose a shallow hidden well above the drawers.

William Vile favoured rococo styles. His furniture is known for superb design and proportion, as well as for precise craftsmanship and carving, though much of his carving was done by John Bradburn.

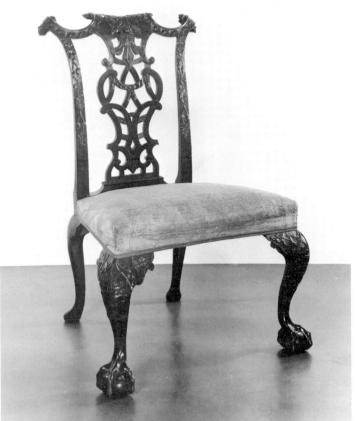

65

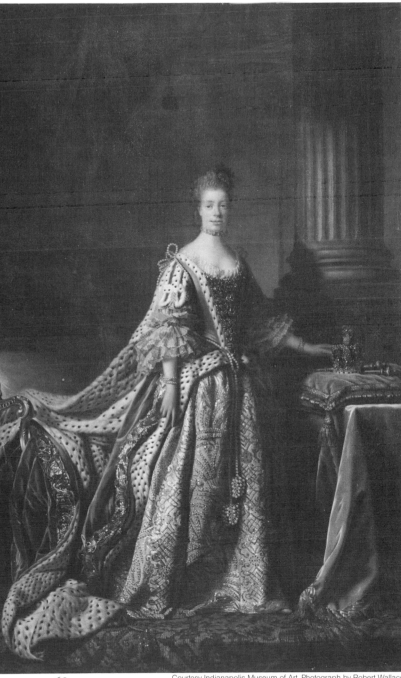

63

65
Carved Sidechair

English, c. 1750
Mahogany, 97.8 x 61.0 (38½ x 24)
Victoria and Albert Museum, London, W.24-1951

The epitome of the Chippendale chair form that emerged in the mid-18th century, this highly carved piece is one of a set of sixteen made for Lord Dovedale of Westwood Park, Droitwich. The back is formed in the typical Chippendale manner, with a central pierced and carved splat, a frame decorated with oak leaves and acorns, and uprights that terminate in substantial scrolls. The heavy cabriole legs, adorned with vine leaves, terminate in solid claw-and-ball feet.

This cabriole leg was the favourite form for English and colonial American chairs until about 1770. Then it began to be displaced by the simpler straight square "Marlborough" leg that is seen on later 18th-century Canadian examples.

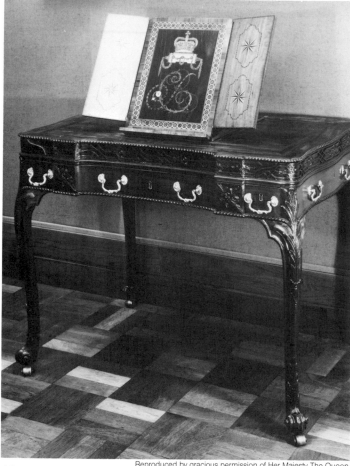

66

66
Queen Charlotte's Reading Stand

English, London, c. 1770–80
Veneered and inlaid oak, 40 x 61 (15¾ x 24)
By gracious permission of Her Majesty The Queen

This highly decorated adjustable reading stand, commissioned by Queen Charlotte, displays inlays of tulipwood, mahogany, sycamore, boxwood, purplewood, tortoise shell, and ivory—some stained and engraved. The hinged side-wings are ornamented with shaded stars, and the central surface with the queen's cipher, CR, under a crown, and a border design.

67 (See colour plate page 30.)
Tea-Kettle and Stand

English, marked by Thomas Heming, London, 1761–62
Silver-gilt, 38.1 (15)
By gracious permission of Her Majesty The Queen

The newly renovated Buckingham House needed not only furniture and pictures, but also quantities of silver, which was commissioned from the favoured and fashionable London makers—sometimes as single pieces and sometimes as large services. One of the most esteemed artisans was Thomas Heming, who received an order from Queen Charlotte for an ornate tea-kettle. The outcome was this rococo piece, with particularly fine shell feet on the separate base, which includes an alcohol burner. The kettle, engraved with the queen's cipher, has been at Buckingham House—later Buckingham Palace—and in use since it was made.

Thomas Heming had already produced a large coronation service for George III. By 1765 he was advertising himself as "Goldsmith to His Majesty".

THE CREATION
OF BRITISH CANADA

THE ROYAL PROCLAMATION OF 1763

The Proclamation of 1763 was in many ways Canada's first constitution. It provided for the creation of civil government, with a representative assembly, and English law, in the newly named Province of Quebec, whose western boundary was defined as a line running from Lake Nipissing to approximately the site of present-day Cornwall, Ontario. The formulators of the Proclamation were also motivated by a desire to appease the Indians around and west of the Great Lakes by granting them territorial guarantees. Further colonial settlement was prohibited west of a line along the headwaters of all rivers draining into the Atlantic from the Allegheny Mountains.

In spite of the provisions of the Proclamation of 1763, however, no representative assembly was formed in Quebec, and French civil law continued to be the rule of the day, along with English criminal law. To the Thirteen Colonies, the "Proclamation Line", stifling westward expansion, was another sour ingredient to be added to an already bubbling pot.

THE NEXT DECADE

Britain imposed a benevolent rule over her new French-speaking population of about sixty-five thousand. The stipulations of the surrender of New France—the maintenance of property rights, freedom of religion, and French civil law—had left the social structure of New France essentially intact. Seigneurs, senior clergy, and government officials were allowed repatriation to France, but there was no great exodus.

With the British army, and in its wake, had come an influx of British and colonial American merchants, who quickly began to dominate the western fur trade and the import and export trade. At first there was little friction, for the British merchants provided both a far greater supply of consumer goods and much broader markets for furs, lumber, and agricultural exports than had ever existed under the French regime. The British brought prosperity, and the English-speaking and French-speaking Canadians soon became economically linked and interdependent.

The English-speaking population in Quebec though small was growing. It comprised colonial American as well as British settlers, who soon came to resent the restrictions of military rule, and what they saw as Governor Murray's clique and his favouritism towards the French. Murray, in turn, detested the British merchants; he regarded them as "licentious fanatics", determined to destroy both his authority and the French cultural fabric. The clamour reached London and early in 1765 Murray, his military commander, the attorney general, and the chief justice were all recalled by the British secretary of state.

In mid-1766 Brigadier General Guy Carleton became the civil governor of Quebec. His appointment satisfied both the French-speaking and the English-speaking populations, and tranquillity again prevailed in Quebec—for a time. The American colonies to the south, however, had grown increasingly restive by the 1760s, and renewed war with France was always a possibility. Carleton saw a need to strengthen Quebec, which meant securing the loyalty, cooperation, and support of the "new subjects", who could, he felt, provide an army of eighteen thousand men if necessary. The allegiance of seigneurs and clergy seemed to be the key to that support, and to the security of Canada.

The Proclamation of 1763 had stressed the introduction of English law and an elected assembly, with the idea in mind that English-speaking settlers would quickly flood in. When they failed to do so, Carleton became an advocate of the theory that the French Canadians would feel most secure and be most supportive of colonial government with a return to the semi-feudal autocracy, state church, and civil law of the French regime.

Carleton returned to England in 1770 to press his case. Although the British Parliament was far more concerned with the Thirteen Colonies, Carleton achieved his goal with the passage of the Quebec Act in 1774.

THE QUEBEC ACT OF 1774

The Quebec Act, which was largely Carleton's achievement after four years' effort, recognized the shortcomings of the Proclamation of 1763. It essentially reversed the earlier provisions designed to create uniformity among all North American colonial governments—uniformity based on English institutions. According to the new act, Quebec reverted substantially to the

traditions of the French regime, and to rule by governor and appointed council rather than by elected assembly. The act guaranteed the Roman Catholic religion and the primacy of the church, French property and civil law, the privileges of seigneurs, and the system of feudal land tenure.

This combination of authoritarian government and established Catholicism just beyond their borders did not sit well with the New England colonies. Moreover, by the terms of the act all of the west, from Lake Superior south to the junction of the Mississippi and Ohio rivers, was annexed to Quebec. The colonies saw this as another move to confine their settlement to the eastern coastal plain.

To the Thirteen Colonies, already on the verge of war, the Quebec Act was the final straw. Carleton had also overestimated the effect of the act in securing French Canadian loyalty. In fact many French Canadians resented its terms, and while they did not join the American Revolution, they were at best hardly spirited in defence even against American invasion.

Segment of the manuscript of the Royal Proclamation of 1763. Public Record Office, London

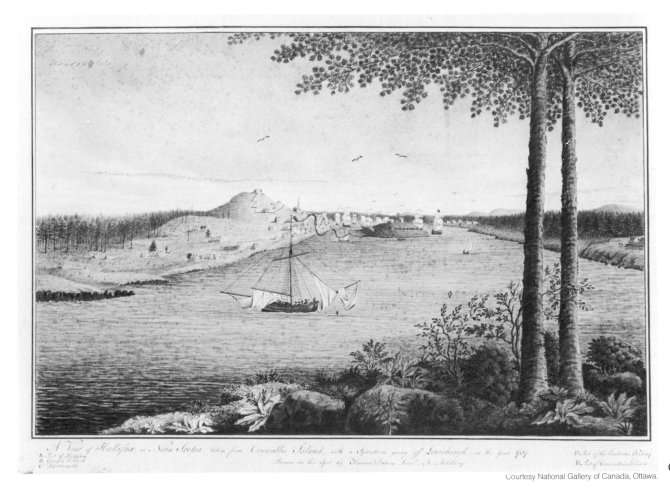

68

68
A View of Halifax, 1757

Inscribed and signed by Thomas Davies (1737?–1812), Halifax, 1757
Watercolour on paper, 38.1 x 51.1 (15 x 20⅛)
National Gallery of Canada, Ottawa, 6268

This painting—the earliest known watercolour by Thomas Davies and one of the earliest views of Halifax—was done during Davies' first summer in Canada. An artillery lieutenant, Davies commanded a small bomb vessel mounting a sixteen-inch mortar. The vessel was to take part in a planned attack on Louisbourg in 1757, which was later postponed for a year.

The inscription on the watercolour reads " A View of Hallifax in Nova Scotia, taken from Cornwallis Island, with a Squadron going off [to] Louisburgh in the Year 1757. Drawn on the Spot by Thomas Davies Lieut: R. Artillery."

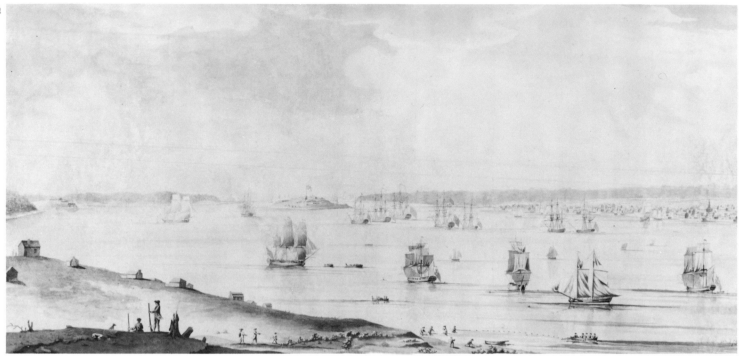

68a
A View of Halifax, 1757

Signed by Benjamin Garrison, Halifax, 1757
Black and grey wash on paper, 36.3 x 64.4 (14¼ x 25⅜)
Royal Ontario Museum, Canadiana Department, Sigmund
Samuel Collection, 950.66.5

This scene of Halifax, showing the fleet forming in the harbour
for the planned expedition against Louisbourg in 1757, was done
from the Dartmouth shore, with Halifax in the right background.
The inscription, "View of Halifax taken in July, 1757", indicates
that the drawing was executed immediately after the fleet arrived
from England.

Benjamin Garrison, though not known as an army or a navy
officer, was obviously well trained in the British school of marine
watercolour painting. The scene clearly stems from personal
observation, not from others' sketches.

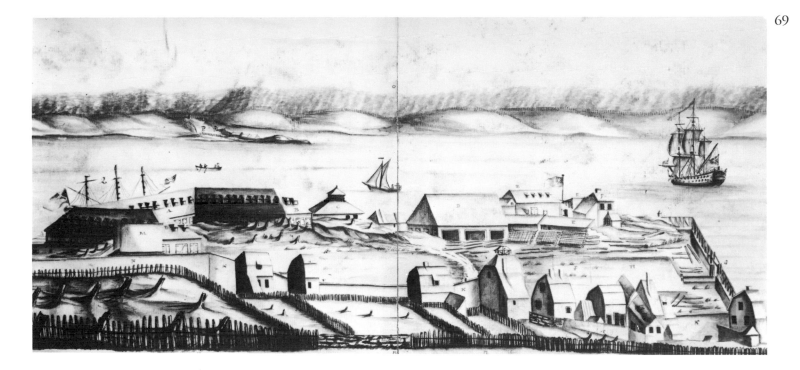

69
A View of His Majesty's Dockyard at Halifax

Artist unknown, Halifax, c. 1760
Ink and wash on paper, 21.9 x 36.0 (8⅝ x 14⅛)
Royal Ontario Museum, Canadiana Department, Sigmund
Samuel Collection, 958.97

Halifax, founded in 1749 as a British naval base to counter
French Louisbourg, was by 1760 a thriving garrison and navy
town. Louisbourg no longer posed a threat to British Nova
Scotia; the fortress had been captured in 1758 and was in the
process of demolition.

The inscription on the drawing reads "A View of His Majesty's
DockYard at Halifax, Nova Scotia, May 21th, 1760." It also
identifies specific buildings in the town.

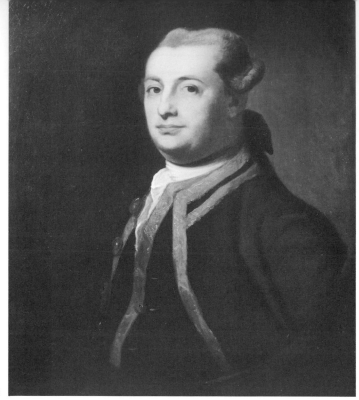

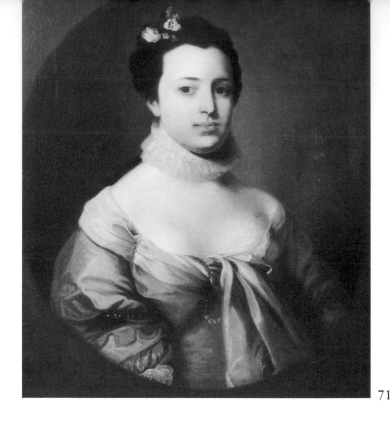

70
Portrait of Michael Francklin

Attributed to John Singleton Copley (1738-1815), Boston,
c. 1762-70
Oil on canvas, 76.2 x 63.5 (30 x 25)
Royal Ontario Museum, Canadiana Department, Sigmund
Samuel Collection, 957.242.1

Michael Francklin (1720-82) was born in England, but came to
Halifax in 1752 as one of the early independent immigrants. In
Nova Scotia he became a successful merchant and a public
figure; he served in the house of assembly, as a justice of the
peace, and on the governor's council. In 1766 Francklin was
appointed lieutenant governor of Nova Scotia. Three years later
the appointment was extended to Prince Edward Island, when it
became a separate colony. Francklin held both offices until 1776.

John Singleton Copley, probably the finest American portrait-
ist of the colonial period, was born and trained in Boston, where
he opened a studio about 1755. It was there that he painted the
portraits of Michael Francklin and his wife, Susannah (see no.
71). As the threat of war grew, Copley, like Gilbert Stuart
(1755-1828), left Boston for England. Unlike Stuart, Copley
remained in England, where his son eventually became lord
chancellor.

Since Copley's practice was to paint his subjects with at least
one hand showing (see no. 81), it is very likely that these canvases
have at some point been reduced from a larger format.

71
Portrait of Susannah Francklin

Attributed to John Singleton Copley (1738-1815), Boston,
c. 1762-70
Oil on canvas, 76.2 x 63.5 (30 x 25)
Royal Ontario Museum, Canadiana Department, Sigmund
Samuel Collection, 957.242.2

Susannah, the daughter of an Acadian, Joseph Boutineau, was
born in Nova Scotia. She married Michael Francklin in 1762,
and over the years bore him five sons and five daughters.

Pairs of portraits of husband and wife were often commissioned
in the 18th century (by patrons who could afford them). It is very
likely that the Francklins sat for Copley in Boston shortly after
their marriage.

72

Block-Front Lowboy

American, Boston, c. 1735–50
Walnut, 80.0 x 85.1 (31½ x 33½)
The Dietrich Brothers Americana Corporation, Philadelphia,
8.2.1.909

The lowboy, which was generally used as a dressing table or a small sideboard, emerged as a specifically American design in the early 18th century. The type was later made in British Canada.

This elegant lowboy represents probably the earliest New England block-front form, as well as the rarest. The case encompasses six drawers in two rows. The drawers on the left and the right have convex block-carved fronts; the centre ones have concave fronts. The cabriole legs of the piece are unusually delicate and finely proportioned. Two other similar examples are known, though the maker remains unidentified.

Block-carving of case and drawer fronts to form serpentine curves—instead of the more complex method of steam-bowing—was a technique widely used by French Canadian cabinetmakers throughout the 18th century. Later on, cabinetmakers in the Maritimes also adopted the block-carving method.

72

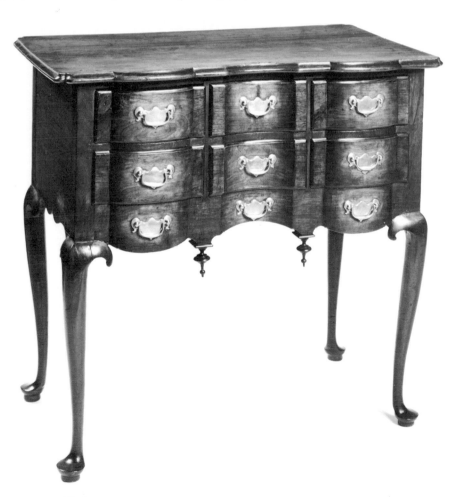

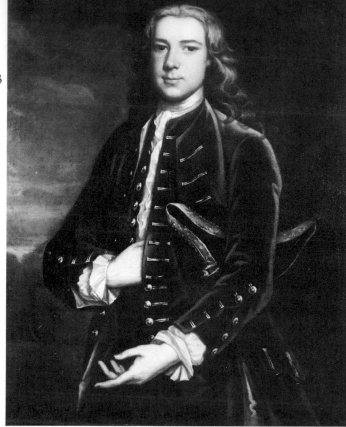

73

73
Portrait of James Monk, Sr

Signed by John Wollaston (c. 1710–67), probably New York,
dated 17?3
Oil on canvas, 91.4 x 71.1 (36 x 28)
Private collection

James Monk (c. 1700–1765) was one of the earliest independent
immigrants to British Canada. He came to Halifax from Boston
in 1749, the very year Halifax was founded. Although his
background is somewhat obscure, it is known that he was with
Pepperrell's expedition against Louisbourg in 1745 (see nos. 13,
14). In November of that year Governor William Shirley of
Massachusetts appointed Monk commissary general of the
American garrison at Louisbourg. Monk later became first
solicitor general of Nova Scotia. His son James, Jr (see no. 241)
served a long term as chief justice of the Court of King's Bench in
Montreal.

John Wollaston, who was born in England, first appeared in
the American colonies between 1747 and 1749. He painted in
New York and then in Virginia and Maryland, until his departure
for India in 1759. Although little is known of his life, he was a
very prolific painter; some three hundred of his American-period
portraits are known.

74
An East View of Montreal

Thomas Patten, Montreal, c. 1761
Watercolour on paper, 27.3 x 50.1 (10¾ x 19¾)
Royal Ontario Museum, Canadiana Department, Sigmund
Samuel Collection, 956.198

This view of Montreal, done shortly after the capitulation of the
city to the British in 1760, was drawn from shipboard. In 1762
the watercolour was engraved and published in London by
Thomas Jefferys as *An East View of Montreal in Canada.*

Thomas Patten, who was obviously trained in the military
school of watercolour painting, accompanied General Jeffrey
Amherst's army through the Montreal campaign of 1760, but
little else in known about him.

75
A View of Montreal, 1762

Inscribed by Thomas Davies (1737?–1812), Montreal, 1762
Watercolour on paper, 35.4 x 53.7 (14 x 21⅛)
National Gallery of Canada, Ottawa, 6272

By 1762 Davies had been posted to Montreal. He had also
become more proficient in painting artistic landscapes that went
beyond the purely topographical renderings for which he had
been trained. The foreground subject in this picture—the couple
resting under trees on Île Sainte-Hélène—exemplifies accepted
18th-century picturesque style.

Among the well-defined buildings in the walled city in the
background are the Recollet church, the convent of the Grey
Nuns, and the fort. The inscription reads "A View of Montreal in
Canada Taken from Isle St. Helena in 1762."

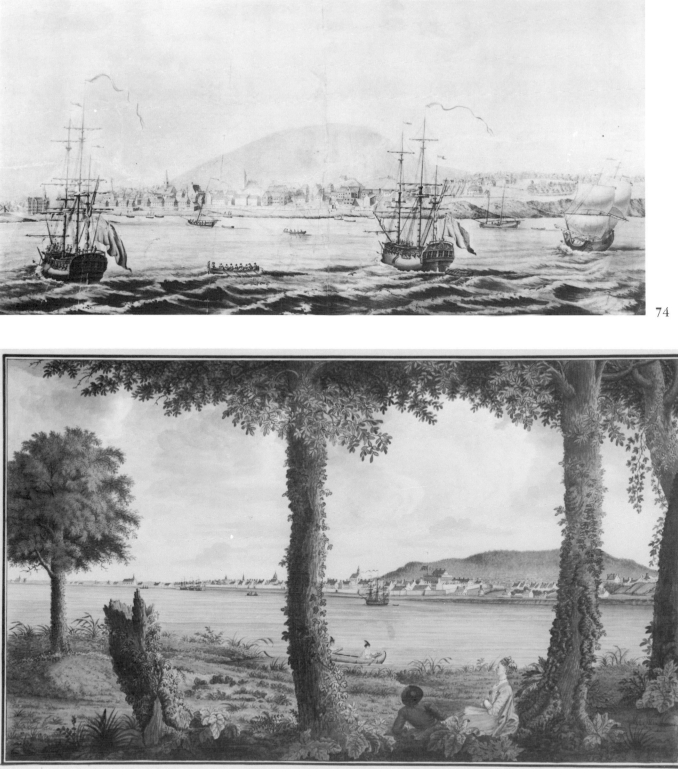

74

75

75a

76

98

75a
A View of Annapolis Royal

J. F. W. DesBarres (1722–1824), Nova Scotia, 1763–73
Aquatint and watercolour, 27.9 x 48.4 (11 x 19)
Royal Ontario Museum, Canadiana Department, Sigmund
Samuel Collection, 960x278.11

After its capture by the British in 1710, the French settlement of
Port Royal was renamed in honour of Queen Anne. This view of
Annapolis Royal, done more than fifty years later, is one of the
many illustrations engraved and hand coloured for DesBarres'
Atlantic Neptune, a compilation of his great collection of charts
and plans, published in four volumes issued between 1774 and
1779.

Joseph Frederick Wallet DesBarres was born in Switzerland,
but was educated and learned to draw at the Royal Military
Academy in Woolwich, England. After service with the British
army in North America during the Seven Years' War, DesBarres
spent a decade surveying and charting the coasts and harbours of
Nova Scotia and Cape Breton Island. The gratifying results of his
labours are to be seen in *The Atlantic Neptune*, his lasting
monument.

76
Drop-Leaf Table

Canadian, Quebec, probably Eastern Townships, c. 1760–80
Maple and birch, 71.7 x 116.8 (28¼ x 46)
Royal Ontario Museum, Canadiana Department, gift of Miss
Helen Norton, 957.134

Very little furniture derived from English styles seems to have
been made in British North America during its first few decades.
The early English-speaking populations depended on imported or
homemade furniture.

This drop-leaf table, with a round top and two swing legs, is
one of three similar examples known. The club-footed cabriole
legs and extended scalloped-end aprons make the design form
more typical of earlier New England furniture of the Queen
Anne period. The table may well have been produced by a
colonial American carpenter or cabinetmaker who migrated
independently into the area of the Eastern Townships after 1760.

Courtesy National Portrait Gallery, London.

77

77
Portrait of General James Murray

Artist unknown, c. 1770–80
Oil on canvas, 127.0 x 101.6 (50 x 40)
National Portrait Gallery, London, bequest of E. R. B. Murray,
3122

James Murray (1721–94), one of Wolfe's three brigadiers,
assumed command of the British forces at Quebec late in 1759.
Within a year he was appointed military governor of Quebec,
under Jeffrey Amherst as commander of British forces in North
America. After the Proclamation of 1763 Murray became the
first British civil governor of the province.

Murray's conciliatory attitude towards the French Canadians
became increasingly irksome to the British and American
merchants who settled in Quebec after 1760. Two years after his
appointment as civil governor, Murray was recalled to London to
face an inquiry (he was replaced temporarily by Paulus Irving,
and then by Guy Carleton). Although he was exonerated of all
charges against him and remained titular governor of Quebec
until 1768, Murray did not return to Canada.

78
Demi-Lune Card Table

English, c. 1740–60
Mahogany, 74.5 x 84.5 (29⅜ x 33¼)
Royal Ontario Museum, European Department, gift of the
W. Garfield Weston Charitable Foundation, 971.146.4

As a form, the card or games table, with a fold-over top and one or two swing legs for support, was English in origin, but it was also commonly made in North America throughout the 18th century and well into the 19th. In an age without television and other modern pastimes, the games table was an essential piece of furniture; many examples survive.

This table has a folding top that is round when extended, and a deep skirt whose lower applied edge is carved with oblique gadroon ornaments. The cabriole side leg and back swing legs end in simple club feet. Only the front leg has a foliate-carved knee and more elaborate claw-and-ball foot.

79

78

79
Portrait Miniature of General Guy Carleton

Artist unknown, English, c. 1771–74
Oil on ivory, 5.7 x 5.5 (2¼ x 2⅛)
Royal Ontario Museum, European Department, gift of Helen
A. Boomer and Jessy I. Boomer, 935.23.1

Guy Carleton (1724–1808) was not a regular sitter for portraitists, and as a consequence few renditions of him exist from life. This very well-executed but unsigned miniature was painted in London, probably in the early 1770s. Carleton, who was then governor of Quebec, was in England at the time, lobbying and pressuring for the drafting and passage of what became the Quebec Act of 1774, which was designed to improve relations between the English-speaking and French-speaking Canadians.

EXPLORATION
AND CARTOGRAPHY

No nation has been more assiduous than Britain in exploring and charting the world's oceans and waterways. Although the science of hydrography had advanced slowly, the mid-18th century saw the beginning of a period of great activity, made possible by Britain's development of superior navigational equipment. In the drive to increase knowledge of navigation, which was vital to the nation's military and commercial interests, ships of the Royal Navy circumnavigated the globe.

Each new addition to the Empire was followed by extensive studies, but not only British possessions were examined and plotted. The coasts and harbours of Britain's enemies, or potential enemies, were also subjected to rapid "running surveys". Just such a reconnaissance of the St Lawrence was made by James Cook—under enemy fire—in advance of the arrival of the British fleet off Quebec in 1759. St Pierre and Miquelon were not returned to France after the Seven Years' War until Cook, aboard HMS *Tweed*, had surveyed them and established the existence of a third island.

The 18th-century land and marine explorers of Canada's coasts— men such as James Cook, John Montresor, Samuel Holland, Frederick DesBarres, and George Vancouver—explored, sounded, plotted, and sketched. Without benefit of aerial surveys or computers, they often produced charts so accurate that many modern ones are based on them, with only minor corrections.

Before the mid-19th century, British marine maps and charts were highly individualized, and often decorative. Included in colourful renditions were views of landfalls, headlands, and entrances to harbours or bays, often embellished with shoreline buildings or fortifications.

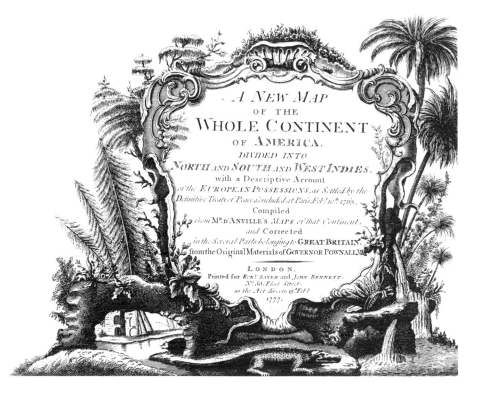

80

80
Celestial Globe

English, Benjamin Martin (1704–82), London, c. 1765
Mahogany, brass, and paper, 88.9 x 90.2 (35 x 35½)
Harvard University Collection of Historical Scientific Instruments, Cambridge, Massachusetts, gift of Jonathan Belcher

This celestial globe on its finely carved frame was produced by Benjamin Martin, one of the best instrument makers in London in the 1760s. The globe is one of a pair given to Harvard College in 1765 by Jonathan Belcher (1710–76), an early alumnus.

Jonathan Belcher, the son of a governor of Massachusetts, studied law at Harvard (Class of 1728). In 1754 he was appointed chief justice of Nova Scotia and a member of the colony's executive council. On the death of Governor Charles Lawrence in 1760, Belcher became temporary chief administrator and a year later was made lieutenant governor of Nova Scotia.

Harvard Hall in Cambridge was destroyed by fire in 1764, and with it the library and all the scientific apparatus. As a consequence, Jonathan Belcher ordered from Benjamin Martin "a pair of 28 inch globes [one terrestrial, one celestial] in mahogany, carved frames with silvered and lacquered meridians, etc.", which he presented to the college.

81

81
Portrait of Colonel John Montresor

John Singleton Copley (1738–1815), Boston, c. 1771
Oil on canvas, 76.2 x 63.5 (30 x 25)
The Detroit Institute of Arts, Founders Society Purchase, Gibbs-Williams Fund, 28.144

John Montresor (1736–99) was the son of a military engineer, James Gabriel Montresor (1702–76). Both father and son served with General Edward Braddock's ill-fated expedition into Pennsylvania in 1755. John Montresor was also at the sieges of Louisbourg and Quebec, and he spent the next fifteen years surveying, mapping, and planning fortifications in Quebec, Boston, New York, and Philadelphia. He was appointed chief civil engineer for North America in 1775, but returned to England three years later.

John Montresor sat for Copley in Boston about 1771, when the artist was at the zenith of his skill and reputation in his American period. The result was this strong portrait.

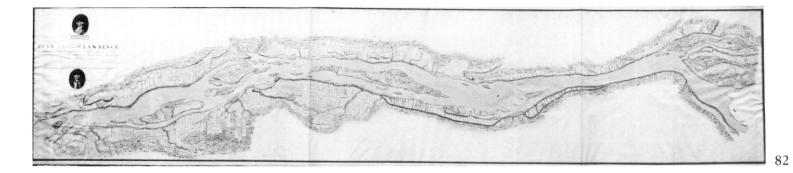

82

82
Plan of the River St Lawrence from Montreal to the Parish of Berthier...

Lieutenant John Montresor (1736–99) and Captain Samuel Holland (1728?–1801), Montreal, c. 1760–63
Ink and watercolour on paper, 65.4 x 311.7 (25¾ x 122¾)
Royal Ontario Museum, Canadiana Department, Sigmund Samuel Collection, 960x281.23

Immediately after the fall of New France in 1760, the British commander in chief, General Jeffrey Amherst, ordered a survey of the St Lawrence River between Montreal and Quebec. The survey, carried out by John Montresor and Samuel Holland, resulted in a series of fine manuscript charts. This one includes shoreline markings and landmarks, as well as coloured medallion portraits of James Wolfe and Jeffrey Amherst, probably done by Montresor.

The accuracy of the chart is a tribute to the excellence of British survey techniques and cartography in that period. Except for the addition of recent aids to navigation, modern charts are little changed.

83
Surveyor's Plane-Table Compass

American, B. Platt, Columbus, Ohio, c. 1820
Brass, 38.1 x 20.5 (15 x 8⅛)
Royal Ontario Museum, Canadiana Department, 970.342

The plane-table compass was, and in fact still is, used for rough land surveys and direction finding. With the compass mounted in a level position on a tripod or a staff, sightings taken through the upright bars make it possible to determine the exact direction from one point to another. While the instrument is not as accurate as a transit or a theodolite, it is considerably faster to use. Smaller hand-held versions remain standard equipment for campers and hikers today. Made in Columbus, Ohio, this instrument was used for early 19th-century land surveys in Upper Canada.

83

84

85

84
Surveyor's Sextant
English, Thomas Jones (1775–1852), London, c. 1820–30
Brass, 30.5 x 20.3 (12 x 8)
Royal Ontario Museum, Canadiana Department, gift of Mrs
Owen Strickland, 925.32

A land instrument analogous to the marine sextant (see no. 87),
the surveyor's sextant was mounted on a tripod and used in
terrestrial surveys to obtain precise readings of latitude and
longitude.

This sextant, engraved with the maker's name and address,
Thomas Jones, 62 Charing Cross, London, belonged to Captain
Richard Vidal of the Royal Navy, who came to Canada in 1834
and settled in Sarnia. It was later used by Vidal's son Alexander,
who held the position of provincial land surveyor from 1843 to
1853. In 1873 Alexander Vidal was appointed to the Canadian
Senate, in which he served until his death in 1906.

85
Davis Quadrant or Backstaff
English, early 18th century
Brass and boxwood, 62.2 (24½)
Royal Ontario Museum, Canadiana Department, bequest of
William Eason Humphreys, 958.9.1

The Davis quadrant was the standard navigational instrument of
the 17th and early 18th centuries. It was first designed about
1595 by Captain John Davis, or Davys (1550?–1605), an English
navigator and Arctic explorer, whose name was given to the
channel between Baffin Island and Greenland. The Davis
quadrant was still in use to some extent in the 19th century. A
simpler version of it was in fact part of the survival kit in life rafts
during World War II.

86
Hadley Quadrant

English, marked by Spencer, Browning, and Rust, London,
c. 1790–1810
Ebony, bone, and brass, 33.7 (13¼)
Royal Ontario Museum, Canadiana Department, bequest of
William Eason Humphreys, 958.9.2

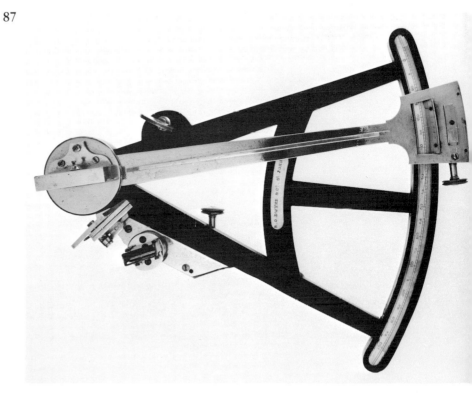

The Hadley quadrant, or octant, the prototype of the modern
sextant, was developed by John Hadley (1682–1744) in England
in 1732. Hadley also developed the first practical reflecting
telescope.

Although the Hadley quadrant became standard equipment
for most Western navigators, it was superseded within a few
decades. Very soon after its invention, the adoption of the
lunar-distance system for determining longitude created a need
for an instrument capable of sighting angles greater than ninety
degrees. Captain John Campbell of the Royal Navy developed a
more advanced instrument—essentially the modern sextant—
about 1757. The quadrant, however, remained in use for many
years. This example dates from the turn of the 19th century.

87
Sextant

English, c. 1790–1810
Ebony and brass with ivory scales, 27.9 (11)
Royal Ontario Museum, Canadiana Department, 958.11.2

This Campbell sextant, of the type that became standard in the
late 18th century, is English in origin. It may have been made by
Spencer, Browning, and Rust, a firm known to have sold
instruments wholesale to dealers, for it is one of the few known
early navigational devices to bear a Canadian marking: "R.O.
Dwyer & Company, St. Johns". The name was probably that of a
Newfoundland dealer in marine supplies.

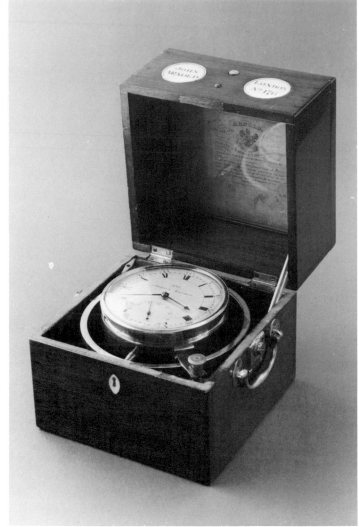

Courtesy Vancouver Maritime Museum.

88
Chronometer of George Vancouver

English, John Arnold (1734–99), London, 1791
Brass, mahogany case, 19.7 x 18.4 (7¾ x 7¼)
Vancouver Maritime Museum, purchased through a grant from the Ministry of Communications

The marine chronometer, a highly accurate and well-balanced shipboard clock, was one of the great technological innovations of the 18th century. An instrument that told the exact time at last allowed navigators to determine longitude with considerable precision. This chronometer by John Arnold was made on Admiralty order for George Vancouver (1758?–98), just before Vancouver departed in 1792 to explore the northwest coast of North America.

Vancouver, in fact, was charged with a twofold mission: to claim the territory at Nootka Sound that had been assigned to Britain by the Nootka Convention in 1790, and to explore and survey the North Pacific Coast. It was Vancouver who first sighted the currently active volcano that he named Mount St Helens, in honour of Alleyne Fitzherbert, Baron St Helens, who had adjudicated the dispute between Britain and Spain for claim to Nootka Sound. Vancouver's own name was given to the present-day city in British Columbia and to the island. The journals of Vancouver's surveys and explorations between 1792 and 1794 were published in 1798, in three volumes with an atlas.

After Vancouver's death his chronometer passed to Commander Matthew Flinders, an English explorer who circumnavigated Tasmania and surveyed parts of the coast of Australia. It later was issued to Captain William Bligh, who though remembered chiefly for the mutiny aboard his ill-fated *Bounty* went on to become governor of New South Wales.

John Arnold, who had apprenticed as a watchmaker under his father, established his own business about 1760. Among the many notable commissions he received were one for a watch for George III and three for chronometers for Captain James Cook. Although all three Cook chronometers failed, Arnold became the major English maker of the instruments, with a factory in Essex. The fact that George Vancouver requested one for his Pacific voyages indicates the high regard for Arnold's chronometers in the late 18th century.

89
Statue of Captain James Cook

English, John Tweed (1869–1933), late 19th century
Bronze, 92.7 x 34.3 (36½ x 13½)
Royal Ontario Museum, Canadiana Department, Sigmund
Samuel Collection, 951.53

This striking bronze of James Cook (1728-79)—holding navigators' dividers in his right hand and a telescope in his left—is probably a trial casting. It appears to be a preliminary statue, cast by John Tweed for Gervase Beckett, to serve as a model for the much larger statue of Cook that stands on West Cliff overlooking Ursk harbour in Whitby, the English port where Cook first apprenticed as a seaman.

The explorations and surveys that provided so much new knowledge brought Cook international esteem. During the American Revolution, Benjamin Franklin ordered that any American warship encountering Cook's vessels should consider them friendly neutrals rather than belligerents, and should not impede their progress. In 1777 the French navy was issued similar orders.

The journals of Cook's epic journeys of 1772 through 1775 were published in 1777 in two volumes, with the title *A Voyage Towards the South Pole and Round the World.* By the time the volumes were issued, Cook had already departed on his fateful last expedition, which ended with his death in the Hawaiian Islands in 1779.

John Tweed was a noted English portrait sculptor whose works include numerous monuments and war memorials in Britain. Tweed trained in Glasgow, London, and Paris, where he became a friend of the renowned French sculptor Rodin.

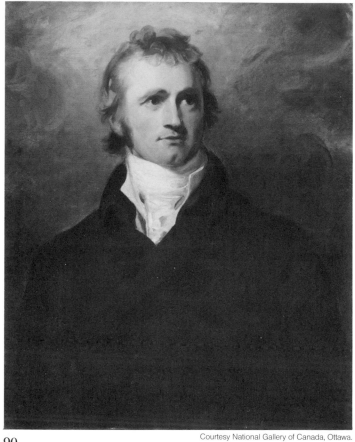

90

90
Portrait of Sir Alexander Mackenzie

Sir Thomas Lawrence (1769–1830), London, c. 1800–1802
Oil on canvas, 76.3 x 64.0 (30 x 25¼)
National Gallery of Canada, Ottawa, Canadian War
Memorials Collection, 8000

Alexander Mackenzie (1764–1820), fur trader and western explorer, was born in Scotland but emigrated to New York with his father at the age of ten. After his father died during the American Revolution, Alexander settled with his Uncle John in Glengarry County, Ontario. In 1788, as a partner in the recently formed North West Company, Mackenzie went to supervise the Athabaska fur-trading district. The following year he set out with a small party to try to find a route to the Pacific. The expedition discovered the river that now bears Mackenzie's name and travelled down it only to find the Arctic Ocean at its mouth. It was not until 1793 that Mackenzie made the famous journey that led him to the Pacific. In 1799 he went to England, where he published the account of his journeys and was knighted. Three years later he returned to Canada to take up a partnership in the XY Company, another fur-trading enterprise, but in 1808 he departed for Scotland.

Thomas Lawrence, although largely self-taught, became the most fashionable London portraitist of his period and introduced a new romantic style in the 1780s. Lawrence succeeded Sir Joshua Reynolds as principal painter to the king in 1792, became a member of the Royal Academy of Arts in 1794, and was knighted in 1815. He enjoyed a distinguished career, exhibiting regularly at the academy, and received many commissions from George III and later from the prince regent.

THE AMERICAN REVOLUTION
1775-1783

The American colonies had been rumbling with discontent since before 1748 and over the next two decades they grew militant. The situation became explosive during the 1770s, when isolated incidents of violence flared up—the Boston Massacre in 1770, the burning of the British revenue cutter *Gaspé* in 1772, and the Boston Tea Party in 1773. The increasing radicalism of the colonies, pitted against the continuing stubbornness of George III, finally erupted in armed conflict at the battles of Lexington and Concord, Massachusetts, on 19 April 1775. The American siege of British-occupied Boston followed.

Although most French Canadians resented the terms of the Quebec Act, only a few hundred actually went south to join the Revolution. On the other hand, there was no surge of support for Guy Carleton's government; his calls for militia enlistments received at best a weak response. The French Canadians for the most part remained neutral; *anglais* versus *anglais* was not their affair.

Nova Scotia, unlike Quebec, was English-speaking; its population of about seventeen thousand was largely comprised of New Englanders who had gradually settled there ever since 1713. Because the population was scattered in isolated settlements, Nova Scotia was less self-sufficient than the older American colonies, and far more dependent economically on Britain. Thus in spite of strong kinship ties with the colonies, there was little inclination to join the Revolution. There was also no serious American effort to draw Nova Scotia into the conflict; George Washington, in fact, opposed an invasion. Except for privateering, which was considered honest sport, Nova Scotia remained neutral and raised no threat to British control.

The New England colonies and French Canada had been engaged in periodic warfare and constant settlement-raiding for nearly a century. With old enmities lingering, an American invasion of Quebec was quite predictable. The Continental Congress of October 1774 had protested the Quebec Act with its reestablishment of official Catholicism and authoritarian government. When the French Canadians failed to rally to appeals to join the Revolution, Congress finally authorized an invasion in June 1775.

Governor Guy Carleton, who had sent two regiments to reinforce besieged Boston, was left with only some six hundred British troops in Quebec. Although his instructions were to raise six thousand militia, he was able to gather only a few hundred. General George Washington, who had been appointed commander in chief of Continental forces, however, was no better able to spare troops for an assault. Moreover, the colonies lacked sea power, and the St Lawrence River remained open to British reinforcements.

Ticonderoga fell to Continental forces in May 1775, St Jean, Quebec, on 2 November, and Montreal on 12 November. In a winter campaign, General Benedict Arnold led fourteen hundred men overland through Maine to Quebec—only half made it—while General Richard Montgomery marched east from Montreal with about three hundred troops.

In early December the combined army of about a thousand men, without heavy artillery or proper shelter, laid siege to Quebec, which was defended by Carleton and some eighteen hundred mixed troops. On 31 December, Montgomery mounted a surprise pre-dawn assault. He himself was killed in the encounter, and half of the besieging force was either killed or captured. The siege of Quebec was reinforced and continued through the winter, but the arrival of a British fleet in May 1776 compelled the Americans to retreat. The retreat ended any major military threat to Canada, though Carleton was too slow in pursuit to accomplish a real victory.

The following year saw the invasion of the American colonies from Canada. A mixed British and German army of about six thousand, under General John Burgoyne, proceeded south by the old Lake Champlain route. The plan called for Burgoyne's force to link up with an army under General Sir William Howe, which was to march north from New York. The objective was to sever New England from New York and the southern American colonies. When Howe failed to move in support of the campaign, Burgoyne was left to face some eighteen thousand Continental troops under General Horatio Gates. On 17 October 1777 Burgoyne surrendered his army near Saratoga, New York.

Saratoga was the decisive battle of the American Revolution, for the victory gave credibility to the Continental cause and brought France into the war on the American side. While the war

continued for another four years, it was already over as far as Canada was concerned. The threat of external invasion was not to occur again until 1812.

France came into the American Revolution more through enmity for Britain than in support of the Americans. Many Americans, in fact, were suspicious of their old enemy, who for a century had launched raids on their frontiers. The entry of France at first made the Canadian position appear perilous, but Canada's safety was really assured more by international power politics than by any inability of the Americans to invade again.

A joint French-American invasion was planned for 1778, but it was vetoed by Washington, who had no wish to see Canada possibly become a French colony again. By 1780, when Washington was prepared to invade, the plan was quashed by the French, whose objective was to keep the United States weak and dependent on their support. That goal was easier to realize if Canada remained under British control.

The surrender of Lord Cornwallis at Yorktown, Virginia, in October 1781 brought the war to an end, but treaty negotiations went on for a year. Britain was nearly bankrupt and the war had become increasingly unpopular at home; she wanted to cut her losses. The French and Spanish, however, had ambitions as well. After months of manipulation, haggling, and recrimination, the Treaty of Paris was signed. It confirmed British recognition of the United States as an independent country, with an agreed and roughly defined Canadian-American border, much the same as the present boundary from the Atlantic Ocean west to Lake of the Woods. It has often been said that Canada was created by the American Revolution, which in many ways is quite true.

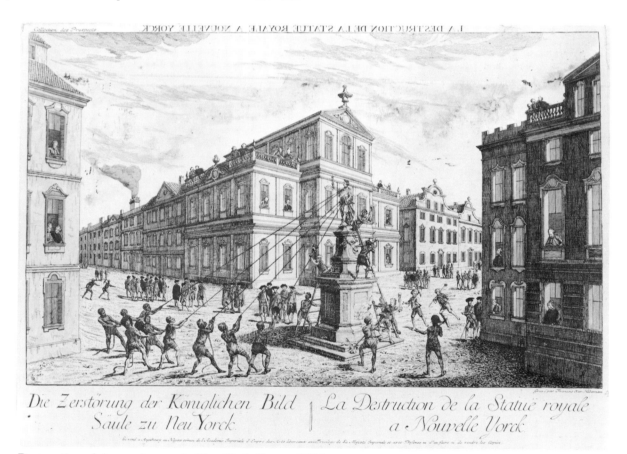

Die Zerstörung der Königlichen Bild Saule zu Neu Yorck. | La Destruction de la Statue royale a Nouvelle York.

Destruction of the royal statue in New York City, c. 1776.
Royal Ontario Museum, Canadiana Department, 949.150.17

91 (See colour plate page 30.)
Block-Carved Secretary-Desk

American, Goddard/Townsend School, c. 1760–70
Mahogany, 258.4 x 101.6 (101¾ x 40)
Museum of Fine Arts, Boston, gift in the name of Bernon E.
Helme and Nathaniel Helme, 40.790

Among the most elegant examples of colonial American furniture are the block-carved pieces made by the Goddard and Townsend families of Newport, Rhode Island. This secretary, on short cabriole legs with scrolled returns, is of the so-called "six-shell" type. Ten examples are known, all varying one from another.

In this piece, three shell carvings, two in relief and one intaglio, decorate the desk lid, with the motifs repeated on the upper bookcase doors. There are as well three intaglio-carved shells in the desk interior, one at the top of each compartment. The block and reverse-block carving occurs in the three drawers, the desk lid, and the bookcase doors; this technique was also used on some Boston and Quebec furniture (see nos. 40, 72). The broken-arch pediment with a single central finial was common on colonial American tall-case pieces, even on tall clocks.

Four generations of Goddards and Townsends—both Quaker families—were cabinetmakers in Rhode Island. Daniel Goddard was a carpenter. His sons John and James became cabinetmakers, as did three of their sons and one grandson. The enterprise grew into one of the largest cabinetmaking concerns in America, producing furniture until the early 19th century.

Three of John Goddard's sons emigrated as Loyalists to Nova Scotia, where one of them briefly listed himself as a cabinetmaker. However, no Nova Scotia Goddard furniture has ever been identified.

92
Salver or Platter

American, marked by Paul Revere II (1735–1818), Boston, 1761
Silver, 4.9 x 33.3 (1⅞ x 13⅛)
Museum of Fine Arts, Boston, gift of Henry Davis Sleeper in memory of his mother, Maria Westcote Sleeper, 25.592

This handsome silver salver, with a moulded edge and cast and applied scroll and shell ornaments, sits on three cast and applied cabriole legs. The engraved crest is that of the New England Chandler family. The salver was made as a wedding present for one of their brides, Lucretia Chandler (1728–68).

The famous silversmith Paul Revere II was apprenticed to his father, who died in 1754. At the age of nineteen the son was thus compelled to pursue his craft independently. Three years after his father's death, Paul Revere established a business in Boston. He flourished not only as a goldsmith and silversmith, but also as an engraver who produced book illustrations, trade cards, watchpapers, and labels (see no. 93). An ardent patriot, he became a legendary hero for his midnight ride in April of 1775 to warn the people of Massachusetts that the British soldiers were coming. After the war he practised as a silversmith and later as a copper and bronze founder.

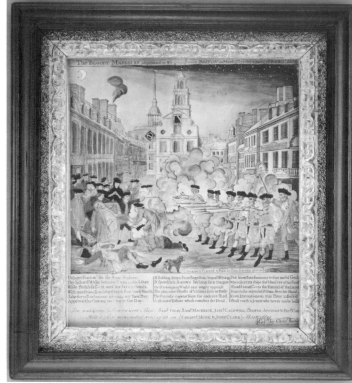

Courtesy Museum of Fine Arts, Boston.

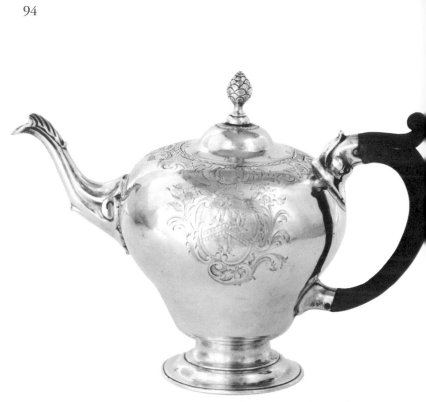

Courtesy Museum of Fine Arts, Boston.

93
The Boston Massacre

American, engraved and published by Paul Revere II
(1735–1818), Boston, April 1770
Line engraving, hand coloured, 24.4 x 21.9 (9⅝ x 8⅝)
Museum of Fine Arts, Boston, Centennial gift of Watson Grant
Cutter, 67.1165

Although best known as a silversmith, Paul Revere II was also a
prolific engraver. More than a hundred prints by him have been
identified. Among the most famous of them is *The Boston
Massacre*, which carries the inscription "THE BLOODY
MASSACRE perpetrated in King Street BOSTON on March 5th,
1770 by a party of the 29th REGT." In fact, Paul Revere himself
was not on the scene; his rather hasty engraving was copied from
an earlier one by Henry Pelham. This version, hand coloured by
Christian Remick (1726–73), is in its original carved frame.

Revere's print, which was published in several versions and in
large editions, had great news value and even greater propaganda
value. It is credited with helping to consolidate the determination
of the American colonies to be free of British domination.

94
Engraved Teapot

American, Paul Revere II (1735–1818), Boston, c. 1770
Silver, 17.1 (6¾)
Museum of Fine Arts, Boston, bequest of Mrs Beatrice
Constance (Turner) Maynard in memory of Winthrop Sargeant,
61.1160

This globular teapot, in the inverted pear shape popular in
England, is remarkably similar to the teapot Revere holds in the
famous portrait of him by John Singleton Copley. The teapot has
a pineapple finial and is engraved with the coat of arms of the
Reverend Jonathan Parsons (1705–76). The wooden handle
with scrolled grip was typical on teapots of this period.

95
Head of George III

English, c. 1765
Marble, 27.0 x 24.5 (10⅝ x 9⅝)
McCord Museum, McGill University, Montreal, gift of
E. W. Grey, M15885

When General Guy Carleton arrived to take up his post as lieutenant governor of Quebec in 1766, he carried in his cargo a full-figure standing marble statue of George III, a gift of the king to the city of Montreal. The statue was placed in the Place d'Armes. On 1 May 1775 a group of French Canadians sympathetic to the cause of the colonies in the American Revolution—or at least unsympathetic to British rule—painted the statue black, hung a string of potatoes around the neck, and put a mitre on the head. On the statue they then attached a French sign that translated "This is the Pope of Canada." Although a reward of one hundred guineas was offered, the miscreants were never caught.

In the spring of 1776, just as General Benedict Arnold's small American army was about to retreat to Lake Champlain, the statue was smashed and the pieces were dumped down a well. Throughout two generations the story of the statue remained alive and finally in September 1828 the head alone was recovered from the well.

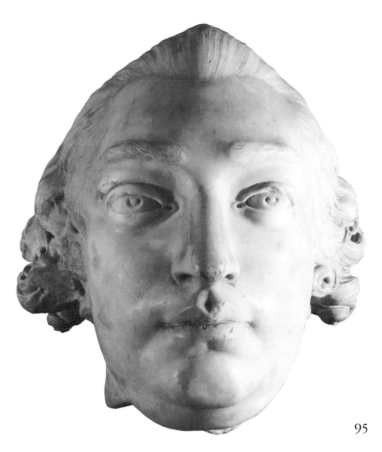

95

96
George Washington at the Battle of Princeton

Signed and dated by Charles Willson Peale (1741–1827),
Philadelphia, 1781
Oil on canvas, 241.4 x 155.4 (95 x 61⅛)
Yale University Art Gallery, New Haven, Connecticut, given
by the Associates in Fine Arts and Mrs Henry B. Loomis in
memory of Henry Bradford Loomis, B.A., 1875, 1942.319

George Washington (1732-99), commander in chief of the
Continental army during the American Revolution, and later the
first president of the United States, is perhaps the most renowned
figure in American history. Born in Virginia, he worked as a
surveyor until he was made a lieutenant colonel in the Virginia
militia. Although his first encounter with the French at Fort
Necessity in 1754 was a debacle (see no. 24), Washington served
with distinction during the Seven Years' War. He became a
leader of the opponents to British colonial policies and in 1775
was appointed to command the Continental forces.

This portrait was done by Charles Willson Peale from sketches
made in late 1776 and early 1777 during the battles of Trenton
and Princeton, New Jersey, which forced a British withdrawal to
New York. There are twenty-one known versions of the portrait.

Charles Willson Peale is perhaps best known for his portraits
of George Washington, who sat for the artist regularly over a
period of twenty years. Peale, however, was a diverse artist, who
was not only a painter of portraits, both full-size and miniature,
but was a proficient sculptor and engraver as well. He had studied
with Benjamin West in London; in fact, he was one of the first of
the stream of West's colonial American students.

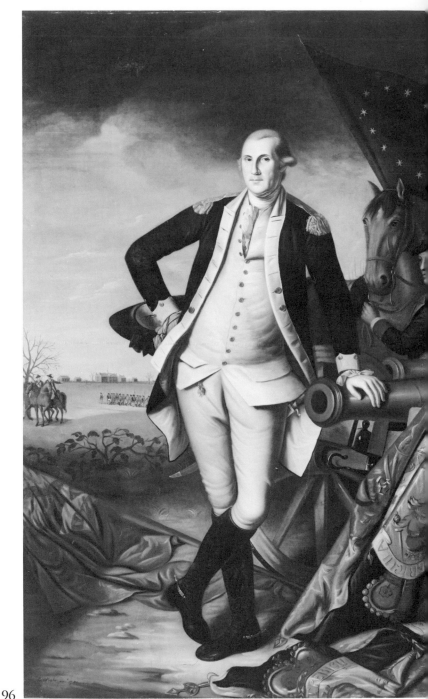

96

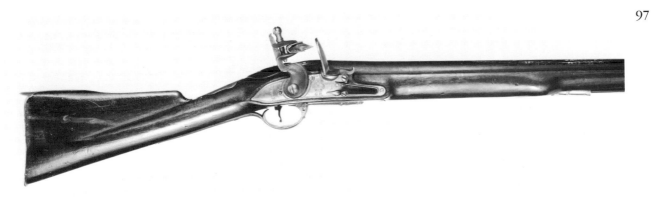

Courtesy Royal Canadian Military Institute, Toronto.

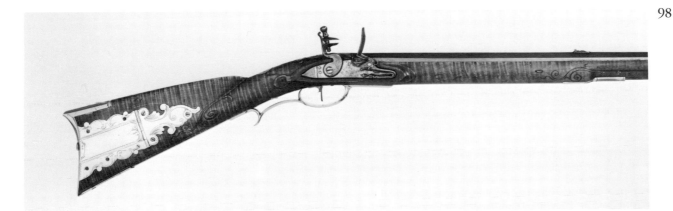

97
Flintlock Musket, Short Land Pattern

English, c. 1770–80
Steel, walnut stock, brass mounts, 146.7 (57¾)
Royal Canadian Military Institute, Toronto

The standard British infantry musket during the period of the American Revolution was a shortened version of the earlier Long Land Pattern "Brown Bess" (see no. 10). Except for a reduction in the length of the barrel from forty-six to forty-two inches, there was little substantive change in the new design. In fact, the older Long Land Pattern muskets remained in service in some regiments as late as the Napoleonic Wars (1796–1815).

98
Pennsylvania Flintlock Rifle

American, c. 1770–75
Steel, maple stock, 149.9 (59)
Royal Ontario Museum, European Department, 935.30.19

The American Pennsylvania rifle evolved in the colonies during the 18th century as a long-barrelled, muzzle-loading weapon with a small bore, usually of forty to fifty calibre. European muzzle-loading rifles were typically shorter and of larger calibre, but also had a limited effective range. The Pennsylvania rifle was accurate within a half-metre circle at a range of up to nine hundred metres.

The Pennsylvania rifle was used by specialized American companies throughout the American Revolution, usually in actions that required accurate long-range shooting. It was not, however, a suitable military weapon for general issue or large-scale engagements, since it was more delicate and far slower to load than the smooth-bore musket.

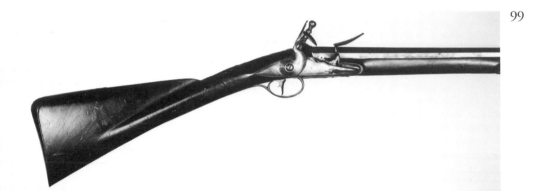

Courtesy Canadian War Museum, Ottawa.

99
Officer's Light Flintlock Musket or Fusil
English, Newton (active c. 1770–1815), c. 1775–80
Steel, walnut stock, 146.6 (57¾)
Royal Ontario Museum, European Department, 932.21.13

Instead of (or sometimes as well as) swords or pistols, field officers, particularly junior ones, often carried light muskets or fusils, which they had purchased privately. These weapons were typically of smaller calibre and lighter in weight than the heavy "Brown Bess" muskets issued to the soldiers. Loaded with bird shot rather than a ball, the light fusil was also usable as a fowling piece. Although more elaborate and more highly finished than standard muskets, only rarely were fusils truly elaborate, in the manner of presentation pieces.

Little is known about Newton except that he was a gunmaker in Grantham, Lincolnshire. His active dates have been defined from the time range of his surviving work, which includes officers' pistols and light muskets, and also breech-loading rifles.

100
Flintlock Musket, French Pattern of 1763
French, Charleville Arsenal, c. 1770–80
Steel, walnut stock, 139 (54¾)
Canadian War Museum, Ottawa

Supplied to the Continental army and carried by French forces in America after 1777, the French Pattern of 1763 musket was the main infantry weapon used by the colonies and their allies during the American Revolution. It was essentially an improved version of the French Pattern of 1717 musket (see no. 11), greatly strengthened by the addition of steel bands to reinforce the forestock and barrel. The British army did not replace thin pins with barrel bands until the 19th century.

In developing its own military weapons, the United States followed the French pattern closely in all musket models through the first half of the 19th century.

101
Portrait of Joseph Brant

Signed by George Romney (1734–1802), London, c. 1776
Oil on canvas, 127.0 x 101.6 (50 x 40)
National Gallery of Canada, Ottawa, 8005

Joseph Brant (1742–1807), who was to become a Mohawk chief and the principal war leader of the Iroquois Confederacy, was born on the banks of the Ohio River, where his people had journeyed from the Mohawk valley. His sister Molly became the second wife of Sir William Johnson, an Irish baronet who was granted a large tract of land in the Mohawk valley (see no. 113).

In the American Revolution, Brant championed the British and allied his warriors to their armies. No wonder then that he was honoured and fêted when he went to London about 1776. This portrait was painted there by George Romney. The inscription in the bottom right corner reads "Thayeadanegea, joseph Brant, the Mohawk Chief".

After the war, Brant resettled his Mohawk people on land granted to him along the Grand River in Upper Canada. A convert to Christianity, he spent his late years translating the Book of Common Prayer and the Gospel of Mark into the Mohawk language.

102 (See colour plate page 32.)
Flintlock Pistols

Presented to Joseph Brant (1742–1807)
Scottish, Thomas Murdoch (1730–85), Leith, c. 1785
Steel and silver, 34.3 (13½)
Royal Ontario Museum, European Department, 924.46.1a,b

Among the many gifts and presentations Joseph Brant received in his later years was this pair of flintlock pistols of the traditional Scottish type. The pistols, which have steel rather than wooden stocks, are engraved and inlaid with silver. They were made by Thomas Murdoch of Leith for the Duke of Northumberland, whose crest and monogram adorn the silver escutcheons on the butts. In September 1791 the Duke of Northumberland presented the pistols to Joseph Brant. After the Mohawk chief's death, the pistols passed to his heirs, until they eventually came into the collection of the Royal Ontario Museum.

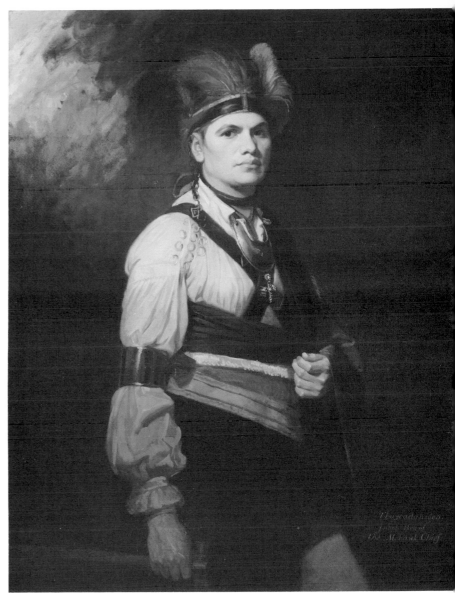

Courtesy National Gallery of Canada, Ottawa.

101

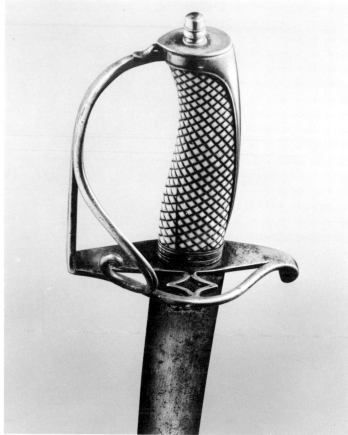

Courtesy Royal Canadian Military Institute, Toronto.

103
Infantry Officer's Sword

Presented to Joseph Brant (1742–1807)
English, c. 1775–79
Steel, brass and ivory mounts, 86.4 (34)
Royal Canadian Military Institute, Toronto

The presentation of weapons as gifts was very common, but the weapons themselves were not necessarily highly ornamented, any more than were presentation silver pieces. This sword is in the basic pattern of the 1770s for British infantry officers; it is somewhat longer than the short sabre of General Richard Montgomery (see no. 105). The grip is of ivory and the hilt of cast brass, which perhaps was originally silvered. Although there is a long-established tradition that the sword was presented to Joseph Brant, the donor is unknown.

Unlike the standardized muskets of the 18th century, the basic officer's sword displayed a great variety of detail. A regulation sword pattern did not appear until the 19th century.

104 (See colour plate page 31.)
The Death of General Montgomery in the Attack on Quebec

John Trumbull (1756–1843), New York, c. 1826
Oil on canvas, 182.9 x 274.3 (72 x 108)
Wadsworth Atheneum, Hartford, Connecticut, purchased of the heirs of the Artist's Estate, 1844.2

In late 1775 the American Revolution was exported to Canada in the form of two small, ill-equipped invasion forces bent on the capture of Montreal and Quebec. The invaders, under the command of generals Richard Montgomery and Benedict Arnold, expected the support of French Canadians against General Guy Carleton and the British garrisons, but it did not materialize. In an assault on Quebec on the night of 31 December 1775, Montgomery was killed and Arnold wounded. The siege, however, was maintained until spring, when the Continental forces were driven back to Crown Point.

The Irish-born Montgomery (1738–75) had served in the British army from 1756 to 1772, when he resigned and settled near New York City. At the outbreak of the American Revolution he was appointed a brigadier general in the Continental army. Montgomery and Carleton may well have known each other, since both had been present at the siege of Havana in 1762 (see no. 52).

After graduating from Harvard, John Trumbull accepted a commission in the Continental army, but he soon resigned to take up painting. In 1780 he left for England to study with John Singleton Copley and Benjamin West. The following year he was arrested as an American spy, jailed for seven months, and then deported. He returned to England in 1784.

Influenced by Benjamin West's paintings such as *The Death of Wolfe* (see no. 44), in 1786 Trumbull embarked on his own series of historical scenes with *The Death of General Warren at the Battle of Bunker Hill*. The series also included this painting and two others: one of the surrender of the British general John Burgoyne at Saratoga in 1777, and one of the final capitulation of General Charles Cornwallis at Yorktown in 1781—the event that brought an end to hostilities. In 1826 Trumbull made huge panoramic copies of his original pictures.

105
Short Sabre of General Richard Montgomery
English, c. 1765–75
Steel, silver hilt, 83.8 (33)
Royal Ontario Museum, Canadiana Department, 962.185.1

This sabre was carried by General Richard Montgomery (1738–75), one of the American commanders at the siege of Quebec in 1775. After the general's death in the pre-dawn assault of 31 December (see no. 104), the sword was collected with his other effects, and returned to his widow by General Guy Carleton.

Although the blade may be of German origin, the grotesque-mask quillon and the scrolled pommel and guard over a horn grip represent a fine example of English silverwork on swords. The silverwork is unmarked.

105

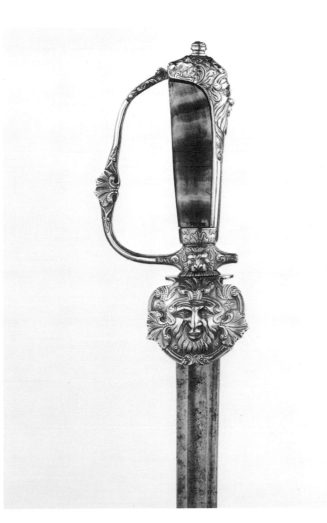

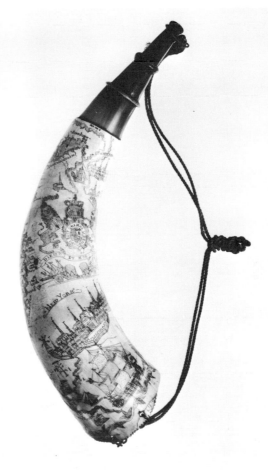

106
Carved Powder Horn of General Richard Montgomery
American, c. 1755–75
Horn, 35.5 x 8.3 (14 x 3¼)
Royal Ontario Museum, Canadiana Department, Sigmund Samuel Collection, 962.185.3

As well as a short sabre (see no. 105), General Richard Montgomery (1738–75) carried with him at the ill-fated siege of Quebec in 1775 this intricately carved map horn, which perhaps dates from the Seven Years' War. The rich carving and colouring depict a map of the Lake Champlain – Richelieu River route from Albany to Montreal. The ornamentation includes a view of the fortified town of Montreal, a lion, a unicorn, and a British coat of arms.

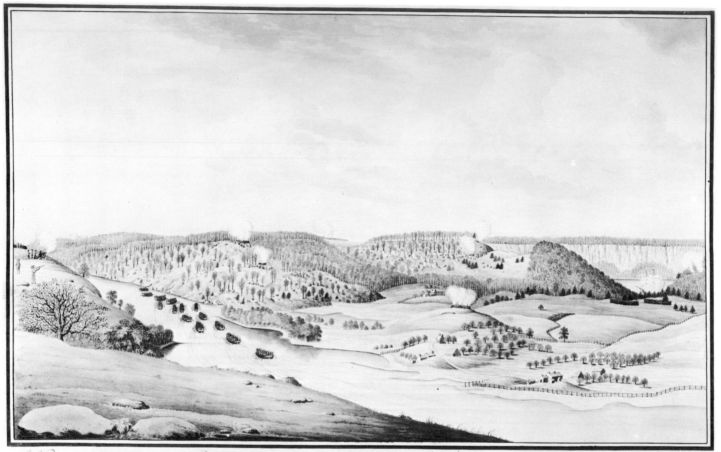

A View of the Attack against Fort Washington and Rebel Redouts near New York on the 16 of November 1776 by the British and Hessian Brigades. Drawn on the Spot, by Thos Davies Capt R R of Artillery.

107
The Attack on Fort Washington, 1776

Inscribed and signed by Thomas Davies (1737?–1812), New York, 1776
Watercolour on paper, 31.1 x 44.4 (12¼ x 17½)
The New York Public Library, I. N. Phelps Stokes Collection, 1776-B-93

Thomas Davies was in command of a British battery of four twelve-pound cannon when he did this drawing of the assault on Fort Washington, which was situated on a hill at the northern end of Manhattan Island. In retreat from Long Island, General George Washington and his forces were trying to hold Manhattan and the lower Hudson valley against a vastly superior British force of some one hundred ships under the command of Admiral Lord Richard Howe and thirty thousand troops led by his brother General Sir William Howe. Fort Washington proved to be indefensible, and the Continental force continued the retreat into New Jersey.

The full inscription on the drawing reads "A View of the Attack against Fort Washington and Rebel Redouts near New York on the 16 of November 1776 by the British and Hessian Brigades. Drawn on the Spot, by Thos. Davies Capt. R. R: of Artillery."

108
Landing of the British Forces in the Jerseys, 1776

Inscribed and signed by Thomas Davies (1737?–1812), New York, 1776
Watercolour on paper, 25.7 x 41.9 (10⅛ x 16½)
The New York Public Library, Emmet Collection, 1776-C-6

Having routed General George Washington's troops from New York (see no. 107), the British forces crossed the Hudson River to New Jersey on 20 November 1776. Thomas Davies, who was with General Charles Cornwallis's army during this operation, pictured the British troops landing in shallops and climbing the New Jersey palisades opposite Manhattan Island.

The British chased Washington's retreating army across New Jersey to the Delaware River, but they missed several opportunities for definitive engagements. Washington was able to regroup his men and make successful counterattacks at Trenton on 25 December and at Princeton on 3 January 1777 (see no. 96). The Continental forces thus regained the initiative.

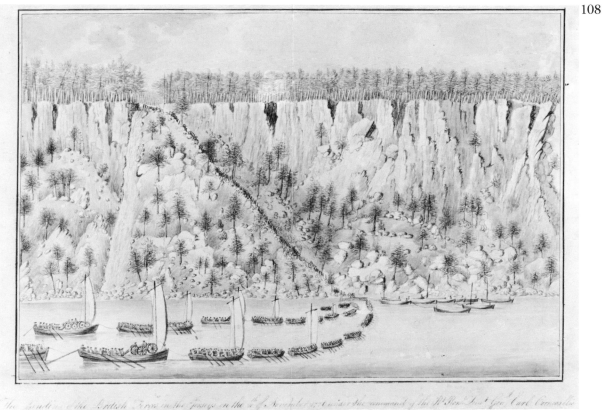

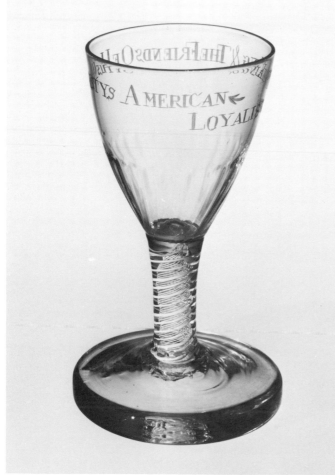

Courtesy The Corning Museum of Glass, Corning, New York.

109
Engraved Wineglass

English, c. 1775
Glass, 10.9 (4¼)
The Corning Museum of Glass, Corning, New York, gift of
The Ruth Bryan Strauss Memorial Foundation, 79.2.90

Stemmed glassware with twisted air-bubble stems was extremely fashionable both in England and in North America in the late 18th century. Fragments of such "air-twist" pieces are often found on North American archaeological sites. This glass has an unusually thick base, an opaque white double-twist stem, and a transparent pattern-moulded bowl. Although specific engravings are unusual on these glasses, the bowl of this one bears the legend "THE KING & THE FRIENDS OF HIS MAJESTYS AMERICAN LOYALISTS".

110
Sword of the First American Regiment (Queen's Rangers)

English, c. 1775–95
Steel, silver mounts, 83.8 (33)
Canadian War Museum, Ottawa

Although the silver escutcheon on the ivory grip of this straight-bladed sword is engraved "1st Am. Regt.", the piece was certainly privately purchased by an officer, not issued to him. The original owner is unknown, but the sword probably belonged to an officer in the first regiment of Queen's Rangers in the American Revolution, or perhaps to one in the reconstituted Queen's Rangers of Upper Canada.

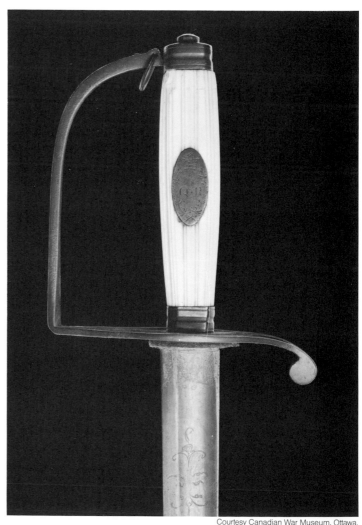

Courtesy Canadian War Museum, Ottawa.

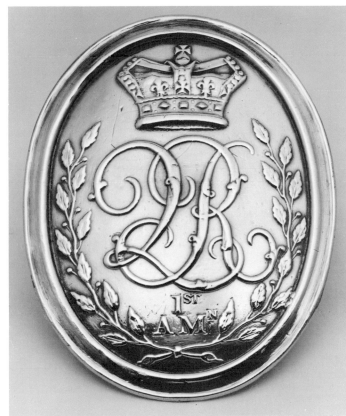

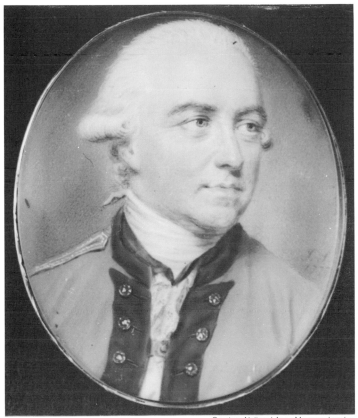

Courtesy National Army Museum, London.

111
Crossbelt Plate of the First American Regiment (Queen's Rangers)

English, unmarked, c. 1776-77
Silver, 8.3 x 6.4 (3¼ x 2½)
Royal Ontario Museum, Canadiana Department, gift of Mrs Ian
M. R. Sinclair, 973.155

The First American Regiment, or Queen's Rangers, was a Loyalist regiment formed in the summer of 1776. Many of its members came to Upper Canada when the American Revolution ended, and the regiment was reconstituted there in 1791.

This silver crossbelt plate was worn by Colonel Samuel Boise Smith, who was commissioned an ensign in the Queen's Rangers in November 1776, and was wounded at the battle of Brandywine in 1777. Within a floral wreath, the plate is embossed with the letters "QR" under a crown, and below that, the marking "1ST AMN". Colonel Smith came to Canada as a Loyalist and in 1798 became commanding officer of the Upper Canada Queen's Rangers.

112
Portrait Miniature of Sir Henry Clinton

Artist unknown, English, 1777
Oil on ivory, 3.7 (1½)
National Army Museum, London, 6007-48

Sir Henry Clinton (1738?-95) was born in Newfoundland while his father, Admiral George Clinton, was governor there. Henry Clinton served with distinction throughout the Seven Years' War and the American Revolution—beginning with the battle of Bunker Hill in 1775. Knighted in 1777, he succeeded Sir William Howe as commander in chief of British forces in North America in 1778, became a full general in 1793, and died while serving as governor of Gibraltar.

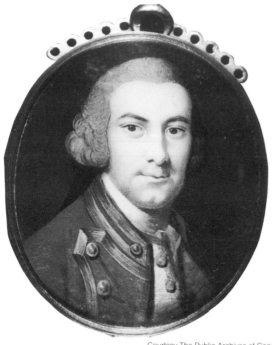

Courtesy The Public Archives of Canada, Ottawa.

113
Portrait Miniature of Sir William Johnson

Artist unknown, English, c. 1760
Watercolour on ivory, 3.8 x 3.4 (1½ x 1⅜)
The Public Archives of Canada, Ottawa, C 83497

William Johnson (1715-74), who was born in Ireland, emigrated to New York about 1738. He settled in the Mohawk River valley, where he prospered as a trader, a diplomat, and a land speculator. He was such a good friend to the Mohawk Indians that they adopted him into their nation.

For more than thirty years Johnson had a notable influence on the actions of the Indian peoples of his region—to Britain's great benefit. In 1755 he was appointed superintendent of Indian affairs and was knighted. Johnson lived in baronial splendour at Johnson Hall, a great manor house he built near Johnstown, New York. His staff included a fiddler, a harpist, and a jester. Numerous mistresses and various children added to the liveliness of the household.

After Sir William died in 1774, his son John maintained his father's ties with the Indians. During the American Revolution, Sir John Johnson organized forces of Loyalists and Iroquois to make raids on the New York frontier. In 1783 he became a Loyalist settler in Canada.

114
Pair of Candlesticks

English, marked by William Cafe, London, 1762-63
Silver, 27.3 x 12.7 (10¾ x 5)
Royal Ontario Museum, Canadiana Department, 966.4.1A–B

This pair of chased candlesticks, with twisted stems and floral decoration on the square bases, was brought to Canada in 1783 by Sir John Johnson, the son of Sir William Johnson (see no. 113). A small coat of arms of the Johnson family—a hand grasping an arrow—is engraved at the junction of the stem and base of each candlestick.

John Johnson (1742-1830), who shared his father's allegiance to the British in the Seven Years' War, was knighted for his services. During the American Revolution he organized Loyalists and Iroquois in New York State and northern Pennsylvania, and between 1777 and 1781 led numerous raids on frontier colonial settlements. After the war Johnson helped to expedite the Loyalist exodus to Canada. In July of 1784 he was able to report to Governor Guy Carleton that 3776 people had been resettled in what was to become the Kingston area of Upper Canada.

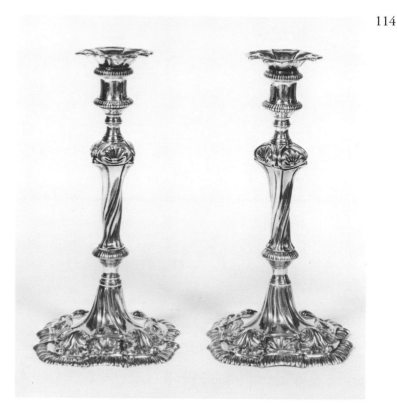

114

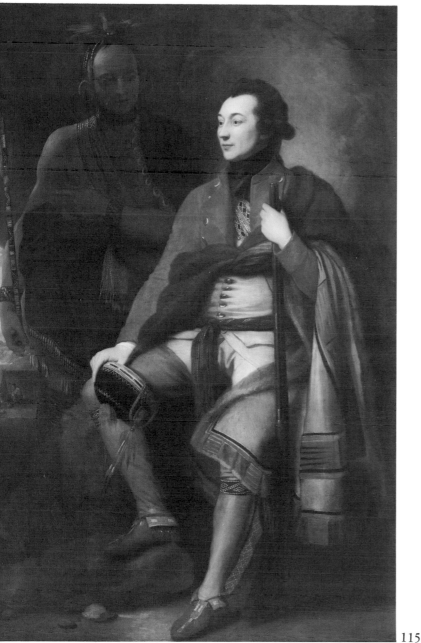

115

115
Portrait of Colonel Guy Johnson

Benjamin West (1738–1820), London, 1776
Oil on canvas, 202.6 x 138.4 (79¾ x 54½)
National Gallery of Art, Washington, D.C., Andrew W. Mellon
Collection 1940, 496

This very famous portrait is traditionally held to be of Guy Johnson (1740–88), and the background figure has sometimes been thought to represent Joseph Brant (see no. 101). It is more likely, however, that the Indian is simply an indeterminate background figure. Eighteenth-century portraitists typically included backgrounds that related to their subjects or commemorated some event in which they had played a notable part.

Guy Johnson, a nephew of Sir William Johnson, "Baron of the Mohawk" (see no. 113), was born in Ireland. Guy came to New York about 1760 and later married his cousin Mary, a daughter of Sir William. When his uncle died in 1774, Guy succeeded him as superintendent of Indian affairs. At the outbreak of the American Revolution, Guy Johnson left New York for Canada and then sailed to England, where Benjamin West did this portrait of him in 1776. Later that year he was back in New York, involved with his cousin Sir John Johnson in organizing Loyalists and Iroquois for raids in the Mohawk valley. After the war Guy Johnson returned to England.

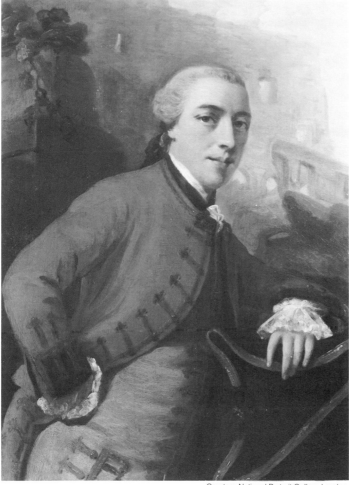

116
Portrait of Major General John Burgoyne

Studio of Allan Ramsay (1713–84), c. 1775–77
Oil on canvas, 50.8 x 35.8 (20 x 14⅛)
National Portrait Gallery, London, 4158

General John "Gentleman Johnny" Burgoyne (1722–92) was a British career army officer, a playwright, a member of parliament, and a well-known London club man. He served briefly in Boston in 1775, but returned to England to seek an independent command. With the help of numerous influential contacts and friends, he secured command of a proposed invasion into New York.

Burgoyne was sent to Quebec in 1777, with a plan that called for him to lead a force towards Albany, while General Sir William Howe marched north from New York. The objective of the campaign was to sever New York and the southern colonies from New England. The campaign began in June, but it was doomed from the start. Burgoyne set out with a much smaller force than he had hoped for, and Howe launched a drive on Philadelphia. Burgoyne ultimately encountered an army of eighteen thousand Americans near Saratoga, New York, in October. Surrounded by the enemy, he surrendered his own force of some six thousand. The event marked a decisive turning point in the American Revolution.

117
Inscribed Punch Bowl

English, probably Liverpool, c. 1777
Tin-glazed earthenware, 11.4 x 29.8 (4½ x 11¾)
Royal Ontario Museum, European Department, 924.16.22

Commemorative or presentation inscriptions were quite common on English tin-glazed or delft pottery in the 18th century. The inside of this example, which is decorated in blue, bears the valediction "Success to General Burgoyne in Canada". The punch bowl may have been made specifically for presentation to General John Burgoyne at one of the many bon voyage parties that heralded his departure for Quebec early in 1777.

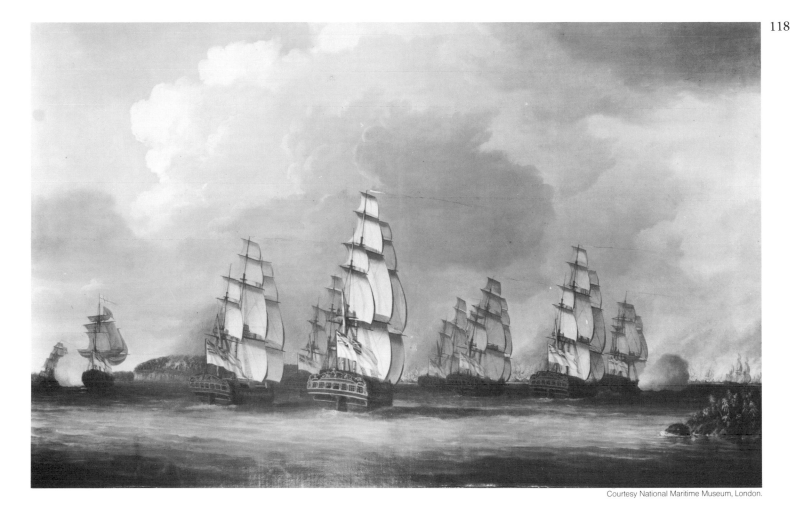

Courtesy National Maritime Museum, London.

118
Battle of Penobscot Bay, 1779

Dominic Serres (1722–93), London, c. 1780
Oil on canvas, 101.6 x 152.4 (40 x 60)
National Maritime Museum, London, OP 1931–37

Encouraged by some successful engagements with privateers, the colony of Massachusetts, which had its own navy, decided in 1779 to retake the Castine peninsula in Maine from the British who had occupied it. Nineteen armed vessels were assembled; among them were two Continental navy ships and some privateers. Twenty transport ships with two thousand troops aboard joined the fleet, which left Boston on 19 July. Colonel Dudley Saltonstall was in command of the fleet, with General Solomon Lovell in charge of the landing force.

The fleet reached upper Penobscot Bay in late July, whereupon Lovell landed his troops, set up an encampment, and sent for reinforcements. In the meantime, Sir George Collier appeared with five British frigates, having sailed from New York to intercept the expedition on the orders of the British commander in chief, Sir Henry Clinton (see no. 112).

There was no real engagement. Taken by surprise, most of the American naval commanders landed their crews, ran their ships aground, and burned them. Those that tried to escape were easily captured. Saltonstall and Lovell with their seamen and troops walked for weeks through the Maine wilderness back to Massachusetts, arriving in late September.

This disaster marked the end of a separate navy for the colony of Massachusetts. Collier's success prompted the British government to propose that Maine be made a separate British North American colony, to be named New Ireland. However, the defeat of General Lord Charles Cornwallis's forces at Yorktown, Virginia, in 1781 and the subsequent peace negotiations put an end to that proposal.

119
Bombé Secretary-Desk

American, attributed to Gibbs Atkins (1739–1806), Boston,
c. 1770–76
Mahogany, 254.0 x 119.5 (100 x 47)
Private collection

A supreme example of Loyalist furniture, this secretary-desk is of
the English bombé type, known to have been made in the
American colonies only in Boston. The piece has ornate mirrors
on the bookcase doors, reeded and carved side pilasters, and shell
carvings in the interior.

The desk was made for Captain Martin Gay (1726–1809), a
Boston brass founder, coppersmith, and ship owner, and it is still
used by one of his direct descendants. When the British withdrew
from Boston in 1776, Gay, who was a Loyalist, sailed with the
evacuation fleet to Halifax, taking with him his daughter, his son,
"his man London", and his mahogany secretary-desk. Since he
had his own vessel, he also had the privilege of transporting
heavy furniture. Later, Gay emigrated from Halifax to London,
but he returned to Boston in 1792, still in possession of his
favourite desk.

A small number of pieces of Loyalist furniture are known and
treasured in Nova Scotia and New Brunswick, but none of the
proportions and quality of this desk. Few emigrating Loyalists, in
fact, were ship owners with the option of transporting furniture
or other heavy cargo. Most carried only readily portable possessions,
including favourite pieces of silver.

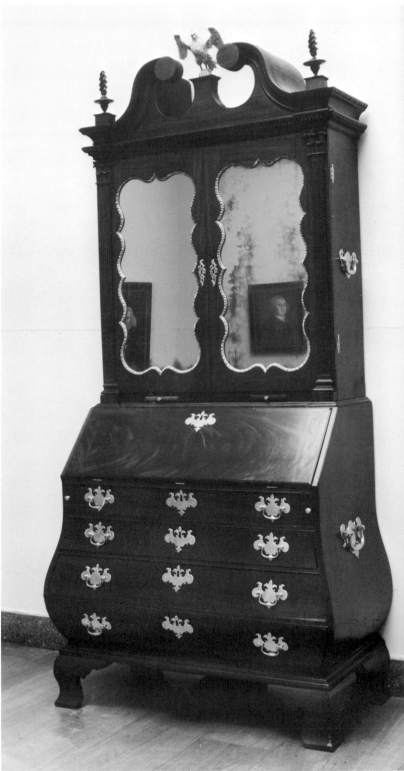

119

Photograph by Barry Donahue.

120
Hot-Water Jug

English, marked by William Holmes, Sr (1717–82/83), London, 1776
Silver, 30.2 x 8.3 (11⅞ x 3¼)
Royal Ontario Museum, European Department, gift of Mrs J. E. Burnside, 941.8.31

The urn-shaped body of this handsome jug is mounted on a tapered stem, a gadrooned round foot, and a square base. Fluting decorates the lower two-thirds of the body, and a flame finial adorns the lid. The piece is in the neoclassical style that first began to become popular in England in the 1760s, and gradually supplanted the earlier Georgian forms.

121 (See colour plate page 32.)
Coffee Urn

American, marked by Paul Revere II (1735–1818), Boston, c. 1793
Silver, 45.4 x 11.7 (17⅞ x 4⅝)
Museum of Fine Arts, Boston, gift of Henry Davis Sleeper in memory of his mother, Maria Westcote Sleeper, 60.1419

As the popularity of coffee as a hot beverage increased, the large coffee urn became a necessary part of a major silver service. By the 1790s Paul Revere had adopted the neoclassical silver forms then at the height of fashion in England.

This very well-formed and delicate piece, with thin applied handles and an ivory-handled spigot, sits on a square base with small claw-and-ball feet. The pine-cone finial on the lid was a typical Revere motif, common in his work even of the 1760s. The back of the urn is engraved "BAC", for Burrell Carnes of Lancaster, Massachusetts, for whom the piece was made.

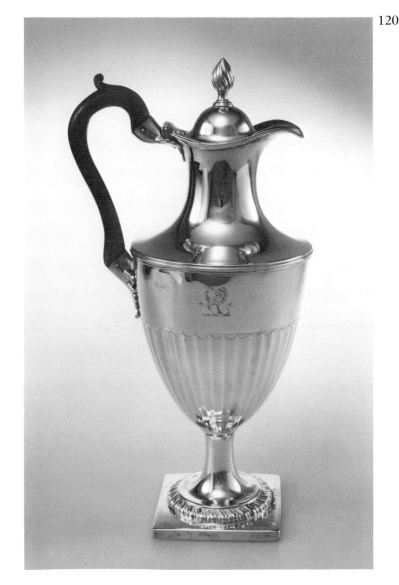

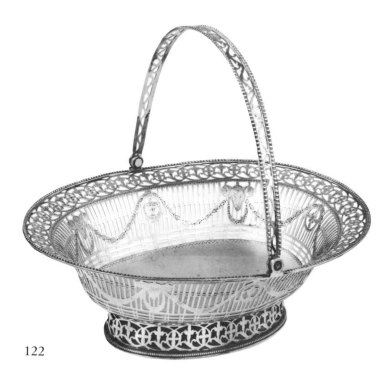

122

122
Openwork Cake Basket

English, marked by Hester Bateman, London, 1779
Silver, 10.5 x 35.7 (4⅛ x 14⅛)
Royal Ontario Museum, European Department, bequest of
Dorothy C. M. Oxley, 968.293

With its finely pierced and slotted pattern of bands and swags and
its swing handle, this Hester Bateman cake basket reflects the
excellence achieved by superior English silvermakers during the
1770s. Engraved small urns, quatrefoils, and rams' heads
complete the decoration.

Hester Bateman is today one of the best-known English
silvermakers of the 18th century. Determined to expand her
husband's small business after his death, she first registered her
own mark in 1761. Hester Bateman finally retired in 1790 at the
age of eighty-one, and turned the business over to her sons.

123

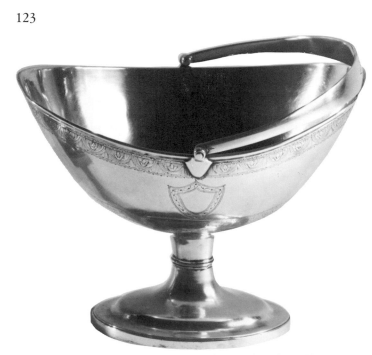

123
Sugar Basket

Canadian, marked by Robert Cruickshank (1748–1809),
Montreal, c. 1800–1805
Silver, 18.6 (7⅜)
National Gallery of Canada, Ottawa, Henry Birks Collection of
Canadian Silver, 1979, 25711

English neoclassical styles and forms were adopted by Canadian
silversmiths rather earlier than they were by Canadian cabinet-
makers. This graceful melon-shaped bowl with a bail-loop handle
is mounted on a pedestal with a round base. The rim of the bowl
is decorated with an engraved classical frieze.

A sugar basket and tongs formed part of a large tea or coffee
service. The basket held lump sugar that consisted of small
pieces broken off from a large cone.

Courtesy National Gallery of Canada, Ottawa.

BRITISH NORTH AMERICA
TO 1791

The end of the American Revolution brought Canada her first major influx of settlers. The Revolution had created a refugee group of about one hundred thousand Loyalists, who, resented and victimized by the patriots, were left with little choice but to seek exile in England, the West Indies, or Canada.

Early in 1782 Sir Guy Carleton, who had left Canada in 1778 to take up a new office in Ireland, was appointed commander in chief of British forces in North America and ordered to New York to organize the evacuation of British troops and Loyalists. During the one year of 1783 he arranged for the reception of some thirty thousand Loyalists—more than twelve hundred of them former slaves—and dispatched them to Nova Scotia, which then encompassed New Brunswick as well. Another five hundred, the first contingent of Upper Canadian Loyalists, went first to Cataraqui (now Kingston). Some ten thousand other Loyalists set off for Canada independently, travelling overland and settling largely in present-day eastern Ontario.

The arrival of forty thousand new settlers within a single year—a number twice that of the previous English-speaking population—created extreme problems of resettlement and supply. Loyalists received land grants and were issued tools and an initial supply of food and clothing. Still, the absorption of the new Loyalist immigration took ten years. The experience, coupled with lessons learned from the American Revolution, led to numerous changes in the structure of British North America.

The west, too, was opened up by the Treaty of Paris, which abrogated the old "Proclamation Line" of 1763. This freed the huge area south of the Great Lakes and west of the highlands of the Appalachians, as well as present-day Ontario, for an expansion of settlement, and migrations and mobility of population that continue to the present day.

Attracted by cheap or free land, thousands of non-Loyalist Americans streamed into Canada, and particularly Upper Canada, from the 1780s until 1812. Unlike many of the Loyalists, these people were largely frontiersmen, pioneers, and farmers, who began the great task of clearing wilderness lands and settling them. Disbanded regiments—English, Scottish, and mercenary German—were resettled as well; they received the same land grants, tools, and provisions as had the Loyalists.

Nearly half of the Loyalist immigrants in the Maritimes settled on the north shore of the Bay of Fundy; they founded Saint John and other settlements extending well up the Saint John River valley. This population of fifteen thousand, remote from Halifax, yet governed from there, almost immediately began to petition for separate status. Britain saw virtue both in colonial disunity and in a new buffer province between Nova Scotia and the United States. Thus in 1784 Nova Scotia was partitioned into the provinces of New Brunswick and Nova Scotia. Cape Breton Island was separated as well and granted its own governor and council, but was reannexed to Nova Scotia in 1820.

Agitation for change in the Quebec Act of 1774 began almost as soon as the act was passed, for it satisfied no one but Carleton and the Quebec seigneurial class and clergy. Certainly the act had no appeal for the new settlers flooding in after 1783. It did not provide for levies of local taxes, for freehold ownership of land, for representative self-government, or for the introduction of English civil law. Agitation for repeal of the Quebec Act increased after 1784. By 1790 present-day Quebec had a substantial English-speaking population. What is now southern Ontario had a mixed population of about ten thousand and was growing rapidly. Yet the region was still part of the Province of Quebec and was governed under the terms of the Quebec Act, which were now obsolete.

Finally in 1791 the British Parliament passed an amendment to the Quebec Act, known as the Constitutional Act. It created the provinces of Lower Canada and Upper Canada and became in effect Canada's third constitution, under which the country was to be governed for the next fifty years.

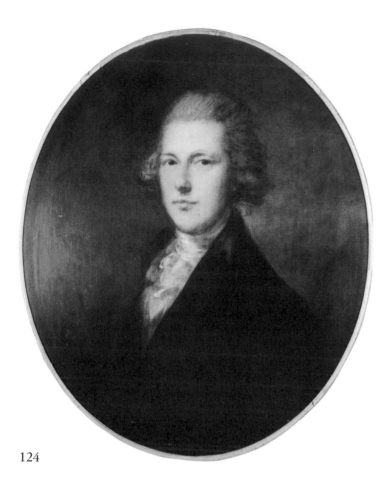

124

124
Portrait of the Younger William Pitt

Attributed to Thomas Gainsborough (1727–88), London, c. 1785
Oil on canvas, 71.1 x 58.4 (28 x 23)
Royal Ontario Museum, Canadiana Department, Sigmund Samuel Collection, 961.158.1

The younger William Pitt (1759–1806) was the second son of William Pitt, first Earl of Chatham, the British war minister who had urged the vigorous prosecution of the Seven Years' War. In his father's footsteps, the son, too, pursued a political career, and his rise was meteoric. Pitt was only twenty-four when he first became prime minister in 1783 (he has been called Britain's greatest prime minister).

Pitt appointed the men who represented Britain in the negotiation of the Treaty of Paris, which recognized the United States as an independent country in 1783, and established the boundaries between it and British North America. Three years later Pitt's cabinet recommended to the king the appointment of Sir Guy Carleton, first Baron Dorchester, as governor in chief of British North America. Pitt himself was largely responsible for passage of the Constitutional Act of 1791, which created the provinces of Upper Canada and Lower Canada.

Thomas Gainsborough was a landscape artist and portraitist who at the height of his successful career was regarded as second only to Sir Joshua Reynolds. Gainsborough began to paint in the 1740s. He was a founding member of the Royal Academy of Arts in 1768, but, because of a series of disagreements, after 1774 he exhibited only at his own studio. Although Gainsborough preferred doing idyllic landscapes, he gained his greatest reputation as a portraitist, particularly for his full-figure pictures.

Unlike many portraitists, including Reynolds, Gainsborough mainly worked alone and did not employ assistants for costume, backgrounds, or drapery. His only student and assistant, in fact, was his nephew, Gainsborough Dupont, who may possibly also have worked on this portrait of Pitt.

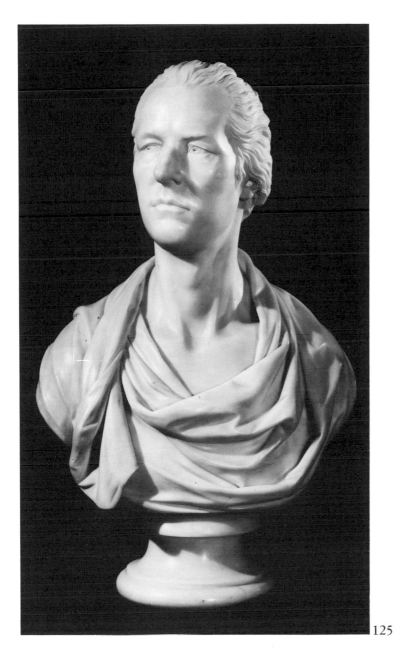

125
Portrait Bust of the Younger William Pitt

Joseph Nollekens (1737–1823), London, 1810
Marble, 71.1 (28)
Royal Ontario Museum, Canadiana Department, Sigmund
Samuel Collection, 958.230

This portrait bust resting on a column was executed after the
death of the younger William Pitt (1759–1806). It is done in a
classical style, with a noble head and toga-like drapery.

Joseph Nollekens, who was born in England, was the son of
Joseph Franciscus Nollekens (1702–48), a Flemish painter in the
style of Watteau. Nollekens did numerous portrait busts of
famous people, including not only Pitt, but also George III, David
Garrick, George Canning, and Lord Castlereagh. Many of the
busts were done in multiple copies.

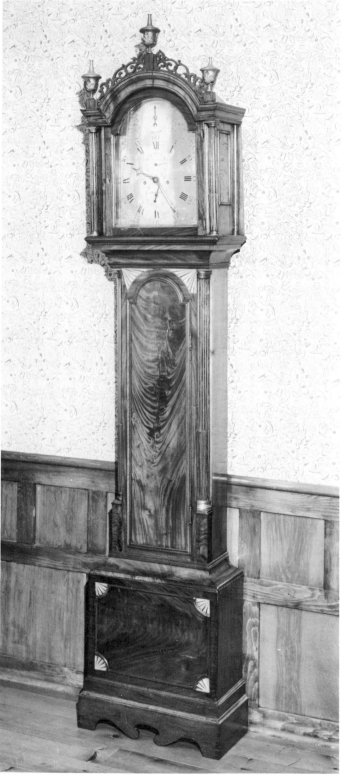

126
Tall Clock

Canadian, marked by James Orkney, Quebec, c. 1785–1800
Mahogany, with satinwood inlays, 235.0 x 52.1 (92½ x 20½)
Royal Ontario Museum, Canadiana Department, purchased
through a Province of Ontario grant, 959.244

This mahogany tall clock is embellished with imported
satinwood fan inlays in the pendulum case and base, fluted
brass-stopped quarter-columns, and bracketed base and feet. The
brass face is engraved "James Orkney/Quebec", though the
actual works are English.

Because many of his marked pieces have survived, James
Orkney is among the best-known early Canadian clockmakers.
He worked in Quebec from about 1783 until after 1820, at three
successive locations. He was probably a New England Loyalist
who migrated to Quebec during or immediately after the
American Revolution. This clock, with open fretwork above an
arched hood and three brass finials, is very much a Massachusetts
rather than an English type.

127 (See colour plate page 33.)
Halifax from the Harbour, 1792

Signed and dated by William Elliott (1765/70–1838), Halifax,
1792
Oil on canvas, 66.0 x 132.1 (26 x 52)
Royal Ontario Museum, Canadiana Department, Sigmund
Samuel Collection, 948.39.6

Halifax in 1792 was an active mercantile centre and military and
naval garrison city, whose population had tripled since 1783. In
the foreground of this view of Halifax harbour, an admiral's
barge or cutter approaches the vessel to the left. In the dockyard
is a vessel tipped over for hull repairs.

William Elliott was an amateur but very competent marine
painter whose career was the Royal Navy. He advanced from
ensign to lieutenant in 1782, and to captain in 1810. Elliott
exhibited annually at the Royal Academy of Arts, London, from
1784 to 1789, but is not recorded as having exhibited at all after
1791. His latest known picture is dated 1794.

126

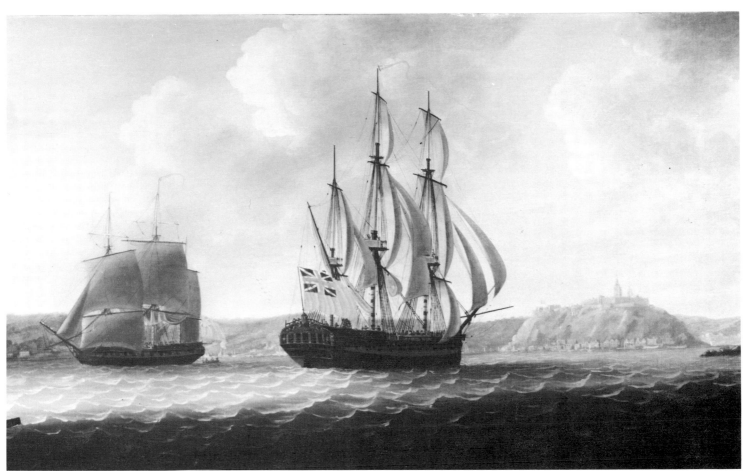

128

128
HMS *Pearl* off Quebec, 1785

Signed by William Elliott (1765/70–1838), London, 1785
Oil on canvas, 72.4 x 124.5 (28½ x 49)
Royal Ontario Museum, Canadiana Department, Sigmund
Samuel Collection, 961.2

In the foreground of this view of Quebec, the frigate *Pearl*—on
which the artist served—is approaching and about to pass a vessel
coming from upriver. On the right, Lower Town is nestled at the
waterline, with the Citadel rising high above it.

 This is one of Elliott's earlier canvases, undoubtedly done—as
was his Halifax view (see no. 127)—from his own sketches. It
was exhibited at the Royal Academy of Arts, London, in 1786.
The following year Elliott both engraved and published some of
his paintings, though not those of Halifax and Quebec.

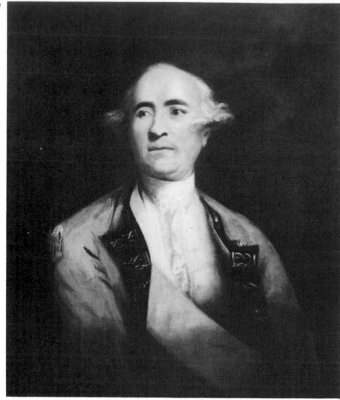

Courtesy National Portrait Gallery, London.

129
Portrait of General Frederick Haldimand

Studio of Sir Joshua Reynolds (1723–92), London, c. 1778
Oil on canvas, 76.2 x 63.5 (30 x 25)
National Portrait Gallery, London, 4874

In 1778 General Frederick Haldimand (1718–91) was appointed to replace Sir Guy Carleton as governor of Quebec. Haldimand, who was Swiss-born, had already served with the British army in North America during the Seven Years' War.

A native knowledge of the French language helped Haldimand in maintaining the loyalty of French Canadians during the American Revolution. He encountered endless trouble, however, in his attempts to placate the English-speaking population, who were urging the repeal of the Quebec Act of 1774, and the French Canadians, who feared the loss of their special rights conferred by the act. After Carleton succeeded Sir Henry Clinton as commander in chief of British forces in North America in 1782, Haldimand cooperated with him very effectively in the resettlement of Loyalists. Haldimand was recalled to England in the summer of 1784 and was knighted the following year.

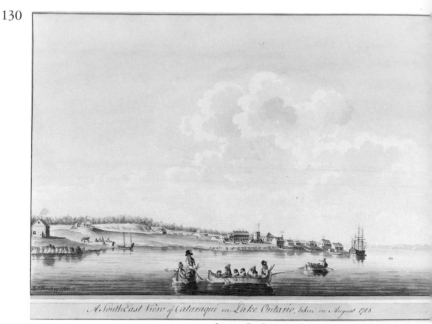

A South East View of Cataraqui on Lake Ontario, taken in August 1783.

Courtesy The Public Archives of Canada, Ottawa.

130
A View of Cataraqui, 1783

Signed and dated by James Peachey (active 1773-97), Kingston, 1785
Ink and watercolour on paper, 41.9 x 55.9 (16½ x 22)
The Public Archives of Canada, Ottawa, C 1511

When the Treaty of Paris of 1783 ceded the British posts at Oswego and Carleton Island to the United States, Major John Ross, who had been commander at Oswego, was ordered to Cataraqui (later Kingston) to develop a town and military base in preparation for the arrival of Loyalist settlers the following year. This view, inscribed "A South East View of Cataraqui on Lake Ontario, taken in August 1783", was sketched by James Peachey before Ross had completed his mission.

Cataraqui lay on the site of French Fort Frontenac. Ross and his men built on and around the ruins of the old fort. In the winter of 1783/84 they even moved buildings from Carleton Island across the frozen St Lawrence to Cataraqui. Very rapidly barracks, storehouses, wharfs, and a hospital took shape.

James Peachey, an army surveyor and draftsman, was posted to North America three times between 1774 and 1797. Like Thomas Davies (see nos. 32, 33, 33a, 68, 75, 107, 108), Peachey left a large and handsome pictorial record of his years in Canada. He made many maps and plans of his surveys, and painted numerous watercolours, four of which were published as aquatints in London between 1784 and 1786.

131
A View of Cataraqui, 1784

Signed by James Peachey (active 1773–97), Kingston, 1784
Ink and watercolour on paper, 41.6 x 56.2 (16⅜ x 22⅛)
The Public Archives of Canada, Ottawa, C 1512

This second Peachey view of Cataraqui (Kingston) is inscribed "A View of Cataraqui on the Entrance of Lake Ontario in Canada, taken from Capt. Brant's house July 16th, 1784". A great deal of progress had been made since the previous year (see no. 130). According to John Ross's own reports, additional building included another wharf, a grist mill, a saw mill, a naval storehouse, and several houses, even one for the Mohawk chief Joseph Brant, which measured fifty feet by twenty-five feet.

The five hundred Loyalists who had elected to go to Cataraqui spent the winter of 1783/84 at Sorel, Quebec, camped briefly at Johnstown in June, and then came on to Cataraqui in early July. Others soon followed them; by early 1785 a total of nearly five thousand Loyalists had been settled in the Kingston and Bay of Quinte area. Adolphustown was established in 1784, Napanee in 1785, Picton in 1786, and Belleville and Trenton by 1790. Settlement continued to grow along the Lake Ontario shore wherever a natural harbour existed or a river offered sites for water-powered mills.

132
Corner Chair

American, New York, c. 1760–75
Mahogany, 81.3 x 59.1 (32 x 23¼)
Museum of Fine Arts, Boston, gift of Mr and Mrs Maxim Karolik, 41.600

The corner chair, a specialized type for parlours and reception rooms, evolved in England in the early 18th century, and became common in the New England colonies after about 1750. The sitter usually straddled the front corner, with his or her back embraced by the semi-round chair back. Although purely English in its basic design, this finely carved example with cabriole legs and claw-and-ball feet is typical of New York cabinetwork and ornamentation of the third quarter of the 18th century.

132

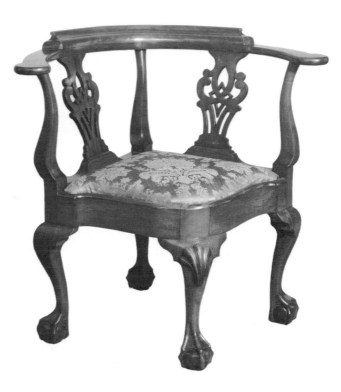

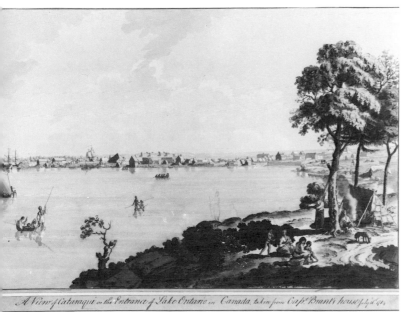

A View of Cataraqui on the Entrance of Lake Ontario in Canada, taken from Capt. Brant's house July 16th, 1784

131

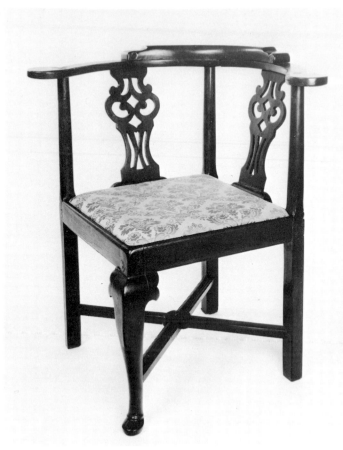

133
Corner Chair

Canadian, Nova Scotia, c. 1785–1800
Stained birch, 79.1 x 48.9 (31⅛ x 19¼)
Royal Ontario Museum, Canadiana Department, 973.136.1

Canadian examples of the corner chair are very rare, probably because it was beginning to disappear as a popular form by the time of the post–American Revolution settlement of Canada. The type is limited to Nova Scotia and New Brunswick and is still closely derived from the basic English design. Well constructed but without carving, this chair with its obsolescent cabriole front leg is the best Canadian example known. It is made of stained birch—called the "poor man's mahogany"—which was a very common wood for furniture in the Maritimes.

134
The Falls of Montmorenci

G. B. Fisher (1764–1834), c. 1792, published by J. W. Edy, London, 1795
Aquatint and watercolour, 42.2 x 62.1 (16⅝ x 24½)
Royal Ontario Museum, Canadiana Department, Sigmund Samuel Collection, 960x66.8

Montmorency Falls occur at the mouth of the Montmorency River a few kilometres northeast of Quebec. From the top of a bluff, the river plunges seventy-five metres to the St Lawrence below. The site was, and still is, a favourite sightseeing and picnic spot for residents of Quebec. The cascading water makes a spectacular display in summer and forms huge ice cones in winter.

Lieutenant George Bulteel Fisher of the Royal Artillery became aide-de-camp to the Duke of Kent and Strathearn while the latter was commander of British forces in Nova Scotia after 1796. A well-known watercolour artist, Fisher exhibited at the Royal Academy of Arts, London, between 1780 and 1808.

135
The Falls of the Chaudière

G. B. Fisher (1764–1834), c. 1792, published by J. W. Edy, London, 1795
Aquatint and watercolour, 41.5 x 61.5 (16⅜ x 24¼)
Royal Ontario Museum, Canadiana Department, Sigmund Samuel Collection, 960x66.9

The Chaudière Falls, on the south shore opposite Quebec, descend into the St Lawrence River just south of the present Pierre Laporte bridge. Although they have been pictured many times, they were perhaps less popular with artists and visitors than the Montmorency Falls, simply because they were more difficult of access.

George Bulteel Fisher did a series of six Canadian scenes, which were published in aquatint by J. W. Edy as *Six Views in North America.* The scenes were dedicated to "His Royal Highness Prince Edward, Major-General, Commanding His Majesty's Forces in the Province of Nova Scotia".

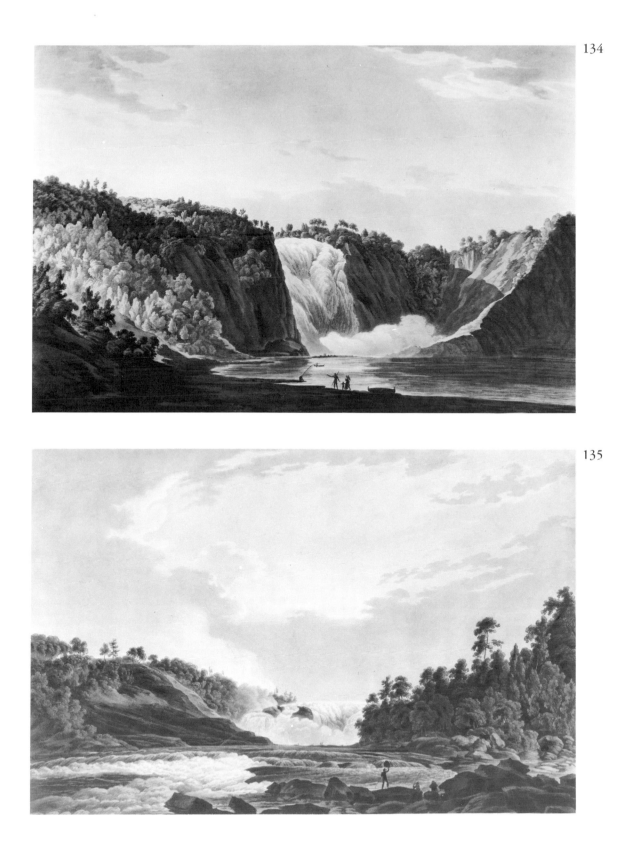

134

135

136

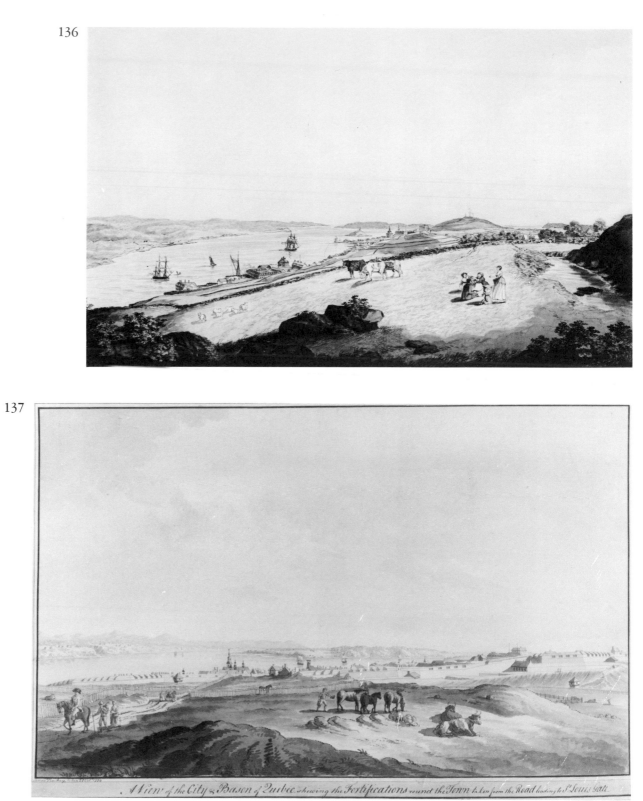

137

A View of the City & Bason of Quebec shewing the Fortifications round the Town taken from the Road leading to S.t Louis Gate.

140

136
A View of Halifax from Fort Needham

G. I. Parkyns (c. 1749/50–1820), 1800, published by James
Harrison, London, 1801
Aquatint and watercolour, 33 x 54 (13 x 21¼)
Royal Ontario Museum, Canadiana Department, Sigmund
Samuel Collection, 960x276.197

In this view of Halifax, looking south from the Bedford Basin,
the ocean is in the distance. The town itself and Citadel Hill are
in the centre of the scene.

George Isham Parkyns was an English watercolourist and
engraver who visited Halifax in 1800 and did four watercolours,
which he engraved and arranged to have published. For lack of
subscribers, the planned series of aquatints was never completed,
and the prints are today quite rare.

137
A View of Quebec, 1784

Signed by James Peachey (active 1773–97), Quebec, 1784
Etching and watercolour, 42.5 x 61.0 (16¾ x 24)
The Public Archives of Canada, Ottawa, C 1515

In this placid scene, sketched from near the top of Montmorency
Falls, the view is to the southwest, or upriver. Quebec is on the
right, and Point Lévis on the left. The inscription reads "A View
of the City & Bason of Quebec, shewing the Fortifications round
the Town taken from the Road leading to St Louis Gate."

Foreground figures of animals and people, generally at ease,
were a requisite element of the 18th-century British style for
scenic paintings. The figures served as well to provide focus,
scale, and proportion. James Peachey, like Thomas Davies (see
no. 75), almost invariably included such figures in his pastoral
views.

138 (See colour plate page 34.)
Portrait of a Slave Girl

François Malepart de Beaucourt (1740–94), Montreal, 1786
Oil on canvas, 69.9 x 61.6 (27½ x 24¼)
McCord Museum, McGill University, Montreal, M12067

Slavery was a legal institution that persisted for many decades in
early British North America. New France, too, had been a
slave-holding colony, and many wealthy people, particularly in
Nova Scotia and Quebec, had acquired slaves. Then some
Loyalist settlers brought their slaves with them.

Most slaves seem to have been personal and domestic servants,
rather than agricultural labourers as they were in the southern
colonies and states. There is little evidence that slaves were
widely mistreated in British North America, and equally little
evidence of any strong anti-slavery sentiment.

General Guy Carleton, however, was opposed to slavery. In his
negotiations with George Washington for the dispatch of
Loyalists from New York, Carleton insisted that former slaves be
sent to Canada as free men and women. Credit for the beginning
of the abolition of slavery in Canada must go to John Graves
Simcoe, the first lieutenant governor of Upper Canada. In 1793
Simcoe pressed the legislature into passing an act forbidding the
introduction of new slaves and providing that children of slaves
then resident become free on reaching the age of twenty-one. In
Lower Canada and the Maritimes, abolition was slower; it came
about gradually through court decisions. The end of slavery in
Canada, however, came only in 1833, when the British Parlia-
ment abolished slavery throughout the Empire.

François de Beaucourt was the son of a French marine (and
amateur artist) who was discharged in New France to settle
there. The son studied in Paris in the 1760s, painted profession-
ally in Bordeaux, and returned to Montreal about 1786. He was
the first Canadian-born artist to study and paint professionally in
Europe, and also achieve any real stature and reputation at home.
Many of de Beaucourt's commissions came from the church.

Portrait of a Slave Girl is considered one of the artist's finest
works, and one of the earliest Canadian portraits executed with
artistic sensibility rather than as a mere recording. The sitter was
de Beaucourt's own slave and servant, and perhaps more. She is
known to have lived in Montreal in 1832, probably having been
freed long since.

139
Cream Pitcher

Canadian, marked by Laurent Amiot (1764–1838), Quebec, c. 1800
Silver, 11.4 x 10.8 (4½ x 4¼)
Private collection

This finely shaped cream pitcher is purely English in form and reflects the design influence that predominated in Quebec by the early 19th century. The pitcher is undecorated, except for its moulded base. The handle is exceptionally thin and delicate for such a piece, and the spout is applied.

The highly productive Laurent Amiot was trained by François Ranvoyze (1730–1819), and appears to have established his own shop in Quebec about 1787 or 1788. Most of his work was done for the church; this quite simple pitcher is a rare example of his secular silver.

140
Tea Service

American, marked by James Musgrave (active 1795–1813), Philadelphia, c. 1800
Silver, teapot 16.8 x 26.7 (6⅝ x 10½)
The Henry Francis du Pont Winterthur Museum, Winterthur, Delaware, 65.1381.1–3

Some of the finest American silver of the Federal period came from Philadelphia, by then a city of considerable wealth and sophistication. These three pieces, with unusual convoluted border decorations, have the classical melon shape and fluted body typical of early 19th-century fashion. The teapot, sugar bowl, and milk pot may well be part of a once larger service.

James Musgrave was active as a silvermaker in Philadelphia from 1795 to 1813.

140

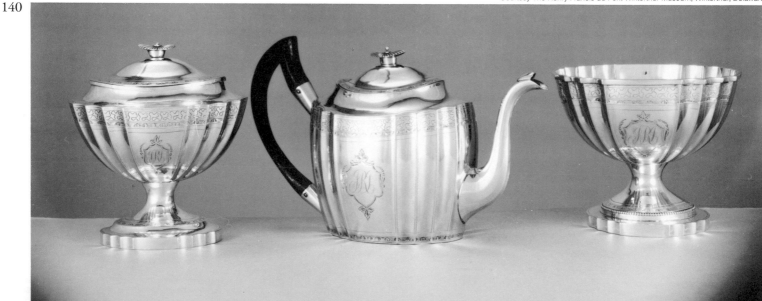

141 (See colour plate page 35.)
Tea Service
Canadian, marked by Salomon Marion (1782–after 1832),
Montreal, c. 1820
Silver, teapot 17 x 29 (6¾ x 11½); sugar bowl 11.5 x 20.0
(4½ x 7⅞); cream pitcher 11.5 x 19.5 (4½ x 7⅝)
National Gallery of Canada, Ottawa, Henry Birks Collection of
Canadian Silver, 1979, 27786–88

Although most Quebec silvermakers depended on church patronage for their livelihood, they also made domestic silver on order. Except for flatware, however, secular pieces usually represented a very small percentage of total production.

This tea service, one of only some six known Canadian sets that remain intact, shows a definite Empire influence in the banding, body repoussé work, and acanthus castings of the upper handles. The spouts reveal a traditional English influence. The pieces are extremely thin and light, as is most Canadian domestic silver. Coinage and scrap silver were the only sources of metal available to Canadian makers, who were thus obliged to make their silver go as far as possible.

Salomon Marion, who was apprenticed to Pierre Huget dit Latour in the mid-1790s, established himself in Quebec about 1805. Like other Quebec makers, he mainly produced church silver. The last known reference to Marion occurs in 1832, but the date of his death is obscure.

142
Pair of Candlesticks
Canadian, marked by Paul Morin (1775–after 1805), Quebec,
c. 1800
Silver, 26.7 (10½)
Private collection

The candlestick is another rare form of Canadian silver, of which very few examples are known. This pair, though in an early 18th-century style, dates from the early 19th century, and once again reflects the English influence on decorative arts forms in French Canada by that time. Except for ring turnings, the candlesticks are undecorated.

Paul Morin was apprenticed first to Louis Robitaille, and then to Laurent Amiot in the middle 1790s (see no. 139). Morin presumably established his own shop before 1800, but there is no record of him, or of any existing pieces of his silver, after 1805,

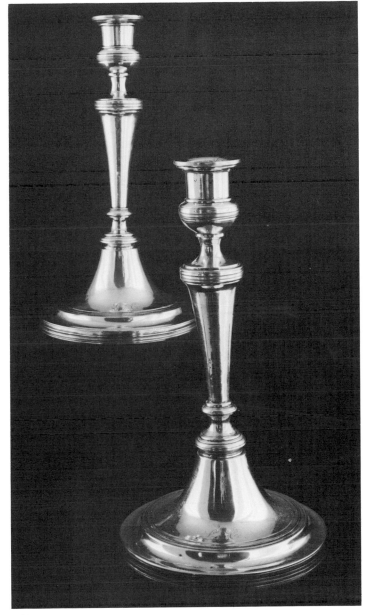

142

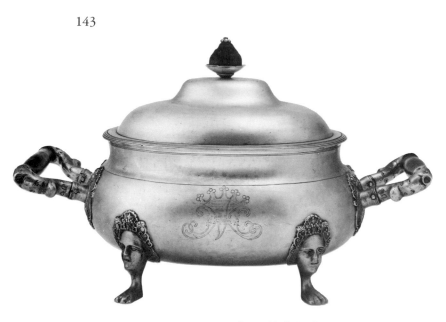

Courtesy Musée de la Basilique Notre-Dame, Montréal.

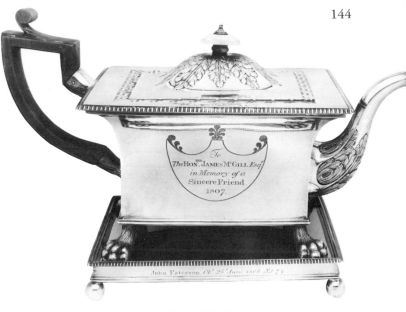

Courtesy McCord Museum, McGill University, Montreal.

143
Soup Tureen

Canadian, marked by Jacques Varin dit Lapistole (1736–91)
and Robert Cruickshank (1748–1809), Montreal, c. 1785–90
Silver, 28.8 x 49.5 (11⅜ x 19½)
Musée de la Basilique Notre-Dame, Montréal

One of the finest known examples of 18th-century Canadian
silver, this large soup tureen with a domed lid was made for the
Basilica of Notre Dame in Montreal. It carries an engraved
monogram of the Sulpician order under a crown. The legs, in the
form of human masks ending in flat paw feet, are extremely
unusual on Canadian silver.

The tureen itself is marked by Jacques Varin dit Lapistole, but
the cover is marked by Robert Cruickshank. This implies either
that Varin and Cruickshank had a short-lived partnership, or that
Cruickshank took on contract work for other silvermakers.

144
Teapot

Presented to James McGill (1744–1813)
English, marked by Charles Hollinshedd, London, 1806–7
Silver, body 15.6 x 21.0 (6⅛ x 8¼)
McCord Museum, McGill University, Montreal, M2615

This teapot is in a tombstone form of the French Empire style.
The Greek key design on the lid, acanthus chasing of the lid and
spout, and lion's-paw feet are all characteristic of the French
Empire style, which was just beginning to become fashionable in
England and did not come into vogue in Canada until ten years
later.

The teapot was a memorial gift to James McGill, founder of
McGill University in Montreal, on the death of his friend John
Paterson; it may have been presented to McGill by Paterson's
widow. The inscriptions on the front read "To the HONBLE.
JAMES McGILL Esqr. in Memory of a Sincere Friend 1807" and
"John Paterson, Obt. 25th June, 1806 AEt. 74". On the back is
inscribed a tribute to the deceased: "He was a Man eminently
distinguished through Life for the Rectitude of his Heart, and
Integrity of his Conduct, and no less endeared to his Friends by
the social Virtues of Benevolence, Sincerity and Affection."

BRITISH NORTH AMERICA
AFTER 1791

GUY CARLETON

If any one person can be credited with guiding Canada through her perilous formative years, it must be Guy Carleton. A career officer in the British army, a friend of James Wolfe, and a veteran of the Quebec and Havana campaigns, Carleton was first appointed lieutenant governor of Quebec in 1766, to succeed James Murray; in 1768 he was made governor.

Conscious of the threat posed by the fractious Thirteen Colonies, Carleton almost single-handedly achieved the passage of the Quebec Act of 1774, which guaranteed the language, laws, and religion of the French Canadians, and initiated the official Canadian policy of biculturalism rather than assimilation that persists to this day. Carleton himself both spoke and wrote excellent French.

At the outbreak of the American Revolution, Carleton successfully defended Quebec against the American invasion and siege of 1775 to 1776, and later he held northern Lake Champlain, the natural invasion route. As a reward for his services, he was knighted. Carleton left Quebec in 1778 on the arrival of his successor, Frederick Haldimand. Early in 1782, however, he was appointed commander in chief of British forces in North America and was sent to New York to organize and supervise the transportation of some forty thousand Loyalist emigrants, as well as the orderly evacuation of thirty-four thousand British troops still in the United States at the end of the American Revolution. In 1784, his job completed, Carleton returned to England. Two years later he was created Baron Dorchester and appointed first governor in chief of British North America. By October 1786 he was back in Quebec.

Lord Dorchester soon began to recommend full confederation for the Canadian colonies, with a governor general and a central legislative government. The idea, however, was too far ahead of its time. It was rejected in London in favour of the Constitutional Act of 1791.

Lord Dorchester sailed for England in 1791, but two years later he returned to Quebec to resume his duties as governor, although he had requested retirement and replacement. After almost thirty years of involvement in the building and structuring of Canada, he departed for England for the last time in 1796.

THE CONSTITUTIONAL ACT OF 1791

The Constitutional Act was proclaimed in 1791 after fifteen years of petitions and pressure for reform of the Quebec Act of 1774. In appointing Lord Dorchester governor in chief in 1786, the British cabinet hoped that he might find a solution to the problem. Dorchester, who was disillusioned by the opposition to the Quebec Act, even among French Canadians, was unable to provide an acceptable alternative. Thus the cabinet opted for separation, as it had in 1784 when Cape Breton Island and New Brunswick were partitioned from Nova Scotia.

The act created two new provinces of Upper Canada and Lower Canada, separated along the present boundary of Ontario and Quebec. Each province was to have a lieutenant governor, a council appointed by him, and an elected assembly. Provisions of the Quebec Act were retained for Lower Canada, but freehold tenure of land was introduced, as was the reserving of a portion of Crown land in each province for support of Protestant clergy. The acceptance of English civil law was left to the discretion of provincial assemblies.

The Constitutional Act reflected the lessons Britain had learned from the American Revolution. The governor in chief of British North America and the lieutenant governors and councils of the provinces retained considerably greater power than was granted to the elected assemblies. In the Thirteen Colonies the assemblies had secured the upper hand and had found strength in unity. In Canada the concept was "divide and rule".

In any event, there was no urge for unity in Canada, no sense of a common nationality, and few economic bonds. The forces that had led to consolidation in the Thirteen Colonies and ultimately to the American Revolution were thus most unlikely to surface in Canada.

THE PEOPLE

The population of British North America grew very rapidly between 1783 and 1812. Some fifty thousand Loyalists had settled in the Maritimes and Upper Canada by 1785, but that was only the beginning. With the end of the "Proclamation Line" in

1783, the independent United States entered a phase of westward expansion and migration that spilled over into Canada. Settlers, sometimes called "late Loyalists", arrived in a continuous stream, seeking new lands.

Provincial lieutenant governors encouraged this migration. John Graves Simcoe of Upper Canada was particularly energetic in offering land grants. By 1798 more than a million acres had been granted, and by 1804 the total was more than 4.5 million acres. By 1814 the population of Upper Canada had grown to ninety-four thousand. Eighty per cent of the immigrants were of American ancestry, but fewer than one-quarter had actual Loyalist origins.

The Eastern Townships of Quebec were at first officially closed to settlement; they were to remain a wilderness buffer between the United States and the St Lawrence River. There was, however, substantial independent migration, and the closure policy was rescinded in 1791. Settlers flowed in from Vermont and New Hampshire, and by 1812 the Eastern Townships had an English-speaking population of nine thousand. The population of Quebec as a whole by 1814 was 335,000, almost triple that of 1784, which in turn had been nearly double the 65,000 French-speaking inhabitants of 1763.

After the initial Loyalist influx in 1783-1784, the Maritimes gained little new population; only a handful of Scottish, Irish, and German settlers arrived. Heavy migration to the Maritimes was to come after 1815, but as late as 1814 settlement was still confined to the coastal strip and a few river valleys.

DECORATIVE ARTS

The decorative arts and specialized crafts were slow to develop in British North America, since they faced strong constraints. From Upper Canada to Newfoundland, the Canadian population after 1760 was concentrated along sea coasts and river and lake shores, within easy market range of British imports. This delayed for decades the necessity for local craft production. The overwhelming competition of British industry, combined with restrictive mercantile laws, made it difficult for specialized craftsmen to establish themselves and to survive economically. Moreover, the early population was widely dispersed in small towns and villages and lived in relatively primitive conditions, without the bases of prosperity or wealth necessary for support of specialized artisans.

Thus the earliest craftsmen were those the society could not do without—carpenters, blacksmiths, and builders of ships, boats, and wagons. There was no market or living for more esoteric craftsmen or artists, such as painters, silversmiths, cabinetmakers, or glassmakers, particularly in pre-American Revolution first-generation settlements. People who could afford to buy table silver, fine furniture, good glassware or ceramics, or to have their portraits painted, ordered or commissioned them from England or the seaboard American colonies.

Fine mahogany furniture was not made in Canada until after 1785, and then only in older and larger urban centres, such as Quebec, Montreal, and Halifax. Silversmithing survived in Quebec after 1760 through the patronage of the church and the seigneurs, but it did not emerge in the Maritimes or in Upper Canada until the later 18th century. Portraiture, too, was limited to a very few artists in Quebec, occasional itinerant British or American portraitists, or local folk artists. No glass was produced in Canada until 1840 and, except for the most basic earthenware utensils, even ceramics came almost entirely from Britain.

145
Portrait of John Graves Simcoe As a Young Man

Attributed to Johan Zoffany (1733–1810), London, 1759
Oil on canvas, 96.7 x 69.2 (38⅛ x 27¼)
The Weir Foundation, Queenston, Ontario, 982.1

John Graves Simcoe (1752–1806) was appointed the first lieutenant governor of Upper Canada in 1791, after passage of the Constitutional Act, which created the two provinces of Upper Canada and Lower Canada. Educated at Oxford, Simcoe entered the army in 1771, and first came to North America with the Thirty-fifth Regiment in 1775. From 1777 to 1781 he commanded the First American Regiment, the original Queen's Rangers.

Simcoe arrived at Newark (Niagara-on-the-Lake) in 1792, established the first legislature of Upper Canada there, and served as lieutenant governor until 1796. Both he and Guy Carleton, first Baron Dorchester, saw Newark as only a temporary capital. Simcoe favoured the site of present-day London, Ontario, but in 1793 on Lord Dorchester's orders, he inspected the site that is now Toronto, and agreed to build the capital of Upper Canada there and to name it York.

As well as for his scenes of people and activity—such as *William Hunter Lecturing on Anatomy at the Royal Academy* (see no. 181)—Johan Zoffany was noted for commemorative portraits and small-scale full-figure portraits. In this portrait, Simcoe is standing beside a tombstone surmounted with an urn dated 1759. The picture was probably commissioned by Simcoe's mother to commemorate the death at sea that year of his sea-captain father—aboard Captain James Cook's sixty-four-gun frigate *Pembroke*.

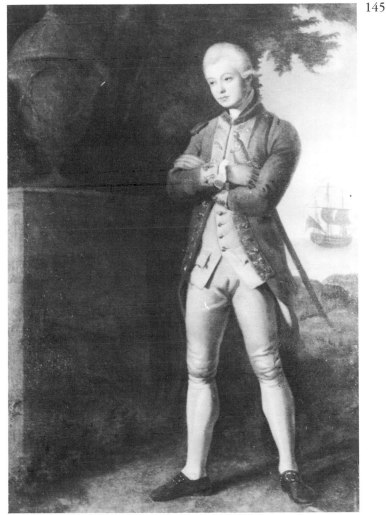

Courtesy The Weir Foundation, Queenston, Ontario.

146
Carved Lion from the Upper Canada Legislature

Canadian, York (Toronto), c. 1799–1800
Gilded pine, 96.5 x 121.9 (38 x 48)
United States Naval Academy Museum, Annapolis, Maryland, *49.2

This lion, which sat in front of the speaker's chair in the legislative building, was carved at York, the capital of Upper Canada—by a carpenter named Starkweather, according to one account. When American troops left York after their six-day occupation of the capital in April 1813, they took with them the carved British lion, the legislature's mace, and the lieutenant-governor's flag. The lion, mace, and flag were transferred as official war trophies to the United States Naval Academy in 1849, and in recent years have been in the academy's museum, although the mace was returned to the Province of Ontario in 1934.

147
The Mace of Upper Canada

Canadian, Newark (Niagara-on-the-Lake), c. 1792
Pine and brass, 142.2 x 11.4 (56 x 4½)
Legislative Assembly of Ontario, Queen's Park, Toronto

On his arrival in Upper Canada, Lieutenant Governor John Graves Simcoe ordered this mace for the first provincial assembly, which was convened at Newark (Niagara-on-the-Lake) on 17 September 1792. Produced by an unknown maker, the mace was turned on a lathe and then gilded. The crowned bonnet was painted red and its arches were made of thin sheet brass.

An early symbol of authority, the mace was carried before the speaker of the house and set on a table in front of him. This mace was used regularly in Upper Canada, first in Newark and then in York, until the American troops who invaded York in April 1813 carried it away, with the carved lion (see no. 146) and the flag from the lieutenant-governor's residence.

Finally in 1934 President Franklin D. Roosevelt returned the mace to the Province of Ontario, in honour of the centennial of the incorporation of the city of Toronto. It has since been on display in the Ontario Legislative Building.

146

Courtesy United States Naval Academy Museum, Annapolis, Maryland.

147

Courtesy Legislative Assembly of Ontario, Queen's Park, Toronto.

148
Proclamation of Lieutenant Governor John Graves Simcoe

Quebec, 7 February 1792
Printed document, 36.2 x 21.0 (14¼ x 8¼)
Royal Ontario Museum, Canadiana Department, gift of
Mrs Stephan A. Heward, 983.87.1

Even before his arrival at Newark to take up his new posting,
Lieutenant Governor John Graves Simcoe was active in soliciting
settlers and promoting land grants in the new province of Upper
Canada. He issued this proclamation outlining the conditions
under which lands could be granted, and in what amounts, early
in 1792, and reissued it four years later. The title reads "A
PROCLAMATION, To such as are desirous to settle on the Lands
of the Crown in the Province of Upper Canada: By His
Excellency JOHN GRAVES SIMCOE, Esquire, Lieutenant Gover-
nor and Commander in Chief of the said Province, and Colonel
Commanding His Majesty's Forces, etc. etc. etc."

Settlers taking up grants were required to clear land for
agriculture and to make physical improvements before they
received a final patent or deed. Grants, moreover, were often
made years in advance of the actual delineation of boundaries,
since Crown surveyors were unable to keep up with the rapid
settlement. Thus many land grants of the early 1790s were not
ultimately patented until a decade later.

149
Land Grant Patent

Upper Canada, 22 May 1804
Ink on parchment, with wax seal, 36.2 x 64.1 (14¼ x 25¼)
Private collection

This land grant patent, signed by William Jarvis, the provincial
secretary of Upper Canada (see no. 150), was issued to Nicholas
Amey (1748–18??), a Loyalist settler. The deed for the one
hundred acres of land taken up by Amey in 1784 was not issued
until twenty years later.

Nicholas Amey was the grandson of Johann Niclass Emigh, a
Palatine German who had settled in the Hudson River valley of
New York in 1712. During the American Revolution, Amey
joined a Loyalist force known as Jessup's Corps, which became
part of the army of General John Burgoyne defeated at Saratoga
in October 1777 (see no. 116). The Amey family migrated to
Sorel, Quebec, moved to the Yamachiche refugee camp in 1779,
and finally resettled in Ernesttown Township, just west of
Kingston, in the spring of 1784. Nicholas Amey drew his
hundred acres by lot at that time.

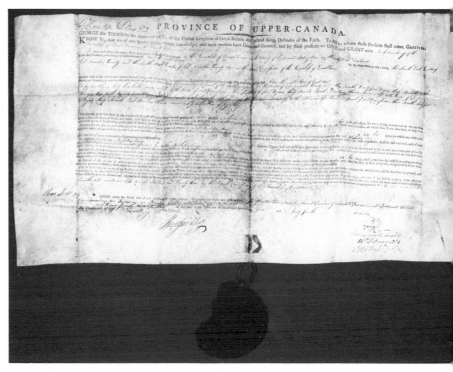

150 (See colour plate page 35.)
Portrait of Colonel William Jarvis and His Son Samuel

Attributed to the Reverend Matthew William Peters
(1741/42–1814), London, c. 1791
Oil on canvas, 107.2 x 91.1 (42¼ x 35⅞)
Royal Ontario Museum, Canadiana Department, purchased
through a grant from the Ministry of Communications,
981.79.1

William Jarvis (1756–1817), who was born in Connecticut,
served in the Queen's Rangers under Lieutenant Colonel John
Graves Simcoe during the American Revolution (see no. 145).
After the war Jarvis went to England, where in 1785 he married
Hannah Owen Peters, the daughter of the Reverend Samuel
Peters, a Connecticut Loyalist who had emigrated to England in
1774. When Simcoe was appointed lieutenant governor of
Upper Canada in 1791, Jarvis accompanied him to serve as
provincial secretary. He held the post until his death, and for a
time was also registrar of deeds.

The Reverend Matthew William Peters (who was not related
to Hannah Jarvis or her father) first started drawing in Dublin.
After moving to London in 1758, he studied under Thomas
Hudson (see no. 15), and in the early 1760s he continued his
studies in Italy. He later entered the Church of England and was
ordained in 1781. He may have become a friend of the Reverend
Samuel Peters at that time. This painting and its companion (see
no. 151) were probably done in England in 1791 or early 1792,
for Jarvis's son Samuel died shortly before the family came to
Upper Canada in May 1792.

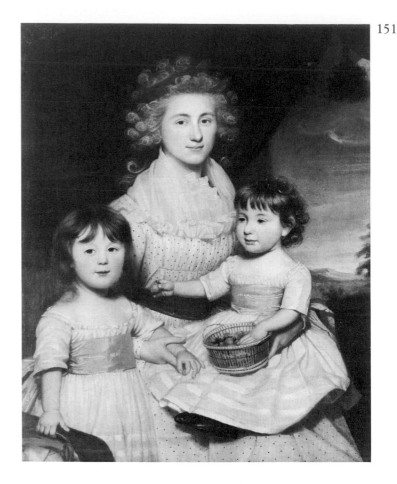

151
Portrait of Hannah Owen Peters Jarvis with Her Daughters Maria and Augusta

Attributed to the Reverend Matthew William Peters
(1741/42–1814), London, c. 1791
Oil on canvas, 106.7 x 90.6 (42 x 35⅝)
Royal Ontario Museum, Canadiana Department, purchased
through a grant from the Ministry of Communications,
981.79.2

Hannah Owen Peters, who was born in Hebron, Connecticut,
went to England with her family in 1774, and married William
Jarvis there in 1785. The couple had three children before they
left England: Samuel (1787), Maria (1788), and Augusta
(1790). After Samuel died in 1792, another son, born in Upper
Canada later that year, was given the same name.

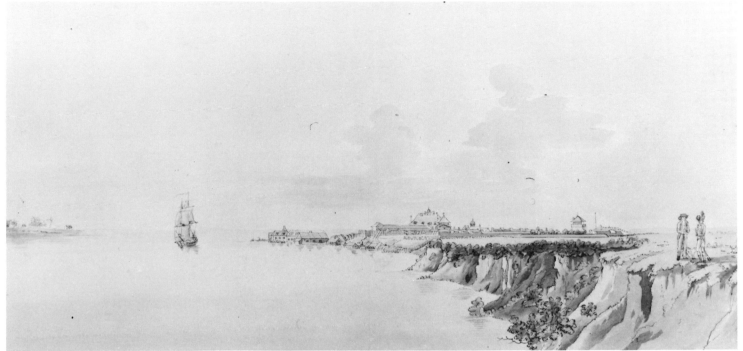

152 (See colour plate page 36.)
Sofa Table

Canadian, Upper Canada, Napanee area, c. 1810–20
Cherry and maple, with leaves extended 77.5 x 152.4 (30½ x 60)
Royal Ontario Museum, Canadiana Department, 954.55

One of the finest existing pieces of early Upper Canadian furniture, this sofa table is stylistically a New York form. The derivative Regency concave legs and central stretcher and the triple-elliptic end leaves reflect the influence of American taste on Canadian preferences at this period. The table itself is of cherry, with only the drawer and false drawer fronts of bird's-eye maple. There are no inlays; the only embellishment is the reeded carving of the central stretcher and the legs. As it was on all Canadian furniture of the early 19th century, the brass hardware is English.

The sofa table, an English Regency form developed in the 1790s, was intended to sit behind rather than in front of a sofa. It typically had either two drawers on each side, or one long drawer flanked by a false drawer front. The leaves, which were usually quite short, were on the ends rather than the sides of such tables.

153
Fort Niagara from the American Shore, 1784

James Peachey (active 1773–97), Niagara, 1784
Watercolour on paper, 29.2 x 53.3 (11½ x 21)
Royal Ontario Museum, Canadiana Department, Sigmund Samuel Collection, 956.129

In this view, Fort Niagara is on the right on the American shore of the river; Newark, now Niagara-on-the-Lake, is dimly seen on the left. Robert Cavelier, sieur de LaSalle, built the first stockade at Niagara in 1678. The fortified stone house in this drawing was erected by the French in 1726. The restored structure stands in what is now a historical park in New York State.

In his capacity as deputy surveyor general of Canada, James Peachey had many occasions to travel to important points on the new boundary between British North America and the United States. He often sketched the places he visited (see nos. 130, 131, 137, 154).

154

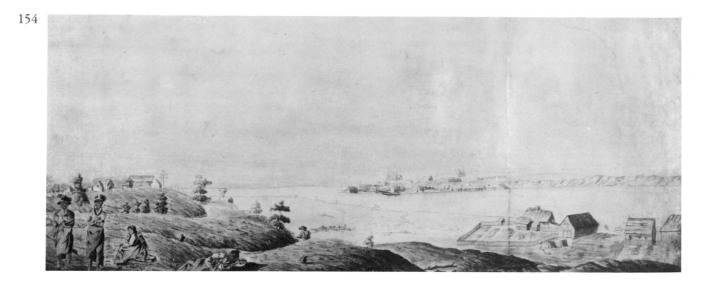

155

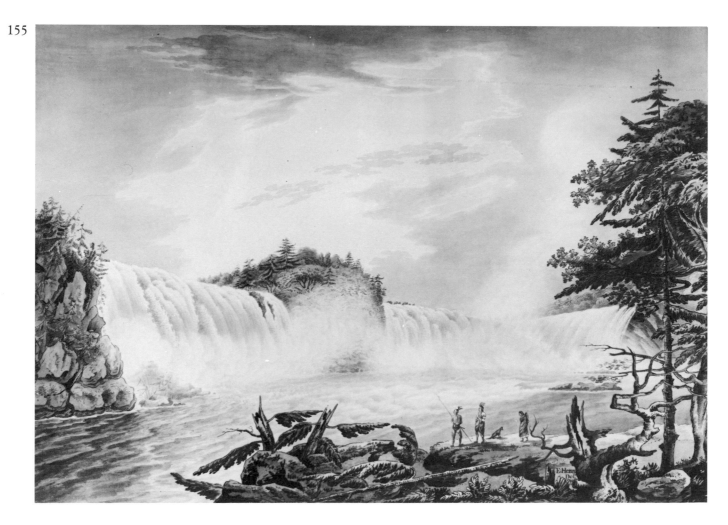

154
Fort Niagara from Navy Hall, 1784

James Peachey (active 1773–97), Niagara, 1784
Watercolour on paper, 24.8 x 60.0 (9¾ x 23⅝)
Royal Ontario Museum, Canadiana Department, Sigmund
Samuel Collection, 950.224.15

In this companion view of the lower Niagara River (see no. 153), Fort Niagara appears on the far shore in the background; the British post, Navy Hall, is on the western shore of the river. The full inscription on the reverse of this scene, in Peachey's hand, reads "A View of the Fort of Niagara at the Entrance of that River on Lake Ontario, taken from Navy Hall on the Opposite Shore."

The Niagara Peninsula was settled almost immediately after the American Revolution—by Loyalists, the beginnings of a northward flow of Pennsylvania-Germans, and Scots and Germans mustered out of various British regiments. Thus it became an established agricultural area well before the creation of Upper Canada as a separate province in 1791.

155
A View of Niagara Falls

Edmund Henn (active 1789–1800), Niagara, 1799
Ink and watercolour on paper, 61.0 x 85.4 (24 x 33⅝)
Royal Ontario Museum, Canadiana Department, Sigmund
Samuel Collection, 961.129

The falls of the Niagara River proved to be a natural attraction for tourists and artists, almost from the time of their discovery by European explorers. Certainly they had a great appeal for the British military topographical artists, of whom Thomas Davies was the first to draw them in 1766. This particularly strong and dramatic view is from below the falls, and shows some Indians standing in the foreground. It was done by Edmund Henn, a captain in the Twenty-fourth Regiment of Foot, which served in Canada from 1789 to 1800.

156
Niagara Falls from an Upper Bank on the British Side

John Trumbull (1756–1843), 1808
Oil on canvas, 61.9 x 92.9 (24⅜ x 36⅝)
Wadsworth Atheneum, Hartford, Connecticut, bequest of
Daniel Wadsworth, 1848.4

One of the earliest known oil paintings of Niagara Falls, this is also one of the more sophisticated views of the natural phenomenon. The foreground setting is placid, with three elegant figures strolling beside the calm waters that lap the near shore. Behind the figures the mists from the powerful waterfall rise high in the air. This is John Trumbull's vision of nature tamed, with the falls too far removed to be alarming.

The American John Trumbull is not generally considered to be a landscape artist, since he is most famous for his historical scenes and monumental battle scenes (see no. 104). Landscape painting, in fact, had not yet really emerged as a primary focus for artists in North America; its heyday awaited the romanticists of the 1820s to the 1840s. Trumbull, however, visited Niagara in 1807, and produced two canvases, this one and another done from the American side.

157
Migration of Wild Pigeons over Old Fort Erie

Signed by Edward Walsh (1756–1832), Fort Erie, 12 April 1804
Watercolour on paper, 25.4 x 35.6 (10 x 14)
Royal Ontario Museum, Canadiana Department, 952.218

One of the great sights of spring in early Canada was the northward migration of passenger pigeons—at that time perhaps the most numerous bird population. Although smaller than present-day urban pigeons, passenger pigeons were a staple source of food. In this scene, hunters are busy bringing down pigeons; so thick were the flights that it was sometimes possible to bag twenty or thirty birds with a single shot from a flintlock musket or a fowling piece. Such intense and unregulated hunting, of course, eventually led to the extinction of the passenger pigeon.

156

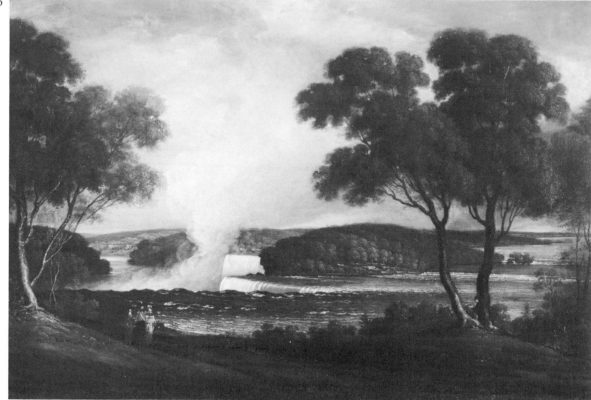

157

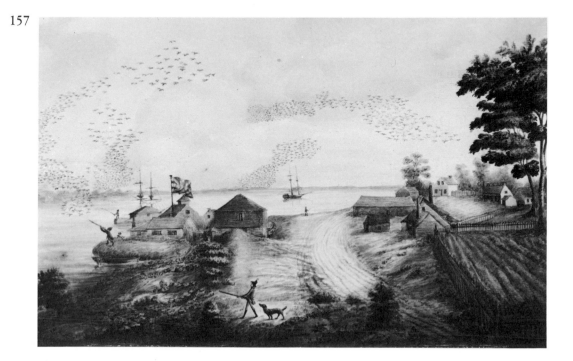

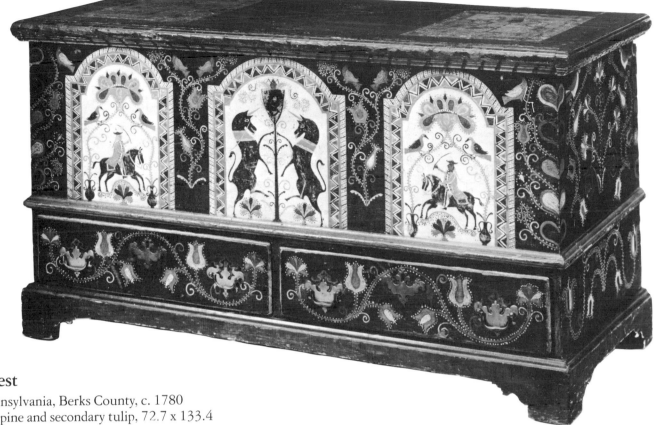

158
Dower Chest

American, Pennsylvania, Berks County, c. 1780
Painted yellow pine and secondary tulip, 72.7 x 133.4
(28⅝ x 52½)
The Metropolitan Museum of Art, New York, Rogers Fund,
1923, 23.16

By the late 18th century the art of decorative painting on
furniture—and also of decorative ceramics—had reached its
height in the Germanic areas of Pennsylvania. On the panels of
this elaborately painted chest a decorative border surrounds a
variety of motifs, such as mounted horsemen, unicorns, urns,
and birds. Around the panels, below them, and on the sides of the
chest a tulip motif is repeated. The style and construction of
these Pennsylvania chests are a mixture of German and Anglo-
American characteristics; this piece, for example, has brass
bail-loop handles on the lower drawers and extended Chippendale
bracket feet.

Although some ornamented Germanic pine chests of this type
were made in Canada in the 19th century, the practice of highly
decorative painting had declined by that time, as it also had in
Pennsylvania. Later 19th-century decorative painting is usually
either rudimentary, or takes the form of graining, which
continued in vogue for decades.

159
Storage Chest

Canadian, Ontario-German, Niagara Peninsula, c.1810
Walnut and maple, 74 x 120 (29⅛ x 47¼)
Private collection

Upper Canadian Germanic furniture of the first quarter of the 19th century follows precisely the traditional forms that emerged in Pennsylvania during the 18th century—a circumstance that often makes the furniture difficult to date precisely. Mixtures of early German and English characteristics that developed in the 18th century have obvious parallels with mixed "Franglais" Quebec furniture of the late 18th and the 19th centuries. The extended derivative Chippendale bracket feet and exposed dovetailing at the corners of this chest indicate a cultural rather than a national or a regional pattern. The drawer fronts are outlined with bands of curly maple.

160

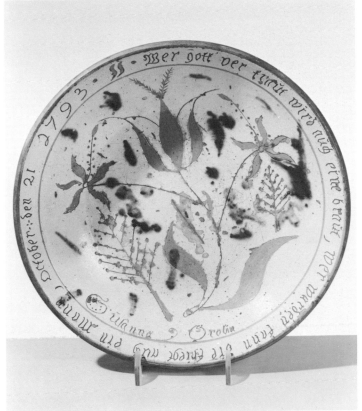

Courtesy Philadelphia Museum of Art.

161
Tall Jar
Canadian, Ontario-German, Waterloo County, c. 1820–50
Earthenware, 46.4 (18¼)
Royal Ontario Museum, Canadiana Department, 949.33

Since it was largely isolated from English importations, Upper Canada of necessity developed indigenous craft industries almost immediately after the first influx of Loyalists. The migration of Pennsylvania-Germans into Upper Canada that began immediately after the American Revolution and continued well into the 19th century included craftsmen as well as farmers. Cabinet-makers, iron workers, and potters were all active before 1800.

The strongest tradition in earthenware was that of the Pennsylvania-Germans. Using local red-firing clays, these artisans established many one-man or family potteries, in which they produced traditional forms and shapes wholly by hand and wheel. The extreme Pennsylvania slip and sgraffito decoration of the 18th century had gradually disappeared (even in Pennsylvania), but the 19th-century potters used a wide variety of metallic glazes to achieve decorative effects that were unique.

This tall jar, a special rather than a production piece, is glazed with a mottled orange on a base copper green. Although it is unmarked (as is most earthenware), the jar was probably intended as a gift.

160
Sgraffito-Decorated Plate
Presented to Susanna Grob
American, Pennsylvania-German, dated 1793
Earthenware, 5.7 x 30.8 (2¼ x 12⅛)
Philadelphia Museum of Art, purchased Baugh Barbar Fund, 59–41–1

Pennsylvania-German potteries in the middle and late 18th century produced extremely decorative earthenware in a German manner, often as specific presentation pieces to commemorate births, baptisms, and marriages. Some of this presentation earthenware was decorated by the sgraffito technique, with the designs scratched through the covering slip or glaze and into the pottery body itself before firing. The sgraffito-outlined decorations were then often slip-painted in different colours.

Susanna Grob and her brother Abram emigrated to Upper Canada in 1800 and settled in the Niagara Peninsula. The name descended as both Grob and Grobb, and some members of the family became Ontario potters later in the 19th century.

161

162 (See colour plate page 36.)
Processional Cross

Canadian, marked by Salomon Marion (1782–after 1832),
Montreal, c. 1815–25
Silver, 71.1 x 35.6 (28 x 14)
Royal Ontario Museum, Canadiana Department, 950.220

Silver processional crosses by Quebec makers are particularly
rare, since most crosses were made of wood or brass—perhaps
because they required a greater amount of metal than any other
single object. This type of cross, which had a socketed base for
mounting a staff, was carried by the crucifer in ecclesiastical
processions. In the centre is a separately cast and applied figure of
Christ. The arms of the cross terminate in unusual fleur-de-lis
finials.

163
Monstrance

Canadian, marked by Laurent Amiot (1764–1838), Quebec,
c. 1815–25
Silver, 45.7 x 14.6 (18 x 5¾)
Royal Ontario Museum, Canadiana Department, 937.57

This very elaborate chased and engraved monstrance represents
the best of Laurent Amiot's church silver. The piece shows
mixed influences—a base reflecting the beginnings of the French
Empire style that became popular after the War of 1812,
combined with traditional Chippendale square bracket feet,
usually found only on furniture. The container for the conse-
crated Host behind the circular glass door is a separate silver-gilt
insert. At one time, every Quebec church of any reasonable
prosperity could boast of silver altar vessels of this quality.

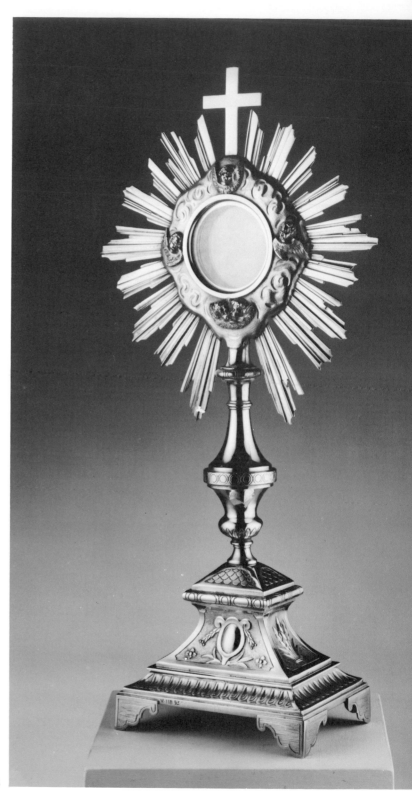

163

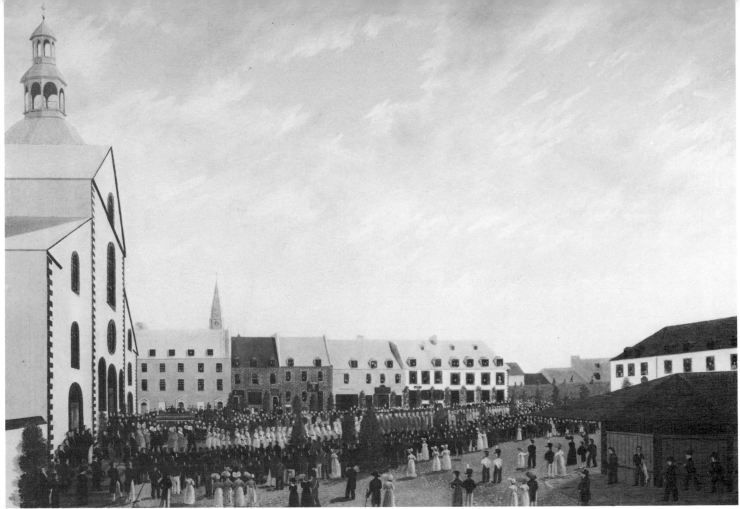

164

164
Procession de la fête-Dieu

Signed by Louis-Hubert Triaud (1794–1836), Quebec, 1824
Oil on canvas, 75.5 x 101.5 (29¾ x 40)
Musée des Ursulines de Québec, 70

The church was a primary influence in French Canadian life in
the 19th century. One of the main annual events, the celebration
of Corpus Christi in late June, is pictured quite dramatically in
this canvas, which is an excellent document of the importance of
religious ceremonies. The procession here is led by the curé of
the Basilica of Notre Dame, along a route marked by the young
fir trees associated with death and funerals. The priest carrying
the monstrance is flanked by four wardens of the parish. Other
clergymen, the choir, and the congregation follow.

Louis-Hubert Triaud, who was born in London of French
parents, spent his boyhood in France. He came to Quebec in
1819 to teach drawing and painting at the Ursuline convent. A
friend and protégé of the Quebec artist Joseph Legaré, Triaud
assisted Legaré in some large projects.

165–167
Portraits of the Reverend Jehoshaphat Mountain, His Wife Mary, and His Daughter

William von Moll Berczy (1744–1813), Montreal, c. 1805–10
Pastels on paper, 22.7 x 20.2; 22.5 x 20.0; 22.1 x 20.0 (8¾ x 7⅞)
Royal Ontario Museum, Canadiana Department, Wintario
grant, 981.54.1–3

The Reverend Jehoshaphat Mountain (1747–1817) came to Canada in 1793 with his younger brother Jacob, who had just been appointed the first Anglican bishop of Quebec. A year later Jehoshaphat went to the Anglican parish at Three Rivers, and in 1803 he became rector of Christ Church in Montreal.

The Mountain brothers were staunch proponents of the traditional and somewhat aristocratic views of the Church of England. When he visited Upper Canada in 1794, Bishop Jacob Mountain found to his horror that the ecclesiastical leaders were "itinerant and mendicant Methodists, a set of ignorant enthusiasts whose preaching is calculated only to perplex the understanding and corrupt the morals; to relax the nerves of industry, and dissolve the bonds of society." From the standpoint of other Church of England clergymen, Nova Scotia with its New England Congregationalist background was in no better spiritual shape. One early Anglican missionary reported that he "found the lower orders of the people, nearly to a man, Presbyterians or fanatics." The Mountains clearly had their life's work cut out for them.

William Berczy, who had first emigrated to New York State, settled in Upper Canada and then in 1805 in Montreal, where he made his living as an artist. He probably did these portraits of the Mountain family shortly after his relocation to Montreal.

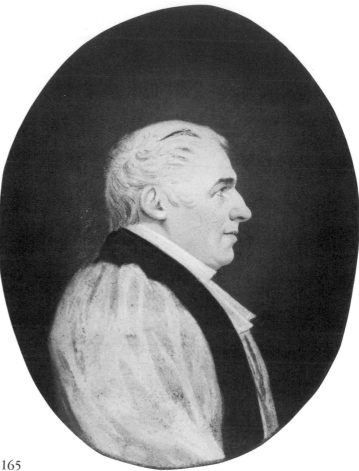

165

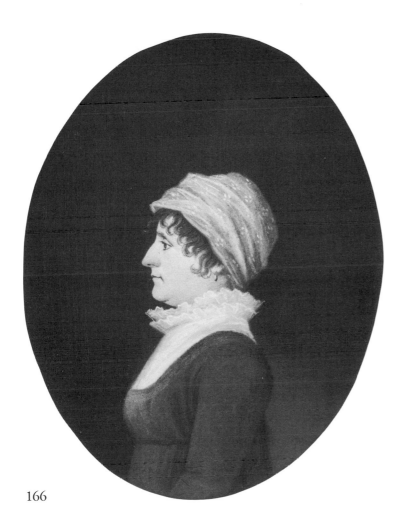

166

167

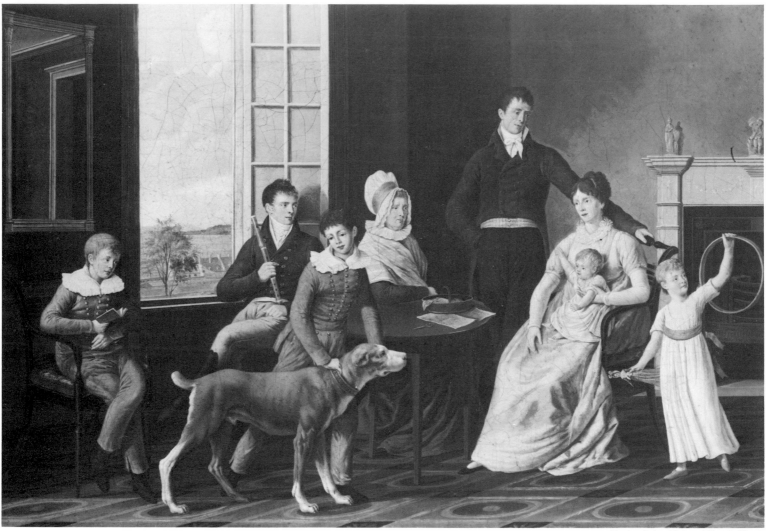

168

162

168
The Woolsey Family
William von Moll Berczy (1744-1813), Montreal, 1809
Oil on canvas, 60.3 x 87.0 (23¾ x 34¼)
National Gallery of Canada, Ottawa, gift of Major Edgar C.
Woolsey, Ottawa, 1952, 5875

This often illustrated group scene of the Woolsey family
is one of William Berczy's few known oil paintings, since
the artist was more disposed to watercolours and pastels. It
was commissioned by John W. Woolsey, a wealthy Quebec City
merchant, after Berczy settled in Montreal in 1805. The dog's
collar is inscribed "I.W. Woolsey 1809". On the back of the
canvas is a label, signed by Woolsey, that states "the family group
represented in this picture was painted in 1809 by Mr. Berczy, an
amateur, assisted by his son William. The eight portraits cost £10
each, the dog Brador was added without cost."

The picture is distinct in that it is a group portrait. It is also an
excellent reflection of the acceptance of English classical taste in
Canadian interior decor and costume of the time. The mantel,
the mirror, and the furniture all attest to this. The view from the
open window places the setting as Quebec.

Except for the watercolours of British military artists, artistic
endeavour in Canada during the late 18th and early 19th
centuries was limited almost exclusively to individual portraiture.
Markets for more varied forms of art, such as landscapes, marine
paintings, or genre scenes, did not emerge until the period of
development after the War of 1812. This complex group
composition is the first of its type done in Canada for a Canadian
patron.

169 (See colour plate page 37.)
Northwest Part of the City of Quebec
George Heriot (1759-1839), Quebec, 1805
Oil on canvas, 73.7 x 109.2 (29 x 43)
Royal Ontario Museum, Canadiana Department, Sigmund
Samuel Collection, 955.227

In this magnificent winter view of Quebec from the St Charles
River, some of the city's residents are engaged in the popular
winter sport of sleighing on the river. A variety of vehicles are
shown: sleighs, carrioles, and on the left even a dog sled.
Sleighing was a sport that could be dangerous, for horses
regularly slipped and fell and sleighs sometimes overturned.

This painting in oils is unusual for George Heriot, who
worked almost exclusively in pencil and watercolour. As the
buildings and the sleighs demonstrate, the artist was a masterly
and meticulous draftsman, with a fine sense of perspective.

170 (See colour plate page 37.)
Sheraton Sideboard
Canadian, Montreal, c. 1800-1820
Mahogany, satinwood, maple, and secondary pine, 100.3 x 171.5
(39½ x 67½)
Royal Ontario Museum, Canadiana Department, 967.166

This mahogany and mahogany veneer sideboard reflects the
range of exotic woods being imported into Canada as precut
veneers early in the 19th century. In the centre of the middle
drawer is an inlaid oval of satinwood in a rectangle of maple.
Although satinwood was very popular in England, its earliest
known use as a veneer in Canadian furniture dates from no
earlier than 1810 to 1812. The top and bottom case edges of the
sideboard are decorated with geometric band inlays, which also
outline the maple rectangle and the edges of the doors. The light
Sheraton legs are reeded.

Early in the 19th century Montreal became the Canadian
centre of sophisticated cabinetmaking and furniture. The fact
reflected the city's growing economic status and its importance as
the seaport for rapidly expanding Upper Canada and the west.

171

172

164

171
A View of Quebec, c. 1798

Inscribed and signed by George Heriot (1759–1839), Quebec, c. 1798
Watercolour on paper, 50.8 x 88.9 (20 x 35)
Royal Ontario Museum, Canadiana Department, 981.208

In this pastoral scene, the farms along the banks of the St Charles River are in the foreground. Quebec is to the right, with the St Lawrence River flowing beyond it. The city has developed and grown considerably since 1760. In fact, a great deal of new building has taken place in the interim since James Peachey sketched Quebec in 1784 (see no. 137).

Most of George Heriot's drawings and watercolours were done in small size, on sketchpad paper (see nos. 182, 183). This is one of his few surviving large-scale views. The inscription in the bottom right corner reads "N:W: View of the City & Fortifications of Quebec, taken from the banks of the St. Charles."

172
A View of Montreal, 1806

Signed by Edward Walsh (1756–1832), Montreal, 1806
Watercolour on paper, 35.5 x 52.3 (14 x 20⅝)
Royal Ontario Museum, Canadiana Department, Sigmund Samuel Collection, 952.217

This splendid view of Montreal and the St Lawrence beyond it, with Île Sainte-Hélène to the left, was done from McTavish's monument at the top of the mountain overlooking the city and the river. It was published as an aquatint by Rudolph Ackermann in London in 1811.

Edward Walsh was born in Ireland and received a medical degree from the University of Glasgow in 1791. From 1796 to 1802 he served as an army doctor in Ireland and on the Continent. Two years later he came to Canada to join the Forty-ninth Regiment, later transferring to the Sixty-second. His watercolours of the places where he was stationed—Montreal, Fort Erie, and Fort George—were published as aquatints between 1811 and 1814.

173

173
Portrait of Edward, Duke of Kent and Strathearn

George Dawe (1781–1829), London, 1818
Oil on canvas, 87.6 x 68.9 (34½ x 27⅛)
Private collection

Edward Augustus (1767–1820) was the fourth and rather difficult son of George III. After entering the army in 1786, Edward ran up heavy debts. In 1790 the king posted him to Gibraltar, but he quickly became unpopular there and was withdrawn and sent to Canada, where he served from 1791 to 1793. Edward was then promoted to the rank of major general, and at his own request joined Sir Charles Grey's force in the West Indies in 1794. Two years later he returned to Canada, now with the rank of lieutenant general, but was invalided back to England in 1798. The following year Edward became Duke of Kent and Strathearn, achieved the rank of general, and was appointed commander in chief of forces in British North America. Ill health forced him to resign this appointment and return to England in 1800. Just two years before he died, Edward married Victoria Mary Louisa, widow of the Prince of Leiningen; the couple had one child, Victoria, who became queen in 1837.

George Dawe was a portraitist who exhibited both at the British Institution (1806–13) and at the Royal Academy of Arts (1804–18). In 1816 he did the first of his many portraits of Princess Charlotte and Prince Leopold of Belgium. He was also commissioned by various other European kings and princes, including Czar Alexander I of Russia. Among his royal patrons was George III. This portrait of the Duke of Kent and Strathearn is one of a number of versions done by Dawe in 1818.

174 (See colour plate page 38.)

Secretary-Desk of Edward, Duke of Kent and Strathearn

Canadian, Quebec, c. 1792–1800
Mahogany, 213.4 x 111.8 (84 x 44)
Royal Ontario Museum, Canadiana Department, gift of
F. St George Spendlove, 962.81

One of the finest known examples of English-Canadian furniture of the Georgian period, this secretary-desk was made in Quebec for Edward, Duke of Kent and Strathearn, either between 1792 and 1793 or between 1796 and 1799. The piece is of mahogany with secondary pine and poplar. The only ornamentation is found in the carved moulding of the upper door panels and the strong lion's-paw feet. The shaped upper bookcase doors suggest a French Canadian maker working in an English manner. The desk has been tentatively attributed to François Baillarge of Quebec, the famous church carver of the late 18th century.

175

Banjo Clock

American, William Cummens (1768–1834), Boston, c. 1810–25
Mahogany, painted glass, 105.4 x 25.4 (41½ x 10)
Museum of Fine Arts, Boston, bequest of Charles Hitchcock
Tyler, 32.297

Driven by a weight and equipped with a pendulum, the banjo clock is really a wall-mounted version of the standing tall clock. It was a favourite early 19th-century type in New England, where many extremely elaborate clocks were produced, although it never became popular in Canada. The only known Canadian examples are those made by Martin Cheney of Montreal.

This ornate banjo clock has a gilded bracket applied to the base and a painted-glass pendulum-case cover. On the lower glass door is a painted oval view of Boston. The side arms and the eagle finial are of brass. The face of the clock is inscribed "Warranted for Dr. Bugbee" (Bugbee was the maker's father-in-law).

William Cummens, who had apprenticed with Simon Willard, worked in Roxbury, Massachusetts, after about 1790. The painted-glass covers on his clocks are attributed to Charles Bullard.

176
Bracket Clock

Canadian, marked by François Doumoulin, Montreal,
c. 1785–1800
Mahogany, 47.6 x 27.3 (18¾ x 10¾)
Royal Ontario Museum, Canadiana Department, 950.23

Among the commoner forms of English clocks of the late 18th century was the so-called bracket clock, which could be hung on a bracket extended from a wall, although it was also provided with feet for standing on a mantel or sideboard. The form did not achieve great popularity in the United States, but in Canada the bracket clock was second only to the tall clock. Some thirty examples of fine late 18th-century Canadian bracket clocks are known at present.

This clock has English works, though the brass face is marked by François Doumoulin. The case was made by a French Canadian cabinetmaker working in an English manner. It is fully mahogany-veneered over secondary pine, with no separate inlays.

177
Sleighing in New Brunswick

Sir Richard George Augustus Levinge (1811–89), Saint John,
c. 1835–36
Watercolour on paper, 32.1 x 47.8 (12⅝ x 18⅞)
National Gallery of Canada, Ottawa, 9933

In this scene, the officers of Richard Levinge's regiment and their guests are about to depart on a sleighing party. The men are dressed in fur-collared coats, the ladies in their finest fur coats, capes, and muffs. A leopard-skin carriage robe draped over the sleigh in the foreground adds an exotic touch to the scene. Such Sunday afternoon outings were typically followed by a formal regimental dinner and possibly a dance, with music provided by the regimental band (see no. 178).

Richard Levinge was an artist and a writer as well as an army officer. He was commissioned in the Forty-third Regiment in 1828, and posted to Saint John, New Brunswick, in 1835, in time for the winter overland march to Montreal during the Lower Canada Rebellion of 1837. He was later stationed at Niagara, Drummondville, and Amherstburg, before finally returning to England in 1840.

178
Meeting of the Sleigh Club at the Barracks

Signed by Richard George Augustus Levinge (1811–89),
Saint John, c. 1835–36
Watercolour on paper, 28.2 x 50.0 (11⅛ x 19⅝)
Royal Ontario Museum, Canadiana Department, Sigmund
Samuel Collection, 953.186.2

This delightful scene of a regimental sleighing party about to depart on an outing was a preparatory sketch for a lithograph published in London in 1838. It typifies the life of British officers on garrison service in Canada after the War of 1812 (see no. 177).

From surviving pictures and description, it seems that post-war garrison life in Canada was one constant party. Garrison duties were hardly onerous, and many of the officers were men of independent means. They dominated the social life of any community in which they were stationed. Civilians—unattached women in particular—vied for invitations to military balls. Life in the soldiers' barracks, of course, was a somewhat different matter, and provoked a substantial rate of desertion.

177

Courtesy National Gallery of Canada, Ottawa.

178

LIFE IN
BRITISH NORTH AMERICA

MEDICINE

The state of medicine and medical care in 18th-century North America was primitive at best. Diseases such as smallpox, measles, dysentery, typhoid fever, cholera, tuberculosis, influenza, typhus, scarlet fever, and even the plague swept whole populations. Doctors were rare and, with the exception of the very few who had university training, learned their craft through apprenticeship. Even surgeons were considered craftsmen rather than professionals. Concepts of germs, infection, contagion, nutrition, hygiene, or sanitation were unknown.

Medicine was often practised with an absence even of common sense, with "spirits", "vile humours", or "noxious vapours" generally accepted as the causes of disease. Treatments such as bleeding, induced sweating, and the administering of truly bizarre and sometimes poisonous potions, including mercury compounds, are known to have killed patients by the thousands.

Severe wounds, whether incurred through accidents or in battle, were usually fatal. Some seventy per cent of compound-fracture patients eventually died, as did ninety per cent of victims of internal injuries, and eighty per cent of those wounded in battle. Military life was, in fact, perhaps the least survivable, largely because of crowded and primitive living conditions and limited and poor food. The military mortality rate from disease was normally three to five times that of battlefield casualties.

It is no understatement that medical attention in this period more often than not precipitated death, or that coffin making rather than building was the single most constant business of carpenters and cabinetmakers. No reliable statistics exist on normal mortality in late 18th-century Canada, but some figures for the early United States (1780s) are certainly relevant.

Children, lacking immunities, were the most vulnerable. It was a rare mother who did not bury at least one child, and many parents were left with no surviving children at all. Probably fewer than half of all children born lived to the age of ten. Figures and opinions on the life expectancy of adults vary, but on average not more than one person in ten lived to be fifty. Those that did reach the half-century mark, however, had often acquired such resistance to disease that they could live on into their seventies or eighties. Still, to live long enough to die of old age was exceptional.

Canadians, like Americans, nonetheless appear to have enjoyed a lower rate of mortality than the British or the Continental Europeans. Better or more advanced medical care, however, was hardly responsible. More abundant and varied food in North America raised general health levels, and wider dispersal of population hindered the spread of contagious disease and lessened the effects of lack of sanitation.

In spite of the fact that there existed a very small number of physicians who were true scientists, little substantial advance in medical understanding or knowledge occurred during the late 18th or the early 19th century. Only after about 1840 did real progress begin, and not until about 1860 to 1870 was the average patient better off with a doctor than without one.

MUSIC AND DRINK

Other than music and drink, 18th-century Canada enjoyed few diversions. Passive entertainment—radio, television, or movies—did not of course exist, and only occasional concerts or travelling plays provided any sort of cultural life, even in the larger cities. Entertainment required participation, in card and table games, amateur music, singing and dancing, and other group activities.

Most gatherings were fuelled by strong drink: West Indies or Halifax rum, brandy, local beer, or French wine. Per capita consumption of alcohol was far greater than it is today, and the temperance movement did not begin until the 19th century. Every village had at least one tavern, and often several, and some cities and towns had more taverns than all other businesses combined. It has been said of Halifax in the 1780s that half of the population was employed in making rum and the other half in consuming it.

Not only entertainments and festivities but also work that required group effort often ended with the participants rowdy, raucous, or comatose. Barn framing could hardly be raised and pinned, or a vessel launched and floated, without the requisite keg or kegs of rum, brandy, or beer. British North America's early decades were a time of hard and unending physical labour offset by unfettered and intemperate entertainment. Music and drink were usually inseparable.

THE FUR TRADE

After 1760 the western fur trade, the economic foundation of New France, came under the control of British merchants based in Montreal. In competition with the Hudson's Bay Company, however, the Montreal merchants were at a disadvantage, for their transport costs were far greater than those of the Hudson's Bay Company, which operated from Hudson Bay.

As had the French before them, the Montreal merchants sent trading agents with canoe convoys of trade goods to the western interior; the canoes returned to Montreal laden with furs. The Hudson's Bay Company had always confined its posts to the shores of Hudson Bay, depending on the Indians to bring in their furs. The direct trading of the Montreal merchants forced the Hudson's Bay Company to extend into the interior. Its first inland post, Cumberland House on the Saskatchewan River, was established in 1774.

The Montreal merchants recognized that competition among themselves was ruinous and they began to combine operations as early as 1769. Small partnerships were formed and dissolved regularly, until in 1787 a twenty share partnership became the North West Company. Western traders formed the rival XY Company in 1797, but it soon merged with the North West Company. After 1804, under the chief director William McGillivray, the North West Company held a monopoly of the Montreal-based fur trade, with the Hudson's Bay Company its only serious competitor.

As the fur trade expanded ever westwards, the natural cost advantages of shipping to and from Hudson Bay, as opposed to Montreal, gradually became decisive. In 1821 the North West Company was absorbed into the Hudson's Bay Company, which then assumed complete control of the Canadian fur trade. The long heyday of the Montreal fur trade came to an end. The Montreal merchants diversified into more profitable areas—timber, grain and other staples, and manufactures—and gradually made Montreal into a major North American commercial metropolis.

TRANSPORTATION

Transportation was one of the greatest problems in early Canada. Roads of the period were few and crude. Hacked through the wilderness, full of stumps and holes, with deep mud, choking dust, or frozen ruts in season, the roads were for many decades suitable only for light and torturous horseback travel. They were useless for transporting heavy or fragile cargo. A surveyor in 1802 wrote of Upper Canada that "ten miles of road fit for any kind of wheeled carriage is not to be found in the Province."

Water transport, by virtually any form of craft and raft that would float, was far preferable. It was the lower Great Lakes and the St Lawrence and their tributaries—the prime routes from Upper and Lower Canada to the sea—not the roads that dictated the patterns of settlement and the development of agriculture and trade.

Timber from the shores of Lake Ontario was floated in huge rafts to Montreal. In 1802 Upper Canada alone exported more than eight million bushels of wheat and flour to Britain by the St Lawrence River route.

Still, the countless rapids and shallows of the St Lawrence required constant trans-shipment of cargoes. Steamboats first appeared on the St Lawrence River in 1809, and on Lake Ontario in 1816, but lack of cooperation between Upper and Lower Canada inhibited navigational improvements. Only in the 1820s did canal building commence. The first Lachine Canal, built around the Lachine Rapids at Montreal, was only four feet deep. The Rideau Canal, opened in 1832 from present-day Ottawa to Kingston, was designed to link the Ottawa River with Lake Ontario and the upper St Lawrence. The first Welland Canal, between Lake Erie and Lake Ontario, was begun in 1829 and opened in 1833; it became vital to Upper Canadian transportation after the New York State Erie Canal was inaugurated in 1825. With the Erie Canal, Upper Canada at last had another route to the sea for imports and exports, via the Hudson River and New York. It was the completion of the Erie Canal, too, that finally precipitated improvements to navigation on the St Lawrence River.

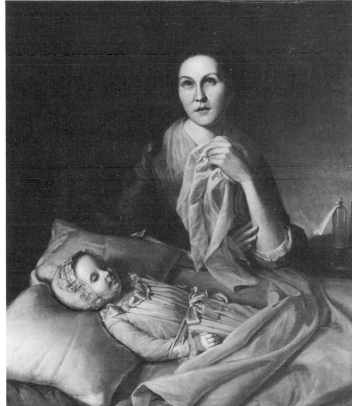

179

Courtesy Philadelphia Museum of Art. Photograph by Will Brown.

179
Rachel Weeping

Charles Willson Peale (1741–1827), Philadelphia, 1772–76
Oil on canvas, 94.3 x 81.9 (37⅛ x 32¼)
Philadelphia Museum of Art, gift of The Barra Foundation,
Inc., 1977-34-1

This unusually direct and personal portrayal of a mother mourning the death of her child was painted by Charles Willson Peale as a memorial to his daughter Margaret, who died of smallpox in 1772. The initial version of 1772 was a record of Margaret alone, chin and hands bound in preparation for burial. In 1776 Peale added the distraught weeping mother to the composition, transforming the scene from a melancholy record of a dead child to a traumatic picture of mourning.

Peale kept this work in his studio, covered by a curtain. He never intended *Rachel Weeping* for a wide, impersonal audience, nor did he publicly exhibit the painting during his lifetime.

180
Physician Treating a Patient

Signed by Jan Josef Horemans the Elder (1682–1759),
Antwerp, c. 1721
Oil on canvas, 52.4 x 59.8 (20⅝ x 23½)
Wellcome Institute for the History of Medicine, London,
15/1974

In this rare early 18th-century view of the interior of a physician's surgery, the patient is obviously undergoing some very unpleasant procedure at the hands of a young surgeon or apprentice, under the supervision of a bewigged senior physician. In the doorway the next patient nervously waits his turn. The woman seated to the right seems about to be sick. All the accoutrements of a medical office—surgical and pharmaceutical equipment and apothecary containers—are ranged on the shelves of a cabinet on the right wall.

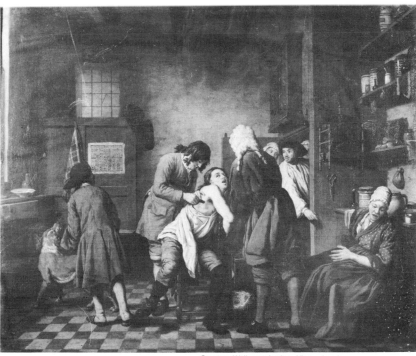

180

Courtesy Wellcome Institute Library, London.

181
William Hunter Lecturing on Anatomy at the Royal Academy

Signed by Johan Zoffany (1733–1810), London, c. 1772
Oil on canvas, 77.5 x 103.5 (30½ x 40¾)
Royal College of Physicians, London

William Hunter (1718–83), who trained at Edinburgh, Glasgow, and St George's Hospital, London, became one of the most distinguished surgeons of his day, specializing in obstetrics. He was elected to the Royal College of Physicians in 1756, and became physician to Queen Charlotte after 1762. Throughout his career Hunter was a scientist, a teacher, an experimenter, and a seeker of knowledge.

It was accepted 18th-century academic practice for young and aspiring artists to study anatomy. Thus when the Royal Academy of Arts was founded in 1768, Hunter was appointed professor of anatomy. In this scene he demonstrates with a live model, in addition to a plaster figure and a skeleton. The only member of the audience identified is Sir Joshua Reynolds, who is seen on the left, holding an ear trumpet.

Johan Zoffany, who was born and trained in Germany, went to London in 1760. With the impresario David Garrick as his supporter, Zoffany created naturalistic theatre paintings and domestic conversation pieces (groups of people engaged in activities). Zoffany received many commissions from the royal family, and George III nominated him to the Royal Academy. He spent much of the 1770s in Italy, and of the 1780s in India. On his return to England in 1789, Zoffany went into semi-retirement. Only a few pictures are known from after that date, and he appears to have retired completely by 1800.

181

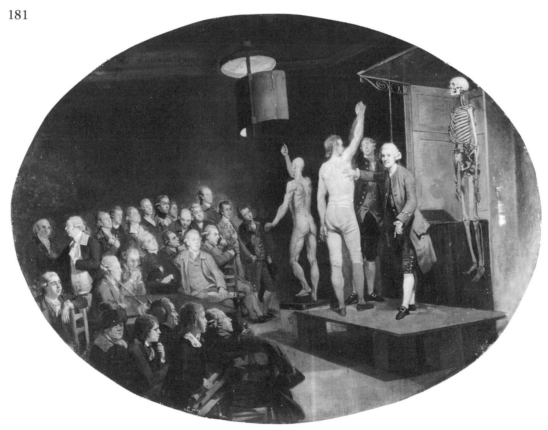

Courtesy Royal College of Physicians, London.

172

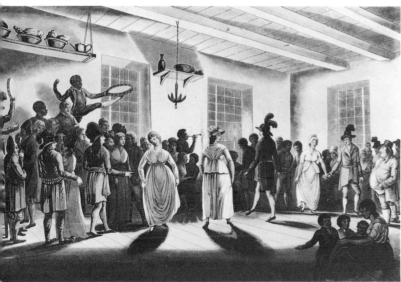

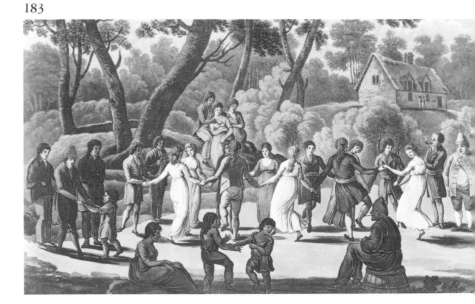

182
Minuets of the Canadians

George Heriot (1759–1839), London, 1807
Aquatint and watercolour, 24.8 x 36.5 (9¾ x 14⅜)
Royal Ontario Museum, Canadiana Department, Sigmund
Samuel Collection, 949.150.14C

With dancers in the foreground and spectators and musicians ranged around the room, this sizeable party typifies the highly participatory musical life in early Canada. The music is provided by two visible tambourines, and probably a keyboard instrument and certainly some fiddles out of view. In the assemblage are French Canadians, wearing both *fléchées* and toques, several people in clearly English costume, and also several blacks—an unusual touch. The blacks, including the musician playing his tambourine with his foot, may have been slaves, but they may equally well have been Loyalist ex-slaves who were sent to Halifax from New York and then migrated into Quebec.

Scottish-born George Heriot had studied and learned the military style of drawing, but he did not pursue an army career. He came to Quebec in 1792 as a civilian employee of the army ordnance paymasters department. In 1799 he was appointed deputy postmaster general of British North America, and he served in that post until his return to England in 1816. Heriot, who drew constantly, left hundreds of sketches which still survive. He also published two books: *The History of Canada* (London, 1804) and *Travels Through the Canadas* (London, 1807). The latter was illustrated with aquatints after his own drawings, of which this one was plate 43.

183
La Danse ronde

George Heriot (1759–1839), London, 1807
Aquatint and watercolour, 23.1 x 36.1 (9⅛ x 14¼)
Royal Ontario Museum, Canadiana Department, Sigmund
Samuel Collection, 949.150.14D

The second of George Heriot's dance scenes for *Travels Through the Canadas* (London, 1807) was this outdoor round dance, a country jig performed to the tunes of one or more fiddlers. One musician, with his violin, is visible just beside the gyrating group of dancers, who are being mimicked by some small boys in the foreground.

In neither of Heriot's dance pictures (see no. 182)—destined after all as illustrations for public distribution—is there so much as a cask, a bottle, or even a glass in sight, though some men are smoking clay pipes. There is no doubt, however, that such entertainments were liberally fuelled.

184

185
The Sense of Hearing
Signed by Philippe Mercier (1689?–1760), London, 1740–50
Oil on canvas, 132.0 x 153.6 (52 x 60½)
Yale Center for British Art, New Haven, Connecticut,
Paul Mellon Collection, B1974.3.19

In the polite society of Britain, music appreciation—whether one performed or listened—had its place as a refined and civilized pastime, to be stimulated perhaps with a little sherry or other wine, but nothing stronger. The custom carried to North America, where society's enjoyment of music revolved around concerts, at-homes, and family gatherings. The contrast between the milieu of chamber music and the environment of English country and folk music paralleled, or even exceeded, that between the ambiences of classical music and "punk rock" today. This difference in musical preferences, like that in drinking habits, reflected among other things the wide spread between the very wealthy and the poor, a spread that has been drastically narrowed since the 18th century.

Philippe Mercier, who was of Huguenot origin, became active in England about 1725. He painted portraits and "fancy pictures" of the type of this scene. Working very much in the French manner, he was instrumental in introducing French styles of painting to England in the early 18th century. This picture of a musical quartet of women is one of five "sense" paintings he did. All five were engraved and published in London by Carrington Bowles.

184
Punch Bowl of the Free and Easey Society
English, probably Liverpool, c. 1767–70
Tin-glazed earthenware, 20.8 x 54.0 (8¼ x 21¼)
Royal Ontario Museum, European Department, 922.19.17

Eighteenth-century consumption of distilled spirits often occurred in the form of punch—a mixture of several ingredients rather than today's preferred drink of one spirit combined with one non-alcoholic mix. As well as rum, brandy, or whisky, punches typically included sugar, spices, and lemons; the concoction was mixed in a large bowl and then ladled into cups. Thus the punch bowl was a requisite amenity in any large household, club, tavern, or military mess.

Inscribed on the inside of this bowl are the words "FREE AND EASEY SOCIETY"— probably a Liverpool or Norwich association. The bowl is handsomely decorated in blue, with chinoiserie motifs on the outside and appropriate grape vines and bunches of grapes on the inside. It is an uncommonly large bowl, adequate to provide libation for a sizeable gathering.

185 Courtesy Yale Center for British Art. Photograph by Michael Marsland.

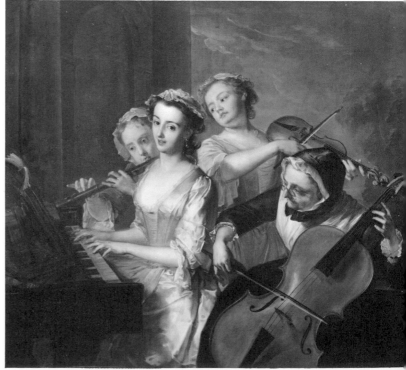

Courtesy Joseph Brant Museum, Burlington, Ontario.

186
Sign for the King's Head Inn, Burlington

Canadian, Upper Canada, 1794
Painted pine, 77.2 x 62.2 (30⅜ x 24½)
Joseph Brant Museum, Burlington, Ontario, 965.007.8

From old English pubs to contemporary Toronto bars, taverns have always had their distinctive names. "The King's Head Inn 1794" is the designation on one side of this sign, which hung on an iron bracket outside the tavern as a signal to the thirsty. On the other side is a portrait bust of George III, with the inscription "George the IIIrd King of Great Britain."

The King's Head Inn at Burlington Beach, though hardly the first tavern in Upper Canada, was officially opened in 1794 by Lieutenant Governor John Graves Simcoe. It became a principal stopping place and refuge on the road between Niagara and York. On 10 May 1813 the inn was fired on from two American schooners on Lake Ontario; the red-hot cannon shot set it ablaze.

187

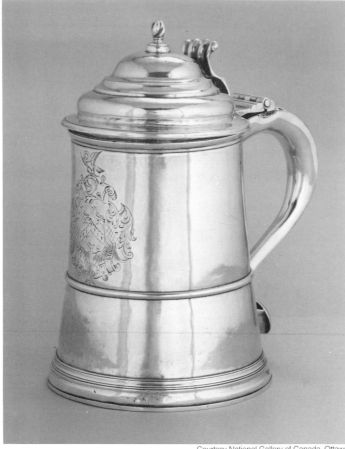

188

Courtesy National Gallery of Canada, Ottawa.

187
Lidded Tankard

American, marked by Edward Winslow II (1669–1753),
Boston, c. 1730–40
Silver, 21.3 (8⅜)
National Gallery of Canada, Ottawa, 26811

Edward Winslow II, a member of an illustrious Massachusetts family, probably apprenticed under Jeremiah Dummer. He became one of colonial New England's finest silversmiths, though he was so involved in public offices that one wonders where he found time to pursue his craft.

This tankard descended to his son Edward III (1746?–1815), a prominent Loyalist who served during the American Revolution and came to Saint John in 1783. Edward Winslow III was instrumental in securing the partition of New Brunswick from Nova Scotia in 1784; after that he became surrogate general and was later appointed to the New Brunswick supreme court.

188
Decanter and Stopper

Irish, Waterford, c. 1785
Glass, 24.8 x 8.5 (9¾ x 3⅜)
Royal Ontario Museum, European Department, 960.222

This finely cut decanter, with its facets and fluting, represents the finest glasswork being done at Waterford in the late 18th century. The engraved motifs form part of the arms of the Penrose family, indicating that the decanter was probably made for William Penrose, one of the founders of the Waterford Glass-works.

176

189
Wineglass

English, c. 1785–90
Glass, 15.0 x 8.3 (5⅞ x 3¼)
Royal Ontario Museum, European Department, 964.241.2

The ovoid-bowl wineglass was produced in almost infinite variety during the 18th century, often in large sets. This one has a hexagonal rather than a round stem. One side of the bowl is diamond stippled with a commemorative head of George III in a scrolled oval. While the glass itself is English, the engraving is probably Dutch and is attributed to David Wolff.

189

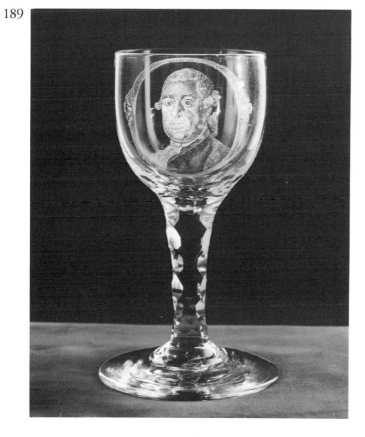

190
Hot-Punch Pot

English, marked Wedgwood, c. 1780
Creamware, 19.5 (7⅜)
Royal Ontario Museum, European Department, 928.18.6

In wintertime, punches were often served hot in mugs—a custom that is still popular. Recipes abound, particularly for combinations of rum, cinnamon, nutmeg, and cloves, mixed with sugared water. This creamware punch pot, stamped on the base with the Josiah Wedgwood mark, provides an early example of transfer printing. One side is inscribed "Good Health and Success To the Right Honble. the EARL of DERBY. Long may he live, Happy may he be, Blest with Content, And from Misfortune free".

190

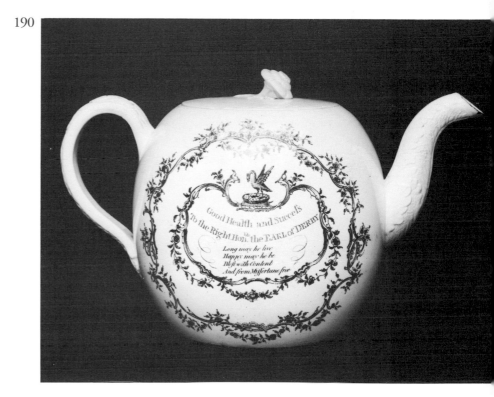

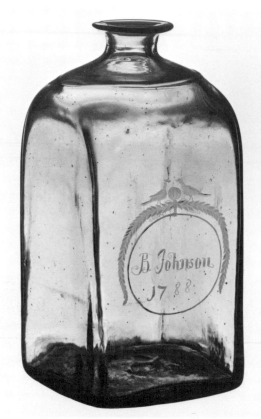

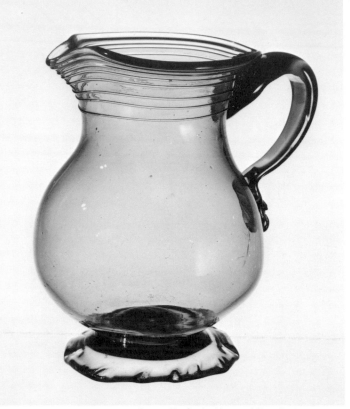

Courtesy The Corning Museum of Glass, Corning, New York.

Courtesy The Corning Museum of Glass, Corning, New York.

191
Engraved Case Bottle

American, Amelung Glass-works, New Bremen, Maryland,
dated 1788
Glass, 18.1 (7⅛)
The Corning Museum of Glass, Corning, New York, 73.4.138

Since spirits were often shipped in small casks, and decanted by
purchasers into their own containers, case bottles or flasks—as
well as decanters—were a requisite part of any gentleman's
equipage. Special travelling cases were fitted with padded spaces
to accommodate square flasks, usually with cork stoppers, from
which travellers could fortify themselves against the rigours of
the spine-jarring roads of the period.

This clear-glass mould-blown flask, from the famous glass-
works of John Frederick Amelung at New Bremen, Maryland, is
engraved with the name of its owner, "B. Johnson", and the date,
"1788", under a wreath of leaves and two standing birds. Often
found on decorated pottery as well, the birds were a favourite
Pennsylvania-German motif.

192
Blown Pitcher

American, southern New Jersey, c. 1800–1820
Glass, 18 (7⅛)
The Corning Museum of Glass, Corning, New York, 50.4.7

The basic turn-of-the-century glass form in North America was
free-blown, with additions such as handles, a foot, or decoration
applied separately. The decoration of the neck of this pitcher was
formed by spiralling a thread of hot glass over the already formed
body before the handle was applied. The glass was generally
impure, as it is in this piece, and was usually green or aquamarine
in colour.

Pitchers similar to this one, suitable for table or bar ware, were
produced at many New Jersey and New York State glass-works.
Virtually identical forms were later made in Canada at the
Mallory Glass-works, Mallorytown, Upper Canada, in 1839–1840.

Courtesy The Corning Museum of Glass, Corning, New York.

193
Mould-Blown Decanter

American, Boston and Sandwich Glass Company, Massachusetts, c. 1825–35
Glass, with stopper 27.5 (10⅞)
The Corning Museum of Glass, Corning, New York, 50.4.136

Decorative decanters for spirits became very fashionable in the late 18th and early 19th centuries (and still are). They were usually placed on top of sideboards or serving tables. This baroque-patterned colourless-glass decanter, with a stopper, has a cast-in medallion labelled "GIN". It is an imitative form, for more expensive English cut-glass decanters generally had a separate engraved silver label suspended on a thin chain. The decanter, however, is an 18th-century form that has lasted, substantially unchanged, to the present day.

194
Card Table

American, Massachusetts, c. 1795–1810
Mahogany, maple, and rosewood, 71.8 x 91.8 (28¼ x 36⅛)
Museum of Fine Arts, Boston, gift of C. Jay French, 22.616

The folding-top card table remained popular well into the 19th century, though by the late 18th century the light Hepplewhite and Sheraton design forms had supplanted the earlier Chippendale. This example is veneered with mahogany, banded with rosewood, and has a centre oval inlay of mahogany in a curly maple rectangle. It has square-tapered legs and pin feet, and a single gate leg to support the extended folding top leaf. This card-table form was particularly popular in New England, where it was widely made.

194 Courtesy Museum of Fine Arts, Boston.

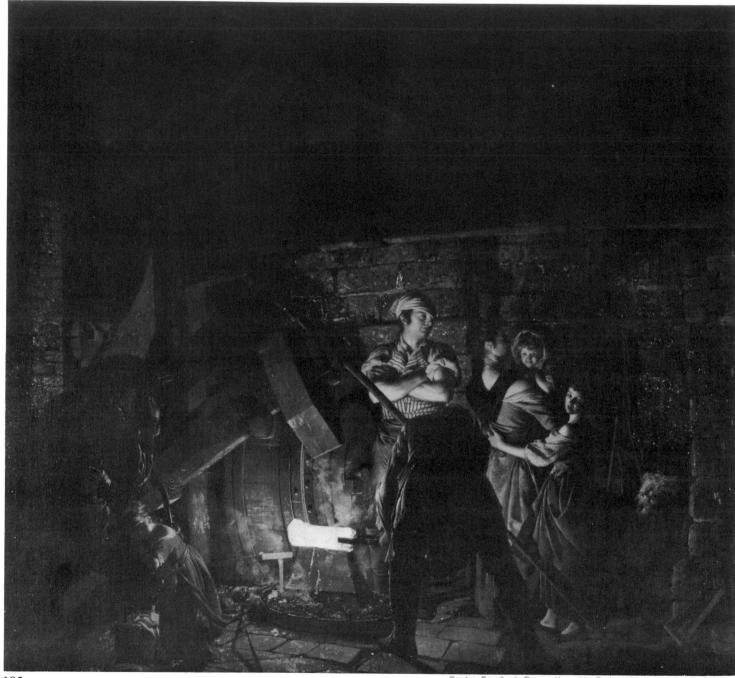

195

180

195
The Iron Forge

Joseph Wright of Derby (1734–97), Derby, 1772
Oil on canvas, 120.7 x 129.5 (47½ x 51)
Broadlands, Romsey, Hampshire, England. The home of
Lord Mountbatten

This scene shows a water-powered tilt hammer, weighing some
150 to 250 kilograms, pounding an iron bar. Hammering worked
out both air pockets and excess carbon; the result was a wrought
iron far stronger and more malleable than brittle cast iron.

The forging of iron with tilt hammers was common in
Canadian as well as in British foundries. The earliest iron works
in Upper Canada, for example, the Mason-Van Norman foundry,
began to operate in 1818, on the Lake Erie shore south of
Simcoe, Ontario. Like Fonderie St-Maurice in Quebec, it mainly
produced castings, but it also had a heavy tilt hammer (recovered
in ROM archaeological excavations in 1968). The Mason-Van
Norman foundry continued in business until it, like the St-
Maurice foundry, exhausted its ore and charcoal sources in
1847.

Joseph Wright of Derby painted several scenes of iron forges
and blacksmiths' shops. This one, dramatically lit by the glow of
the hot iron bar, reflects Wright's use of lighting to create vivid
effect and visual impact. Wright was well in advance of most of
his contemporaries in using techniques that became common
only in the 19th century.

196–197
Fur Trader Greeting Indian Trappers
Indians at a Waterfall

Artist unknown, probably European, c. 1820
Watercolour on paper, each 51.7 x 74.0 (20⅜ x 29⅛)
Royal Ontario Museum, Canadiana Department, 966.136.1–2

These sparkling but naive views of groups of Indians show a wide
range of extremely colourful costume. In the first one, the trader
(or officer?) on his horse wears a military cap, but his coat is tied
with a Quebec *fléchée*. The waterfalls in the second picture are
almost certainly Niagara. In the background is a European
gentleman, in top hat, with an Indian bearer leading a pack
horse.

The costume in these watercolours runs the gamut from Nova
Scotian to Prairie, and some of it is certainly illusory. The
pictures are undoubtedly composites done from descriptions, and
are probably German or Austrian in origin.

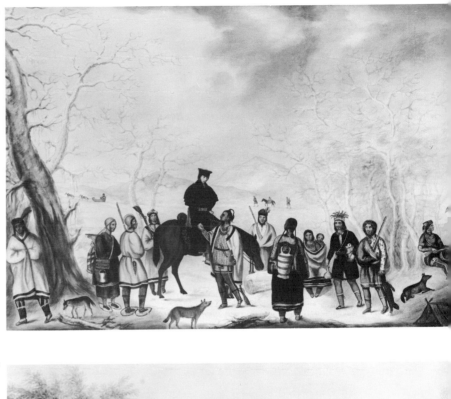

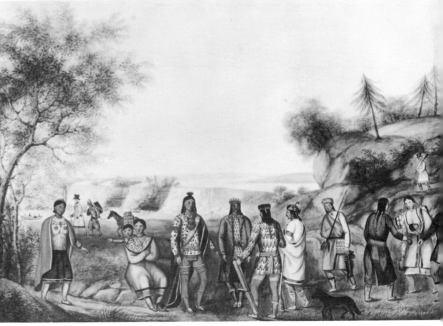

198
Indian Department Trade Gun

English, marked by Robert Wheeler and Son (active 1813–30),
London, c. 1815–20
Steel and brass, walnut stock, 129.5 (51)
Royal Ontario Museum, Canadiana Department, 975.107.1

Trade guns were bartered for beaver or presented to Indians by individual traders, but they were also distributed directly by British Indian agents. They appear to have been purchased by the British Indian Department from its usual contractors and shipped to Indian agents in Canada for presentation as gifts of the government.

This trade gun has a lock that was converted in the 1830s or 1840s from flintlock to the newer percussion system. The butt stock is stamped with the mark of the British Indian Department, the letters I and D with a broad arrow between. Although the gun is marked by Robert Wheeler and Son and stamped with the fox-in-circle symbol of the North West Company, it also bears British government inspection and proof marks. Since such guns were never distributed in great numbers, they are extremely rare today.

199 (See colour plate page 32.)
Flintlock Pistol

Presented to William McGillivray (1764?–1825)
Scottish, John Murdoch (active 1750–98), Doune, c. 1790
Steel and silver, 31.4 (12⅜)
Royal Ontario Museum, Canadiana Department, 970.265

The Scottish pistol, stocked in steel rather than wood, remained a distinct regional form well into the 19th century. Many existing examples were associated with Scots who were active in North America. This pistol, with its typical double-scrolled or ram's-horn butt, was presented to William McGillivray, probably about 1804 when he became chief director of the North West Company. The silver escutcheons on the butt are engraved: on one side with the McGillivray coat of arms, and on the other with the crest of the North West Company. The steel pistol, too, is elaborately chased and inlaid with silver.

William McGillivray, who was born and educated in Scotland, came to Canada in 1784 as a clerk for the North West Company. In little more than a year he was in the Red River department, and in 1786/87 he was in charge of the post at Lac des Serpents. He became a partner in the company in 1790, and chief director in 1804, on the death of his uncle Simon McTavish. Fort William in Upper Canada was named after McGillivray in 1807. With his brother Simon, he helped to negotiate the merger of the North West Company and the Hudson's Bay Company in 1821, and became a director of the joint board. McGillivray retired to England about 1824 and died there the following year.

200
Presentation Indian Trade Gorget

English, marked by Crespin Fuller, London, 1813
Silver, 11.8 x 10.4 (4⅝ x 4⅛)
Royal Ontario Museum, Department of Ethnology, HD 6317

In the 18th century the gorget, a vestigial piece of armour, was often worn in the British army as a symbol of rank. It also became a form of Indian trade silver, frequently used as a presentation piece. It was worn suspended around the neck on a thong tied to the two wings.

Engraved decoration adorns this example. In the centre is the royal coat of arms, on each side a battle-axe, a spear, and a sword crossed in a drum, and below it a tomahawk in a floral wreath. The gorget is inscribed with the initials "G R" and the words "by order of His Royal Highness" (George, Prince Regent). The absence of a recipient's name suggests that this gorget may have been one of a number presented on the orders of the Prince of Wales to Canadian Indian chiefs.

201
Large Pendant Cross

Canadian, marked by Pierre Huguet de Latour, Sr or Jr,
Montreal, c. 1800
Silver, 30.5 x 20.3 (12 x 8)
Royal Ontario Museum, Canadiana Department, on loan from the Henry Birks Collection, National Gallery of Canada, Ottawa, L978.27.23

Any silver cross of this size was certainly a presentation piece rather than an item of ordinary trade. This cross was ordered by one of the several fur-trading companies located in Montreal in the late 18th century. In the centre is an engraving of a pig (similar known crosses display other animals). Such a cross would have been worn only on ceremonial occasions, suspended around the neck on a rawhide thong.

202
Trade Silver Armband

English, marked by William Bateman, London, 1820
Silver, 5.9 x 27.3 (2⅜ x 10¾)
Royal Ontario Museum, Canadiana Department, L982.8.1

202

This armband bears the first mark of William Bateman, a grandson of the famous English silvermaker Hester Bateman. It was probably made as a gift for an Indian chief, perhaps on order from the North West Company. The engraving of the royal coat of arms of 1801–1816 may well have been done later, and in Canada, for the central royal arms are reversed—a mistake unlikely to be made by an English engraver.

Most English-made Indian trade silver came to Canada through the Hudson's Bay Company, for distribution in the northern fur-trade region. The North West Company, with headquarters in Montreal, more typically acquired its trade silver from Montreal and Quebec makers.

203 (See colour plate page 38.)
War Party at Fort Douglas...

Signed by Peter Rindisbacher (1806–34), Winnipeg, 1823
Watercolour on paper, 26.5 x 32.7 (10⅜ x 12⅞)
Royal Ontario Museum, Canadiana Department, Sigmund Samuel Collection, 951.87.3

Peter Rindisbacher emigrated from Switzerland with his family to settle in Lord Selkirk's Red River Colony in 1821. He was already an artist and illustrator. In Canada he soon became acquainted with Captain Andrew Bulger (1789–1858), who was appointed governor of the Red River Colony (Assiniboia) in 1822. After hiring the young Rindisbacher as a clerk at Fort Garry, Bulger gave him personal commissions for watercolours, including some scenes of past events in Bulger's life done from Bulger's descriptions (see no. 206). When Bulger left the Red River late in 1823, he took his pictures with him. This watercolour is inscribed "A War party at Fort Douglas discharging their Guns in the Air as a token of their peaceable Intentions."

204
Deputation of Indians from the Mississippi Tribes...

Signed by Peter Rindisbacher (1806–34), Winnipeg, 1823
Watercolour on paper, 38.1 x 47.6 (15 x 18¾)
Missouri Historical Society, St Louis

This is one of Peter Rindisbacher's historical Red River scenes, painted on commission for Captain Andrew Bulger (see nos. 203 and 205). The watercolour is inscribed "Deputation of Indians from the Mississippi Tribes, to the Governor-General of British North America, Sir George Prevost, Bart, Lieutenant-General &c. &c., in 1814."

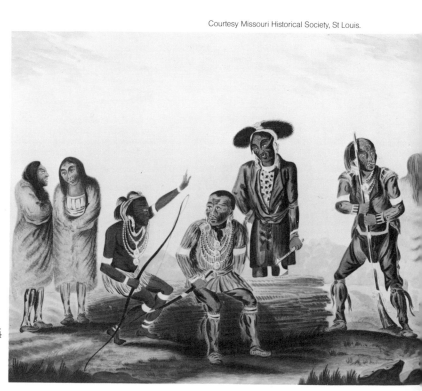

204

205

Captain Andrew Bulger Meeting with Chippewa Chiefs and Warriors at Fort Douglas...

Peter Rindisbacher (1806–34), Winnipeg, 1823
Watercolour on paper, 21.6 x 29.8 (8½ x 11¾)
McCord Museum, McGill University, Montreal, M965.9

Another of Peter Rindisbacher's Red River series (see nos. 203 and 204), this watercolour is inscribed "Captain Bulger, Governor of Assiniboia, and the Chiefs & Warriors of the Chippewa Tribe, of Red Lake, In Council, in the Colony House, in Fort Douglas, May 22nd 1823." Captain Bulger, who presides over the council, is seated in the chair on the right, flanked by two aides. Fort Douglas was the Hudson's Bay trading post for the Selkirk colony; after the merger with the North West Company in 1821, it was replaced by Fort Garry.

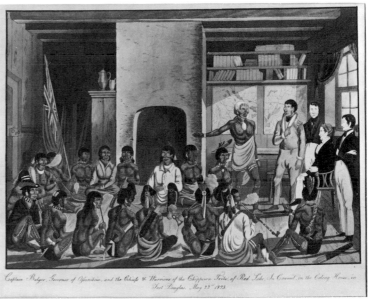

205

Courtesy McCord Museum, McGill University, Montreal.

206

W. A. Bulger Saying Farewell...

Signed by Peter Rindisbacher (1806–34), Winnipeg, 1823
Watercolour on paper, 36.2 x 60.6 (14¼ x 23⅞)
Amon Carter Museum, Fort Worth, Texas, 262.68

Under the terms of the Treaty of Ghent, which established the boundary between the United States and Canada along the line of the Great Lakes, the British were obliged to give up Fort MacKay at Prairie du Chien, Wisconsin. On 22 May 1815 Captain Andrew Bulger left the post he had commanded. Eight years later he had Peter Rindisbacher picture for him this scene of his farewell ceremonies. The watercolour is inscribed "Captain W. Andrew Bulger saying Farewell to the Chiefs and Principal Indian Warriors at Fort MacKay, Prairie du Chien, Wisconsin, on 22 May, 1815."

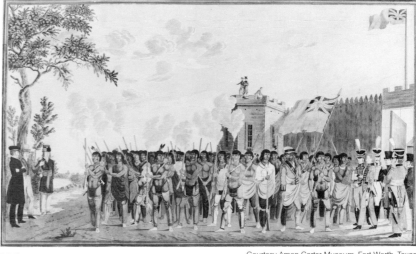

206

Courtesy Amon Carter Museum, Fort Worth, Texas.

207
Mishap at the Ford

Signed by Alvan Fisher (1792–1863), New York, 1818
Oil on wooden panel, 72.4 x 88.9 (28½ x 35)
In the collection of The Corcoran Gallery of Art, Washington,
D.C., Museum Purchase, 1957, 57.11

Mishap at the Ford shows an open coach stuck in the mud at the
edge of a river crossing, with its passengers in a state of some
agitation. That was only one of any number of accidents that
could befall travellers on the primitive roads of the period—in the
United States or in Canada. Many roads in fact were suitable only
for horseback travel or for walking, certainly not for wheeled
vehicles.

Alvan Fisher was among the first specialized American
landscape painters; he became known while he was still in his
early twenties. Fisher travelled in Europe from 1825 to 1827.
From then on, he can be considered one of the early landscape
artists whose romanticizing of nature led to the Hudson River
School of the 1830s and 1840s.

208
Celebrations for the Opening of the Erie Canal

Signed by Anthony Imbert (active 1825–34, died c. 1837),
New York, 1825
Oil on canvas, 61.0 x 114.3 (24 x 45)
Museum of the City of New York, anonymous gift, 49.415.1

This scene records the celebrations in New York City on 4
November 1825 to mark the first time water was let into the Erie
Canal system, lock by lock. Cannons fired signals along the entire
route as each section was filled.

The opening of the Erie Canal gave a great economic boost to
Upper Canada, as well as to the new American West. The St
Lawrence River with its many rapids and shoals was not yet a fully
viable shipping route. Road systems in both Canada and the
United States remained very primitive until the coming of the
automobile. The Erie Canal, which connected Buffalo on Lake
Erie with Albany on the Hudson River, provided Upper Canada
with its first reliable transportation route to the sea. Within ten
years Upper Canada built the Welland Canal, which stretched
across the Niagara Peninsula between Lake Erie and Lake
Ontario. In New York the Oswego Canal, completed in 1828
from the Erie Canal at Syracuse to Oswego on Lake Ontario,
opened another route from Upper Canada to the sea.

The Erie Canal was the conception and accomplishment of
DeWitt Clinton (1769–1828), who served as governor of New
York from 1817 to 1823. The canal route was first explored in
1810, but the project was interrupted by the War of 1812.
Construction finally commenced in 1816.

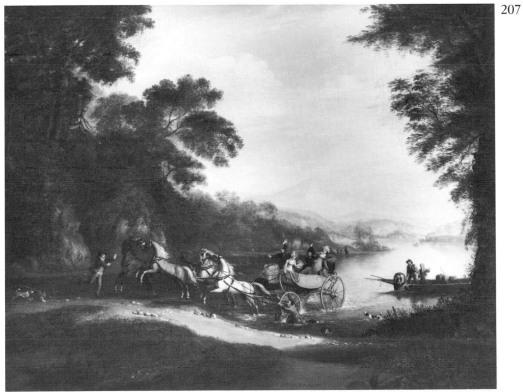

207

Courtesy The Corcoran Gallery of Art, Washington, D.C.

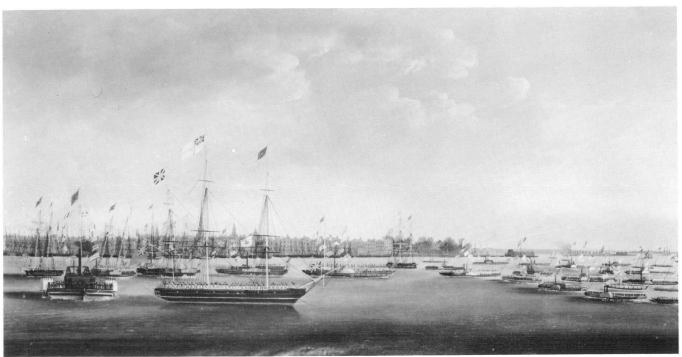

208

Courtesy Museum of the City of New York.

THE WAR OF 1812

The War of 1812 was the last of the conflicts that contributed to the creation of modern Canada; it was also the last war to be fought in part on Canadian territory. The causes went back twenty years, to British retention of western posts ceded to the United States by the Treaty of Paris in 1783, to American refusal to recognize Loyalist claims, and to unresolved maritime issues.

By 1793 Britain and France were once again at war. British impressment of sailors from neutral American vessels on the high seas generated a battle between the British frigate *Leopard* and the American frigate *Chesapeake* as early as 1807. Britain's blockade of the north coasts of Europe after 1806 further roused the free-trading United States. And when growing resistance by the Indians to American westward expansion led to Tecumseh's attempt to form an Indian defensive federation, many Americans felt that the move was inspired by the British. Another sea battle, between the American *President* and the British *Little Belt*, in May 1811 aggravated an already tense situation. Canada was caught in the middle, certain to become a battleground again if war broke out. Governor General Lord Dorchester had foreseen the possibility as early as 1795.

The battle of Tippecanoe in November 1811, in which American forces met Tecumseh's Indian followers, convinced the western and frontier congressmen, the "war hawks", that only the expulsion of British authority from North America could end the frontier Indian threat. This was more fuel for the fire. Britain maintained her European blockade and, strapped for naval crewmen, refused to abandon impressments of sailors from neutral vessels. War was inevitable and was finally declared in June 1812.

The war began with little enthusiasm for fighting, particularly on the part of the Americans. Although one American goal was the occupation of Canada and replacement of British rule, no serious, much less determined, effort was ever made to achieve that objective. Military campaigns were short, uncoordinated, and indecisive. The numbers of troops involved were small, especially compared with those that had participated in the Seven Years' War and the American Revolution.

At the beginning of the war the defence of Canada lay with some forty-five hundred regular troops and unenthusiastic local militias. Britain, totally committed against Napoleon in Europe, could dispatch little help. In the United States dissension prevailed: New England refused to support the war, and the south had more interest in acquiring Florida. Trade between New England and the Maritime Provinces continued, affected only by the privateers who always proliferated in wartime. So marked was the inclination for trade over fighting that more than sixty per cent of the beef consumed by British troops in Canada came from New York and Vermont.

In May 1814 a temporary lull in the European war freed British armies for service in Canada, but by then peace negotiations were already in progress. With Britain financially and militarily exhausted and the United States heartily tired of the war, the Treaty of Ghent was signed on 24 December 1814. It transferred no territory, did nothing for the western Indians, and made no mention of neutral rights or impressment of seamen (which in any event had become a non-issue with the end of the European wars). Still, in providing for future commissions to settle disputes over fisheries, trade and commerce, and boundaries, the Treaty of Ghent laid the groundwork for a permanent peace in North America.

The Rush-Bagot Agreement of 1817 brought virtual naval disarmament on the Great Lakes, so that land fortifications soon became redundant. In 1818 the western border between Canada and the United States was agreed on as the forty-ninth parallel from Lake of the Woods to the Rocky Mountains. Thus was created the world's longest international border without fortification or defences. In the aftermath of the War of 1812 there developed a pattern of commissions, conventions, and arbitrations for settlement of Canadian-American disputes that prevails to this day.

Canadian-American stresses and disputes are and always have been numerous, and opportunities for war have emerged more than once since 1814. Ultimately, however, the pattern of negotiation has prevailed, particularly as Canada's legislative and commercial independence from Britain gradually increased. Never again has Canada become a pawn in a British dispute or, except by her own determination, been drawn into a British war.

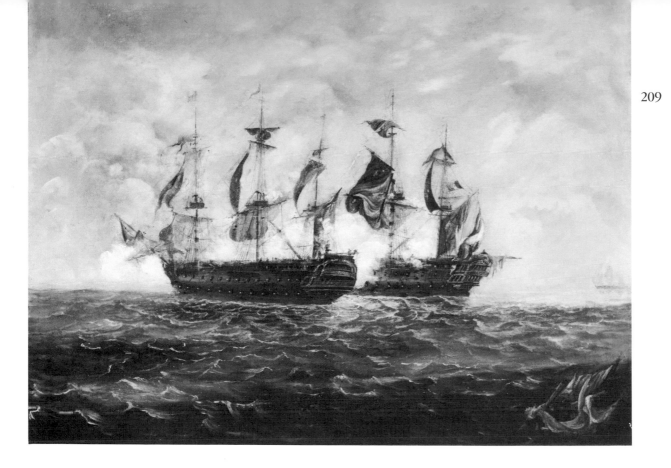

209
Engagement Between a British and
a French Warship

Signed by George Godsell Thresher (c. 1779–1859), probably
New York, c. 1805–10
Oil on canvas, 56.3 x 61.0 (22⅛ x 24)
Private collection

In this scene, two large vessels, one British and one French, are engaged in battle—perhaps an incident in the famous battle of Trafalgar in 1805. The stresses of the long and exhausting struggle known as the Napoleonic Wars eventually pitted Great Britain against the United States in the War of 1812. Inevitably Canada was drawn into the conflict.

George Thresher served as a junior officer and captain's clerk in the British navy. While visiting Paris during a temporary respite under the Treaty of Amiens, he was taken prisoner when war was resumed in 1803. Thresher escaped, according to legend hidden in a cart of cabbages. By 1805 he was in New York, where he taught drawing and painting and worked as a marine artist. He moved to Montreal in 1816, went on to Halifax in 1821, and finally settled in Charlottetown in 1829. He went on painting and teaching, although he was occupied as deputy colonial secretary and registrar of deeds.

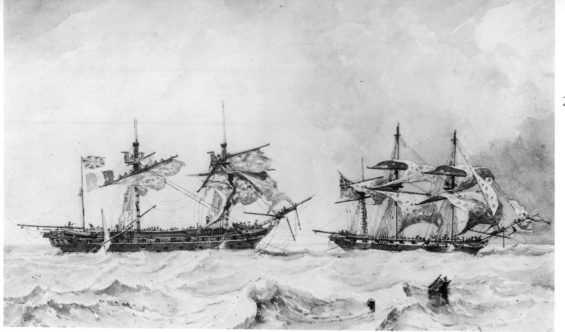

210
The British Corvette *Bonne Citoyen* Towing Her Prize

George Webster (active after 1797, died 1832), London, 1809
Brown wash and ink on paper, 27.6 x 42.5 (10⅞ x 16¾)
Royal Ontario Museum, Canadiana Department, Sigmund Samuel Collection, 955.78

By the time the War of 1812 began, Britain had been at war with France almost continuously since 1793. Halifax, the primary naval base in British North America, occasionally saw the results of an engagement (see nos. 224–227).

On 6 July 1809 the twenty-one-gun British corvette *Bonne Citoyen* (captured from the French in 1796) came upon the French *Furieuse* in the act of taking a British transport ship. After a six-hour battle, the *Furieuse* surrendered. The *Bonne Citoyen* towed her prize halfway across the Atlantic into Halifax harbour. The *Furieuse* was repaired, rerigged, and taken into the British navy without a change of name. The inscription on the picture reads "The British corvette *Bonne Citoyen*, 21 guns [Commander William Mounsey] towing her prize, the French ship *Furieuse,* into Halifax, Nova Scotia, after a 6 hour action on 6th July, 1809."

George Webster was an excellent but little-known marine artist who first exhibited in London in 1797 and continued to exhibit until his death. His work was shown at the British Institution in 1816 and at the Royal Academy of Arts in 1826. This watercolour is a sketch for an aquatint published in London by R. and D. Havell in 1810.

211
Flintlock Musket, India Pattern

English, marked by the Tower Armouries, c. 1805–15
Steel, walnut stock, brass mounts, 139 (54¾)
Royal Ontario Museum, Canadiana Department, 967.12

The India Pattern musket, with a shorter barrel (thirty-nine inches) than the Short Land pattern and a strengthened lock, was first developed in the 1790s by the East India Company, but it became the final version of the "Brown Bess" type (see nos. 10, 97). This musket is marked on the barrel "76th Regt." The Seventy-sixth Regiment, a veteran of the Duke of Wellington's peninsular campaigns, came to Canada in 1814 and served briefly on Lake Champlain. The regiment was stationed in Canada through 1826.

211

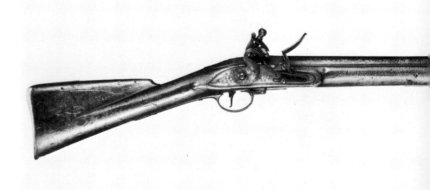

212
Sword

Presented to Chief Little Knife, 1815
English, c. 1813–14
Steel, silver hilt, 94 (37)
Canadian War Museum, Ottawa

This sword is a presentation variation of the British
1796 pattern infantry sword. It was a gift to Chief Little Knife
from Lieutenant Colonel Robert McDouall, who was in com-
mand at Michilimackinac when it was successfully defended
against the Americans in 1814. The silver hilt, with marks for
1813-1814, is attributed to George Turner of Exeter. Fourteen
other such swords were presented to various recipients in
Montreal in 1814, but none of them is now known.

213
Flintlock Musket, United States Model of 1808

American, Harpers Ferry Armory, 1812
Steel, walnut stock, 149.9 (59)
Canadian War Museum, Ottawa

The United States government established its first armoury at
Springfield, Massachusetts, in 1793, to produce muskets for the
army. A second armoury was set up at Harpers Ferry, Virginia
(now West Virginia) in 1801. The standard United States
musket, in various models, was patterned on the French designs
with which Continental armies had been equipped during the
American Revolution (see no. 100). This musket is marked on
the lockplate, "Harpers Ferry", with the date of manufacture,
"1812".

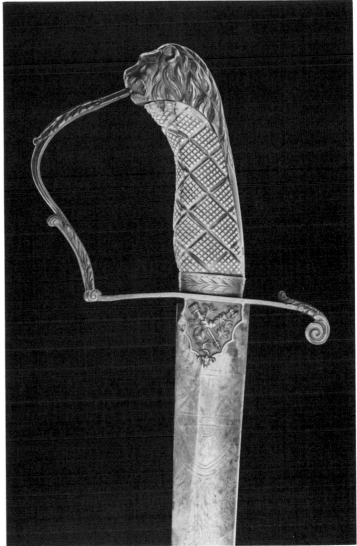

Courtesy Canadian War Museum, Ottawa.

213

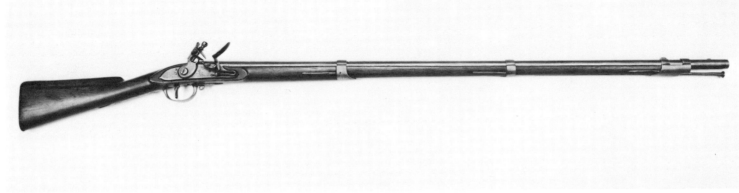

Courtesy Canadian War Museum, Ottawa.

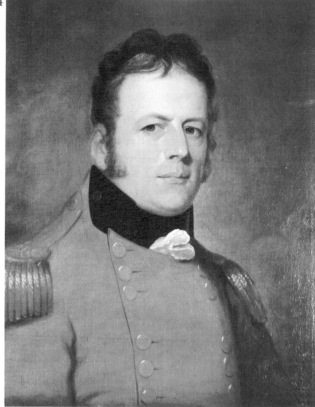

Courtesy McCord Museum, McGill University, Montreal.

214
Portrait of Sir George Prevost

Attributed to Robert Field (c. 1769–1819), Halifax, c. 1808–11
Oil on canvas, 68.6 x 53.3 (27 x 21)
McCord Museum, McGill University, Montreal, gift of the
Honourable J. K. Ward, M403

Sir George Prevost (1767–1816), governor in chief of Canada
from 1811 to 1815, was also commander in chief of British
forces in Canada during the War of 1812. As a civil governor he
was extremely successful, but as a military commander he was
held responsible for the British withdrawal from Sackets Harbor,
New York, in 1813 and for the defeat at Plattsburg in 1814. He
was recalled to London in 1815.

 This portrait of Prevost was undoubtedly done during his term
as lieutenant governor of Nova Scotia from 1808 to 1811.
Robert Field, who had studied in London, emigrated to the
United States in 1794 and arrived in Halifax in 1808. He became
the leading portrait painter on the Canadian eastern seaboard and
remained so until 1816, when he departed for Jamaica.

215
Card Table

Canadian, Montreal, c. 1810
Mahogany, 73.7 x 91.4 (29 x 36)
Royal Ontario Museum, Canadiana Department, 958.19.1

This table was made for Sir James Monk (1745–1826), whose
family left Massachusetts to settle in Halifax the year it was
founded (see no. 73). Monk studied law both in Nova Scotia and
in England and in 1794 was appointed chief justice of the Court
of King's Bench in Montreal.

 The table, with ovolo corners and a fifth swing leg, is veneered
in mahogany over pine. The string inlays of the skirt and legs are
of maple. This piece is a very good and specific example of the
influence of New England styles and Loyalist cabinetmakers on
early eastern Canadian furniture.

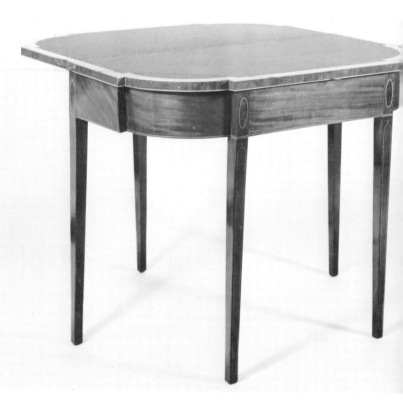

215

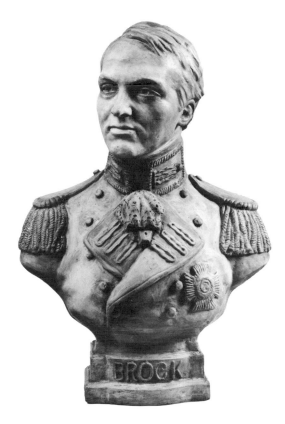

wounded during the battle, but the initial assaults had been repulsed. In the roster of commanders in the War of 1812, who for the most part ranged from inept to incompetent—on both sides—Isaac Brock is notable as one of the few outstanding leaders.

The death of Brock at Queenston Heights in October 1812 generated a wave of Brock memorabilia, which though not of the magnitude of the Wolfe vogue fifty years earlier was still copious (see no. 218). This terracotta bust was done in 1896 by Hamilton T. C. P. MacCarthy, who studied first under his sculptor father in London and then in Europe, and came to Toronto in 1885. MacCarthy later moved to Ottawa, where he mainly produced busts of public figures and designed and sculpted large monuments.

216
Portrait Bust of General Sir Isaac Brock

Signed by Hamilton MacCarthy (1847-1939), Toronto, 1896
Terracotta, 40 (15¾)
Royal Ontario Museum, Canadiana Department, gift of Justice
Dalton C. Wells, 964.232

In the opening campaign of the War of 1812, it was certainly the rapid reaction of the lieutenant governor and military commander Isaac Brock (1769-1812) that saved Upper Canada from possible American occupation. Brock was convinced that the majority of the population—non-Loyalist American settlers—was fundamentally disloyal, and that his best hope was to "speak loud and look big". He was probably right, for militia did desert at Malden and in Norfolk County.

Brock's hurried march with a few hundred men to the Detroit River brought both the retreat from Upper Canada of General William Hull, the American commander, and the surrender of Detroit. Brock then rushed back to Niagara to meet the American attack at Queenston, in which the various American commanders failed to support one another and the New York militia refused to cross the Niagara River. Brock was mortally

217
Portrait Miniature of a Uniformed Officer

Gerald Hayward, after J. Hudson, London, c. 1805
Oil on ivory, 9 x 7 (3½ x 2¾)
Royal Ontario Museum, Canadiana Department, bequest of
Mary Fitzgibbon, 921.42.2

This example of the style of portrait miniature of military figures that was widespread in the early 19th century descended in the Brock family. It was done about 1805 and is probably of Isaac Brock before he came to Canada, though it may be of one of his brothers. While most portrait miniatures lack backgrounds, this one includes a classical Greek fluted pillar on the left.

217

Pocket Compass

Presented to Tecumseh by General Isaac Brock, 1812
English, c. 1810
Brass, 1.5 x 5.5 (⅝ x 2⅛)
Royal Ontario Museum, Department of Ethnology, gift of the
Independent Order of Foresters, 911.3.154

This compass, with "To Tecumseh from 'Brock' Aug. 1812"
engraved on the lid, was supposedly given to Tecumseh by
General Isaac Brock when the Shawnee chief and the lieutenant
governor conferred and joined forces near Amherstburg, Upper
Canada. According to the story, Tecumseh never understood why
or how a compass performed differently from a watch. The
engraving was added by a jeweller in Detroit, on the order of
Chief Oshawana, after Tecumseh's death in 1813.

Tecumseh (1768?-1813), son of the Shawnee chief Pucke-
shinwau, became leader of the Indian tribes of the old northwest
after 1800. He was allied with British Canada in opposition to
the continuing American westward expansion. At the outbreak
of the War of 1812, Tecumseh, with his forces, was present at
the capture of Detroit and active on the Detroit frontier in the
spring and summer of 1813. He was killed in the battle of the
Thames on 5 October 1813. Because of his ability to unite a
number of diverse Indian tribes, Tecumseh is remembered as one
of the greatest Indian leaders of the early 19th century.

Portrait Miniature of General Sir Isaac Brock

Signed by Alyn Williams (1865-1941), London, 1897
Pastel and gouache on paper, 17.8 x 14.0 (7 x 5½)
Royal Ontario Museum, Canadiana Department, bequest of
Mary Fitzgibbon, 921.42.3

A reflection of the enduring esteem for General Sir Isaac Brock
(1769-1812), this portrait was done in 1897, specifically for
Miss Mary Fitzgibbon, who later bequeathed it to the Royal
Ontario Museum. It was copied after a life portrait of Brock by
William Berczy, which was painted in 1811 and at the end of the
century still belonged to the Brock family of the island of
Guernsey, Brock's birthplace.

By the late 19th century miniature painting was a dying art,
one of the many casualties of technological progress—in this
instance the development and growing popularity of photography.
The English miniaturist Alyn Williams was one of the last
practitioners of the art.

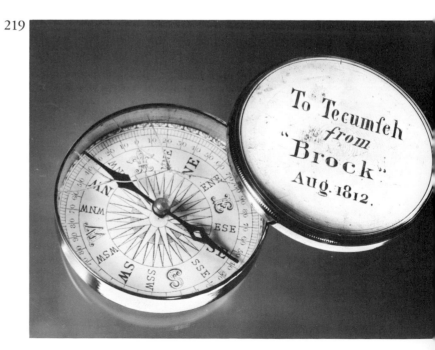

220

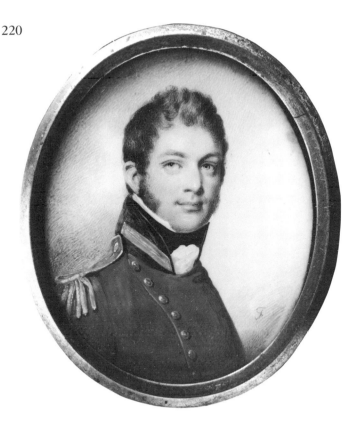

Portrait Miniature of an Officer of the Ninety-Sixth Regiment

Artist unknown, probably English, 1810–12
Oil on ivory, 6.7 x 5.4 (2⅝ x 2⅛)
The Public Archives of Canada, Ottawa, C 83487

This unidentified officer belonged to the Ninety-sixth Regiment of Foot, which was posted to Canada in 1813. The portrait miniature, which was probably painted in England, is unsigned. It is typical, however, of portraits of military figures done in great numbers by what in the early 19th century amounted to an English miniature-portrait industry. Both original works and multiple copies of portraits were produced, particularly of famous figures.

221

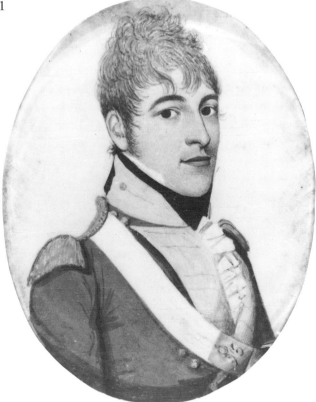

Courtesy The Public Archives of Canada, Ottawa.

220
Portrait Miniature of Lieutenant Colonel Thomas Pearson

Signed by Robert Field (c. 1769–1819), Halifax, 1811
Watercolour on ivory, 7.9 x 6.0 (3⅛ x 2⅜)
Royal Ontario Museum, Canadiana Department, purchased through a grant from the Ministry of Communications, 980.277

Thomas Pearson (c. 1780–1847), a British army officer, was stationed in Halifax after 1806. In February 1812 he was appointed inspecting field officer for Upper Canada and in the ensuing war served at the battles of Chrysler's Farm, Oswego, and Chippewa. Pearson remained in the army and finally became a lieutenant general in 1841. His portrait by Robert Field is one of very few known early Canadian miniatures.

Halifax, with its garrisons, naval base, and mercantile activity, was a sufficiently prosperous city before the War of 1812 to allow an English painter such as Robert Field to make a good living as a portraitist. Field lived in Halifax from 1808 to 1816, and some ninety of his works from that period are recorded—standard portraits as well as miniatures (see no. 214).

222

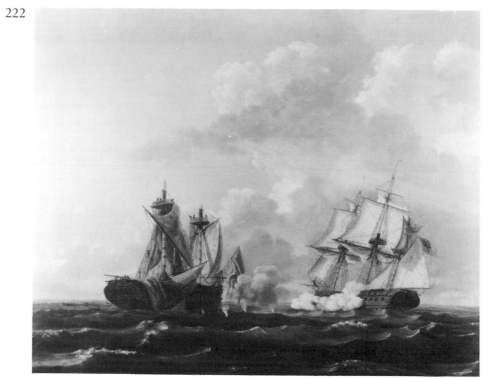

223

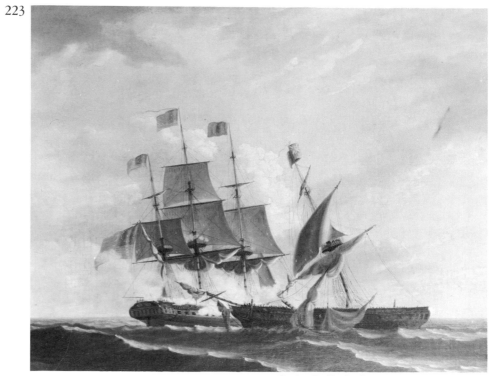

222

Engagement Between the *United States* and the *Macedonian*, 1812

Signed by Thomas Birch (1779-1851), Philadelphia, 1813
Oil on canvas, 73.7 x 87.6 (29 x 34½)
The Historical Society of Pennsylvania, Philadelphia, gift of
William K. Romberger

During the first year of the War of 1812, the United States navy was successful in several single-ship engagements with British vessels. This scene is representative of the numerous paintings and prints done to commemorate these actions (see nos. 223, 224-227, 228). American frigates of 1812 were generally somewhat larger and heavier and mounted more guns than British frigates, which were thus at a disadvantage in single-ship actions with American vessels of the same rate.

On 25 October 1812, Captain Stephen Decatur of the frigate *United States* engaged the British frigate *Macedonian* off the island of Madeira. The *Macedonian* was dismasted, captured, repaired sufficiently for a voyage, and brought as a prize to New London, Connecticut. There she was fully refitted for service in the United States navy.

Thomas Birch was born in London and came to the United States in 1794 with his father, who was an engraver and a miniaturist. He trained under his father, but established his own portrait studio in Philadelphia about 1800. Although Birch specialized in portraits, he also did many marine paintings, particularly during the War of 1812 (see nos. 223, 228), and he broadened his subject range to landscapes as well. *Engagement Between the* United States *and the* Macedonian was exhibited at the Pennsylvania Academy of the Fine Arts in 1813, and engraved for a print by Benjamin Tanner.

223

Engagement Between the *Constitution* and the *Guerrière*, 1812

Signed by Thomas Birch (1779-1851), Philadelphia, 1814
Oil on canvas, 73.7 x 91.4 (29 x 36)
The Historical Society of Pennsylvania, Philadelphia, gift of
William K. Romberger

In the first important American naval victory of the War of 1812, the heavy fifty-five-gun frigate *Constitution*, under the command of Captain Isaac Hull, dismasted and captured the British forty-nine-gun *Guerrière*. The action occurred on 19 August 1812 about 750 miles east of Boston. Because the *Guerrière* could not be jury-rigged adequately for sailing, Hull was forced to burn his prize. The *Constitution*, known as "Old Ironsides", was saved from retirement and break-up in 1828 and is now restored and permanently berthed at Boston.

Thomas Birch probably did this picture in 1814, and exhibited it at the Pennsylvania Academy of the Fine Arts that year. It was engraved for an aquatint by Cornelius Tiebout.

224-227

Engagement Between HMS *Shannon* and USS *Chesapeake*, 1813

From paintings by J. C. Schetky (1778-1874), published by
Smith, Elder and Company, London. c. 1830
Lithograph and watercolour, each 31.0 x 43.5 (12¼ x 17⅛)
Royal Ontario Museum, Canadiana Department, Sigmund
Samuel Collection, 960x282.31-34

The sea war turned in Britain's favour in 1813, with the capture of the American frigate *Chesapeake* by HMS *Shannon*, under the command of Captain R. H. King. The engagement occurred on 1 June off the Massachusetts coast, almost within sight of Boston, which the *Shannon* was blockading. In spite of the famous words of her mortally wounded captain, James Lawrence—"Don't give up the ship"—the *Chesapeake* was forced to surrender after an action that lasted less than fifteen minutes. As so many prizes before her had been, the *Chesapeake* was taken into Halifax. The arrival is recorded in the last print of the series (no. 227).

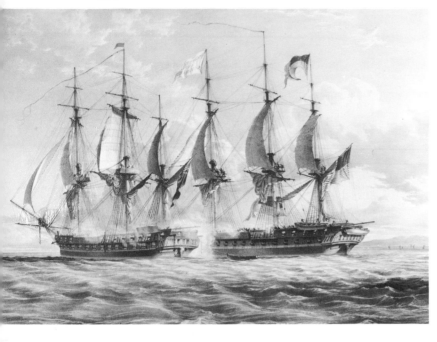

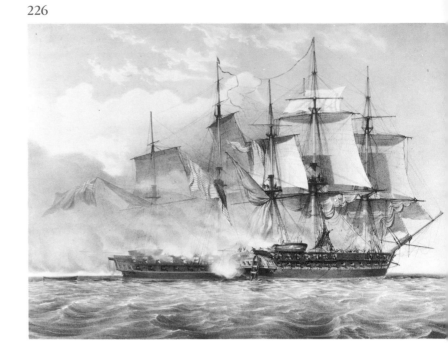

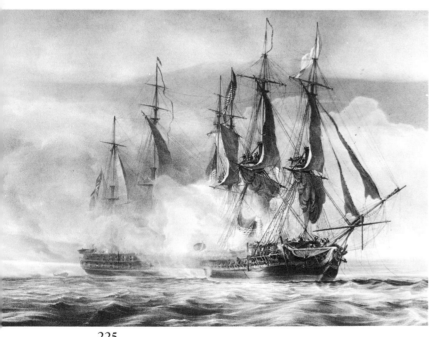

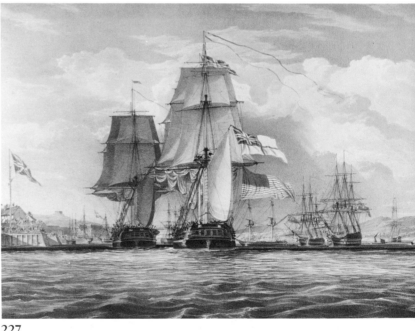

228 (See colour plate page 39.)
The Battle of Lake Erie, 1813

Thomas Birch (1779–1851), Philadelphia, 1814
Oil on canvas, 167.6 x 245.1 (66 x 96½)
Pennsylvania Academy of the Fine Arts, Philadelphia, gift of
Mrs C. H. A. Esling, 1912.15

During the winter of 1812/13, a young American naval officer,
Lieutenant Oliver Hazard Perry, who had been assigned to
command of naval forces on Lake Erie, built a small fleet of
vessels at Erie, Pennsylvania. By summer he had ten vessels in
commission. On 10 September, near Put-in-Bay, Perry's small
fleet met and defeated an even smaller British force under the
command of Captain Robert Barclay. The battle of Lake Erie led
to the American recovery of Detroit, a British retreat into Upper
Canada, and an abortive American invasion, which was never
pressed.

This panoramic scene of Oliver Perry's victory on Lake Erie in
1813 was Thomas Birch's most monumental sea-battle picture
of the War of 1812. It was first exhibited at the Pennsylvania
Academy of the Fine Arts in 1814.

229 (See colour plate page 40.)
Model of a French First-Rate Ship

English, by a French prisoner of war, c. 1800–1815
Bone and wood, 53.3 x 50.8 (21 x 20)
Royal Ontario Museum, Canadiana Department, gift of
Charles S. Band, 960.18

The Napoleonic Wars of 1793 to 1815 generated many
prisoners of war, particularly seamen. French prisoners in
England were confined to prisoner hulks—permanently anchored
older vessels—where they could conceivably have languished in
miserable conditions for ten years or more before being exchanged.
During this time they often worked on very elaborate ship
models, designed from memory augmented by observation from
their prison hulks, which were located in various harbours
around England (see no. 230). Laboriously made, mainly from
beef and chicken bones saved from the prisoners' poor rations,
these miniature ships have become known as "prisoner of war"
models. Tradition has it that this superb example represents the
Beaucentaure, the flagship of the French admiral Pierre de
Villeneuve at the battle of Trafalgar in 1805.

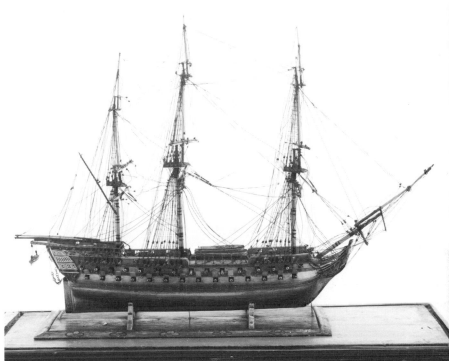

230
Model of a British Third-Rate Ship, or Frigate

English, possibly by a French prisoner of war, c. 1800–1815
Mixed woods, 34.3 x 45.7 (13½ x 18)
Royal Ontario Museum, Canadiana Department, bequest of
Reginald S. Northcote, 963.94

The standard vessel of the British navy during the Napoleonic
Wars was the frigate, or third-rate ship. Larger first-rate ships
were generally reserved for blockade duty or the major fire-power
of large battle fleets. Frigates, which were faster and more
manoeuvrable, were more flexibly and independently assigned.
Generally the frigate was from 35 to 45 metres long, had a
displacement of 750 to 1000 tonnes, and carried between 40 and
60 guns on two gun decks. It was capable of sailing on lengthy
voyages anywhere in the world.

During the War of 1812 available British frigates were
somewhat smaller and mounted fewer guns than the newer
American frigates—one reason for the number of American
single-ship victories in 1812 and 1813 (see nos. 222, 223). The
British navy, moreover, after twenty years of war, was in poor
condition, with dilapidated vessels manned by impressed and
ill-trained crews.

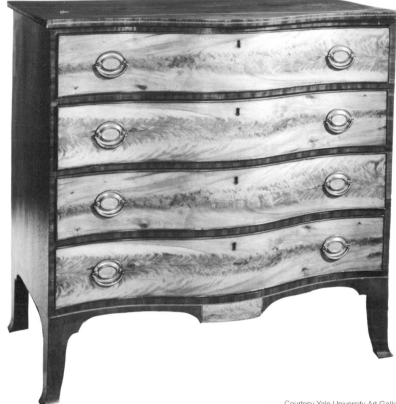

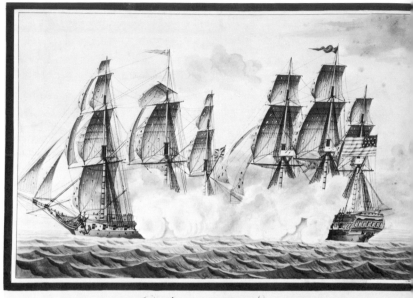

Combat soutenu par une Fregate Americaine le Président...

Courtesy Yale University Art Gallery.

231
Serpentine-Fronted Chest of Drawers

American, Boston, Massachusetts, 1785–1815
Mahogany and satinwood, 98.7 x 102.6 (38⅞ x 40⅜)
Yale University Art Gallery, New Haven, Connecticut, Mabel
Brady Garvan Collection, 1930.2017

An English form of the mid and later 18th century, the serpentine-fronted chest became extremely popular in New England after 1780. The drawer fronts and skirt panel of this very elegant piece are veneered with feather-grained satinwood; the edges of the top and skirt are outlined with geometric band inlays. Steam-bowing of drawer fronts to create a serpentine curve replaced the earlier colonial method of block-carving (see no. 72). The very few serpentine-fronted chests and sideboards known from the Canadian Maritime Provinces, however, still employed the block-carving technique.

232
Engagement Between the American Frigate *President* and the British Frigate *Endymion*, 1815

Artist unknown, French, 1815
Ink and watercolour on paper, 40.1 x 54.3 (15⅞ x 21⅜)
Royal Ontario Museum, Canadiana Department, Sigmund
Samuel Collection, 960x276.57

The engagement on 15 January 1815 between the *Endymion* and the *President*, in which the latter was disabled and captured, occurred after the war's end. After months of negotiations, the Treaty of Ghent had been signed on 24 December 1814, but it took another month for the news to reach North America and much longer to reach ships at sea. The greatest single battle of the war, the battle of New Orleans on 8 January 1815, was also fought after the war had officially ended. Ironically, that battle entailed a loss of three thousand British troops, including all four British generals involved. The last hostile action of the War of 1812 was an abortive engagement between HMS *Cornwallis* and the United States frigate *Hornet* on 28 April 1815.

233
The Launching of the *St Lawrence*, 1815

Artist unknown, Kingston, 1815
Ink and watercolour on paper, 33.0 x 55.9 (13 x 22)
Royal Ontario Museum, Canadiana Department, 967.106.1

Designed as a first-rate ship, or ship-of-the-line, the *St Lawrence*, with three gun decks, was the largest warship ever launched on the Great Lakes. The vessel was planned and originally drawn by master shipwright John William at the naval yard in Kingston, Upper Canada, and was built by John Dennis. The original plans are now in the Admiralty Record Office, London.

The *St Lawrence*, however, came too late to see service and was in fact never commissioned. Neither the United States nor Britain had any desire for what could only have become an arms race on the Great Lakes (see no. 234). Thus the Rush-Bagot Treaty was negotiated and signed in 1817; it restricted naval forces and armaments on the Great Lakes to a minimal police level. Land fortifications were not mentioned, but without naval forces, they quickly became redundant. The Rush-Bagot Treaty is still in effect, so that even present-day Canadian and American coast guard vessels are unarmed.

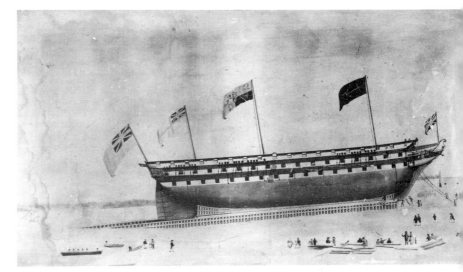

233

234
The Dual Launching of the *Newash* and the *Tecumseh*, 1815

Artist unknown, Kingston, 1815
Ink and watercolour on paper, 33.0 x 55.9 (13 x 22)
Royal Ontario Museum, Canadiana Department, 967.106.2

Like the *St Lawrence*, the single-deck sloops-of-war *Newash* and *Tecumseh* were launched after the end of the War of 1812 (see no. 233). Built and launched at Chippewa Creek, Upper Canada, they too became redundant with the signing of the Rush-Bagot Treaty in 1817.

234

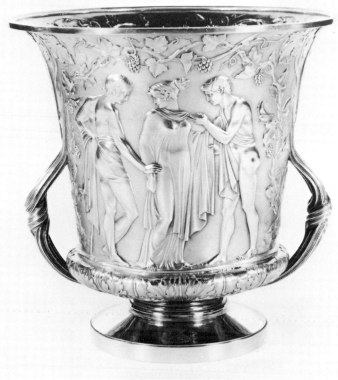

Reproduced by gracious permission of Her Majesty The Queen.

235
Two-Handled Vase

Presented to His Royal Highness Prince George (1762–1830)
English, marked by Paul Storr, London, 1812
Silver-gilt, 23.4 (9¼)
By gracious permission of Her Majesty The Queen

By the early 19th century the neoclassical style had pervaded not only architecture and furniture but also silver, in North America as well as in Britain. This vase, designed by John Flaxman and made by Paul Storr, was derived from a description of a cup in the first Idyll of the Greek poet Theocritus (fl. c. 270 B.C.).

On one side of the vase is an engraved representation of two men contending (and it would seem rather forcefully) for the favour of a maiden. On the other side the engraved decoration includes a fisherman dragging his net and a boy watching a vineyard while a fox steals his food. The motifs are framed in grape vines, and the handles are in the form of vine stems. The base is engraved with the cipher of Queen Charlotte, who presented the piece to her son George, the prince regent, and later George IV.

236 (See colour plate page 40.)
Two-Handled Cup

Presented to the Reverend Joseph Hudson
Canadian, William Stennett (active 1811–47), York (Toronto), 1833
Silver, 31.8 (12½)
Royal Ontario Museum, Canadiana Department, on loan from the Cathedral Church of St James, Toronto, gift of J. H. Crang, L972.16

One of the finest extant pieces of Canadian silver, and certainly the single finest early Upper Canadian piece, this cup was made by William Stennett for presentation to the Reverend Joseph Hudson, assistant to the Reverend John Strachan, rector of York. The cup was a departure gift when Hudson left York in 1833 to take up a posting to the Mariners' Chapel in Quebec.

In 1811 William Stennett emigrated from England to Bermuda, where he worked as a jeweller and watchmaker. No known Bermuda silver is attributed to him. About 1820 Stennett left Bermuda for Kingston, Upper Canada; he came to York early in 1828, and remained until his death in 1847.

237
Portrait Miniature of George III

Henry Bone (1755–1834), London, 1807
Enamel on porcelain, 13.8 x 11.0 (5⅜ x 4⅜)
Royal Ontario Museum, European Department, bequest of Harrison G. Fraser, 981.214.12

George III (1738–1820; reigned 1760–1820), depicted in hundreds if not thousands of endlessly copied portraits, was also a favourite of the miniaturists. This enamelled porcelain miniature of the king in uniform is inscribed on the reverse: "His Majesty, London, August, 1807, painted by Henry Bone, ARA, enamel painter to His R. H. the Prince of Wales, after Wm. Beechey".

237

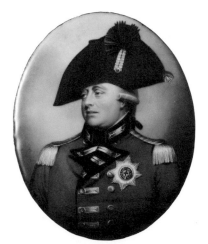

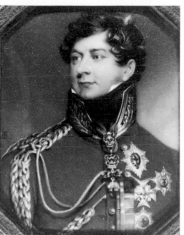

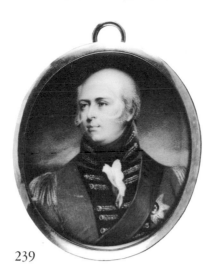

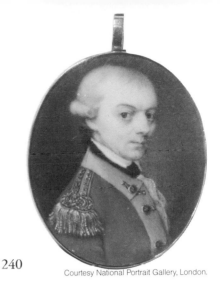

238

239

240

238
Portrait Miniature of George, Prince of Wales

Henry Bone (1755–1834), London, c. 1812
Enamel on porcelain, 8.1 x 6.5 (3¼ x 2½)
The Public Archives of Canada, Ottawa, C 83503

In 1811 Parliament finally declared George III (1738–1820; reigned 1760–1820) incurably insane and appointed his eldest son, George, Prince of Wales (1762–1830), prince regent. The prince was poorly regarded because of his rakish habits, which did not change when he acceded to the throne in 1820. His divorce proceeding against his queen, Caroline, in fact only served to make her a popular heroine.

Most of Henry Bone's miniatures on ivory, which are uncommon, were done from life. His many enamel portraits on porcelain, conversely, are mainly copies, produced in quantity for general sale.

239
Portrait Miniature of Edward, Duke of Kent and Strathearn

William Bate (active c. 1790, died c. 1845), London, 1810
Enamel on copper, 4.8 x 3.8 (1⅞ x 1½)
Royal Ontario Museum, Canadiana Department, Sigmund Samuel Collection, 962.32

Edward, Duke of Kent and Strathearn (1767–1820), who was first posted to Canada in the early 1790s and ultimately was made commander in chief of forces in British North America, sat for a number of artists during his life. In this miniature by William Bate he is wearing gold epaulettes and the Order of the Garter.

Little is known of the artist other than that he came to London originally from Dublin, and exhibited at the Royal Academy of Arts from 1799 to 1807. Bate did a number of other miniature portraits of members of the royal family.

240
Portrait Miniature of General Robert Prescott

Signed by John Bogle (1746?–1803), London, 1776
Oil on ivory, 4.4 x 2.9 (1¾ x 1⅛)
National Portrait Gallery, London, 3963

The extremely small miniature became a popular form in England in the third quarter of the 18th century, but by 1780 the fashion was passing. This fine example is engraved on the reverse of the frame: "General Robert Prescott—Governor of Canada. Returned to England 1799. Died December 21, 1816." Prescott is shown in the uniform of the Twenty-eighth Regiment of Foot.

Robert Prescott (1725–1816), who succeeded Guy Carleton, first Baron Dorchester, as governor in chief of Canada in 1797, had served several times with the British army in North America: at the siege of Louisbourg in 1758 (see no. 32), as aide-de-camp to General Jeffrey Amherst in 1759 (see no. 31), and in the American Revolution. In 1796 Prescott returned to Canada as lieutenant governor of Lower Canada and was appointed governor in chief the following year. Although poor health compelled him to return to England in 1799, Prescott retained his post as governor in chief until 1807 (his duties were performed by deputies).

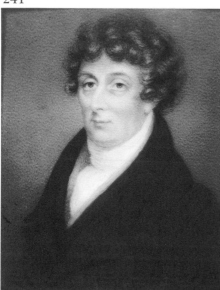

Courtesy McCord Museum, McGill University, Montreal.

241
Portrait Miniature of James Monk

Artist unknown, English, c. 1810-20
Oil on ivory, 15.6 x 13.7 (6⅛ x 5⅜)
McCord Museum, McGill University, Montreal, M22340

James Monk (1745-1826), whose family left Boston to settle in Halifax in 1749, became attorney general of Quebec in 1776 and of Lower Canada in 1792 (see no. 73). Two years later he was appointed chief justice of the Court of King's Bench for Montreal (see no. 215). From 1819 to 1820 Monk served as temporary administrator of the government of Lower Canada. In 1824 he retired and went to live in England, where he was knighted the following year.

242-243
Silhouettes of a Man and a Woman

Artist unknown, Canadian, from Spadina House, Toronto, c. 1820-30
Black gouache and grey watercolour on paper, 7.8 x 6.0 (3⅛ x 2⅜); 7.9 x 6.4 (3⅛ x 2½)
Royal Ontario Museum, Canadiana Department, gift of R. B. F. Barr, 971.322.6-7

Another miniature form, the silhouette, which was far less expensive than a full portrait, became extremely popular after the War of 1812. The subjects of these gouache silhouettes are uncertain, but they may be Robert Baldwin (1804-58) and his wife, Augusta Elizabeth.

With the exception of work done by Robert Field during his eight years in Halifax (see no. 220), and by a few other portraitists, little miniature painting was produced in Canada during the Georgian period. It was probably too rarefied a specialty to provide a practitioner a livelihood in a small and scattered market.

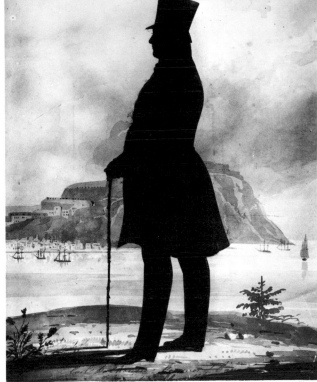

244
Silhouette of George Ramsay, Ninth Earl of Dalhousie

Signed by Jarvis Hanks (active c. 1799–1852), Quebec, c. 1826–27
Black paper over watercolour, 29.4 x 22.3 (11½ x 8¾)
The Public Archives of Canada, Ottawa, C 95138

As governor in chief of Canada from 1819 to 1828, George Ramsay, ninth Earl of Dalhousie (1770–1838), presided over the rapid growth of Canada's population and economy in the period after the War of 1812. He also endured the same sort of political difficulties that his predecessors had encountered, in particular direct conflict with Louis Joseph Papineau and the French-speaking majority in the Lower Canada assembly in the late 1820s. Among his accomplishments was the founding in 1824 of Canada's first learned society, the Quebec Literary and Historical Society.

Lord Dalhousie was a career army officer who had served throughout the Napoleonic Wars. He had first come to Canada in 1816, as lieutenant governor of Nova Scotia. After his term as governor in chief of Canada, he returned to England and the following year was appointed commander in chief of British forces in India.

In this unusual silhouette of Dalhousie, done while he was governor in chief of Canada, a black paper cutout of the figure is laid over a background watercolour panorama of Quebec.

245–246
Portrait Miniatures of Matthew Whitworth-Aylmer, Fifth Baron Aylmer, and Lady Louisa Anne Aylmer

Signed by Charles Jagger (c. 1770–1827), Bath, c. 1825
Watercolour on ivory, 9 x 7 (3½ x 2¾)
Royal Ontario Museum, European Department, gift of Floyd Chalmers, 981.209.1–2

Matthew Whitworth-Aylmer, fifth Baron Aylmer (1775–1850), was governor in chief of Canada from 1831 to 1835. Like his predecessor, Lord Dalhousie, and the new king, William IV, who assumed the throne in 1830, Aylmer participated in a new aspect of the development of Canada—the post-creation period of internal organization and consolidation. As governor in chief, he encountered the same problem that had plagued Lord Dalhousie, the hostility of Louis Joseph Papineau and the French-speaking majority in the assembly of Lower Canada. Lord Aylmer was recalled in 1835, convinced by then that no governor could establish friendly relations with the assembly.

247

Portrait Miniature of William IV Before His Accession

Peter Futvoye (active c. 1805–30), Bath, c. 1825
Oil on ivory, 4.5 x 3.5 (1¾ x 1⅜)
Private collection

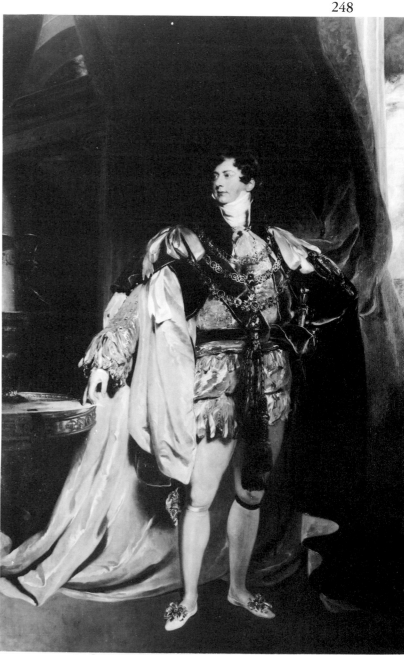

247

The Duke of Clarence, the third son of George III, acceded to the throne as William IV (1765–1837; reigned 1830–37) on the death of his brother George IV (the second son had died in 1827). The Georgian age of style and fashion had already largely passed, but William's brief reign of seven years marked a connecting link between it and the beginnings of the industrial age in North America. William was succeeded by his niece Victoria, the daughter of the Duke of Kent and Strathearn (see no. 173), whose accession ushered in the long Victorian era.

248

248

Portrait of George IV

Signed by Thomas Lawrence (1769–1830), London, 1821
Oil on canvas, 293 x 203 (115⅜ x 79⅞)
The City of Dublin, The Hugh Lane Municipal Gallery of Modern Art

George Augustus Frederick (1762–1830; reigned 1820–30) assumed the throne in 1820 on the death of his father George III. He had, however, been serving as prince regent since 1811, when his father was declared mentally incompetent.

George IV had gained his father's permanent ill-will, in part for extravagant and dissolute habits, but also for close association with parliamentary opposition leaders. In 1795 he married Caroline of Brunswick, but within five years he was estranged from her. He initiated, and later dropped, divorce proceedings, but he refused to allow the queen to attend his coronation. All in all, George IV was one of Britain's less notable or successful monarchs.

Sir Thomas Lawrence, whom George IV inherited as principal painter to the court, did the official coronation portrait in 1820. Early in his reign the king planned to make state visits to all British dominions. He commissioned this portrait from Lawrence and presented it to the Corporation of Dublin in January 1821, in advance of his proposed visit in August. George's Irish journey set a precedent. He was the first British king to visit Ireland—except to lead an army against it—and also on that journey he became the first monarch to travel by steamship.

206

BIOGRAPHIES OF
ARTISTS

IRENE SZYLINGER

William Bate (active c. 1790, died c. 1845)

Very little has been documented of the life of William Bate. He was born in Dublin, into a family with a long tradition as watchmakers and jewellers. He must have received some training from his father, though it is not known that he had instruction in painting or drawing.

William Bate became a specialist in miniature portraits in watercolour and in enamel (see no. 239). He established a successful practice in Dublin and by 1799 was also active in London. Bate began to exhibit at the Royal Academy in 1799 and continued to do so until 1807. He is recorded as "painter in enamel" to Princess Elizabeth and Frederick, Duke of York, two of George III's progeny.

François Malepart de Beaucourt (1740–94)

François Beaucourt, one of the finest early Canadian portraitists, was born in La Prairie, near Montreal. He was the son of Paul Malepart de Beaucourt (1700-1756), a French-born soldier who was posted to New France in 1720. When Paul Beaucourt left the army, he settled in La Prairie and took up painting.

François first studied painting with his father, who then encouraged him to seek training in Europe. François went to Bordeaux to pursue his studies and married there in 1773. For some fifteen years he worked as a portrait artist in Europe, travelling extensively to obtain commissions.

Only for the last eight years of his life was François Beaucourt active in Canada. He returned from Europe in 1786 and soon established his reputation in Quebec, through private as well as church commissions. In 1792 Beaucourt settled in Montreal, where he placed advertisements in the *Gazette* enumerating his various talents, among which he noted portraiture and interior decoration. It was in the year of his return to Canada that Beaucourt painted his impressive *Portrait of a Slave Girl* (see no. 138).

William von Moll Berczy (1744–1813)

William Berczy, the son of a German diplomat, studied at the Academy of the Arts in Vienna and at the University of Jena. Before coming to Canada in 1794, he travelled extensively on the Continent. For a time he was a member of the artistic community in Rome, where he encountered artists with a neoclassical orientation. During those years Berczy worked as an artist and an architect and was probably also involved in some business ventures.

In 1790 Berczy participated in an emigration scheme to bring a group of Germans to New York State. When the sponsoring company failed to support Berczy, he and his group eventually settled near York (Toronto) in Upper Canada. There Berczy continued to paint—in oil, pastel, and watercolour—but he also maintained business connections, which gave him opportunities to work as an architect and builder in the earliest stages of the development of the city.

After 1803 Berczy made painting his profession. He travelled to Quebec City and Montreal in search of commissions and finally settled in Montreal in 1805. There he acquired both private and church patrons for his portraits, architectural designs, and decorations (see nos. 165-167). Of all his paintings, the group portrait *The Woolsey Family* is probably the best known (see no. 168).

Thomas Birch (1779–1851)

In late 1793 Thomas Birch sailed from England with his father, William Birch, aboard the *William Penn*. In Philadelphia, where they settled, William Birch continued to practise his profession of engraver and miniaturist. Thomas received his early art training as an assistant in his father's studio, where he helped in the engraving of landscapes and views around Philadelphia, which were published in 1800.

Thomas Birch preferred to paint marine views, but when he first established his own studio he worked mainly on portraits, including miniatures. The War of 1812 gave him an opportunity to document the historic sea battles that brought glory to the United States navy (see nos. 222, 223, 228). In 1814 *The Battle of Lake Erie* (no. 228) was exhibited at the Pennsylvania Academy of the Fine Arts, where Birch held the office of keeper from 1811 to 1816. An explanatory key accompanied the painting, so that viewers could identify the protagonists in the large canvas.

A quality of precision of execution permeates all of Birch's work, marine paintings as well as country landscapes. To a certain degree this may be attributed to his early experience as an engraver.

John Bogle (1746?–1803)

Although John Bogle painted some large portraits, he is best known for his many miniatures. Bogle studied art at a Glasgow drawing school, but nothing is known of his teachers or the duration of his training.

Bogle established a career as a miniature painter first in Edinburgh and then in London. In 1769 and 1770, while he was still in Edinburgh, he exhibited with the Society of Artists in London. After he settled in London about 1770, he showed his paintings at the Royal Academy from 1772 until 1794. Bogle's practice as a miniature portraitist flourished in London (see no. 240), though he returned to Edinburgh in 1800 and lived there until his death.

Henry Bone (1755–1834)

Henry Bone, the son of a wood-carver and cabinetmaker, was a successful miniature painter whose patrons included George III, George IV, and William IV (see nos. 237, 238). As a young man, the artist painted china in Plymouth, and later he was apprenticed for six years in Bristol. By 1779 Bone was established in London, though he pursued commissions in travels outside the city.

Bone gained his livelihood from painting designs for lockets, jewellery, and watches. A year after he settled in London, however, Bone began to make his mark as a miniaturist. Many of his enamels are copies, but most of the miniatures he painted on ivory are originals. To enhance his reputation, Bone displayed collections of his enamel miniatures in his home in London. These were particularly appealing, owing to the freshness of colour he achieved in this medium.

From 1781 until his death, Bone exhibited at the Royal Academy, the British Institution, the Society of British Artists, and the Free Society of Artists (1783). He became an associate of the Royal Academy in 1801 and gained full status as an academician in 1811. In the year of his death, eighty-five of Bone's enamels of prominent people were exhibited at the Society of British Artists.

Canaletto (1697–1768)
(Giovanni Antonio Canal)

Although he was born in Venice and is best known for his views of his native city, Canal, commonly known as Canaletto, spent a decade in London after 1746. His training began with his father, Bernardo, who worked in the theatre and took his son to Rome in 1719. There Canaletto studied topographical painting and engraving.

On his return to Venice, Canaletto established a studio and began to paint views of the city for patrons, many of whom were British travellers. During this period the artist turned increasingly to pen-and-ink drawing, and to novel subjects such as festivals and ceremonies. His graphic production included etchings as independent works, rather than as preparatory sketches. The landscapes for which he is best remembered are not always precise representations of a specific view. Canaletto is known to have selected segments of views from diverse sources and organized them into a single idealized composition.

Canaletto went to England in 1746 in pursuit of patrons, whose Grand Tours of the Continent were thwarted by the War of the Austrian Succession. Once in London, he was successful in acquiring important patrons such as Lord Brooke, the Duke of Beaufort, Sir Hugh Smithson (later Duke of Northumberland), and the Duke of Richmond, for whom he painted city views and landscapes of country estates (see no. 1).

Canaletto returned to Venice in 1755 and remained in his native city for the rest of his life. He was elected to the Academy of Venice in 1763. His most famous project of this period comprises twelve paintings of ceremonies involving the doges of Venice, which were later engraved by Francesco Guardi (1712–93). When Canaletto died, a large number of paintings and drawings were sold from his estate to George III, so that the Royal Collections became a wealthy repository of his works.

John Singleton Copley (1738–1815)

John Singleton Copley's artistic education began in his native Boston, with lessons from his stepfather, Peter Pelham (1695–1751), a painter and mezzotint engraver. During this early period Copley may also have been influenced by John Smibert (1688–1751) and John Greenwood (1727–92). Greenwood and another painter, Joseph Blackburn, who arrived in Boston in 1755, were instrumental in acquainting Copley with the elements of contemporary English rococo portraiture style. In addition to oil portraits, his main subject in America (see nos. 70, 71, 81), Copley produced miniatures in oil on copper, as well as works in pastel.

Although Copley did not go to Europe until 1774, his reputation as a portrait painter preceded him. While he was still in Boston, he exhibited regularly in London from 1760 to 1767. His portrait of Henry Pelham (1765), which was shown at the Society of Artists, brought favourable responses from Joshua Reynolds (1723–92) and Benjamin West (1738–1820).

On his arrival in Europe, Copley toured extensively to experience at first hand the paintings of the masters of Italy, Germany, the Netherlands, and France. In 1775 he decided to settle in London, where he was to remain for the rest of his life. There Copley not only produced some of his finest portraits, but he also worked very successfully in the complex genre of history painting. His reputation grew, and he was granted a full membership in the Royal Academy in 1779, although he was not to produce his diploma picture until 1782.

Copley's strength lay in his ability to depict contemporary subject matter with truth and elegance. He is as well known for his portraits as for his huge paintings of historic events, which he invested with documentary information as well as with aesthetic merit.

Thomas Davies (1737?–1812)

Thomas Davies was a soldier by profession and an artist by avocation. Born at Shooters Hill near Woolwich, Davies was enrolled as a cadet at the Royal Military Academy in 1755. Gamliel

Massiot was drawing master at the time, and from him Davies received the training that would establish him as one of the most successful topographical artists of his day.

Davies' career in the Royal Artillery was advanced mainly in North America, where he was posted on four separate occasions: 1757-62, 1764-c. 1767, 1773-c. 1779, and 1786-90 (see nos. 32, 33, 33a, 68, 75, 107, 108). Davies is best remembered for his ability to document the terrain of the New World in plans and surveys. As he was also an amateur naturalist and ornithologist, he sketched some of the flora and fauna that he observed on his travels. In spite of frequent absences from England, Davies managed to exhibit fairly consistently at the Royal Academy from 1771 until 1806.

Davies' published set of six engravings, *Six Views of North American Waterfalls* (London, c. 1768), are dedicated to General Sir Jeffrey Amherst, in commemoration of Davies' service in the general's forces during the Seven Years' War. The engravings were later used as illustrations in travel literature.

George Dawe (1781–1829)

George Dawe is known for his portraits of royal sitters. In 1816 he began his many versions of portraits of Princess Charlotte and Prince Leopold of Belgium. He had already established his reputation and had exhibited at the British Institution between 1806 and 1813 and at the Royal Academy between 1804 and 1818. While in the employ of George III and Queen Charlotte, Dawe received portrait commissions from other members of the royal family and from their relatives on the Continent.

After the death of Princess Charlotte in 1817, Dawe continued to work under the patronage of the prince, but he also painted several versions of the Duke and Duchess of Kent (see no. 173). For the next decade Dawe travelled extensively in Europe to acquire and fulfil commissions; his patrons were mainly members of European royal houses, among them Czar Alexander I of Russia.

Joseph Frederick Wallet DesBarres (1722–1824)

Frederick DesBarres had an extraordinarily long life and a varied career. His education began in his native Basel and continued at the Royal Military Academy in Woolwich. In the course of his life, DesBarres became an accomplished and successful surveyor, topographical artist, and mapmaker (see no. 75a).

DesBarres served with the British army in North America in the Seven Years' War. He spent the following decade surveying and mapping the coasts of Nova Scotia for the British Admiralty. This work culminated in the publication of *The Atlantic Neptune* in 1777.

From 1784 to 1787 DesBarres was lieutenant governor of Cape Breton Island and from 1804 to 1812, when he was in his eighties, he held the same office in Prince Edward Island. DesBarres died in Halifax at the venerable age of 103.

James Duncan (1806–81)

James Duncan's artistic career was multi-faceted. In his native Ireland he worked as an illustrator, a lithographer, and a painter. After he settled in Montreal in 1830, Duncan made a living as an artist, working in pen and ink, oil, and watercolour (see no. 7). During the Rebellion of 1837 Duncan joined the Montreal Light Infantry. That was also the year he produced the designs for the Bank of Montreal penny and half-penny coins, which were exhibited in 1851 at the Great Exhibition in the Crystal Palace in London.

Duncan is best remembered for his Montreal scenes that appeared in 1839 as engravings in *Hochelaga Depicta: The Early History and Present State of the City and Island of Montreal*, a publication edited by Newton Bosworth. Duncan's artistic talents extended to every aspect of its production.

In another project in 1850, Duncan was responsible for preparing the drawings for the lithography stones from which six Montreal views were produced and printed. He also did illustrations for the *Canadian Illustrated News* and the *Illustrated London News* and taught art privately and in public institutions. And, as a partner in the firm of Young and Duncan, the artist worked with photographers and ambrotypists, producing portraits in the new media.

Duncan became well ensconced in Montreal society and affiliated himself with numerous professional organizations. He exhibited with the Society of Canadian Artists (1867-72) and the Art Association of Montreal (1865-79), at the Quebec Provincial Exhibition (1863-65), and as an associate of the new Royal Canadian Academy in 1881.

William Elliott (1765/70–1838)

William Elliott's primary profession lay with the Royal Navy. He became a lieutenant in 1782, a commander in 1790, and then a captain in 1810. His travels were extensive, for he is said to have been posted to China, Canada, and the West Indies.

Although nothing is known of Elliott's artistic training, his travels provided him with the opportunity to paint numerous canvases, many of which were later made popular through engravings. His subjects were always related to some aspect of marine activity, such as naval battle scenes or harbour views (see nos. 127, 128). Elliott exhibited with the Free Society of Artists in 1790 and 1791 and at the Royal Academy from 1784 until 1789.

Robert Field (c. 1769–1819)

Robert Field was born in England and studied at the Royal Academy school in London before emigrating in 1794 to the United States, where he began a career as a miniature painter. In England he had become familiar with the work of talented artists such as Benjamin West (1738-1820). In North America his painting came to rival that of Gilbert Stuart (1755-1828). As his popularity grew, portrait commissions took Field from Boston to Philadelphia, Baltimore, and

Washington. Among his illustrious clients were Thomas Jefferson and Martha Washington.

With commissions mounting, Field produced portraits in all manner of size and medium; he worked in oil and in watercolour, on full-sized canvases and on ivory miniatures. The ease with which he captured the likeness of a sitter provided the best publicity for him. Field also tried his hand at engraving portraits—his own and those of others—and that no doubt added to his growing reputation.

In 1808 Field moved to Halifax, where he established a thriving business that kept him occupied for eight years (see nos. 214, 220). From the moment of his arrival, Field received commissions from the most influential people of the province, for example, Sir George Prevost, the lieutenant governor, whose portrait Field painted in 1808. During the time he was in Halifax, Field produced some fifty oil portraits.

In 1816 Field left for the British garrison in Kingston, Jamaica, in search of more commissions. Three years later he died there of yellow fever.

Alvan Fisher (1792–1863)

Alvan Fisher, who was born in Needham, Massachusetts, did not begin to train as an artist until he was in his twenties. At the age of eighteen he was working as a clerk in a general store. Sometime later Fisher was apprenticed to a Boston artist, John R. Penniman (1782–1844), with whom he worked as a sign and decorative painter for about two years.

By 1814 Fisher was earning a living as a portraitist and had also expanded his repertory to include animal and genre scenes and landscapes (see no. 207). The influence of the landscape artists that he met in Philadelphia about 1820—Thomas Birch (1779–1851), Thomas Doughty (1793–1856), and the young Thomas Cole (1801–48)—swayed him firmly towards landscapes. For the next few years Fisher travelled the countryside sketching the scenes he saw. In 1825 he went to Europe. His trip took him from England, to France, to Switzerland, and then to Italy. On his return, he settled in Dedham, near Boston, where he married and remained for the rest of his life.

Fisher became associated with the landscape artists who later formed the Hudson River School. He sketched his landscape scenes from firsthand observation and then did his finished paintings in his studio. In search of new subjects, he travelled throughout the northeastern United States. His well-known views of Niagara Falls are mementoes of those journeys. Towards the end of his life Fisher remained in Dedham, painting from the many sketches he had executed on his travels.

Throughout his career Fisher exhibited in Boston, New York City, Philadelphia, and Baltimore. He became an honorary member of the National Academy.

Sir George Bulteel Fisher (1764–1834)

George Bulteel Fisher combined a distinguished military career with an avocation as a painter. He was born in Peterborough, England, and it is likely that he studied at the Royal Military Academy at Woolwich, where he would have received training in drawing and painting.

By 1782 Fisher was a second lieutenant in the Royal Artillery. In 1791 he came to Canada and later became aide-de-camp to the Duke of Kent. His years in North America yielded six Canadian views and one American view, which were engraved in aquatint by J. W. Edy and published in London in 1795 and 1796 (see nos. 134, 135). Fisher exhibited his landscapes, which were mainly in watercolour, at the Royal Academy in 1780, 1800, and 1808.

In recognition of his services, Fisher was knighted. Towards the end of his life, he was appointed to the distinguished position of commandant of the Royal Military Academy at Woolwich.

Peter Futvoye (active c. 1805–30)

Little is known about the life or career of Peter Futvoye. During his active years he lived in Bath, where he was possibly teaching various decorative art techniques. It was also in Bath that he undertook commissions for miniature portraits (see no. 247).

Thomas Gainsborough (1727–88)

When he was only thirteen, Thomas Gainsborough left his native town of Sudbury in Suffolk for London, where he studied with the French engraver and book illustrator Hubert Gravelot (1699–1773). Under Gravelot, who was then engraver and drawing master at St Martin's Lane Academy, Gainsborough developed the drawing style that would remain in evidence throughout his career. He learned landscape painting by copying and imitating the 17th-century works of artists such as Jacob van Ruisdael (1628/29–82).

Gainsborough's attraction to landscape as a subject had its origins in his attachment to the countryside of his native Suffolk. From the time he returned to Suffolk in 1748, Gainsborough continued to paint the landscape, with increasing virtuosity. He was able to put this expertise to use in the backgrounds of the portraits he painted when he began to make his living as an artist.

It was in Ipswich that Gainsborough turned to various types of portraits, including groups placed in landscape settings, which represented a kind of conversation piece. After six years in Ipswich, the artist moved to Bath, where his paintings began to reflect the more elegant ambience of that fashionable spot.

Gainsborough first exhibited his paintings at the Society of Artists in 1760. In 1768 he was invited to become a founding member of the Royal Academy, even though he lived outside London at the time. When Gainsborough moved to London in 1774, his success as a portrait painter enabled him to pursue his landscape painting. But it was his portraiture that assured his eminent position

in London (see no. 124), especially after 1777, when he received his first commission from the royal family.

In the final decade of his life Gainsborough experimented with diverse subjects and media. In his drawing, his etching, and his oil painting, he continually searched for the true expression of the mood and emotional content of every subject.

Isaac Gosset (1713–99)

Isaac Gosset was born into a Normandy family that fled to Jersey and later settled in London. He probably received his earliest training with his uncle Matthew Gosset (1683-1744), who established a solid reputation as a sculptor.

A much respected artist, Isaac Gosset invented a formula for wax that enabled him to sculpt the medium in a more refined manner than had been possible. His technique and his approach to the sitter gained him much success, and he produced a great number of wax portraits. The list of his sitters includes George III, Queen Charlotte, Lord North, David Garrick, and General James Wolfe (see no. 48).

In his association with the famous ceramist Josiah Wedgwood, Gosset produced portraits of George I and George II, among others. Gosset exhibited at the Society of Artists and the Free Society from 1760 until 1778.

Edmund Henn (active 1789–1800)

Edmund Henn is recorded as a captain in the Twenty-fourth Regiment of Foot, which served in Canada from 1789 to 1800. For part of that time he was stationed in Detroit and Michilimackinac. The phenomenon of Niagara Falls evidently attracted Henn, as it did many military artists of the 18th century (see no. 155).

George Heriot (1759–1839)

George Heriot was almost entirely self-motivated in his determination to paint. There are no records that he ever received any art training, and he never made a living from his avocation. He was employed by the board of ordnance at Woolwich, where he may have had contact with Paul Sandby (1725/26-1809), who was art teacher at the Royal Military Academy. There is no evidence that Heriot ever attended the academy, although while he was in Woolwich (1785-91) he painted extensively in watercolour, using small sketchbooks, many of which exist in Canada.

Heriot became a civil servant and in 1792 was posted to Quebec as clerk of cheque for the ordnance department. In 1799 he was appointed deputy postmaster general of British North America and in 1804 he also undertook the position of clerk of survey for the ordnance department. He held both offices concurrently until 1816, the year he left Canada.

Heriot's postal duties took him on journeys throughout Upper and Lower Canada, and beyond. On his travels Heriot painted hundreds of views (see nos. 169, 171), many of which were later published as aquatints in his books *History of Canada* (vol. 1, London, 1804) and *Travels Through the Canadas* (London, 1807). His *Minuets of the Canadians* and *La Danse ronde* appeared in the latter (see nos. 182, 183). They are only two of Heriot's many works that provide a visual record of the life and customs of Canadians in his day.

On his return to England, Heriot travelled on the Continent. His drawings and watercolours from those travels were also later published as aquatints. Much of Heriot's work remains in the form of sketches, which he later used as a basis for finished watercolours. In his publications, Heriot demonstrated an understanding of theories espoused by 18th-century thinkers regarding the picturesque and the sublime, but none of the theories restricted his particular clarity in recording the facts.

Joseph Highmore (1692–1780)

Although Joseph Highmore spent seven years training for the law, he never actually practised. After completing his law studies in 1714, Joseph, the nephew of the court painter Thomas Highmore (1660-1720), went to study at the academy of Godfrey Kneller (1646/49-1723). In spite of a rather late beginning, Highmore began to paint for a living almost immediately after his arrival at the academy.

Highmore is well known for the twelve paintings he did to illustrate his friend Samuel Richardson's novel *Pamela*. In comparison with the satirical scenes of William Hogarth (1697-1764), Highmore's illustrations emerge as straightforward recordings painted in a gentle, lyrical manner. Highmore's style of narrative painting was also more elegant and much less acerbic than that of Hogarth.

Highmore is best remembered for the portraits he produced continuously from 1728 until his retirement to Canterbury in 1762 (see no. 38). A man of letters throughout his life, Highmore turned to writing after he gave up painting. He wrote on a variety of subjects, such as perspective, morals, and religion.

Jan Josef Horemans the Elder (1682–1759)

Jan Josef Horemans the Elder seems to have spent his entire life in Antwerp, the city of his birth. He studied first with the sculptor Michiel van der Voort (1667-1737), and from 1694 until 1700 with Jan van Pee (c. 1640-1710). At the age of twenty-four, Horemans became a master in the Guild of St Luke.

Horemans is best known for group portraits of figures in simple settings (see no. 180). He painted labourers and peasants as well as members of the bourgeoisie. His subject matter reflected the tradition of genre painting, especially the Dutch and Flemish tradition in which all subjects were worthy of being painted. Patronage did not dictate subject matter. Horemans's oeuvre encompasses card players, shoemakers, innkeepers, vendors of every

kind, and intimate domestic scenes of poor as well as bourgeois families.

Thomas Hudson (1701–79)

Thomas Hudson thrived as a fashionable portrait painter between 1740 and 1760 (see no. 15). He was born in Devon and trained under Jonathan Richardson (c. 1665–1745), then a popular society portraitist, whose daughter Hudson married. Richardson's publication *An Essay on the Theory of Painting* (London, 1715) may initially have drawn Hudson to him.

Hudson is recorded to have been in London as early as 1725. He must have seen the works of Jean-Baptiste Van Loo (active in London 1737–42), a fashionable portraitist whose clientele Hudson inherited, along with that of Richardson. Until 1740 the influence of Richardson remained very strong, though Hudson was slowly achieving his own style. The retirement of his well-connected father-in-law in 1740 no doubt helped to establish Hudson's success as a portraitist.

During this period Hudson began to collect Old Master prints, drawings, and paintings, sending his apprentice Joshua Reynolds (1723–92) to bid for him at sales. Reynolds and Joseph Wright of Derby (1734–97) were two of Hudson's most famous students.

In spite of exposure to paintings in France, the Netherlands, and Italy, Hudson maintained his old style, which suited the conservative requirements of his sitters. They preferred the formal and documentary approach for which Hudson is known to the more casual and interpretative mode adopted by contemporaries such as William Hogarth (1697–1764) and Joseph Highmore (1692–1780). Once a formula for a portrait was established, Hudson probably did little more than execute the face of his sitter. The rest of the painting—background, drapery, and details of the setting—was left to a team of studio assistants and drapery painters.

Two artists with whom Hudson collaborated were the van Aken brothers, who were active in London from the 1720s on. Alexander van Aken (Flanders, 1701–57) engraved some of Hudson's portraits; Joseph (1699–1749) was involved as a drapery painter. Hudson, like many successful portrait painters, also drew on his Old Master collection for inspiration in structuring his compositions. His own store was greatly augmented when he inherited Richardson's outstanding collection.

Anthony Imbert (active 1825–34, died c. 1837)

Anthony Imbert was a French naval officer who was captured and imprisoned by the British during the Napoleonic Wars. In the course of his lengthy incarceration, Imbert taught himself the rudiments of marine painting.

For reasons that are not clear, Imbert emigrated to the United States and settled in New York City in 1824. There he worked as a marine painter and a lithographer. In 1825 he was commissioned to produce engravings to illustrate Cadwallader Colden's *Memoir* (New York, 1825), published to commemorate the opening of the Erie Canal. Imbert's painting in this exhibition is the only known version in oils of the event (see no. 208). Imbert is best remembered for the prints he made of New York City views after A. J. Davis (1803–92), which were executed between 1826 and 1828.

Charles Jagger (c. 1770–1827)

Charles Jagger was a competent miniature painter who remained in the English provinces for most of his active life. Except for a brief period in Liverpool, where he may have studied, Jagger worked almost exclusively in his native Bath (see nos. 245–246).

The artist is said to have taken great pains to capture precisely the individual characteristics of each sitter's face. This diligent and accurate rendering was no doubt instrumental in attracting the clients who enabled Jagger to earn a living as a miniature portraitist. His method of painting backgrounds included both hatching and stippling, and sometimes horizontal brush strokes that resulted in a pattern resembling a series of hexagons.

Sir Godfrey Kneller (1646/49–1723)

Although Kneller later trained in Italy, early Dutch influences remained dominant throughout his career. Kneller was born in Lübeck, where his father, Zacharias Kneller, was also a painter and a surveyor. When he was about seventeen, Godfrey Kneller went to Amsterdam and studied with Ferdinand Bol (1610–80), a former pupil of Rembrandt (1606–69). In the early 1670s Kneller was in Rome, where Carlo Maratta (1625–1713) and Gian Battista Baciccia (1639–1709) were the leading portraitists. While he was in Italy, Kneller travelled to Naples and Venice, where he worked as a portraitist and studied the works of Titian (c. 1490–1576).

Kneller settled in England about 1676 and may have been introduced at court by 1677, although very few examples of portraits done between 1677 and 1683 exist, perhaps because of travels he undertook at that time. Within a short period, Kneller became a prominent painter of aristocratic members of London society. As his work matured, he displayed a particularly sharp sensitivity to his sitters' personalities.

Part of Kneller's fame rests on two series of paintings. The first, which he began about 1690, is the "Hampton Court Beauties". The second series, the forty-two "Kit-Cat Club" portraits, he produced between 1702 and 1717. Unlike the portraits Kneller painted with the help of studio assistants (see no. 9), these two series strongly reflect the individual personality of each sitter.

Kneller's studio in London was closer to a factory than a studio, in that the artist employed dozens of assistants and was known to have numerous sitters each day. Only the rudimentary features of each sitter were drawn from life; the remainder of the portrait was completed in the absence of the sitter. Kneller portraits thus reflect a

kind of team effort, which resulted in the establishment of portrait formulas.

Kneller became established through the reigns of Charles II and James II and was principal painter to William and Mary. In 1691 he was knighted and in 1715 he was created a baronet.

Sir Thomas Lawrence (1769–1830)

Thomas Lawrence began his painting career at the precocious age of ten, when he first drew portraits of the guests at his father's inn. Until he became a student at the Royal Academy in 1786, Lawrence lived in Devizes, Oxford, and Bath, supporting himself by working as a portraitist in pencil and pastel. He did not use oils until his arrival in London.

One year after his brief enrolment at the academy, Lawrence began to exhibit his pastel portraits and in 1789 he showed his first full-length oil portrait, which gained him the approval and patronage of the royal family. In 1792 he replaced Joshua Reynolds (1723–92) as principal painter to George III. Two years later Lawrence became a full academician. His painting reflected a combination of the influence of the Reynolds style of portraiture and his own unique sense of drama (see nos. 90, 248). His fluid brushwork and sensitive use of colour place Lawrence at the forefront of the romantic sensibility prevalent in the late 18th century.

Lawrence, who was knighted in 1815, is best known for his portraits, in particular for his romantic interpretation in his series of portraits of the victorious leaders of the allies in the Napoleonic Wars. The series was commissioned by the prince regent in 1818. To fulfil the commission, Lawrence travelled to Aix-la-Chapelle and then went on to Vienna and Rome. When he returned to London in 1820, Lawrence succeeded Benjamin West (1738–1820) as president of the Royal Academy.

Sir Richard George Augustus Levinge (1811–89)

Richard Levinge was a British career army officer and an amateur painter. Posted to Saint John, New Brunswick, in 1835, he was active in the suppression of the Rebellion of 1837. He returned to England in 1840 and retired from the army eight years later when he succeeded to the baronetcy.

In spite of military obligations, Levinge found time during his stay in Canada to record the leisure moments of the men in his garrison. *Sleighing in New Brunswick* and *Meeting of the Sleigh Club at the Barracks* provide a fairly detailed representation of the types of sleighs, horses, and clothing in use at the time (see nos. 177, 178). The pictures also give us a glimpse of the housing and street layout of Saint John in the early 19th century.

Hamilton MacCarthy (1847–1939)

Hamilton Plantagenet MacCarthy first studied sculpture in his native London with his father, Hamilton W. MacCarthy. In addition, he received instruction at the Marylebone School in London and later in Antwerp. While he was still in England, MacCarthy exhibited at the Royal Academy between 1874 and 1884.

MacCarthy came to Canada in 1885 and very soon became an associate of the Royal Canadian Academy; he was made a full member the following year. He is well known for small portrait busts of public figures (see no. 216), and for a number of public monuments.

Philippe Mercier (1689?–1760)

Philippe Mercier was born to a French expatriate tapestry maker in Berlin, where he attended the painting academy. He later studied in Italy and France, where he made etchings after Antoine Watteau (1684–1721).

Mercier's first known dated painting is a conversation piece, and though it is unclear whether it was painted in London, Mercier was one of the earliest artists to practise this type of informal group portraiture. After he became active in London about 1725 or 1726, he continued to produce this type of painting until the patronage of Frederick, Prince of Wales, in 1728 enabled him to branch out and do full-length individual portraits.

Although the royal patronage did not last very long, Mercier was able to obtain commissions from other sources. In the late 1730s he painted larger portraits, sometimes of groups, which were later engraved. His practice thrived; by 1740 he was settled in Yorkshire and making a living from his portrait commissions, for which he continued to travel. Mercier is said to have gone to London in 1747 to sell his paintings dealing with the five senses (see no. 185).

Peter Monamy (1680–1749)

Peter Monamy is best known for his marine paintings. He was born in London and as a young man was apprenticed to a London house painter and decorator for about seven years. There is no evidence that he received any formal art instruction and it is commonly accepted that he was self-taught. He was attracted to the Thames River and found a wealth of subjects around the shipping docks.

While he was teaching himself to draw and paint, Monamy studied the works of the younger Willem van de Velde (1633–1707). As a consequence, his work shows a strong affinity with the Dutch marine tradition. Monamy adopted the younger van de Velde's compositional structure in his renderings of ships firing salutes, examples of which exist in the National Maritime Museum in Greenwich. Although Monamy had a good knowledge of ships and the sea, it is likely that his compositions were often derived from other paintings.

While Monamy attained a certain degree of expertise as a marine painter (see no. 13), he did not venture to explore other subject matter. Nonetheless, his marine scenes remain a fine record of ships in the early part of the 18th century.

Joseph Nollekens (1737–1823)

Joseph Nollekens was the son of Joseph Francis Nollekens (1702–48), an Antwerp painter who moved to London in 1733. The younger Nollekens, known as a sculptor, probably received the rudiments of his artistic education with his father. When he received a prize from the Society of Arts in 1760, Nollekens left for Rome, where he was to remain for a decade. He sent sculptures to London for exhibitions and also began to deal in antique sculptures that he had restored.

Through his achievements in Rome, Nollekens established a solid reputation. On his return to London, he became an associate of the Royal Academy in 1771 and a full academician the following year. He showed his works at the Royal Academy from 1771 until 1816 and his success at these exhibitions provided a growing number of commissions.

Nollekens worked in stone, plaster, and terracotta, producing sculptures ranging from portrait busts to architectural ornaments depicting ancient mythological figures and motifs. He made multiple copies of many of his portrait busts, including the one of the younger William Pitt (see no. 125), of which Nollekens himself sold seventy-four.

George Isham Parkyns (c.1749/50–1820)

Born in Nottingham, England, George Isham Parkyns exhibited landscapes and engravings in London from 1772 until 1813. He is known as a painter, an engraver, and a publisher. While in London, he published *Monastic Remains and Ancient Castles in Great Britain*.

When he came to the United States about 1794, Parkyns collaborated with James Harrison of New York in a proposal to produce twenty-four aquatints of rural and city views of America. Parkyns seems to have settled in Brooklyn for a time, since several of his drawings for this series were on view at his home there in 1796. *A View of Halifax from Fort Needham* (see no. 136), also published by James Harrison, in 1801, confirms the long association between the two men.

Richard Paton (1717–91)

Very little is known of Richard Paton, who produced some of the most important 18th-century naval paintings. He was born in London into a very poor family, but managed to gain employment as assistant to the painter on Commander Sir Charles Knowles's ship. Except for that experience, Paton never received formal training as a painter.

In 1742 Paton secured the position of assistant accountant in the Excise Office, and painted only during his leisure hours. His production was slow and uneven, but he was relieved of the necessity to earn a living as an artist. Paton had a keen eye; some influence from other marine painters such as Samuel Scott (1702?–72) and Charles Brooking (c. 1723–59) is clearly discernible (see nos. 34, 37).

Paton exhibited his paintings at the Society of Artists from 1762 until 1770, and at the Royal Academy from 1776 until 1780. He began to receive recognition from the time he showed *The Battle of Lagos* (1759) and *The Foudroyant* (1758) at the Society of Artists in 1762. Paton engraved some of his paintings, or had engravings of them made by P. C. Canot. That practice, as well as notices of his exhibited paintings, brought him praise from George III, as well as from the public.

James Peachey (active 1773–97)

James Peachey, who was in the British army, is known to have spent three periods in North America: 1774–75, 1780–86, and 1787–97. He was active at first as a survey draftsman under Samuel Holland (1728?–1801), then surveyor general of Quebec, producing up-to-date maps and surveys. During his second visit, Peachey was promoted to deputy surveyor general, still under Holland, and worked primarily in Quebec. Part of his responsibility was the allocation of lots of land to Loyalist settlers.

While he was fulfilling his obligations to the British army, Peachey also drew, sketched, and painted continuously (see nos. 130, 131, 137, 153, 154). It is known that on his return to London, after the second period in North America, Peachey produced outline etchings of his views, which were then hand coloured. He also published aquatints of his Canadian topographical views. During this period (1786–87) Peachey exhibited his Canadian watercolours at the Royal Academy. In addition, he produced his own etchings to illustrate *The Book of Common Prayer Translated into the Mohawk* by Joseph Brant (London, 1787).

Meanwhile James Peachey was gaining advancement in the army. During his third sojourn in North America, he was promoted to captain. He continued to survey and sketch the Niagara region and the Montreal and Quebec areas.

Charles Willson Peale (1741–1827)

Charles Willson Peale, who had a varied career, did not take up painting until he was twenty-one. Peale was born in Maryland and was apprenticed as a boy to a saddler in Annapolis from 1754 until 1761. After his apprenticeship, Peale operated his own business as a saddler and repairer of clocks for the next five years. He had his first brief art lessons in 1763 with John Hesselius (1728–78) and spent some time in the studio of John Singleton Copley (1738–1815) in Boston in 1765. Two years later Peale arrived in London to study with Benjamin West (1738–1820). While he was in London, Peale exhibited with the Society of Artists.

On his return to the United States, Peale found work in Annapolis, where he remained until 1775. Three years of military service followed and by 1778 Peale was settled with his family in

Philadelphia (see no. 179). Peale had painted his first portrait of Washington in 1776; now he was commissioned by the Supreme Executive Council of Pennsylvania to paint Washington again. He also painted Washington at the battle of Princeton (see no. 96). Peale was slowly building his reputation as a painter, though the growing number of commissions did not prevent him from applying his energies to his diverse interests. The scope of his activities was impressive. He found time to be an inventor, a painter of portraits (miniature as well as full-size), and a curator of a natural history and science museum and of a fine arts museum.

Peale opened his picture gallery in 1782, and his museum of natural history four years later. The star exhibit there was the skeleton of a mastodon, which had been exhumed under Peale's supervision. Peale had no assistants, but he married three times and fathered seventeen children, several of whom became competent artists and assisted him in all his endeavours.

Peale continued to paint portraits throughout his career and was active in founding the Pennsylvania Academy of the Fine Arts. He published and gave lectures on diverse subjects ranging from the building of wooden bridges to natural history, and even to tips on domestic harmony. His experiments and inventions encompassed a broad range of interests which did not diminish with age.

The Reverend Matthew William Peters (1741/42–1814)
Born on the Isle of Wight, Matthew William Peters was brought up in Dublin. It was there he began to sketch, and as early as 1756 he received prizes for his drawings. Peters went to London about 1758 to study with Thomas Hudson (1701–79); he was given a monetary award by the Society of Arts in 1759. Later the Dublin Society sent him to Italy, and in 1762 he was at the academy of Pompeo Batoni (1708–87) in Rome. The following year he became a member of the Florence Academy.

Peters went to the Continent for one more extended period between 1772 and 1776. During this time he spent two years in Venice and copied paintings by Rubens (1577–1640) in Paris and by Correggio (c. 1489–1534) in Parma. In Paris he saw provocative paintings by such artists as Jean-Baptiste Greuze (1725–1805), which prompted his own foray into the subject of women in inviting poses. Between 1776 and 1779, Peters painted pictures of suggestive, smiling ladies, which were published as engravings.

After his first sojourn in Europe, Peters exhibited in London. He showed portraits at the Society of Artists between 1766 and 1769, and exhibited at the Royal Academy from 1769 until 1785. He was an associate of the academy in 1771 and became a full academician in 1777.

After Peters was ordained in the Church of England in 1781, his artistic output gradually diminished. He began to paint religious subjects, but produced little for private commissions; a few of his religious paintings were engraved. Peters also worked on some

scenes from Shakespeare and portraits of poets. After he resigned from the Royal Academy in 1788, Peters painted very little, although the two group portraits in this exhibition were done about 1791 (see nos. 150, 151).

Allan Ramsay (1713–84)
By the time young Allan Ramsay arrived in London about 1733 to study at the studio of Hans Hysing (1678–1752/53), he was already somewhat conversant with drawing and sketching. A native of Edinburgh, Ramsay was the son of a poet and book dealer. In 1736 he went to study art in Italy. At first he worked with Francesco Fernandi, known as Imperiali (1679–1741), in Rome, and then with Francesco Solimena (1657–1747) in Naples.

It was during his first visit to Italy that Ramsay learned to execute material texture, poses, and gestures in the distinguished manner that would set him apart from other painters. He was in Italy a second time after 1754 to study contemporary portraiture. On his return to London in 1757, Ramsay's popularity increased, owing to his astute interpretations of his sitters' personalities. He was invited to paint the portrait of the Prince of Wales, along with other royal portraits. Although he had established a thriving business, Ramsay reached the apex of his career when the Prince of Wales came to the throne as George III in 1760 and appointed Ramsay principal painter in ordinary.

In that position Ramsay secured commissions to paint the king and queen (see nos. 62, 63). Because of the large demand for these official, full-length portraits, Ramsay neglected many requests from private patrons. He also engaged a good number of assistants, who were responsible for the duplication of the numerous versions of these royal portraits.

To his contemporaries, Ramsay was as much a man of letters as an artist. In 1754 he published *Dialogue on Taste* in response to *Analysis of Beauty* published by William Hogarth (1697–1764) a year earlier. In the 1770s Ramsay grew more active as a writer; his preferred subject was politics. He was widely travelled and came in contact with writers and philosophers in England and on the Continent. Ramsay died in Dover, on his way home to London from his fourth trip to Italy.

Sir Joshua Reynolds (1723–92)
One of the most renowned portrait painters of the 18th century, Reynolds first left his native Devonshire for London in 1740. There he was apprenticed to Thomas Hudson (1701–79) for about three years; during that time he embarked on his own independent career in Devonshire and London. The influence of William Hogarth (1697–1764) and Allan Ramsay (1713–84) is much more discernible at this formative stage than that of his teacher, Hudson.

As was the fashion of the day, Reynolds went to Rome in 1750; he returned to England in 1752 having accomplished the required

overland Grand Tour. While in Italy he studied the paintings of the great Italian masters such as Raphael (1483-1520), Correggio (c. 1489-1534), Titian (c. 1490-1576), and Michelangelo (1475-1564). Even before Reynolds became the first president of the new Royal Academy in 1768, his reputation as a portrait painter was established and his business exceeded that of any other contemporary portraitist. As early as 1755 he had almost a hundred sitters—a volume that required more and more studio assistants and apprentices (see nos. 31, 129).

His portraits often incorporated references to motifs from paintings he had seen on the Continent, which were drawn from antiquity and the High Renaissasnce. References to the antique were *de rigueur* in order to demonstrate a "compleat" education and satisfy the dictates of fashion.

Reynolds's prestigious reputation as a painter and an intellectual raised the status of artists in his day. His circle included Edmund Burke, Samuel Johnson, and Horace Walpole, among others. During his twenty-year affiliation with the Royal Academy, his annual *Discourses* expounding a rigid philosophy of ideal art became famous. The aesthetic tenets of this philosophy, derived from classical art, were directly opposed to the more romantic ideas emerging towards the end of the 18th century. In 1781 Reynolds visited Holland and Flanders. The more informal Dutch and Flemish paintings he saw on that trip provided him with a new set of references that led to a mellowing of his style of execution.

Although his position was quite strong, and he succeeded Allan Ramsay as principal painter to the court, Reynolds never found favour with George III, who preferred Thomas Gainsborough (1727-88). Towards the end of his life, Reynolds was less active; he retired in 1789 when his eyesight began to fail.

Peter Rindisbacher (1806-34)

Peter Rindisbacher's training is unknown, and yet during his short life he made a living as an artist and an illustrator for publications. He was born in Switzerland and at the age of fifteen emigrated with his family to settle in Lord Selkirk's Red River Colony.

The fledgling artist drew illustrations of the trip from Dordrecht to Hudson Bay and sketched the fur-trade route to Fort Garry. Once in the Red River Colony, Rindisbacher earned a living by selling his views of the settlement to men working for the Hudson's Bay Company. Six of his watercolours were produced as lithographs by W. Day after H. Jones in London in 1825. At the time no credit was given to Rindisbacher as the author of the views. Rindisbacher also did some watercolours on commission for the governor of the Red River Colony (see nos. 203, 204, 205, 206).

After much hardship, the Rindisbacher family moved to Illinois in 1826. Soon afterwards the artist was providing illustrations for *The American Turf Register and Sporting Magazine*.

George Romney (1734-1802)

George Romney received his earliest training in the shop of his father, a cabinetmaker in Dalton-in-Furness, Lancashire. His formal instruction in England lasted two years, from about 1755 until 1757, while he was a pupil with lesser known artists in Kendal and York.

Romney moved to London in 1762 but remained there only a year before leaving for Paris. In Paris he observed at first hand the paintings of artists such as Eustache Le Sueur (1616-55), which provided him with certain of the classical principles that would be a primary source of inspiration. Romney, like many of his contemporaries, particularly on the Continent, was preoccupied with the antique. He, too, spent two years in Italy, primarily in Rome and Venice, from 1773 to 1775. There he could study the ancient as well as the Renaissance sources that formed his repertory of motifs.

On his return to London, Romney settled into a thriving portrait business (see nos. 51, 101). Although he never exhibited at the Royal Academy, Romney was much respected as a painter and a thinker.

J. C. Schetky (1778-1874)

John Christian Schetky had an illustrious career as a marine painter and art teacher that spanned nearly eighty years. He was born in Edinburgh, where he attended the High School. Although little is known about his art training, he must have had some instruction, for at the age of fifteen he was assisting his mother, who gave drawing lessons. He took over her practice completely on her death two years later.

In 1801 Schetky travelled to the Continent, stopping in Paris, Geneva, Rome, and Florence. After this requisite tour, he taught drawing to undergraduates at Oxford for six years. That position permitted him to travel in the summers and to go on sketching tours. From 1808 to 1811 Schetky was professor of civil drawing at the Military College in Great Marlow, and from 1811 to 1836 professor of drawing at the Royal Naval Academy in Portsmouth. Schetky was made painter in watercolours to the Duke of Clarence, and in 1820 he became marine painter in ordinary to George IV. During this time he continued to paint marine pictures while he taught, on his own travels, and for commissions. He was conversant with the works of many contemporary artists and corresponded with several, for example J. M. W. Turner (1775-1851). In 1844 Schetky was made marine painter in ordinary to Queen Victoria.

Schetky's final teaching post was in Addiscombe, where he was professor of drawing at the East India College from 1837 until 1855. In spite of his teaching schedule and extensive travels, Schetky managed to exhibit at the Royal Academy from 1805 until 1872. His sea voyages, often undertaken for his patrons, and in their company, provided Schetky with his favourite subject matter. He worked in oil and in watercolour, and later in life he used pen and

ink. His oeuvre largely comprises marine views, detailed paintings of ships, and scenes related to royal sea voyages (see nos. 224-227).

Samuel Scott (1702?–72)

Little is known of Samuel Scott's origins and training. His student William Marlow, who was with him from 1756 until 1761, confirmed that Scott was born in London. It is known that Scott obtained a position in the Stamp Office that required only a small amount of his time but provided a regular income. The consequent degree of freedom may have facilitated Scott's painting career.

Scott emerges as a prominent figure through his involvement in two major projects, which entailed topographical and marine painting. One was a commission George Lambert (1700-1765) received to paint views of the East India Company settlements. Lambert was responsible for the architectural drawings and Scott undertook the marine subjects. The second project was the illustrations for a manuscript by William Hogarth (1697-1764) on his travels with a group of artists in 1732. Some of the sketches from this trip were later engraved by Scott with Hogarth. Scott also painted views of Plymouth and Mount Edgecumbe, which were engraved and published between 1750 and 1755.

Although his sea travel was very limited, Scott is famous for marine views, especially those illustrating naval actions during the Seven Years' War (see nos. 41, 42). These commissions were executed in his studio in Covent Garden, and the influence of Willem van de Velde (1633-1707) can be discerned. The Dutch artist's use of colour and his dramatic effects were a rich and constant resource for Scott.

Scott's reputation also rests on his depictions of London. Scott became especially adept in a type of city view inspired by the painting of Canaletto (1697-1768), who arrived in London in 1746. Scott's pen-and-ink drawings of the city date from as early as 1738. From the 1740s on, Scott concentrated on large oil canvases of London views, painted with a keen eye and little romanticized style. The subject of the city and the Thames yielded some of the strongest paintings Scott was to produce (see no. 2).

In 1761 Scott began to exhibit at the Society of Artists, and over the next ten years also showed at the Royal Academy and the Free Society. Owing to failing health, Scott moved to Bath, where he spent the last decade of his life.

Dominic Serres (1722-93)

Dominic Serres had an eventful beginning as a rebellious young man. He was born in Gascony and educated at the famous Benedictine school at Douai, but he resisted his parents' ambition to have him enter the church. Instead he fled to Spain and took up the life of a seaman. In time he became navigator of a trading vessel in the West Indies. He was captured and taken as a prisoner to London, most likely in 1748 during King George's War.

On his release, Serres settled in Northamptonshire and commenced a career in painting. His first mentor in England was another marine painter, Charles Brooking (1723-59). It was from Brooking that Serres learned the rudiments of painting, and it was due to their relationship that he began to acquire a clientele.

In spite of the fact that he was French, Serres was successful in England. He documented the British side of naval actions during the Seven Years' War and the American Revolution (see nos. 3-6, 52, 118). It has been suggested that his depiction of events is sometimes more accurate than the written records.

As Serres' reputation grew, he began to exhibit his marine views with the Incorporated Society of Artists, of which he became a member in 1765. He also exhibited with the Free Society, and from 1769 until his death with the Royal Academy, of which he was a founding member in 1768. Serres' position in London reached its apex when he was appointed marine painter to George III in 1780. A year before his death, Serres became librarian at the Royal Academy.

John Smibert (1688-1751)

Scottish born John Smibert was a house painter and plasterer in Edinburgh; on his arrival in London he became a coach painter and copier of paintings for art dealers. In 1719 Smibert left for Italy, where he was to spend most of his visit studying in Florence and Rome. When he returned to London in 1722, Smibert established a reputation as a portraitist and practised successfully until his departure for America.

Smibert left England in 1728 as a member of George Berkeley's group, whose aim was to establish a school in Bermuda for the education of American Indians. Berkeley had invited Smibert to join the group as a teacher of art and architecture. Although Berkeley returned to England when he failed to receive government money for his scheme, Smibert remained in America and settled in Boston in April 1729.

Smibert was already forty-one years old when he arrived in New England. He brought to his new practice a somewhat dull, late baroque style, as well as a collection of copies after painters such as Raphael (1483-1520), Nicolas Poussin (1594-1665), and Van Dyck (1599-1641), whose works Smibert had seen on his European travels. Once settled, Smibert adopted the prevalent realistic portrait style that suited New England sitters and his popularity grew; he augmented his income by selling engravings of well-known paintings. Many of Smibert's portraits, including the one of Sir William Pepperrell, done about 1746, were engraved (see no. 17).

Francis Swaine (c.1719/20–82)

The earliest known document that sheds any light on Francis Swaine's life is a list dated 1735 of clerks and officers employed by the "Treasurer and Commissioners of His Majesty's Navy". Swaine is recorded as a messenger.

It is quite likely that Swaine was a self-taught artist, though his work shows some influence of Charles Brooking (1723–59), a contemporary ship and marine painter. Another influence, that of Peter Monamy (1680–1749), is especially apparent in Swaine's rendition of a calm sea. The relationship between Swaine and Monamy is undocumented, but Swaine named his son Monamy.

Swaine's reputation derived from his success as a marine painter (see nos. 35, 43, 45, 46). Recognition came to him in his lifetime from the Society of Artists, where he exhibited from 1761 until his death. In fact, seven of his pictures were shown posthumously the following year.

George Godsell Thresher (c. 1779–1859)

George Thresher is known as a marine painter and a teacher of painting. He emigrated from England to America, and first worked in New York City, from about 1806 until 1812. He then opened a school for drawing, painting, and writing in Philadelphia.

In 1821 Thresher established the Academy of Drawing and Painting in Saint John, where he continued to teach and paint. In 1829 Thresher moved with his family to Charlottetown. There he went into business as a sign painter and decorator, while his wife taught art and painted city views. Although Thresher did not paint for a living, he continued to produce marine views throughout his life (see no. 209).

Louis-Hubert Triaud (1794–1836)

Louis-Hubert Triaud was born in London to French parents and spent his youth in France. Little is known about his early training as a painter, though at the age of twenty-six he is recorded as active in Quebec City. Records show that he painted *Procession de la fête-Dieu* in June 1824, while he was engaged as drawing and painting instructor at the Ursuline convent in Quebec City (see no. 164). The accounting records also document payments made to Triaud for restoration work on paintings belonging to the collection of the convent.

John Trumbull (1756–1843)

John Trumbull was one of America's most distinguished painters of current events. It was his documentation of the American Revolution in particular that earned the artist great renown. Trumbull was born in Lebanon, Connecticut, and brought up in a comfortable and sophisticated social environment. He attended Harvard, where he was graduated in 1773. When the Revolution broke out, Trumbull joined the army and became George Washington's aide-de-camp in 1775.

After leaving Harvard, Trumbull dabbled in painting by doing family portraits and views from ancient history. He had no formal art training until 1780, when he left for London with the intention of studying painting. There, while painting in the studio of Benjamin West (1738–1820), Trumbull was exposed to the best standards of history painting, which further inspired him to depict the contemporary history of America. Trumbull unfortunately did not desist from his anti-British stance and within a year of his arrival in England he was arrested on a charge of treason, imprisoned, and then compelled to leave the country.

On his return to England in 1784, Trumbull resumed his art studies with West and also attended classes at the Royal Academy. It was during this period that Trumbull painted scenes of the heroic events of the Revolution, which firmly established him as a prominent artist. In 1786 alone he produced *The Death of General Warren at the Battle of Bunker's Hill* and *The Death of General Montgomery in the Attack on Quebec* (see no. 104), which were later published as prints.

From 1794 until 1804 Trumbull also undertook diplomatic responsibilities on behalf of the Americans in London and let his painting career lapse somewhat. When he returned to New York in 1804, Trumbull earned his living by painting portraits and began his long involvement as a director of the American Academy of Fine Arts. During a subsequent stay in London (1809–12) Trumbull exhibited literary and religious subjects at the Royal Academy. After that visit, Trumbull once again settled in New York and exhibited with the American Academy, of which he was president from 1816 to 1835. Trumbull continued to paint portraits, landscapes, and allegorical subjects, but his greatest triumph was achieved in the scenes from the Revolution commissioned by Congress in 1817 for the rotunda of the American Capitol.

In 1831 Trumbull sold most of his paintings to Yale College, where a gallery was built to house the collection. He retired to New Haven and wrote his biography, which was published in 1841 with twenty-three plates engraved from his own drawings.

John Tweed (1869–1933)

John Tweed was trained in Glasgow with James Ewing (1831–1900), in London with Hamo Thornycroft (1850–1925), and in Paris with Jean Falguière (1831–1900). Tweed is best known for his portrait sculpture, which occurs mainly on monuments such as war memorials. Examples of his work can be found in London in Westminster Abbey, All Souls' Church, and St Paul's Cathedral.

The cast of Captain James Cook (see no. 89) reflects Tweed's talent for interpreting his subject. Although it is not the final version of the statue, the firm posture and set expression evoke Cook's strength of character and determination.

Edward Walsh (1756–1832)

Edward Walsh was born into one of the oldest families in Waterford, Ireland. He received his schooling in England and then went on to the University of Edinburgh and later to the University of Glasgow, where he received a medical degree in 1791. As a young man, Walsh

was interested in literary pursuits. He founded a literary society in Waterford and published some poetry. About 1792 his proposal for a universal alphabet appeared in *Anthologia Hibernica*. As a medical man, Walsh contributed articles to *The Medical and Physical Journal*, *The Edinburgh Medical and Surgical Journal*, and *The Amulet*.

Walsh started his career as a doctor aboard a ship sailing to the Gulf of Mexico. In 1796 he became assistant surgeon to the Sixty-fifth Regiment of Foot and the following year was transferred to the Twenty-ninth Regiment. In his capacity as assistant surgeon to the latter, he participated in an expedition to Holland in 1799, which he recorded and illustrated in *A Narrative of the Expedition to Holland, in the Autumn of the Year 1799: Illustrated with a Map of North Holland and Seven Views of the Principal Places Occupied by the British Forces* (London, 1800). In 1800 Walsh was promoted to the rank of surgeon and transferred to the Forty-ninth Regiment.

It was to join the Forty-ninth Regiment that Walsh came to Canada. He arrived at its headquarters in Fort George, Upper Canada, in 1804. While in Canada, Walsh also spent some time in Montreal, Fort Erie, York, and the St Joseph and St Mary settlements on Lake Huron. Wherever his duties took him, he managed to draw and to paint in watercolour. Walsh returned to England in 1807 and continued in the British forces until weakening health forced him to retire after the battle of Waterloo (1815).

Many of the views Walsh painted in Canada, such as those of Montreal, Lake Erie, Fort Erie, Fort George, and Queenston, were published as aquatints by Rudolph Ackermann between 1811 and 1814 (see nos. 157, 172).

Benjamin West (1738–1820)

Benjamin West was born in Springfield, Pennsylvania. His father, an innkeeper, did not stand in the way of his son's precocious inclination towards drawing and painting. West received some art instruction in Philadelphia from an English artist, William Williams (1727–91).

Through his reading, West recognized the importance of historical painting and the wealth of sources for such painting in ancient history. To further his education, West went to Italy in 1759. He was much influenced by Renaissance and baroque paintings, as well as by contemporary painters, in particular, Anton Raphael Mengs (1728–79) and Pompeo Batoni (1708–87), who espoused the neoclassical style prevalent in the late 18th century.

In 1763 West settled in London, where he was welcomed as an accomplished painter and established a successful career. He was a founding member of the Royal Academy in 1768 and its president from 1792 to 1820, except for one year.

Although West painted portraits (see no. 115), his fame rests largely on his often oversized historical paintings, which reflect morality lessons from the Bible, as well as from ancient and contemporary events. The death of General James Wolfe at the battle of the Plains of Abraham, for example, typified bravery and military commitment that West found worthy of commemoration (see no. 44). In his dramatic documentation of the historic event in the colonies, West has all the protagonists in contemporary dress to emphasize the validity of current events as subjects for painting. West structured the painting in a more conventional manner, however, with the figures in a continuous tableau, slightly reminiscent of a stage setting. The movement of the entire group is stressed in the individualized postures of shock shown by each of its members. The drama of the event is heightened by the strategic highlighting of Wolfe and the sky at the left. The pliant body of Wolfe is central to the composition, as it is, of course, to the narrative.

When the original version of *The Death of Wolfe* was exhibited at the Royal Academy in 1771, West received at least four requests for copies. The popularity of the painting increased not only because of the timeliness of the topic, but also because it was engraved by William Woollett in 1776; the prints sold immediately in large numbers. The success of the painting brought West the appointment of history painter to the king and wealth that no doubt helped him to provide his generous hospitality to American painters visiting London to further their artistic education.

John Wollaston (c. 1710–after 1767)

John Wollaston was born in England and began his painting career before his arrival in New York, where he remained from 1749 until 1753, painting portraits for a living and establishing himself professionally. His work took him to various parts of America, but he returned most frequently to Philadelphia. His travels also extended to India, and then back to England.

Although most of Wollaston's work reflects a concern for replication, his portrait of James Monk shows that the artist was also quite capable of capturing the personality of his sitter (see no. 73). Wollaston was one of the early British artists to acquaint fledgling painters in the colonies with techniques from abroad. It is notably his technique for painting textiles that has given him his reputation.

Joseph Wright of Derby (1734–97)

Joseph Wright of Derby studied in London with Thomas Hudson (1701–79) from 1751 to 1753 and again during 1756. In 1773 he travelled to Italy and worked there for two years. Back in England, Wright briefly established himself in Bath, anticipating that he would inherit the clientele of Thomas Gainsborough (1727–88) there. He is reported to have returned to his native Derby in 1778 and settled into a career of portrait painting.

In the 1760s Wright produced the paintings for which he is best remembered. They reflect a serious treatment of subjects related to the emerging Industrial Revolution. Paintings such as *Experiment*

with a Bird in an Air Pump (1768) were inspired by Wright's desire to document scientific and industrial experiments. Yet he imbued these paintings with all the drama and awe usually associated with the romanticized vision of landscape painting; he explored different modes of representing light, natural and artificial, as well as its reflective effects. Wright was aware of the research of such men as Erasmus Darwin, as well as of the developing industries in the Midlands and the scientific aims of groups such as the Lunar Society.

During the same period Wright also produced portraits in which he experimented with the effects of light and rural landscapes seen in moonlight. At the Royal Academy, where he exhibited from 1778 to 1782 and from 1788 to 1794, Wright also showed paintings of literary subjects such as *The Dead Soldier* (1789), which were later engraved. Wright also exhibited at the Society of Artists, where *The Iron Forge* was shown in 1772 (see no. 195). Although his enthusiasm for the factual and scientific did not abate, Wright's rendition of his subject was nearly always affected by his dramatic response to the landscape or setting.

Johan Zoffany (1733–1810)

Johan Zoffany was born Johannes Josephus Zauffaly near Frankfurt am Main. He began his artistic education with his father, who was cabinetmaker and architect to the court of Alexander Ferdinand, Prince von Thurn und Taxis, in Regensburg. It was there that Johannes was apprenticed to Martin Speer (c. 1702-65). About 1750 he went to Rome, where he observed at first hand the work of artists who turned to ancient Greek and Roman and Renaissance painters for inspiration.

In 1760 Zauffaly settled in London and it was there that he changed his name. At first Zoffany made a living as a decorator of clock faces and a drapery painter. With the support of the impresario David Garrick, he undertook to paint stage scenery and his reputation began to grow. By 1762 Zoffany was exhibiting at the Society of Artists and in 1769 George III nominated him to the Royal Academy.

Zoffany is best known for his conversation pieces—crowd scenes in a particular setting, with figures striking individual animated poses, or scenes of activity in which meticulous attention is paid to detail (see no. 181). Initially Zoffany used this genre to depict actors in costume in a scene from an actual play. In time, the conversation pieces, which were also produced in England by William Hogarth (1697-1764) and Thomas Gainsborough (1727-88), developed into portraits of groups in other milieus, particularly family groups. The conversation pieces reveal a world of information about contemporary taste in housing, clothing, hairstyles, and customs. One of Zoffany's best-known and most complex conversation pieces is *The Tribuna of the Uffizi* (1772-77/78), commissioned by Queen Charlotte, who had become the artist's patroness, and painted in Florence.

Zoffany's individual portraits enabled him to concentrate more fully on developing his sitters' personalities (see no. 145). He received portrait commissions throughout his life; among the most notable are his portraits of the family of Empress Maria Theresa of Austria.

After successful patronage in Europe, Zoffany returned to London in 1779 and remained there until 1783. When *The Tribuna* was not lauded by critics, Zoffany lost his position with the king and queen. With his clientele much decreased after a long absence, Zoffany decided to go to India. There he continued to paint portraits as well as conversation pieces, for which he now had an established set of formulas and made changes only to accommodate Indian motifs in the settings. At Lucknow, where Europeans were somewhat more relaxed about recording the extent of their absorption in things Indian, Zoffany was able to capture more of the exotic details of local Indian costume, settings, and artifacts.

Zoffany returned to London in early 1789, having amassed a substantial amount of money. He exhibited for the last time in 1800 and is not known to have painted during the final decade of his life.

BIBLIOGRAPHY

IRENE SZYLINGER

ARMS AND ARMOUR

Blackmore, Howard L. *British Military Firearms*. New York: Arco, 1962.

Brown, M. L. *Firearms in Colonial America*. Washington, D.C.: Smithsonian Institution Press, 1980.

Gooding, S. James. *The Canadian Gunsmiths 1608 to 1900*. West Hill, Ont.: Museum Restoration Service, 1962.

Hicks, James E. *Notes on French Ordnance, 1717 to 1936*. Mount Vernon, N.Y.: Private publication, 1938.

Latham, John Wilkinson. *British Military Swords*. London: Hutchinson, 1966.

Peterson, Harold L. *The American Sword, 1775-1945*. New Hope, Pa.: River House, 1954.

_____. *Arms and Armor in Colonial America 1526-1783*. Harrisburg, Pa.: Stackpole Books, 1956.

Rogers, H. B. C. *Weapons of the British Soldier*. London: Seeley Service, 1960.

ART AND ARTISTS

Allodi, Mary. *Canadian Watercolours and Drawings in the Royal Ontario Museum*. 2 vols. Toronto: Royal Ontario Museum, 1974.

Andre, John. *William Berczy: Co-Founder of Toronto*. Toronto: Borough of York, 1967.

Archibald, E. H. H. *Dictionary of Sea Painters*. Woodbridge, Suffolk: Antique Collectors' Club, 1980.

Baigell, Matthew. *A History of American Painting*. New York: Praeger, 1971.

Baskett, John, and Dudley Snelgrove. *English Drawings and Watercolours 1550-1850 in the Collection of Mr and Mrs Paul Mellon*. Exhibition catalogue. New York: Pierpont Morgan Library, 1972.

Bayard, Jane. *Works of Splendor and Imagination: The Exhibition Watercolor, 1770-1870*. New Haven: Yale Center for British Art, 1981.

Bell, Michael. *Painters in a New Land*. Toronto: McClelland and Stewart, 1973.

Bénézit, E., ed. *Dictionnaire des peintres, sculpteurs, dessinateurs et graveurs*. New edition, entirely revised under the supervision of the heirs of E. Bénézit. [Paris]: Librairie Grund, 1959-1962.

Brewington, Dorothy E. R. *Dictionary of Marine Artists*. Salem, Mass., and Mystic, Conn.: Peabody Museum of Salem and Mystic Seaport Museum, 1982.

Brigham, Clarence S. *Paul Revere's Engravings*. Second revised edition 1954. New York: Atheneum, 1969.

Carrick, Alice van Leer. *A History of American Silhouettes*. First edition 1928. Rutland, Vt.: Charles E. Tuttle, 1968.

Cooke, Martha E. *W. H. Coverdale Collection of Canadiana: Paintings, Watercolours, and Drawings*. Ottawa: Public Archives Canada, 1983.

Cooper, Helen A., with essays by Patricia Mullan Burnham, Martin Price, Jules David Prown, Oswaldo Rodriguez Roque, Egon Verheyen, and Bryan Wolf. *John Trumbull: The Hand and Spirit of a Painter*. Exhibition catalogue. New Haven: Yale University Art Gallery, 1982.

The Corcoran Gallery of Art. *A Catalogue of the Collection of American Paintings in The Corcoran Gallery of Art*. Vol. 1. Washington, D.C.: The Corcoran Gallery of Art, 1966.

Cordingly, David. *Marine Painting in England 1700-1900*. New York: Clarkson N. Potter, 1973.

Cummings, Frederick, Robert Rosenblum, and Allen Staley. *Romantic Art in Britain: Paintings and Drawings 1760-1860*. Exhibition catalogue. Philadelphia: Philadelphia Museum of Art, 1968.

Davis, Mary. *The Heritage of American Art*. Exhibition catalogue. New York: The American Federation of Arts, 1975.

Evans, Dorinda. *Benjamin West and His American Students*. Exhibition catalogue. Washington, D.C.: Smithsonian Institution Press, 1980.

Evans, G. N. D. *Uncommon Obdurate: The Several Public Careers of J. F. W. DesBarres*. Salem, Mass., and Toronto: Peabody Museum of Salem and University of Toronto Press, 1969.

Fielding, Mantle. *Dictionary of American Painters, Sculptors, and Engravers*. Revised and enlarged 1926. Green Farm, Conn.: Modern Books and Crafts, 1974.

Finley, Gerald. *George Heriot: Painter of the Canadas*. Exhibition catalogue. Kingston: Agnes Etherington Art Centre, Queen's University, 1978.

_____. *George Heriot 1759-1839*. Canadian Artists Series, no. 5, Dennis Reid, ed. Ottawa: National Gallery of Canada, 1979.

_____. *George Heriot: Postmaster-Painter of the Canadas*. Toronto: University of Toronto Press, 1983.

Flexner, James Thomas. *John Singleton Copley*. Boston: Houghton Mifflin, 1948.

Foote, Henry Wilder. *Catalogue of Portraits in the Essex Institute*. Salem, Mass.: Essex Institute, 1936.

Foskett, Daphne. *A Dictionary of British Miniature Painters*. Vols. 1 and 2. New York: Praeger, 1972.

———. *Collecting Miniatures*. Woodbridge, Suffolk: Antique Collectors' Club, 1979.

Gardner, Alber Ten Eyck, and Stuart P. Feld. *American Painting: A Catalogue of the Collection of The Metropolitan Museum of Art*. Vol. 1. New York: The Metropolitan Museum of Art, 1965.

Gaunt, William. *Marine Painting: A Historical Survey*. New York: Viking Press, 1976.

———. *Court Painting in England from Tudor to Victorian Times*. London: Constable, 1980.

Groce, George C., and David H. Wallace. *The New York Historical Society's Dictionary of Artists in America 1564-1860*. New Haven: Yale University Press, 1957.

Guyton, W. Lehman, and James M. Koenig. *A Basic Guide to Identifying and Evaluating American Silhouettes*. Exhibition catalogue. Waynesboro, Pa.: Renfrew Museum and Park, 1980.

Hachey, Paul A. *The New Brunswick Landscape Print 1760-1880*. Exhibition catalogue. Fredericton: Beaverbrook Art Gallery, 1980.

Hardie, Martin. *Watercolour Painting in Britain: The Eighteenth Century*. Vol. 1. Second edition. London: B. T. Batsford, 1967.

Harper, J. Russell. *Early Painters and Engravers in Canada*. Toronto: University of Toronto Press, 1970.

———. *Painting in Canada: A History*. Second edition. Toronto: University of Toronto Press, 1977.

Hayes, John. *Gainsborough Paintings and Drawings*. London: Phaidon Press, 1975.

Hoopes, Donelson F., and Nancy Wall Moure. *American Narrative Painting*. Los Angeles: Los Angeles County Museum of Art and Praeger, 1974.

Hubbard, R. H. *Thomas Davies c. 1737-1812*. Ottawa: National Gallery of Canada, 1972.

———. *Thomas Davies in Early Canada*. Ottawa: Oberon Press, 1972.

———. *Canadian Landscape Painting 1670-1930*. Madison: Elvenjem Art Center, University of Wisconsin, 1973.

Jackson, Mrs E. Nevill. *Silhouettes: A History and Dictionary of Artists*. New York: Dover Publications, 1981.

Jefferys, Charles W. *A Catalogue of the Sigmund Samuel Collection: Canadiana and Americana*. Toronto: Ryerson Press, 1948.

Josephy, Alvin M., Jr. *The Artist Was a Young Man: The Life Story of Peter Rindisbacher*. Fort Worth: Amon Carter Museum, 1970.

Kenin, Richard. *Return to Albion: Americans in England 1760-1940*. New York: Holt, Rinehart and Winston, 1979:1-60.

Kraemer, Ruth S. *Drawings by Benjamin West and His Son Lamar West*. New York: Pierpont Morgan Library, 1975.

Mallalieu, H. L. *A Dictionary of Watercolour Artists up to 1920*. 2 vols. Woodbridge, Suffolk: Antique Collectors' Club, 1976 and 1979.

Marceau, Henri. *Benjamin West 1738-1820*. Exhibition catalogue. Philadelphia: Pennsylvania Museum of Art, 1938.

A. Merriam-Webster. *Webster's Biographical Dictionary: A Dictionary of Names of Noteworthy Persons with Pronunciations and Concise Biographies*. First edition A. Merriam-Webster. Springfield, Mass.: G. and C. Merriam, 1943.

Miles, Ellen G. *Thomas Hudson 1701-1779: Portrait Painter and Collector: A Bicentenary Exhibition*. Exhibition catalogue. London: Greater London Council, 1979.

Millar, Oliver. *The Tudor, Stuart, and Early Georgian Pictures in the Collection of Her Majesty The Queen*. 2 vols. London: Phaidon Press, 1963.

———. *The Later Georgian Pictures in the Collection of Her Majesty The Queen*. 2 vols. London: Phaidon Press, 1969.

Murdoch, John, Jim Murrell, Patrick J. Noon, and Roy Strong. *The English Miniature*. New Haven and London: Yale University Press, 1981.

Noon, Patrick J. *English Portrait Drawings and Miniatures*. New Haven: Yale Center for British Art, 1979.

Oliver, Andrew, and Bryant F. Tolles, Jr. *Windows on the Past: Portraits at the Essex Institute*. Salem, Mass.: Essex Institute, 1981.

Ormond, Richard, ed. *National Portrait Gallery in Colour*. London: Studio Vista, 1979.

Pennsylvania Academy of the Fine Arts. *In This Academy: The Pennsylvania Academy of the Fine Arts, 1805-1967*. Exhibition catalogue. Philadelphia: Pennsylvania Academy of the Fine Arts, 1978:1-137.

Philadelphia Museum of Art. *Philadelphia: Three Centuries of American Art*. Exhibition catalogue. Philadelphia: Philadelphia Museum of Art, 1976.

Piers, Harry. *Robert Field*. New York: Frederic Fairchild Sherman, 1927.

Prown, Jules David. *John Singleton Copley 1738-1815*. Exhibition catalogue. Washington, D.C.: National Gallery of Art, 1965.

Quimby, Ian M. G., ed. *American Painting to 1776: A Reappraisal*. Charlottesville: The University Press of Virginia, 1971:159-80.

Richardson, Edgar P. *American Art*. Exhibition catalogue. San Francisco: Fine Arts Museums of San Francisco, 1976.

Richardson, Edgar P., Brooke Hindle, and Lillian B. Miller. *Charles Willson Peale and His World*. New York: Harry N. Abrams, 1982.

Troyen, Carol. *The Boston Tradition*. Exhibition catalogue. New

York: The American Federation of Arts, 1980.

Wallace, W. Stewart, ed. *The Macmillan Dictionary of Canadian Biography*. Fourth edition, revised, enlarged, and updated by W. A. McKay. Toronto: Macmillan of Canada, 1978.

Waterhouse, Ellis K. *Painting in Britain 1530 to 1790*. Harmondsworth, Middlesex: Penguin Books, 1954.

———. *Reynolds*. London: Phaidon Press, 1973.

———. *The Dictionary of British Eighteenth Century Painters in Oils and Crayons*. Woodbridge, Suffolk: Antique Collectors' Club, 1981.

Webster, Mary. *Johan Zoffany 1733-1810*. London: National Portrait Gallery, 1976.

White, Christopher. *English Landscape 1630-1850: Drawings, Prints, and Books from the Paul Mellon Collection*. Exhibition catalogue. New Haven: Yale Center for British Art, 1977.

Williams, Iolo A. *Early English Watercolours*. Reprint 1952. Bath: Kingsmead Press, 1970.

Wilmerding, John. *American Masterpieces from the National Gallery of Art*. New York: Hudson Hills Press, 1980.

Young, William, ed. *A Dictionary of American Artists, Sculptors, and Engravers*. Cambridge, Mass.: William Young, 1968.

FURNITURE AND DÉCOR

Barber, Edwin Atlee, Luke Vincent Lockwood, and Hollis French. *The Ceramic, Furniture, and Silver Collectors' Glossary*. New York: Da Capo Press, 1976.

Bjerkoe, Ethel Hall. *The Cabinetmakers of America*. New York: Doubleday, 1957.

Cornforth, John. *English Interiors 1790-1848: The Quest for Comfort*. London: Barrie and Jenkins, 1978.

Dobson, Henry, and Barbara Dobson. *The Early Furniture of Ontario and the Atlantic Provinces*. Toronto: M. F. Feheley, 1974.

———. *A Provincial Elegance*. Exhibition catalogue. Kitchener: Kitchener-Waterloo Art Gallery, 1982.

Downs, Joseph. *American Furniture: Queen Anne and Chippendale Periods in the Henry Francis du Pont Winterthur Museum*. New York: Macmillan, 1952.

FitzGerald, Desmond. *Georgian Furniture*. Third revised edition 1947. London: Her Majesty's Stationery Office, 1969.

Fowler, John, and John Cornforth. *English Decoration in the Eighteenth Century*. Princeton: Pyne Press, 1974.

Garvan, Beatrice B., and Charles F. Hummel. *The Pennsylvania Germans: A Celebration of Their Arts 1683-1850*. Exhibition catalogue. Philadelphia: Philadelphia Museum of Art, 1982.

Greenlaw, Barry A. *New England Furniture at Williamsburg*. Williamsburg: Colonial Williamsburg Foundation, 1974.

Hewitt, Benjamin A., Patricia E. Kane, and Gerald W. R. Ward. *The Work of Many Hands: Card Tables in Federal America 1790-1820*. Exhibition catalogue. New Haven: Yale University Art Gallery, 1982.

Horner, William Macpherson. *Blue Book: Philadelphia Furniture, William Penn to George Washington*. Washington, D.C.: Highland House, 1977.

Kane, Patricia. *Three Hundred Years of American Seating Furniture*. Boston: New York Graphic Society Books, 1976.

Kirk, John T. *Early American Furniture*. New York: Alfred A. Knopf, 1970.

Lessard, Michel. *Complete Guide to French Canadian Antiques*. Translated by Elizabeth Abbott. Agincourt, Ont.: Gage, 1974.

Little, Robert. *Chairs: Four Hundred Years of Social and Stylistic Changes*. Montreal: Montreal Museum of Fine Arts, 1982.

Mayhew, Edgar de N., and Minor Myers, Jr. *A Documentary History of American Interiors*. New York: Charles Scribner's Sons, 1980.

Minhinnick, Jean. *At Home in Upper Canada*. Toronto: Clarke, Irwin, 1983.

Montgomery, Charles F. *American Furniture: The Federal Period, in the Henry Francis du Pont Winterthur Museum*. New York: Viking Press, 1966.

Pain, Howard. *The Heritage of Upper Canadian Furniture*. Toronto: Van Nostrand Reinhold, 1978.

Palardy, Jean. *The Early Furniture of French Canada*. Translated by Eric McLean. Toronto: Macmillan of Canada, 1963.

Peterson, Harold L. *American Interiors from Colonial Times to the Late Victorians: A Pictorial Source Book of American Domestic Interiors*. New York: Charles Scribner's Sons, 1971.

Randall, Richard H. *American Furniture*. Boston: Museum of Fine Arts, 1965.

Shackleton, Philip. *The Furniture of Old Ontario*. Toronto: Macmillan of Canada, 1973.

Strange, Thomas Arthur. *English Furniture Decoration, Woodwork, and Allied Arts*. New York: Bonanza Books, 1950.

Symons, Scott. *Heritage: A Romantic Look at Early Canadian Furniture*. Toronto: McClelland and Stewart, 1971.

Ward-Jackson, Peter. *English Furniture Designs of the Eighteenth Century*. London: Her Majesty's Stationery Office, 1958.

Webster, D. B. *English Canadian Furniture of the Georgian Period*. Toronto: McGraw-Hill Ryerson, 1979.

Webster, D. B., ed. *The Book of Canadian Antiques*. Toronto: McGraw-Hill Ryerson, 1974.

Whitehill, Walter Muir, ed. *Boston Furniture of the Eighteenth Century*. Boston: The Colonial Society of Massachusetts, 1974.

GRAVESTONES

Duval, Francis Y., and Ivan B. Rigby. *Early American Gravestone Art in Photographs*. New York: Dover Publications, 1978.

Gillon, Edmund Vincent, Jr. *Early New England Gravestone Rubbings*. New York: Dover Publications, 1966.

Hanks, Carole. *Early Ontario Gravestones*. Toronto: McGraw-Hill Ryerson, 1974.

Trask, Deborah. *Life How Short: Eternity How Long: Gravestone Carving and Carvers in Nova Scotia*. Halifax: Nova Scotia Museum, 1978.

HISTORICAL AND CULTURAL BACKGROUND

Adams, William Howard, ed. *The Eye of Thomas Jefferson*. Exhibition catalogue. Washington, D.C.: National Gallery of Art, 1976.

Allen, Robert S., ed. *The Loyal Americans: The Military Role of the Loyalist Provincial Corps and Their Settlement in British North America*. Exhibition catalogue. Ottawa: National Museums of Canada, 1983.

Ayres, Linda. *Harvard Divided*. Exhibition catalogue. Cambridge, Mass.: Fogg Art Museum, Harvard University, 1976.

Careless, J. M. S., ed. *Colonists and Canadians 1760-1867*. Toronto: Gage, 1971.

Cooper, Wendy A., Jonathan L. Fairbanks, Anne Farnam, Brock W. Jobe, and Martha B. Katz-Hyman. *Paul Revere's Boston: 1735-1818*. Exhibition catalogue. Boston: Museum of Fine Arts, 1975.

Craig, Gerald Marquis. *Upper Canada: The Formative Years 1784-1841*. Toronto: McClelland and Stewart, 1963.

Davidson, Marshall B. *The American Heritage History of Colonial Antiques*. New York: American Heritage, 1967.

Garfield, Leon. *The House of Hanover: England in the Eighteenth Century*. London: André Deutsch, 1976.

Honour, Hugh. *The European Vision of America*. Exhibition catalogue. Cleveland: Cleveland Museum of Art, 1975.

Jarrett, Derek. *England in the Age of Hogarth*. Reprint 1974. Frogmore, St Albans, Hertfordshire: Granada, 1976.

Klingender, Francis D. *Art and the Industrial Revolution*. Revised edition 1947. Edited and revised by Arthur Elton. Fairfield, N.J.: Augustus M. Kelley, 1968.

MacNutt, William Stewart. *The Atlantic Provinces: The Emergence of Colonial Society 1712-1857*. Toronto: McClelland and Stewart, 1965.

Miller, John C. *The First Frontier: Life in Colonial America*. New York: Dell, 1966.

Mingay, G. E. *Georgian London*. London: B. T. Batsford, 1975.

Montgomery, Charles F., and Patricia E. Kane, general eds. *American Art 1750-1800: Towards Independence*. Exhibition catalogue. Boston: New York Graphic Society Books, 1976.

Neatby, Hilda Marion. *Quebec: The Revolutionary Age, 1760-1791*. Toronto: McClelland and Stewart, 1966.

Ouellet, Férnand. *Lower Canada, 1791-1840: Social Change and Nationalism*. Toronto: McClelland and Stewart, 1980.

Palmer, Alan. *The Life and Times of George IV*. London: Cardinal, 1975.

Pearson, Kenneth, and Patricia Connor. *1776: The British Story of the American Revolution*. Exhibition catalogue. Greenwich: National Maritime Museum, 1976.

Philadelphia Museum of Art. *Philadelphia: Three Centuries of American Art*. Exhibition catalogue. Philadelphia: Philadelphia Museum of Art, 1976.

Plumb, J. H. *The First Four Georges*. Reprint 1956. London: Hamlyn, 1974.

———. *England in the Eighteenth Century*. Reprint 1950. Harmondsworth, Middlesex: Penguin Books, 1980.

Plumb, J. H., and H. Wheldon. *Royal Heritage*. London: British Broadcasting Corporation Publications, 1977.

Rudé, George. *Hanoverian London 1714-1808*. London: Secker and Warburg, 1971.

Russell, Loris. *Everyday Life in Colonial Canada*. London: B. T. Batsford, 1973.

Spendlove, F. St George. *The Face of Early Canada*. Toronto: Ryerson Press, 1958.

Stanley, George F. G. *Canada Invaded 1775-1776*. Edited by John Swettenham. Toronto: Hakkert, 1973.

Strong, Roy. *A Pageant of Canada*. Exhibition catalogue. Ottawa: National Gallery of Canada, 1967.

Tracy, Berry B., and William H. Gerdts. *Classical America 1815-1845*. Exhibition catalogue. Newark: The Newark Museum, 1963.

Wilson, Bruce. *As She Began: An Illustrated Introduction to Loyalist Ontario*. Toronto: Dundurn Press, 1981.

POTTERY AND GLASS

Collard, Elizabeth. *Nineteenth-Century Pottery and Porcelain in Canada*. Montreal: McGill University Press, 1967.

———. *The Potters' View of Canada*. Montreal: McGill-Queen's University Press, 1984.

Innes, Lowell. *Pittsburgh Glass, 1797-1891: A History and Guide for Collectors*. Boston: Houghton Mifflin, 1976.

Webster, D. B. *Early Canadian Pottery*. Toronto: McClelland and Stewart, 1971.

———. *Early Slip-Decorated Pottery in Canada*. Toronto: Musson, 1969.

Wilson, Kenneth M. *New England Glass and Glassmaking*. New York: Crowell, [1972].

Zerwick, Chloe. *A Short History of Glass*. Corning, N.Y.: The Corning Museum of Glass, 1980.

SILVER

Buhler, Kathryn C. *American Silver 1655-1825 in the Museum of*